Rave Reviews for Bestselling
FROM COUCH TO CORPORATION
By Iris Martin

"Your book is awesome, as is your friendship, counsel and amazing insight."

President William Jefferson Clinton

"Your book is an extraordinary document, one which lays out an amazing blueprint for the ways we can preserve, protect and enhance the transformative impact which the President has had on this country."

Steve Grossman, former Chairman, Democratic National Committee

'Your book and your advice have been greatly appreciated. My success, and Philadelphia's success, are surely your successes as well."

Governor Ed Rendell

"Having your book, *From Couch to Corporation,* as a handbook, as well as the study performed by you and your Institute, has helped me understand the complexity of organizational change, and how to hit the ground running as Philly's new police commissioner."

John Timoney, Miami Police Commissioner,
former Philadelphia Police Commissioner

"Maintaining flexibility is management's principal responsibility. It is in this area that consultants like Iris Martin can contribute greatly. The Bank of Scotland has benefited from applying Iris's ideas and skills. I commend this book to its readers."

Peter Burt, Chairman, the Bank of Scotland

"For any psychologist and consultant seeking to apply his or her skills to the great challenges of the corporation, this book is invaluable. Lucidly written, concrete, specific and practical."

Nathaniel Branden, PH.D. Author of The Six Pillars of Self Esteem

"One of the few books that looks at organizational change through the prism of personal change. Transformation, that overused word, is given new meaning as the integration between personal growth and deep cultural change."

Dr. Warren Bennis, Distinguished Professor of Business
Administration at USC and author of Creative Collaboration

"The job of a therapist is to create a context for change. Iris Martin draws a beautifully detailed map from the therapist's door into the corporate terrain. Poetic and always rich in examples, she helps readers shape their talents to transform corporations."

Stephen and Carol Lankton, Corporate consultants and authors of
The Answer Within: Tales of Enchantment, Enchantment
and Intervention in Family Therapy and Practical Magic.

"Your book and your work has helped us get a considerable competitive advantage, plus you are a friend who is fun to have around!"

Martin Gray, former CEO, Nat West Bank

MORTGAGE
WARS

Also by Iris Martin, M.S.

From Couch to Corporation
The President's Psychoanalyst

MORTGAGE WARS

How You Can Fight Fraud and Reverse Foreclosure

Iris Martin

PACIFIC COAST PUBLISHING

For information, contact:
Pacific Coast Publishing
2509 Wilshire Blvd.
Los Angeles, CA 90052
Email: Pacificcoastpub@aol.com
Website: www.yourmortgagewar.com

Library of Congress Control Number [To Come]

ISBN 978061526396

10 9 8 7 6 5 4 3 2 1

FIRST EDITION

Available to the book trade via SCB Distributors 1-800-729-6423

PLEASE NOTE: The author and the publisher of this book strongly recommend that any homeowner undertaking a mortgage war consult and retain a qualified attorney. For referrals, go to www.yourmortgagewar.com

Contents

For Michael, with gratitude and wonder.

For Louise for her unwavering support.

And for my friend, Sherrie Savett,
who embodies the brilliance, creativity
and determination of an excellent attorney.

"The institutions seem to adopt the attitude
that since they have been doing this for so long
unchallenged, this practice equates with legal compliance. . .
their weak legal arguments compel the Court
to stop them at the gate."

Judge Christopher A. Boyko

Acknowledgements

My interest in writing this book has come from my lifelong fascination with the process of transformation. Clearly, there is a need for a transformation of the financial services industry and the agencies that oversee it. The conspiracy to defraud homeowners is the most obvious example of the need for transformation.

I also became interested as a former psychotherapist, who, for three decades, specialized in transformational psychology. The home is the family's refuge from the daily stressors of the world. The kitchen is the heartbeat of the home. When families, duped by the conspiracy, were illegally foreclosed and unlawfully evicted from their homes, they suffered irreparable psychological harm. They lost their confidence and faith in each other, they were forced on the street by their fraudulent lenders and they lost their integrity and life savings. I hope this book can help them heal.

I also hope this book motivates them to file a legal complaint and go to court. Even after eviction, there are many remedies at their disposal to undo the damage caused by fraudulent brokers and lenders.

I would like to acknowledge the following people for their inspiration:

First, gratitude and love goes to David Teiger, my brilliant lifelong mentor. I continue to be a figment of his amazing imagination. Without him, none of my achievements would have been possible and my life would have taken a far less interesting turn.

Special thanks to transformational President Bill Clinton, who gave me a world view from the perspective of the Oval Office. I will always treasure our working relationship and continuing friendship and his enthusiastic endorsement of my book, *From Couch to Corporation*.

Deep appreciation goes to my political mentor, former DNC Chairman Steve Grossman, who led me into the White House and helped make "transformation" a household word. His exceptional integrity, brilliant insights and cheerful counsel helped me navigate the world of politics at the highest level.

Much gratitude to Secretary of State Hillary Rodham Clinton for her support and friendship since she was our First Lady. Her warm heart and clear mind have had an enormous impact on our country and the world, and she is, by far, the most brilliant woman of my generation. Her appointment of me on the White House Millennium Council gave me a role in planning the global rollout of the 21st century.

Special thanks to Governor Ed Rendell for his friendship and support for over three decades.

Thanks to Senator Arlen Specter for fighting for the rights of everyday Americans.

Thanks to Robert J. Allan, Stella Allan, Martin Synder and Rod Rummelsberg of the Allan Law Group for their friendship, counsel and pioneering efforts on behalf of homeowners in California.

Thanks to attorney April Charney, "The Foreclosure Killer," for her support in promoting this book. Thanks to attorney Kevin Demet for his generous interpretations of his landmark Andrews vs. Chevy Case pleadings.

Much gratitude to Neil Stearns of Ventureiab for teaching me the culture and customs of Hollywood and protecting me from its landmines.

Special thanks to forensic mortgage auditor Marie McDonnell for sharing her insights and work product. Ditto to auditor Joseph Bosogno.

Eternal gratitude to Nigel Yorwerth and Patricia Spadaro for their advice, counsel, know how and creative involvement in this project. Thanks to Chris Prentiss for introducing me to them and to Aaron Silverman.

Special thanks to Amber Amodeo, who worked on this project as hard as I did. There were many nights we caught ourselves babbling to each other in legalese.

Thanks to Team Iris: Ugaro, Nena, Christine, Melody, Peter Emanuelle and Thor.

Eternal thanks to my mother and my friends who support my creativity. Without them, I would not be a global citizen, nor would I be able to pursue my projects with such passion.

Iris Martin
March 2009, Malibu, California

"Where we love is home. Home that our feet may leave, but not our hearts."

Oliver Wendell Holmes

QUESTION:
What do Judges Boyko, O'Malley, Rose, Shaw,
Rosenblatt, Bryant, Schack, Martin, Foley
and Kurtz have in common?

ANSWER:
They all dismissed foreclosures,
finding in favor of the homeowner.

WHY?:
Because the lenders had
no legal standing to foreclose.

WHAT THIS MEANS:
You may already own your home
free and clear and just don't know it.

"There has been fraud in the solicitation, origination, processing, closing, servicing and securitizing of toxic loans; fraud in the packaging, selling and credit-rating of mortgage backed securities; fraud in the courtroom; fraud in the boardroom, fraud on the floor of the Stock Exchange and fraud in the media who have suppressed this story. There is plenty of fraud to go around."

A retired Appellate Judge

THE CONSPIRACY TO
DEFRAUD
HOMEOWNERS

"It seems a no-brainer that a judge would make sure that every foreclosure has a legal claim."

April Charney, Florida Attorney,
known as "The Foreclosure Killer"

Reversal of Misfortune

It is estimated that in the last three years, over six million homeowners have been foreclosed, the majority foreclosed on illegally. It is also estimated that in the next three years, an additional ten million homeowners will be forced into foreclosure when their toxic loans reset. This is a problem of epic proportions and we must do something about it. If you are a victim of predatory lending, and have been targeted by the conspiracy to defraud homeowners, there is plenty you can do.

The purpose of this book is to help you save your home from fraud or foreclosure and show you how to confront your predatory lender. But first, we must start at the beginning to help you understand why and how your mortgage meltdown occurred. It isn't pretty. But it is real, and you have legal rights and remedies at your disposal. So don't despair. And try to control the natural impulse to jump to the "how to" chapters in this book. It's better for you to take this one step at a time, as it is a steep learning curve even for attorneys to grasp.

As a former psychotherapist and global expert on transformational psychology, I understand the emotional trauma caused by being defrauded and forced into foreclosure. Your

home, next to your family, is your sanctuary, and I will explain not only how you were duped, but the impact it has had, and will continue to have on you and your family. Attachment theory postulates that humans are social beings who have an inherent drive to bond together and form unions. These unions are mostly families, partners or couples.

The home, for most people, is the single largest financial and psychological investment they will ever make in their lifetime. As such, homeowners meet multiple emotional needs just by identifying with and living in their homes. When homes are ripped away, families are fragmented and fractured, and lives are torn apart. Consider being defrauded, foreclosed or evicted as one big identity theft; painful, terrifying and traumatic. I will recommend psychological remedies and successful strategies to help you heal.

In the following chapters, you will learn about the conspiracy created to defraud you, how the fraud was committed and the impact it has had not only on your world, but on the world at large.

Most importantly, you will learn what to do about it. How to assess whether you have been a victim and what steps to take to reverse a foreclosure or eviction action, as well as how to restructure your loan, or get it extinguished. You will also learn how to go to court and seek damages. The courts, you will find, are waking up to the illegal machinations of fraudulent brokers and lenders and taking the side of defrauded homeowners. Therefore, I have included key legal cases, motions and judicial orders to illustrate this hopeful and recent trend.

You are not alone. So let's start at the beginning.

You were quietly living your life, like millions of other homeowners, when the nightmare began. And it led to your mortgage meltdown.

There were many tactics used to seduce you.

You may have been enticed into buying a home you couldn't afford, based on an adjustable mortgage with no money down. You had no way of knowing the home's appraisal had been inflated, or that your mortgage payment would skyrocket, forcing you into foreclosure.

You may have been seduced into taking out a credit line based on equity in your home. Little did you know that a credit crisis was

coming and your cash out would be frozen just as you were halfway through a renovation. Or that your monthly payment was variable, while your cash out was fixed.

Or worst of all, you may have been solicited by an overly zealous loan broker or phoned countless times by "America's Favorite Lender" who convinced you to refinance your fixed rate mortgage into an adjustable rate "negative amortized" loan. In this scenario, you've not only lost the equity in your home and your home itself, but also your life savings by making the adjusted payments to keep a roof over your head for as long as possible.

However you were drawn into the maelstrom of easy credit, inflated real estate and predatory loans, you were initially approached by a predatory broker or lender. A licensed professional with a fiduciary responsibility to protect you: but instead, someone who chose to exploit and defraud you.

This broker or loan officer did not view you, an unsuspecting homeowner, as a client. Rather, you were seen as a pawn used to meet loan quotas determined by Wall Street and engineered by your lender.

The mortgage meltdown that began in your living room has consumed Main Street. Millions of homeowners have been affected and more are in the pipeline to financial ruin. And contrary to the myth, not just subprime homeowners have been affected; middle class and wealthy homeowners have been defrauded as well.

The mortgage meltdown that spread like wildfire has been perpetuated by a conspiracy of brokers, loan officers, title agents, investment banks, financial institutions and government agencies. A conspiracy is "an evil, unlawful or surreptitious plan or plot, formulated in secret agreement, between two or more persons, to commit a crime in concert, or accomplish a purpose through illegal action."

This conspiracy's plan was to defraud you, homeowner, by selling toxic "non-traditional" loans created by Wall Street to meet the market demand for mortgage backed securities. The conspiracy's single motive was greed. Greed in the form of fees, kickbacks, rebates, commissions, bonuses, golden parachutes, premiums and profit.

Everyone—from the realtor who overpriced the property, to the

appraiser who inflated its value, to the mortgage broker who received undisclosed kickbacks and rebates, to the investment banker who engineered the securitization process, to the Fed who encouraged the fraud, to the mortgage servicer who illegally foreclosed, to the lender's attorney who unlawfully evicted—they were all on the take.

The conspiracy relished in your lack of sophistication and inexperience in reading complex and misleading loan documents. It created precise narratives to overcome your objections. And if you are a minority, or elderly, or not versed in English, or had questionable credit or a lackluster financial history, you were the conspiracy's most tantalizing prey.

The conspiracy did not just target the subprime market. Its lust for greed infiltrated every facet of society, from the neighborhoods that were "reverse red-lined" to the wealthy suburbs peppered with two career couples. Whether sub-prime or prime cut, the conspiracy counted on America's general belief that reading loan documents is as mindboggling as interpreting its own x-rays.

The conspiracy unlawfully capitalized on the Federal Reserve's anthem that everyone should own a piece of the American dream. The Fed's intent was to lower interest rates so more Americans could afford homes. The Fed also approved of adjustable rate mortgages, as most homeowners move every seven years. But the Fed did not predict that later, when the U.S. Senate chimed in, claiming that a relaxation of credit and underwriting standards would help more people gain homeownership, the conspiracy was baptized to print money.

The tactics of the conspiracy included misrepresentation and fraud. Misrepresentations about home values and loan products; fraud in concealing the downside of predatory loans and mortgage backed securities. The conspiracy's targets were homeowners and investors, simultaneously defrauded in a parallel scheme of falsely inflated real estate and over-valued derivatives. But in the end, all that was left were loans that could not be paid back and derivatives that could not be monetized.

This conspiracy, largely ignored by the US government, has generated a global financial crisis—the likes of which that have never

been seen before in human history. A sixty trillion dollar crisis so vast and deep, that ultimately, there will not be enough currency in the world to pay for it. An insurmountable pyramid of debt built on poor credit, bad loans, phony ratings, vaporous derivatives and useless credit default swaps. And with over three trillion dollars already thrown in its black hole, it shows not one particle of light.

Further, this mountain of debt, based on real estate that has lost half of its value, cannot be legally linked to the mortgages and notes used to securitize it. Why? In the haste to sell mortgages to Wall Street, assignments and transfers went unrecorded and notes were lost or even destroyed. Crimes, including forgery and RICO, were routinely committed. Homeowners who are challenging their lenders' standing to foreclose are winning in courts across the nation.

Innocent taxpayers, some of them now homeless, are left holding the bag of toxic loans and mortgage backed securities, thanks to the government's bailout of its Wall Street cronies. Investors who believe their shares of mortgage backed securities are legally tied to real estate will get another rude shock when they learn their shares were not legally securitized at all.

But, homeowner, that is not your problem. Your problem is saving your home and ridding yourself of your toxic loan by getting it restructured or extinguished altogether. This book will show you how.

Your home is your investment and psychological haven. You struggled and saved to purchase it. You sacrificed to keep it going. You spent your spare cash to improve it, landscape it, decorate it, renovate it and update it. Your home has housed births, deaths, weddings, bake sales, play dates, Boy Scout meetings, Super bowl parties, yoga classes and holiday celebrations.

And now a conspiracy of predators wants to take it away from you because you can't pay back a toxic loan that never should have been created or sold. One for which your "lender" has already been paid in full plus a hefty premium.

It's time to fight back. It's time to protect your rights and your American dream. You owe it to yourself to take aim against the conspiracy of predators who have defrauded you in the name of profit.

You may ask yourself, how did this happen? How did the economy, buoyed just nine years ago by a transformational president and a budget surplus, suddenly collapse under the weight of so much tainted and worthless paper? Well, the downfall of this sophisticated, digitized, CEO-driven global conspiracy occurred through a combination of sloppy accounting and bad karma.

In its quest to make fast money, the conspiracy conned borrowers, forged documents and split mortgages and notes, rendering them unenforceable. The euphoria of gaining so much wealth just by the click of a mouse was so intoxicating and addictive, that it ignored underwriting standards, risk ratios and leverage models.

During the derivatives explosion, mortgage-backed securities were issued and leveraged before the ink was dry on the predatory loans required to legitimize them. Notes were sliced and diced into multiple paying forward credit-based tranches. Shares were sold based on falsely inflated credit ratings. Derivatives were swapped and gambled to the hilt, making Vegas look prudent by comparison.

And as dirty money begot fleeting money, more homes were built, appraisals were inflated, loan applications were fudged and homeowners defrauded. All the while, the Fed and Wall Street bragged that homeownership had reached an all time high. High on what?

But, as they say, the devil is in the details. When victimized homeowners reeling from payment shock were forced into foreclosure, the karmic cycle reversed. As a tsunami of foreclosures drowned Main Street, flooding homes and forcing homeowners into debt-drenched streets, those who refused to leave took to the courts.

Tragically, some 80% of homeowners, overwhelmed and stressed to the breaking point, wearily succumbed and turned in their keys. But others fought back. In the process, they innocently unraveled the hidden interweaving of conspiring brokerages, banks, investment banks, trusts and credit rating agencies.

This reversal of misfortune is the subject of this book.

Homeowners are now fighting the conspiracy that was determined to destroy the American dream. Homeowners are proving daily that, necessity is indeed the mother of all invention, by devouring law

books, waging legal battles and walking out of court with their mortgages extinguished and their homes free and clear.

Had junk bonds not led to derivatives, had derivatives not led to mortgage backed securities and had the Federal Reserve not praised them as the second coming, there would be no foreclosure crisis. America and the globe would have continued to sleep walk through their financial dealings, relying on politically motivated fiscal policies and corrupt government agency leaders.

But spiritually, this crisis was meant to be. It will spur a revolution on Main Street. It will lead to a transformation of homeowners who will no longer be intimidated by behemoth banks and broken government agencies. It will create a new set of judicial precedents from judges who have disciplined predatory lenders for their arrogance, immorality and greed.

When a few disgruntled homeowners took on the establishment, the collective unconscious cheered. Like neurons charging, lawsuits are cropping up daily in the body judicial. Victories for homeowners have been celebrated from coast to coast. A renewed faith in our legal system is brewing, thanks to an appreciation of the consumer laws governing financial transactions.

Big brother is losing and the Main Street little guy is winning. Consider it divine intervention.

Homeowners are now embracing the Truth in Lending Act and the Real Estate Settlement Procedures Act. They are learning about quiet title, fraud, RICO, usury, unjust enrichment and unfair competition. They are challenging pre-historic bankruptcy attorneys and crooked lenders. They are screaming for transparency and demanding to see their original notes. And judges are throwing lenders out of court that can't produce them.

This book details the revolution, from the Attorney Generals who have filed and settled class action suits against America's largest lenders—to homeowners, not only playing foreclosure defense, but engineering offensive mortgage showdowns in court.

If you own a home and have been victimized by financial terrorism, this book will help you defend yourself and launch an offensive

attack against your predatory lender. You will be able to get your toxic mortgage restructured or totally extinguished. Over 60% of mortgages are adjustable. The majority of adjustable mortgages between 2001 and 2008 were sold, pooled, then sliced and diced into mortgage backed securities. Predatory lenders cannot foreclose on mortgages if they are not a current party of interest on the mortgage and note. Nor can they produce the thousands of parties who each own a sliver as a share of a mortgage backed security, who are the real note holders of sorts.

There are powerful legal remedies at your disposal.

So if you have been defrauded, foreclosed or evicted from your precious home, there is light at the end of the tunnel. It is time for your own personal bailout. It is time to fight back with an arsenal of legal weapons.

If you have already been evicted, there is a good chance it was done unlawfully, based upon a fraudulent foreclosure. You may not be able to get back your home, but you can file a legal complaint and demand damages at least equal or greater than the value of your lost home. If you have already been foreclosed, don't give up and don't move out. There is a good chance that your foreclosure was illegal. And if you are in payment shock and suspect you are a victim of predatory loan practices, get ready to launch your mortgage war.

The predator has become the prey.

The following complaint, filed by Edmund Brown, Attorney General of California, against Countrywide, beautifully details the fraud committed against homeowners just like you. Bank of America recently settled this claim for over 8.7 billion dollars.

CASE STUDY 1

The People of the State of California
v.
Countrywide Financial

Case Study One

EDMUND G. BROWN JR.,
Attorney General of the State of California
ALBERT NORMAN SHELDEN
Senior Assistant Attorney General
RONALD REITER
Supervising Deputy Attorney General
KATHRIN SEARS (Bar No. 146684)
ROBYN SMITH (Bar No. 165446)
BENJAMIN G. DIEHL (Bar No. 192984)
LINDA HOOS (Bar No. 217620)
Deputy Attorneys General
300 S. Spring Street, Suite 1702
Los Angeles, CA 90013
Telephone: (213) 897-5548
Facsimile: (213) 897-4951

Attorneys for Plaintiff,
the People of the State of California

SUPERIOR COURT OF THE STATE OF CALIFORNIA
FOR THE COUNTY OF LOS ANGELES COUNTY
NORTHWEST DISTRICT

Case No.: LC081846
FIRST AMENDED COMPLAINT
FOR RESTITUTION, INJUNCTIVERELIEF,
OTHER EQUITABLE RELIEF, AND CIVIL PENALTIES

THE PEOPLE OF THE STATE OF CALIFORNIA,
Plaintiff,
v.
COUNTRYWIDE FINANCIAL
CORPORATION, a Delaware corporation;
COUNTRYWIDE HOME LOANS, INC., a
New York Corporation; FULL SPECTRUM
LENDING, INC., a California Corporation;
ANGELO MOZILO, an individual;
DAVID SAMBOL, an individual; and
DOES 1-100, inclusive,
Defendants.

COMPLAINT

Plaintiff, the People of the State of California, by and through Edmund G. Brown Jr., Attorney General of the State of California, alleges the following, on information and belief:

I. DEFENDANTS AND VENUE

1. At all relevant times, defendant Countrywide Financial Corporation ("CFC"), a Delaware corporation, has transacted and continues to transact business throughout the State of California, including in Los Angeles County.

2. At all relevant times, defendant Countrywide Home Loans, Inc. ("CHL"), a New York corporation, has transacted and continues to transact business throughout the State of California, including in Los Angeles County. CHL is a subsidiary of CFC.

3. At all relevant times, until on or about December 15, 2004, Full Spectrum Lending, Inc. ("Full Spectrum"), was a California corporation that transacted business throughout the State of California, including in Los Angeles County, and was a subsidiary of CFC. On or about December 15, 2004, Full Spectrum was merged into and became a division of CHL. For all conduct that occurred on or after December 15, 2004, any reference in this complaint to CHL includes reference to its Full Spectrum division.

4. Defendants CFC, CHL, and Full Spectrum are referred to collectively herein as "Countrywide" or "the Countrywide Defendants."

5. At all times pertinent hereto, defendant Angelo Mozilo ("Mozilo") was Chairman and Chief Executive Officer of CFC. Defendant Mozilo directed, authorized, and ratified the conduct of the Countrywide Defendants set forth herein.

6. At all times pertinent hereto, defendant David Sambol ("Sambol") is and was the President of CHL and, since approximately September, 2006, has served as the President and Chief Operating Officer of CFC. Sambol directed, authorized and ratified the conduct of CHL, and after, September, 2006, the Countrywide Defendants, as set forth herein. Defendant Sambol is a resident of Los Angeles County.

7. Plaintiff is not aware of the true names and capacities of the defendants sued as Does 1 through 100, inclusive, and therefore sues these defendants by such fictitious names. Each of these fictitiously named defendants is responsible in some manner for the activities alleged in this Complaint. Plaintiff will amend this Complaint to add the true names of the fictitiously named defendants once they are discovered.

8. The defendants identified in paragraphs 1 through 7, above, shall be referred to collectively as "Defendants."

9. Whenever reference is made in this Complaint to any act of any defendant(s), that allegation shall mean that each defendant acted individually and jointly with the other defendants.

10. Any allegation about acts of any corporate or other business defendant means that the corporation or other business did the acts alleged through its officers, directors, employees, agents and/or representatives while they were acting within the actual or ostensible scope of their authority.

11. At all relevant times, each defendant committed the acts, caused or directed others to commit the acts, or permitted others to commit the acts alleged in this Complaint. Additionally, some or all of the defendants acted as the agent of the other defendants, and all of the defendants acted within the scope of their agency if acting as an agent of another.

12. At all relevant times, each defendant knew or realized that the other defendants were engaging in or planned to engage in the violations of law alleged in this Complaint. Knowing or realizing that other defendants were engaging in or planning to engage in unlawful conduct, each defendant nevertheless facilitated the commission of those unlawful acts. Each defendant intended to and did encourage, facilitate, or assist in the commission of the unlawful acts, and thereby aided and abetted the other defendants in the unlawful conduct.

13. At all relevant times, Defendants have engaged in a conspiracy, common enterprise, and common course of conduct, the purpose of which is and was to engage in the violations of law alleged in this Complaint. This conspiracy, common enterprise, and common course of conduct continues to the present.

14. The violations of law alleged in this Complaint occurred in Los Angeles County and elsewhere throughout California and the United States.

II. DEFENDANTS' BUSINESS ACTS AND PRACTICES

15. This action is brought against Defendants, who engaged in false advertising and unfair competition in the origination of residential mortgage loans and home equity lines of credit ("HELOCs").

16. Countrywide originated mortgage loans and HELOCs through several channels, including a wholesale origination channel and a retail origination channel. The Countrywide employees who marketed, sold or negotiated the

terms of mortgage loans and HELOCs in any of its origination channels, either directly to consumers or indirectly by working with mortgage brokers, are referred to herein as "loan officers."

17. In Countrywide's wholesale channel, loan officers in its Wholesale Lending Division ("WLD") and Specialty Lending Group ("SLG") (now merged into the WLD) worked closely with a nationwide network of mortgage brokers to originate loans. In its wholesale channel, Countrywide often did business as "America's Wholesale Lender," a fictitious business name owned by CHL. In Countrywide's retail channel, loan officers employed by Countrywide in its Consumer Markets Division ("CMD") sold loans directly to consumers. In addition, loan officers employed by Full Spectrum up until December 14, 2004, and thereafter by Countrywide's Full Spectrum Lending Division ("FSLD"), sold loans directly to consumers as part of Countrywide's retail channel.

18. Countrywide maintained sophisticated electronic databases by means of which corporate management, including but not limited to defendants Mozilo and Sambol, could obtain information regarding Countrywide's loan production status, including the types of loan products, the number and dollar volume of loans, the underwriting analysis for individual loans, and the number of loans which were approved via underwriting exceptions. Defendants used this information, together with data they received regarding secondary market trends, to develop and modify the loan products that Countrywide offered and the underwriting standards that Countrywide applied.

19. The mortgage market changed in recent years from one in which lenders originated mortgages for retention in their own portfolios to one in which lenders attempted to generate as many mortgage loans as possible for resale on the secondary mortgage market. The goal for lenders such as Countrywide was not only to originate high mortgage loan volumes but also to originate loans with above-market interest rates and other terms which would attract premium prices on the secondary market.

20. In 2004, in an effort to maximize Countrywide's profits, Defendants set out to double Countrywide's share of the national mortgage market to 30% through a deceptive scheme to mass produce loans for sale on the secondary market. Defendants viewed borrowers as nothing more than the means for producing more loans, originating loans with little or no regard to borrowers' long-term ability to afford them and to sustain homeownership. This scheme was created and maintained with the knowledge, approval and ratification of defendants Mozilo and Sambol.

21. Defendants implemented this deceptive scheme through misleading marketing practices designed to sell risky and costly loans to homeowners, the terms and dangers of which they did not understand, including by (a) adver-

tising that it was the nation's largest lender and could be trusted by consumers; (b) encouraging borrowers to refinance or obtain purchase money financing with complicated mortgage instruments like hybrid adjustable rate mortgages or payment option adjustable rate mortgages that were difficult for consumers to understand; (c) marketing these complex loan products to consumers by emphasizing the very low initial "teaser" or "fixed" rates while obfuscating or misrepresenting the later steep monthly payments and interest rate increases or risk of negative amortization; and (d) routinely soliciting borrowers to refinance only a few months after Countywide or the loan brokers with whom it had "business partnerships" had sold them loans.

22. Defendants also employed various lending policies to further their deceptive scheme and to sell ever-increasing numbers of loans, including (a) the dramatic easing of Countrywide's underwriting standards; (b) the increased use of low- or no-documentation loans which allowed for no verification of stated income or stated assets or both, or no request for income or asset information at all; (c) urging borrowers to encumber their homes up to 100% (or more) of the assessed value; and (d) placing borrowers in "piggyback" second mortgages in the form of higher interest rate HELOCs while obscuring their total monthly payment obligations.

23. Also to further the deceptive scheme, Defendants created a high-pressure sales environment that propelled its branch managers and loan officers to meet high production goals and close as many loans as they could without regard to borrower ability to repay. Defendants' high-pressure sales environment also propelled loan officers to sell the riskiest types of loans, such as payment option and hybrid adjustable rate mortgages, because loan officers could easily sell them by deceptively focusing borrowers' attention on the low initial monthly payments or interest rates. Defendants also made arrangements with a large network of mortgage brokers to procure loans for Countrywide and, through its loan pricing structure, encouraged these brokers to place homeowners in loans with interest rates higher than those for which they qualified, as well as prepayment penalty obligations. This system of compensation aided and abetted brokers in breaching their fiduciary duties to borrowers by inducing borrowers to accept unfavorable loan terms without full disclosure of the borrowers' options and also compensated brokers beyond the reasonable value of the brokerage services they rendered.

24. Countrywide received numerous complaints from borrowers claiming that they did not understand their loan terms. Despite these complaints, Defendants turned a blind eye to the ongoing deceptive practices engaged in by Countrywide's loan officers and loan broker "business partners," as well as to the hardships created for borrowers by its loose underwriting practices. Defendants cared only about selling increasing numbers of loans at any cost, in order to maximize Countrywide's profits on the secondary market.

III. THE PRIMARY PURPOSE OF DEFENDANTS' DECEPTIVE BUSINESS PRACTICES WAS TO MAXIMIZE PROFITS FROM THE SALE OF LOANS TO THE SECONDARY MARKET

25. Defendants' deceptive scheme had one primary goal — to supply the secondary market with as many loans as possible, ideally loans that would earn the highest premiums. Over a period of several years, Defendants constantly expanded Countrywide's share of the consumer market for mortgage loans through a wide variety of deceptive practices, undertaken with the direction, authorization, and ratification of defendants Sambol and Mozilo, in order to maximize its profits from the sale of those loans to the secondary market.

26. While Countrywide retained ownership of some of the loans it originated, it sold the vast majority of its loans on the secondary market, either as mortgage-backed securities or as pools of whole loans.

27. In the typical securitization transaction involving mortgage-backed securities, loans were "pooled" together and transferred to a trust controlled by the securitizer, such as Countrywide. The trust then created and sold securities backed by the loans in the pool. Holders of the securities received the right to a portion of the monthly payment stream from the pooled loans, although they were not typically entitled to the entire payment stream. Rather, the holders received some portion of the monthly payments. The securitizer or the trust it controlled often retained an interest in any remaining payment streams not sold to security holders. These securitizations could involve the pooling of hundreds or thousands of loans, and the sale of many thousands of shares.

28. Countrywide generated massive revenues through these loan securitizations. Its reported securities trading volume grew from 647 billion dollars in 2000, to 2.9 trillion dollars in 2003, 3.1 trillion dollars in 2004, 3.6 trillion dollars in 2005, and 3.8 trillion dollars in 2006. (These figures relate to the ostensible values given to the securities by Countrywide or investors, and include securities backed by loans made by other lenders and purchased by Countrywide.)

29. For the sale of whole (i.e., unsecuritized) loans, Countrywide pooled loans and sold them in bulk to third-party investors, often (but not exclusively) Wall Street firms. The sale of whole loans generated additional revenues for Countrywide. Countrywide often sold the whole loans at a premium, meaning that the purchaser paid Countrywide a price in excess of 100% of the total principal amount of the loans included in the loan pool.

30. The price paid by purchasers of securities or pools of whole loans varied based on the demand for the particular types of loans included in the securitization or sale of whole loans. The characteristics of the loans, such as whether

the loans are prime or subprime, whether the loans have an adjustable or fixed interest rate, or whether the loans include a prepayment penalty, all influenced the price.

31. Various types of loans and loan terms earned greater prices, or "premiums," in the secondary market. For example, investors in mortgages and mortgage backed securities have been willing to pay higher premiums for loans with prepayment penalties. Because the prepayment penalty deters borrowers from refinancing early in the life of the loan, it essentially ensures that the income stream from the loan will continue while the prepayment penalty is in effect. Lenders, such as Countrywide, typically sought to market loans that earned it higher premiums, including loans with prepayment penalties.

32. In order to maximize the profits earned by the sale of its loans to the secondary market, Countrywide's business model increasingly focused on finding ways to generate an ever larger volume of the types of loans most demanded by investors. For example, Countrywide developed and modified loan products by discussing with investors the prices they would be willing to pay for loans with particular characteristics (or for securities backed by loans with particular characteristics), and also would receive requests from investors for pools of certain types of loans, or loans with particular characteristics. This enabled Countrywide to determine which loans were most likely to be sold on the secondary market for the highest premiums.

33. Further, rather than waiting to sell loans until after they were made, Countrywide would sell loans "forward" before loans were funded. In order to determine what loans it could sell forward, Countrywide would both examine loans in various stages of production and examine its projected volume of production over the next several months.

34. Loans that were sold forward were sold subject to a set of stipulations between Countrywide and the purchaser. For example, in a sale of whole loans, Countrywide might agree on October 1 that on December 1 it would deliver 2000 adjustable rate mortgage loans with an average interest rate of 6.0%, half of which would be subject to a prepayment penalty, among other characteristics. (None of these loans would have been made as of October 1.) Based on these stipulations regarding the characteristics of the loans to be included in the pool, an investor might agree to pay a price totaling 102.25% of the total face value of the loans. In other words, the purchaser agreed in advance to pay a premium of 2.25%. Then, if the loans actually delivered on December 1 had a slightly higher or lower average interest rate, the terms of the stipulation would specify how much the final price would be adjusted.

35. The information regarding the premiums that particular loan products and terms could earn on the secondary market was forwarded to Countrywide's pro-

duction department, which was responsible for setting the prices at which loans were marketed to consumers.

36. Countrywide originated as many loans as possible not only to maximize its profits on the secondary market, but to earn greater profits from servicing the mortgages it sold. Countrywide often retained the right to service the loans it securitized and sold as pools of whole loans. The terms of the securitizations and sales agreements for pools of whole loans authorized Countrywide to charge the purchasers a monthly fee for servicing the loans, typically a percentage of the payment stream on the loan.

37. Tantalized by the huge profits earned by selling loans to the secondary market, Defendants constantly sought to increase Countrywide's market share: the greater the number and percentage of loans it originated, the greater the revenue it could earn on the secondary market. Countrywide executives, including defendant Mozilo, publicly stated that they sought to increase Countrywide's market share to 30% of all mortgage loans made and HELOCs extended in the country.

38. In its 2006 annual report, Countrywide trumpeted the fact that "[w]hile the overall residential loan production market in the United States has tripled in size since 2000, from $1.0 trillion to $2.9 trillion at the end of 2006, Countrywide has grown nearly three times faster, going from $62 billion in loan originations in 2000 to $463 billion in 2006."

39. In addition, Countrywide directly and indirectly motivated its branch managers, loan officers and brokers to market the loans that would earn the highest premiums on the secondary market without regard to borrower ability to repay. For example, the value on the secondary market of the loans generated by a Countrywide branch was an important factor in determining the branch's profitability and, in turn, branch manager compensation. Managers were highly motivated to pressure their loan officers to sell loans that would earn Countrywide the highest premium on the secondary market, which resulted in aggressive marketing of such loans to consumers.

40. The secondary market affected Countrywide's pricing of products and, in order to sell more loans on the secondary market, Countrywide relaxed its underwriting standards and liberally granted exceptions to those standards. Countrywide managers and executives, including but not limited to defendants Mozilo and Sambol, had access to information that provided transparency and a seamless connection between secondary market transactions, the loan production process, and managerial and sales incentives.

IV. COUNTRYWIDE ENGAGED IN DECEPTIVE PRACTICES IN THE SALE OF COMPLEX AND RISKY LOANS TO CONSUMERS

41. Countrywide offered a variety of loan products that were both financially risky and difficult for borrowers to understand, including in particular payment option and hybrid adjustable rate mortgages and second loans in the form of home equity lines of credit.

A. The Pay Option ARM

42. Particularly after 2003, Countrywide aggressively marketed its payment option adjustable rate mortgage ("Pay Option ARM") under the direction, authorization and ratification of defendants Mozilo and Sambol. The Pay Option ARM, which Countrywide classified as a "prime" product, is a complicated mortgage product which entices consumers by offering a very low "teaser" rate — often as low as 1% — for an introductory period of one or three months. At the end of the introductory period, the interest rate increases dramatically. Despite the short duration of the low initial interest rate, Countrywide's Pay Option ARMs often include a one, two or three-year prepayment penalty.

43. When the teaser rate on a Pay Option ARM expires, the loan immediately becomes an adjustable rate loan. Unlike most adjustable rate loans, where the rate can only change once every year or every six months, the interest rate on a Pay Option ARM can change every month (if there is a change in the index used to compute the rate).

44. Countrywide's Pay Option ARMs were typically tied to either the "MTA," "LIBOR" or "COFI" index. The MTA index is the 12-month average of the annual yields on actively traded United States Treasury Securities adjusted to a constant maturity of one year as published by the Federal Reserve Board. The LIBOR (London Interbank Offered Rate) index is based on rates that contributor banks in London offer each other for inter-bank deposits. Separate LIBOR indices are kept for one month, six-month, and one-year periods, based on the duration of the deposit. For example, the one-year LIBOR index reported for June 2008 is the rate for a twelve-month deposit in U.S. dollars as of the last business day of the previous month. The COFI (11th District Cost of Funds Index) is the monthly weighted average of the interest rates paid on checking and savings accounts offered by financial institutions operating in the states of Arizona, California and Nevada.

45. Although the interest rate increases immediately after the expiration of the short period of time during which the teaser rate is in effect, a borrower with a Pay Option ARM has the option of making monthly payments as though the interest rate had not changed. Borrowers with Pay Option ARMs typically have four different payment options during the first five years of the loan. The first option is a "minimum" payment that is based on the introductory interest rate.

The minimum payment, which Countrywide marketed as the "payment rate," is the lowest of the payment options presented to the borrower. Most of Countrywide's borrowers choose to make the minimum payment.

46. The minimum payment on a Pay Option ARM usually is less than the interest accruing on the loan. The unpaid interest is added to the principal amount of the loan, resulting in negative amortization. The minimum payment remains the same for one year and then increases by 7.5% each year for the next four years. At the fifth year, the payment will be "recast" to be fully amortizing, causing a substantial jump in the payment amount often called "payment shock."

47. However, the loan balance on a Pay Option ARM also has a negative amortization cap, typically 115% of the original principal of the loan. If the balance hits the cap, the monthly payment is immediately raised to the fully amortizing level (i.e., all payments after the date the cap is reached must be sufficient to pay off the new balance over the remaining life of the loan). When that happens, the borrower experiences significant payment shock. A borrower with a Countrywide Pay Option ARM with a 1% teaser rate, who is making the minimum payment, is very likely to hit the negative amortization cap and suffer payment shock well before the standard 5-year recast date.

48. Instead of making the minimum payment, the borrower has the option of making an interest-only payment for five years. The borrower then experiences payment shock when the payment recasts to cover both principal and interest for the remaining term of the loan. Alternatively, the borrower can choose to make a fully amortizing principal and interest payment based on either a 15-year or a 30-year term.

49. The ever-increasing monthly payments and payment shock characteristic of Pay Option ARMs are illustrated by the following example of a Countrywide loan. The loan had an initial principal balance of $460,000.00, a teaser rate of 1%, and a margin of 2.9% (such that after the one-month teaser rate expired, the interest would be the 1-month LIBOR index plus 2.9%, rounded to the nearest 1/8th percent). After the teaser rate expired, based on the 1-month LIBOR rate as of the date the borrower obtained the loan, the interest rate would increase to 7.00%. Assuming the 7.00% interest rate remained in place, and the borrower chose to make the minimum payment for as long as possible, the payment schedule would be approximately as follows:
a.) $1,479.54 per month for the first year
b.) $1,590.51 per month for the second year
c.) $1,709.80 per month for the third year
d.) $1,838.04 per month for the fourth year
e.) $1,975.89 per month for the first nine months of the fifth year; and
f.) approximately $3,747.83 per month for the remaining twenty-five years and three months on the loan.

50. Once the payments reach $3747.83, this Pay Option ARM will have negatively amortized such that the balance of the loan will have increased to approximately $523,792.33. At that point, the borrower will be faced with a payment more than two-and-a-half times greater than the initial payment and likely will be unable to refinance unless his or her home has increased in value at least commensurately with the increased loan balance. In addition, increases in the LIBOR rate could cause the borrower to hit the negative amortization cap earlier, and also could result in even higher payments. If the interest rate reached 8%, just 1% higher, the negative amortization cap would be reached sooner and payments could reach $4,000.00 per month, or higher.

51. During the underwriting process, Countrywide did not consider whether borrowers would be able to afford such payment shock. Further, depending on the state of the his or her finances, even the interim increases in the minimum payment may well have caused dramatic hardship for the borrower.

52. Even if the borrower elects to make interest-only payments, he or she still will experience payment shock. Again assuming the interest rate stays constant at 7.00% over the life of the loan, the borrower's initial payments would be approximately $2,683.33 for five years. Thereafter, the payment will increase to approximately $3,251.18 per month, an increase of over 20%.

53. Nearly all Countrywide's Pay Option ARM borrowers will experience payment shock such as that illustrated in paragraphs 49 through 52 above. As of December 31, 2006, almost 88% of the Pay Option ARM portfolio held by Defendants consisted of loans that had experienced some negative amortization. This percentage increased to 91% as of December 31, 2007.

54. Countrywide sold thousands of Pay Option ARMs, either through its branches or through brokers. For example, on a national basis, approximately 19% of the loans originated by Countrywide in 2005 were Pay Option ARMs. Countrywide made many of these loans in California.

55. These loans were highly profitable. Countrywide had a gross profit margin of approximately 4% on Pay Option ARMs, compared to 2% on mortgages guaranteed by the Federal Housing Administration.

56. Countrywide retained ownership of a number of loans for investment purposes, including thousands of Pay Option ARMs. Countrywide reported the negative amortization amounts on these Pay Option ARMs (i.e., the amount by which the balances on those loans increased) as income on its financial statements. The negative amortization "income" earned by Countrywide totaled 1.2 billion dollars by the end of 2007.

57. Moreover, Pay Option ARMs with higher margins could be sold for a higher

premium on the secondary market, because the higher margins would produce a greater interest rate and therefore a larger income stream. To insure an abundant stream of such loans, Countrywide pushed its loan officers to sell Pay Option ARMs and paid loan brokers greater compensation for selling a Pay Option ARM with a higher margin, or above-par rate, thus encouraging them to put consumers into higher cost loans. Countrywide also used a variety of deceptive marketing techniques to sell its Pay Option ARMs to consumers.

58. Countrywide deceptively marketed the Pay Option ARM by aggressively promoting the teaser rate. Television commercials emphasized that the payment rate could be as low as 1% and print advertisements lauded the extra cash available to borrowers because of the low minimum payment on the loan. Television advertisements did not effectively distinguish between the "payment rate" and the interest rate on the loans, and any warnings about potential negative amortization in Countrywide's print advertisements were buried in densely written small type.

59. Borrowers, enticed by the low teaser rate, were easily distracted from the fine print in the loan documents and did not fully understand the terms or the financial implications of Countrywide's Pay Option ARMs.

60. When a borrower obtained a Pay Option ARM from Countrywide, the only initial monthly payment amount that appeared anywhere in his or her loan documents was the minimum payment amount. In other words, documents provided to the borrower assumed he or she would make only the minimum payment. Thus, a borrower would not know the monthly payment necessary to make a payment that would, for example, cover accruing interest, until he or she received the first statement after the expiration of the teaser rate, well after all loan documents were signed.

61. Countrywide and the brokers it accepted as its "business partners" misrepresented or obfuscated the true terms of the Pay Option ARMs offered by Countrywide, including but not limited to misrepresenting or obfuscating the amount of time that the interest rate would be fixed for the loan, misrepresenting or obfuscating the risk of negative amortization and the fact that the payment rate was not the interest rate, and misrepresenting or obfuscating that the minimum payment would not apply for the life of the loan.

62. Countrywide and its business partner brokers also misrepresented or obfuscated how difficult it might be for borrowers to refinance a Pay Option ARM loan. In fact, after making only the minimum payment, because of negative amortization the borrower likely would not be able to refinance a Pay Option ARM loan unless the home serving as security for the mortgage had increased in value. This is particularly true in cases for borrowers whose loans have a very high loan-to-value ratio.

63. Countrywide and its business partner brokers often misrepresented or ob-fuscated the fact that a particular Pay Option ARM included a prepayment penalty and failed to explain the effect that making only the minimum pay-ment would have on the amount of the prepayment penalty. If a borrower seeks to refinance after having made the minimum payment for an extended period, but while a prepayment penalty is still in effect, the negative amortization can cause the amount of the prepayment penalty to increase. Prepayment penal-ties typically equal six months worth of accrued interest. As negative amorti-zation causes the loan principal to increase, it also causes an increase in the amount of interest that accrues that each month, thereby increasing the pre-payment penalty.

64. Countrywide and its business partner brokers also represented that the pre-payment penalty could be waived if the borrower refinanced with Countrywide. However, Countrywide sells most of the loans it originates, and Countrywide has at most limited authority to waive prepayment penalties on loans it does not own, even when it controls the servicing (and is often required to pay the pre-payment penalties on loans it does not own in the instances where it is not able to collect the penalty from the borrower).

B. Hybrid ARM Loans
65. In addition to the Pay Option ARMs, Countrywide offered "Hybrid" ARM loans. Hybrid ARMs have a fixed interest rate for a period of 2, 3, 5, 7, or 10 years, and then an adjustable interest rate for the remaining loan term. The products described below were offered with the approval, direction and ratifi-cation of defendants Sambol and Mozilo.

(1) 2/28 and 3/27 ARMs
66. Countrywide typically offered "2/28" Hybrid ARMs through its Full Spec-trum Lending Division. These 2/28 ARM loans have low, fixed interest rates for the first two years (the "2" in "2/28"). The loans often only required interest-only payments during the period the initial rate was in effect, or sometimes for the first five years of the loan.

67. After the initial rate expires, the interest rate can adjust once every six months for the next 28 years (the "28" in "2/28"). During this period, the in-terest rate typically is determined by adding a margin to the one-year LIBOR index, except that the amount the interest rate can increase at one time may be limited to 1.5%. Because the initial rate is set independent of the index, the payment increase can be dramatic, particularly if the loan called for interest-only payments for the first two or five years.

68. Countrywide also offered "3/27" ARMs, which operate similarly to 2/28 ARMs, except that the low initial rate is fixed for three rather than two years, and the interest rate then adjusts for 27 rather than 28 years.

69. Countrywide underwrote 2/28 and 3/27 ARMs based on the payment required while the initial rate was in effect, without regard to whether the borrower could afford the loan thereafter. And, like Pay Option ARMs, Countrywide's 2/28 and 3/27 ARMs typically contain prepayment penalties.

70. A borrower with a 2/28 ARM, like a borrower with a Pay Option ARM, is subjected to steadily increasing monthly payments as well as payment shock. For example, a Countrywide borrower obtained a 2/28 ARM for $570,000, with an initial rate of 8.95% for the first two years. Thereafter, the interest rate was to be calculated by adding a margin of 7.95% to the six-month LIBOR index. The promissory note for this 2/28 ARM provides that the interest rate can never be lower 8.95% and can go as high as 15.95%. Based on the LIBOR rate that applied at the time the borrower received the loan and the terms of the note governing interest rate (and therefore payment) increases, the anticipated payment schedule was:

a.) $4,565.86 per month for two years
b.) $5,141.98 per month for six months
c.) $5,765.48 per month for six months; and
d.) payments of $6,403.01 per month or more thereafter

71. This borrower's monthly payments on this 2/28 ARM will thus increase by approximately 40% just during the 12 months between the end of the second year and beginning of the fourth year of the loan.

(2) 5/1, 7/1, and 10/1 ARMs
72. Countrywide also offered 5/1, 7/1, and 10/1 "interest-only" loans. Marketed as having "fixed" or "fixed period" interest rates, these loans carried a fixed interest rate for the first 5, 7, or 10 years respectively. These loans were underwritten based on the initial fixed, interest-only payment until at least the end of 2005. However, when the fixed rate period expires, the interest rate adjusts once per year and is determined by adding a margin to an index. The monthly payments dramatically increase after the interest-only period, because payments over the remaining 25, 23, or 20 years are fully amortized to cover both principal and interest.

73. For example, if a borrower had a 5/1 loan for $500,000 that remained constant at 7.5% for the life of the loan, the monthly payments during the five year interest-only period would be $3,125.00. The monthly payment would increase to approximately $3,694.96 for the remaining 25 years of the loan. If the interest rate increased to 8% over the remaining 25 years, the payment would jump to $3,859.08 per month.

74. Collectively, 2/28, 3/27, 5/1, 7/1, and 10/1 ARMs will be referred to herein as "Hybrid ARMs."

(3) Countrywide's Deceptive Marketing of its Hybrid ARMs

75. Countrywide marketed Hybrid ARMs by emphasizing the low monthly payment and low "fixed" initial interest rate. Countrywide and its business partner brokers misrepresented or obfuscated the true terms of these loans, including but not limited to misrepresenting or obfuscating the amount of time that the fixed rate would be in effect, misrepresenting or obfuscating the fact that the interest rates on the loans are adjustable rather than fixed, and obfuscating or misrepresenting the amount by which payments could increase once the initial fixed rate expired.

76. Countrywide and its business partner brokers also often misrepresented or obfuscated the fact that Hybrid ARMs, particularly 2/28 and 3/27 ARMs, included prepayment penalties, or represented that the prepayment penalties could be waived when the borrowers refinanced with Countrywide. However, most loans originated by Countrywide are sold on the secondary market and, as described in paragraph 64, above, Countrywide generally cannot waive the terms of loans it does not own, even when it controls the servicing.

77. Countrywide and its brokers also misrepresented or obfuscated how difficult it might be for borrowers to refinance Hybrid ARMs. Although borrowers often were assured that they would be able to refinance, those seeking to refinance Hybrid ARMs after the expiration of the initial interest-only period likely would not be able to do so unless the home serving as security for the mortgage had maintained or increased its value. This was particularly true for borrowers whose loans have very high loan-to-value ratios, as there would be no new equity in the borrowers' homes to help them pay fees and costs associated with the refinances (as well as any prepayment penalties that may still apply).

C. Home Equity Lines of Credit

78. Countrywide also aggressively marketed HELOCs, particularly to borrowers who had previously obtained or were in the process of obtaining a first mortgage loan from Countrywide. Defendants referred to such HELOCs as "piggies" or "piggyback loans," and referred to simultaneously funded first loans and HELOCs as "combo loans." The first loan typically covered 80% of the appraised value of the home securing the mortgage, while the HELOC covered any of the home's remaining value up to (and sometimes exceeding) 20%. Thus, the HELOC and the first loan together often encumbered 100% or more of a home's appraised value.

79. Under the terms of the piggyback HELOCs, borrowers received monthly bills for interest-only payments for the first five years of the loan term (which could be extended to ten years at Countrywide's option), during which time they could also tap any unused amount of the equity line. This was called the "draw period."

80. Because Countrywide offered HELOCs as piggybacks to Pay Option and Hybrid ARMs, 100% or more of a property's appraised value could be encumbered with loans that required interest-only payments or allowed for negative amortization.

81. Countrywide typically urged borrowers to draw down the full line of credit when HELOCs initially funded. This allowed Countrywide to earn as much interest as possible on the HELOCs it kept in its portfolio, and helped generate the promised payment streams for HELOCs sold on the secondary market. For the borrower, however, drawing down the full line of credit at funding meant that there effectively was no "equity line" available during the draw period, as the borrower would be making interest-only payments for five years.

82. Upon the end of the draw period, the HELOC notes generally require borrowers to repay the principal and interest in fully amortizing payments over a fifteen year period. A fully drawn HELOC was therefore functionally a 20- or 25-year closed-end mortgage. However, Countrywide did not provide borrowers with any documents or other materials to help them calculate the principal and interest payments that would be due after the draw, or interest-only, period.

83. Countrywide HELOCs were underwritten not to the fully amortizing payment, but to the interest-only payments due during the draw period. Countrywide typically charged an early termination fee for HELOCs closed before three years, and sometimes would charge a monthly fee for HELOCs where the balance fell below a specified amount.

84. A borrower with an interest-only or a negatively amortizing loan faces even greater payment shock if he or she also has a fully drawn HELOC. For example, a borrower with a fully drawn $100,000 HELOC at a 7.00% interest rate will have monthly interest-only payments of approximately $583.33. At the end of the draw period, the payment will increase to $898.83. This payment increase is in addition to whatever payment increase the borrower is experiencing on his or her first mortgage. This potential dual payment shock is typically obfuscated from or not explained to borrowers. Moreover, a borrower with a piggyback HELOC, particularly a borrower whose first mortgage negatively amortized or allowed interest-only payments, is even less likely to be able to refinance at the time of his or her payment shock unless his or her home has increased in value.

V. COUNTRYWIDE EASED AND DISREGARDED UNDERWRITING STANDARDS IN ORDER TO INCREASE ITS MARKET SHARE

85. Driven by its push for market share, Countrywide did whatever it took to sell more loans, faster — including by easing its underwriting criteria and disregarding the minimal underwriting criteria it claimed to require. By easing

and disregarding its underwriting criteria, Countrywide increased the risk that borrowers would lose their homes. Defendants Mozilo and Sambol actively pushed for easing Countrywide's underwriting standards and documentation requirements, allowed the liberal granting of exceptions to those already eased standards and requirements, and received reports detailing the actual underwriting characteristics and performance of the loans Countrywide funded.

A. Countrywide's Low- and No-Documentation Loans

86. Traditionally, lenders required borrowers seeking mortgage loans to document their income, for example by providing W-2s or tax returns, as well as assets. Countrywide, however, disregarded such documentation requirements with respect to its riskiest loan products and introduced a variety of reduced or no documentation loan programs that eased and quickened the loan origination process. The vast majority of the Hybrid ARMs and nearly all of the Pay Option ARMs originated by Countrywide were reduced or no documentation loans.

87. As an example of one of its widespread no documentation programs, Countrywide made Pay Option ARMs, Hybrid ARMs, and piggyback HELOCs, among other loans, pursuant to its "Stated Income Stated Assets," or "SISA," program. The borrower's income and assets were stated but not verified. Employment was verbally confirmed and income was supposed to be roughly consistent with incomes earned in the type of job in which the borrower was employed. Reduced documentation loans, in turn, allowed borrowers to document their income through the provision of information that was less reliable then the information required of full documentation loans, such bank statements or verbal verification of employment.

88. These low- and no-documentation programs, such as SISA, enabled Countrywide to process loans more quickly and therefore to make more loans. Stated income loans also encouraged the overstating of income — loan brokers and officers either overstated the borrower's income without his or her knowledge, or led the borrower into overstating his or her income without explaining the risk of default that the borrower would face with a loan he or she could not actually afford. According to a former Countrywide loan officer, for example, a loan officer might say, "with your credit score of X, for this house, and to make X payment, X is the income you need to make." Many borrowers responded by agreeing that they made X amount in income.

89. For stated income loans, it became standard practice for loan processors and underwriters to check www.salary.com to see if a stated income was within a reasonable range, with more tolerance on the upside for California salaries. Because loan officers knew about this practice, they too would look at salary.com to figure out the parameters ahead of time and know by how much they could overstate (or fabricate) income.

B. Countrywide's Easing of Underwriting Standards

90. Countrywide also relaxed, and often disregarded, the traditional underwriting standards used to separate acceptable from unacceptable risk in order to produce more loans for the secondary market. Initially, for example, a borrower had to have a credit score of 720 for a stated income loan. As the secondary market's appetite for loans increased, Countrywide relaxed its guidelines so that a borrower with a credit score of 580 could get a stated income loan with 100% financing.

91. Underwriting standards which Countrywide relaxed included qualifying interest rates (the rate used to determine whether borrowers can afford loans), loan-to-value ratios (the amount of the loan(s) compared to lower of the appraised value or sale price of the property), and debt-to-income ratios (the amount of borrowers' monthly income compared to their monthly indebtedness).

92. With respect to qualifying rates, while Countrywide offered loans with initial low payments that would increase, loans were underwritten without regard to borrowers' long-term financial circumstances. Until at least the end of 2005, Countrywide underwrote and approved its Hybrid ARMs based on the fixed interest rate applicable during the initial period of the loan, without taking into account whether the borrowers would be able to afford the dramatically higher payments that would inevitably be required during the remaining term of the loan.

93. In addition, Countrywide's approach to underwriting and marketing Pay Option ARMs diverged. Countrywide underwrote Pay Option ARMs based on the assumption that borrowers would make a fully amortizing payment, rather than the minimum payment, and therefore not experience negative amortization. In contrast, Countrywide marketed Pay Option ARMs by emphasizing the minimum payments. Countrywide continued this underwriting practice even though it knew that many of its Pay Option ARM borrowers would choose to make only the minimum monthly payment and that a high percentage of such borrowers had experienced negative amortization on their homes, as described in paragraph 53, above.

94. Countrywide also underwrote and approved HELOCs based on the borrower's ability to afford the interest-only payments during the initial period of the loan, not based on the borrower's ability to afford the subsequent, fully amortized principal and interest payments.

95. Countrywide eased other basic underwriting standards. Starting in 2003, as Defendants pushed to expand market share, underwriting standards and verification requirements became more flexible to enable underwriters to approve loans faster. Countrywide, for example, allowed higher and higher loan-to-value ("LTV") and combined loan-to-value ("CLTV") ratios — the higher the ratio, the

greater the risk that a borrower will default and will be unable to refinance in order to avoid default. Similarly, Countrywide approved loans with higher and higher debt-to-income ("DTI") ratios — the higher ratio; the greater the risk the borrower will have cash-flow problems and miss mortgage payments.

C. Countrywide's "Exception" Underwriting Compromised Standards

96. Countrywide approved loans that it knew to be high risk, and therefore highly likely to end up in default, by ignoring its own minimal underwriting guidelines. Based on the proposed loan terms and the borrower's financial and credit information, Countrywide's computerized underwriting system ("CLUES") issued a loan analysis report that rated the consumer's credit and ability to repay the loan, and also indicated whether a proposed loan was in compliance with Countrywide's underwriting guidelines. Based on this analysis, the CLUES report would recommend that the loan be approved, the loan be declined, or that the loan be "referred" to manual underwriting. CLUES, for example, might flag a "rule violation" if the borrower's LTV, CLTV or credit score fell outside the guidelines for a given loan product. In such instances, CLUES would make a recommendation to "refer" the loan for further analysis by a Countrywide underwriter.

97. The CLUES result was only a recommendation, not a final decision. The role of the underwriter was basically to verify information and ultimately decide whether to approve a loan based on Countrywide's underwriting criteria. Underwriters could overcome potential rule violations or other underwriting issues flagged by CLUES by adding on "compensating factors," such as letters from the borrower that addressed a low FICO score or provided explanations regarding a bankruptcy, judgment lien, or other issues affecting credit status.

98. Underwriters were under intense pressure to process and fund as many loans as possible. They were expected to process 60 to 70 loans per day, making careful consideration of borrowers' financial circumstances and the suitability of the loan product for them nearly impossible.

99. As the pressure to produce loans increased, underwriters, their superiors, branch managers, and regional vice presidents were given the authority to grant exceptions to Countrywide's minimal underwriting standards and to change the terms of a loan suggested by CLUES. Even if CLUES had recommended denying a loan, the underwriter could override that denial if he or she obtained approval from his or her supervisor.

100. Because of the intense pressure to produce loans, underwriters increasingly had to justify why they were not approving a loan or granting an exception for unmet underwriting criteria to their supervisors, as well as to dissatisfied loan officers and branch managers who earned commissions based on loan volume. Any number of Countrywide managerial employees could

override an underwriter's decision to decline a loan and request an exception to an underwriting standard. Countrywide employees also could submit a request for an exception to Countrywide's Structured Loan Desk in Plano, Texas, a department specifically set up by Countrywide, at the direction of defendants Mozilo and Sambol, to grant underwriting exceptions. According to a former employee, in 2006, 15,000 to 20,000 loans a month were processed through the Structured Loan Desk.

101. Countrywide granted exceptions liberally, further diluting its already minimal underwriting standards for making loans. Countrywide granted exception requests in a variety of circumstances where one or more basic underwriting criteria of the borrower did not meet loan product guidelines, including, for example, LTV or CLTV, loan amount and credit score. Countrywide placed borrowers in risky loans such as Hybrid and Pay Option ARMs, based on stated but not verified income and assets, and then overlooked its few remaining underwriting indicia of risk.

102. To attract more business Countrywide promoted its relaxed underwriting standards and ready grant of exceptions to brokers. For example, Countrywide promoted "Unsurpassed Product Choices and Flexible Guidelines," including (a) "100% financing for purchase or refinancing" loans; (b) "80/20 combo loans for stated Self-Employed and Non Self-Employed;" (c) "Stated Self-Employed and Non Self-Employed loan programs with as low as a 500 credit score." Countrywide stated that its "Specialty Lending Group's experienced and knowledgeable loan experts are empowered to review all loan packages, make sound credit decisions and provide quality lending solutions - yes, even for 'hard to close' loans."

D. Countrywide's Risk-Layering and Pressure to Sell "Piggyback" Loans- Further Loosened Underwriting Practices

103. Countrywide compromised its underwriting standards even further by risk layering, i.e., combining high risk loans with one or more relaxed underwriting standards. Countrywide was well aware that layered risk created a greater likelihood that borrowers would lose their homes.

104. As early as January 2005, Countrywide identified the following borrower/loan characteristics as having a negative impact on the underwriting evaluation process: (a) income or debt ratios that exceed individual program guidelines; (b) loans with potential for payment changes (e.g. ARM loans); (c) borrowers with a low credit score (usually below 660); and (d) minimal down payment from the borrower's own funds.

105. Nonetheless, Countrywide combined these very risk factors in the loans it promoted to borrowers. Countrywide introduced, for example, loan programs that allowed for higher LTVs/CLTVs, less documentation and lower credit

scores. A high risk loan such as a Pay Option ARM could be sold to borrowers with increasingly lower credit scores. In addition, by accepting higher DTI ratios and combining Pay Option ARMs with second mortgages that allowed borrowers to finance a down payment, Countrywide would qualify borrowers with fewer financial resources, and hence a higher likelihood of default.

106. With a second or "piggyback" mortgage, the borrower could get a first loan for 80% of the purchase price (i.e., an 80% LTV) and a second loan for 20% of the purchase price (a 20% LTV), for a combined loan-to-value ratio of 100%. This allowed the borrower to finance a down payment and also avoid paying mortgage insurance (which typically is required if the LTV on a first loan exceeds 80%). Such loans obviously were risky as the borrower had contributed no funds whatsoever to the loan and, if the loan required no documentation, had only stated his or her income and assets.

107. The following examples describe risk layering and underwriting exceptions granted to several California borrowers to whom Countrywide sold Hybrid or Pay Option ARMs. These examples represent only a small percentage of the large number of California residents who are likely facing foreclosure due to Countrywide's widespread practice of risk-layering.

a. A Countrywide loan officer convinced a borrower to take a Pay Option ARM with a 1-month teaser rate and a 3-year prepayment penalty, plus a full-draw piggyback HELOC, based on the loan officer's representation that the value of the borrower's home would continue to rise and he would have no problem refinancing. The borrower's DTI was 47% and FICO was 663. An exception was granted for a 95% CLTV, which exceeded Countrywide's regular maximum allowed CLTV, even though both the CLUES report for the loan and an underwriter review indicated strong doubts about the borrower''s ability to repay the loan and identified multiple layered risks. The loan closed in January 2006, and a Notice of Default issued in June 2007.

b. The CLUES report issued for a loan applicant in February 2005 stated that the DTI ratio was too high for the loan program requested and identified several elements of risk: the loan had a risk grade, the borrower had too low of a credit score, and the proposed LTV was too high. The CLUES report for the loan therefore raised doubts about the borrower's ability to repay the loan. Nonetheless, Countrywide approved a 3/27 ARM with a 3-year prepayment penalty, to an 85-year old disabled veteran with a 509 FICO score, a 59.90 DTI and 69.30 CLTV. The loan closed in February 2005, and a Notice of Default issued in July 2005.

c. The CLUES report for a proposed loan identified multiple layered risks that created doubts about the borrower's ability to make the required payments, including a high CLTV, low borrower reserves and the fact that a borrower had

an open collection account. However, in January 2006, Countrywide granted exceptions for each of these risks, to approve a reduced documentation Pay Option ARM loan with a 3-month teaser rate and a 3-year prepayment penalty, as well as a Piggyback HELOC. The Pay Option ARM was for $352,000, and the Piggyback HELOC was for $22,000. The borrower's credit score was 645, the DTI was 48.22 and the CLTV was 85%. The loan closed in January 2006, and a Notice of Default issued in October 2006.

VI. COUNTRYWIDE ENGAGED IN DECEPTIVE MARKETING PRACTICES TO SELL INCREASING NUMBERS OF LOANS

108. Driven by its push for market share, Countrywide did whatever it took to sell more loans, faster — including by engaging in a number of deceptive marketing practices under the direction and with the ratification of defendants Mozilo and Sambol.

A. Countrywide Deceptively Lulled Borrowers Into Believing That It Was a "Trusted Advisor" Looking Out for the Borrowers' Best Interests

109. Countrywide sought to induce borrowers into believing that it was looking out for their best interest through various types of solicitations. Countrywide published television, radio, and print advertisements, for example, touting itself as "the company you can trust" and urging consumers to "join the millions of homeowners who have trusted Countrywide." Countrywide capitalized on its status as the "number one mortgage lender" and claimed that it was a mortgage loan expert capable of advising customers. For example, Countrywide claimed that it "had years to perfect [its] craft" and offered "industry leading expertise" and that "[w]ith over 35 years of service and one of the widest selections of loan programs, [it] is an expert at finding solutions for all kinds of situations." As another example, Countrywide offered "consultation[s] with our home loan experts" and claimed it "would go the distance with you to help secure a loan program to fit your financial needs and goals."

110. Countrywide also engaged in extensive solicitation campaigns aimed at those borrowers it was easiest for it to find — existing Countrywide customers. Countrywide targeted existing customers with tailored letters and e-mail solicitations, creating the impression that it was a mortgage expert that advised its borrowers, at no cost, regarding the financial mortgage options that were in their best interest. For example, Countrywide took advantage of Pay Option ARM customers' worries regarding potential future "steep payment adjustments," by sending them a "special invitation" to talk with "specially-trained consultants" regarding "your current financial situation, at no charge, to see if refinancing may help put you in a better financial position."

111. Countrywide also created an annual "anniversary" campaign, by sending letters and e-mails to existing customers offering a "free Anniversary Loan Re-

view," which it touted as a "home loan analysis" with an "experienced Loan Consultant." Countrywide advertised itself in these solicitations as, for example, an "expert at finding solutions" and "smart financial options" that would best suit borrowers' financial needs.

112. Countrywide operated an extensive telemarketing operation, aimed both at new potential customers and existing Countrywide customers, in which it touted its expertise and claimed to find the best financial options for its customers. For example, Countrywide instructed its Full Spectrum loan officers to memorize a script that instructed them to "build rapport" and "gain trust" in conversations with potential customers, and to do so with existing customers by "positioning" telephone calls, the true purpose of which was to sell refinance loans, as "Customer Service loan check-up[s]." On these calls, loan officers were instructed to tout both their own and Countrywide's special mortgage loan expertise, and to position themselves as "trusted advisor[s]" with the "long term financial goals" of the borrower in mind. Countrywide instructed FSLD loan officers to state, for example, "I'm an experienced mortgage lending professional specializing in helping people improve their financial situation." Countrywide even instructed loan officers to offer to provide advice on other lender's mortgage loans and to tell potential customers, that "even if you're working with someone else and just want a second opinion — mortgages can be very complicated. I'm here for that."

113. In addition, when handling initial calls from prospective customers, for example, Countrywide instructed its FSLD loan officers to (a) defer discussing interest rates, (b) "overcome objections" regarding potential rates, costs, and "equity drain," and (c) build a rapport by "paint[ing] a picture of a better future" and focusing on the "emotional reasons" each individual customer may want or need a new home loan. Contrary to the kinds of representations described in this paragraph and paragraphs 109 through 112, above, Countrywide often did not sell borrowers loans that were in their best interest.

B. Countrywide Encouraged Serial Refinancing

114. In order to constantly produce more loans for sale to the secondary market, Countrywide aggressively marketed refinance loans to those homeowners it had no trouble finding — Countrywide customers. Countrywide misled these borrowers regarding the benefits of refinancing, including by using the deceptive marketing practices described in paragraphs 119 through 128 below. In addition, Countrywide created a perpetual market for its refinance loans by selling Pay Option and Hybrid ARMs that borrowers would have to refinance because they couldn't afford their current loans. Countrywide knew that borrowers who could not afford the inevitable payment increase on such loans and who were unable to refinance would be at great risk of losing their homes.

115. Countrywide provided lists of existing customers to its loan officers

responsible for outbound marketing. Defendants' loan officers hounded Countrywide customers by phone, mail, and electronic mail with refinance loan offers. For example, FSLD created "highly targeted, national direct mail campaigns on a weekly basis" directed at existing Countrywide customers. FSLD "leads" — telephone numbers for existing, eligible customers — were uploaded into a telemarketing database on a weekly basis.

116. Countrywide even solicited customers who were having trouble making payments or facing foreclosure, without regard to the risk that the customer would default on Pay Option and Hybrid ARM refinance loans. FSLD solicited existing prime customers who had "recurring" missed payments. Countrywide required its customer service representatives to market refinance loans to borrowers who called with questions, including borrowers who were behind on their monthly payments or facing foreclosure.

117. Countrywide also solicited existing customers on other occasions, including on their annual loan "anniversaries" (see paragraph 111, above) and shortly before a rate or payment was to reset on Pay Option or Hybrid ARMs, without regard to whether the loan had a prepayment penalty period that had not yet expired. In doing so, the Countrywide Defendants refinanced borrowers while the prepayment penalty on their prior Countrywide loan was still in effect, often concealing the existence of the prepayment penalty.

118. Countrywide claims that approximately 60% of FSLD's business has been comprised of refinancing Countrywide loans.

C. Countrywide Misled Borrowers About the True Terms of Pay Option and Hybrid ARM Loans by Focusing the Borrowers' Attention on Low Beginning Payments and Teaser Rates

119. Because Pay Option ARM and Hybrid ARMs start with lower monthly payments and interest rates than most other types of loan products, and given their complex nature, Countrywide was able to easily sell such loans to borrowers by focusing on the initial low monthly payments and/or rates and by obscuring or misrepresenting the true risks of such loans.

120. With respect to Pay Option ARMs, the crux of Countrywide's sales approach was to "sell the payment." When presenting a borrower with various loan options, for example, Countrywide would "sell the payment" by showing the borrower the minimum monthly payments for the Pay Option ARM in comparison to other loan products with larger payments. Then, Countrywide would ask which payment the borrower preferred without discussing other differences between the loan products. Naturally, in this situation, most borrowers chose the option with the lowest payment, the Pay Option ARM, without realizing that the payment would last for only a short time before it would begin to increase.

121. If, instead, Countrywide presented the Pay Option ARM as the only option, it would "sell the payment" by emphasizing the low minimum payment and how much the borrower would "save" every month by making such a low payment, without discussing the payment shock and negative amortization that inevitably result when borrowers make minimum payments. Given the complexity of Pay Option ARMs, such a presentation easily misled borrowers regarding the long-term affordability of their loans.

122. Countrywide also represented that the initial monthly payment would last for the entire term of the loan, or for some period longer than that provided for by the loan's terms.

123. Countrywide engaged in similar deceptive representations with respect to Hybrid ARMs. For example, Countrywide focused its sales presentation on the interest-only payments during the initial fixed-rate period, i.e. the 2-year period on a 2/28 ARM or the 3-year period on a 3/27 ARM, not on how the payment would adjust to include both principal and interest after the initial fixed-rate period. It also represented that the payments would last for the entire term of the loan, or for some period longer than that provided for by the loan's terms.

124. When selling Pay Option and Hybrid ARMs, Countrywide engaged in another deceptive practice — rather than selling the payment, it would sell the rate. Countrywide either focused higher rate, or it represented that the initial interest rate would last for a much longer period than it actually did or for the entire term of the loan.

125. Countrywide's letter and e-mail solicitations, as well as telemarketing calls, also focused borrowers' attention on short-term low monthly payments. FSLD loan officers, for example, were required to memorize scripts that marketed low monthly payments by focusing (a) on the potential customer's dissatisfaction with his or her current monthly payments under his or her current mortgage loan and/or (b) on so-called "savings" that result from minimum monthly payments. As just one of many potential examples, to overcome a borrower's claim that he or she already has a loan with a low interest rate, Countrywide required FSLD loan officers to memorize the following response: "I certainly understand how important that is to you. But let me ask you something Which would you rather have, a long-term fixed payment, or a short-term one that may allow you to realize several hundred dollars a month in savings? I am able to help many of my clients lower their monthly payments and it only takes a few minutes over the phone to get started." What the FSLD loan officer did not state was that the borrowers would, in fact, not save money because the payment on the new loan would ultimately exceed the payment on the borrower's current loan.

126. Borrowers subjected to any of the deceptive marketing practices described

above would not understand the true risks and likely unaffordability of their Pay Option or Hybrid ARMs. Many borrowers did not read their loan documents and disclosures before signing because Countrywide often made borrowers sign a large stack of documents without providing the borrower with time to read them. Other borrowers were unable to read English. And, given the complexity of Pay Option and Hybrid ARMs, many borrowers who managed to read their loan documents did not understand the terms of the loans they were being sold.

127. As a result, many borrowers who obtained Pay Option and Hybrid ARMs did not understand that their initial monthly payment would at some point "explode," that their initial interest rate would increase and become adjustable, or that the principal amount of their loans could actually increase. Countrywide received numerous complaints regarding these practices from consumers, including over 3,000 complaints per year handled by the Office of the President alone between approximately January 2005 and August 2007. Many borrowers complained that they did not understand the terms of their Pay Option and Hybrid ARMs, including the potential magnitude of changes to their monthly payments, interest rates, or loan balances. Many borrowers also complained that Countrywide's loan officers either did not tell them about the payment or rate increases on such loans or promised that they would have fixed-rate, fixed payment loans, rather than adjustable rate mortgage loans with increasing payments.

128. Despite these complaints, Defendants did not alter their deceptive marketing practices and did not address the hardship created by their practice of making Pay Option and Hybrid ARMs with little or no regard to affordability. Defendants cared only about doing whatever it took to sell increasing numbers of loans.

D. Countrywide Misled Borrowers About Their Ability to Refinance Before The Rates or Payments on Their Pay Option and Hybrid ARMs Increased
129. If a borrower was able to figure out that he or she had obtained a Pay Option or Hybrid ARM before signing the loan documents, he or she may still have been misled by Countrywide in another way — Countrywide's loan officers often overcame borrower concerns about exploding monthly payments or increasing interest rates by promising that they would be able to refinance with Countrywide into a loan with more affordable terms before the payments or rate reset.

130. Countrywide often represented that the value of a borrower's home would increase, thus creating enough equity to obtain a loan with better terms. However, borrowers with interest-only or negatively amortizing loans that encumbered as much as, if not more than, 100% of their home's appraised value, were highly unlikely to be able to refinance into another loan if their home did not

increase in value. Additionally, any consumers who sought to refinance a Countrywide mortgage would likely incur a substantial prepayment penalty, thus limiting their ability to obtain a more favorable loan.

131. Countrywide loan officers often misrepresented or obfuscated the fact that a borrower's loan had a prepayment penalty or misrepresented that a prepayment penalty could be waived. Countrywide also promised borrowers that they would have no problem refinancing their Pay Option or Hybrid ARMs, when in fact they might have difficulty refinancing due to the existence of prepayment penalties. Prepayment penalties on Pay Option and Hybrid ARMs essentially prevent many borrowers from refinancing such unaffordable loans before their payments explode or rates reset.

132. Countrywide received numerous complaints from borrowers who claimed that they had not been told about the prepayment penalty or that the loan officer promised they would not have one. Again, despite receiving such complaints, Defendants turned a blind eye to deceptive marketing practices regarding prepayment penalties and the resulting adverse financial consequences to borrowers.

E. Countrywide Misled Borrowers About the Cost of Reduced and No Documentation Loans

133. Countrywide touted its low documentation requirements, urging borrowers to get "fastrack" loans so that they could get cash more quickly. However, many borrowers who obtained these loans possessed sufficient documentation to qualify for full document mortgages, and some submitted that documentation to their loan officer or to one of Countrywide's business partner brokers. In emphasizing the ease, speed and availability of reduced or no document loans, Countrywide and its brokers concealed the fact that borrowers could qualify for a lower rate or reduced fees if they elected to apply for a mortgage by fully documenting their income and assets.

F. Countrywide Misled Borrowers Regarding the Terms of HELOCs

134. Countrywide misrepresented the terms of HELOCs, including without limitation by failing to inform the borrower that he or she would not have access to additional credit because he or she was receiving a full draw or that the monthly payment on the HELOC was interest-only and the borrower therefore would not be able to draw additional funds on the HELOC at a later date.

135. Countrywide also misrepresented or obfuscated the payment shock that borrowers would experience after the interest-only payment period on the HELOCs ended. Countrywide's Call Center received large numbers of calls from borrowers complaining that they did not understand that the payments on their full-draw HELOCs would only cover interest or that the interest rates on their HELOCs would adjust and increase.

VII. IN ORDER TO INCREASE MARKET SHARE, DEFENDANTS CRE-ATED A HIGH PRESSURE SALES ENVIRONMENT WHERE EMPLOY-EES WERE REWARDED FOR SELLING AS MANY LOANS AS THEY COULD, WITHOUT REGARD TO BORROWERS' ABILITY TO REPAY

136. Despite touting itself as a lender that cared about its borrowers, Countrywide was, in essence, a mass production loan factory set up to produce an ever-increasing stream of loans without regard to borrowers' ability to repay their loans and sustain homeownership. In order to provide an endless supply of loans for sale to the secondary market, Defendants pressured Countywide employees involved in the sale and processing of loans to produce as many loans as possible, as quickly as possible, and at the highest prices.

137. Defendants created this pressure through a compensation system, which predictably led employees to disregard Countrywide's minimal underwriting guidelines and to originate loans without regard to their sustainability. Countrywide's compensation system also motivated its loan officers to engage in the deceptive marketing practices described in the preceding sections.

138. Defendants incentivized managers to place intense pressure on the employees they supervised to sell as many loans as possible, as quickly as possible, at the highest prices possible. Branch managers received commissions or bonuses based on the net profits and loan volume generated by their branches. In most circumstances, however, branch managers were eligible for such commissions or bonuses only if their branches sold a minimum number of loans during the applicable time period. Branch managers were also rewarded for meeting production goals set by corporate management, increasing the number of loan sold per loan officer, and reducing the time periods between the loan application stage and funding — or penalized for failing to do so.

139. Countrywide provided branch managers with access to computer applications and databases that allowed them to monitor loan sales on a daily basis and pressure employees to "sell, sell, sell." A branch manager could input the type of loan (such as a Pay Option ARM), the principal loan amount, the borrower's FICO score, the loan-to-value ratio, and the level of required documentation (such as Stated Income Stated Asset) and determine what price a borrower would pay for that loan, as well as the amount of profit the loan would likely generate for the branch. Branch managers could also monitor their branches' loan sales performance by tracking loans that were in the process of being underwritten and the prices and characteristics of loans sold by the branch and by particular loan officers, during any specified time period.

140. With such tools available, Countrywide's branch managers were able to constantly pressure loan officers, loan processors, and underwriters to do their part in increasing loan production — by hunting down more borrowers, selling more

loans, and processing loans as quickly as possible, thereby boosting loan production, branch profits, and branch manager commissions and bonuses. This high-pressure sales environment invited deceptive sales practices and created incentives for retail branch managers, other managers, loan officers, loan specialists, and underwriters to jam loans through underwriting without regard to borrower ability to repay.

141. Countrywide created additional pressure to engage in deceptive marketing practices and sell loans without regard to their sustainability by paying its loan officers and managers a modest base salary that could be supplemented by commissions or bonuses. In most circumstances, the employees were eligible to receive these commissions or bonuses only if they, or the employees they supervised, sold a minimum number or dollar volume of loans.

142. Not only did this compensation system create incentives for employees to sell as many loans as possible, as quickly as possible, it also created incentives for retail employees to steer borrowers into riskier loans. For example, Countrywide paid greater commissions and bonuses to CMD managers and loan officers for selling full-draw piggyback HELOCs, as opposed to HELOCs with low initial draw amounts. Countrywide also paid greater commissions and bonuses to FSLD managers and loan officers for "subprime," as opposed to "prime," loans.

143. Countrywide's compensation system also created incentives for wholesale loan officers to steer brokers and their clients into riskier loans. Countrywide's wholesale loan officers worked one-on-one with "business partner" brokers approved by Countrywide. The loan officers cultivated relationships with brokers in order to persuade them to bring their business to Countrywide and, in particular, to work with a particular loan officer so that he or she, and his or her managers, could earn greater commissions. From March 1, 2005 to May 1, 2006, WLD loan officers received higher commissions for refinance Pay Option ARMs and "Expanded Criteria" (loans in which certain underwriting standards were eased) than they did for all other types of refinance loans. In addition, WLD branch managers were rewarded if their branches sold increasing numbers of HELOCs in tandem with loans carrying loan-to-value ratios greater than 80%.

144. Countrywide's compensation system also rewarded employees for selling loans at a premium, i.e., at prices above what borrowers would otherwise qualify for based on Countrywide's posted prices. Monthly commissions were increased for selling loans with premiums and reduced for selling loans with prices below those posted by Countywide. Thus, loan officers in Countrywide's wholesale branches were motivated to persuade loan brokers to negotiate loans at high premiums for their borrowers, which was not typically in the borrowers' best interests.

145. Countrywide's high-pressure sales environment and compensation system encouraged serial refinancing of Countrywide loans. The retail compensation systems created incentives for loan officers to churn the loans of borrowers to whom they had previously sold loans, without regard to a borrower's ability to repay, and with the consequence of draining equity from borrowers' homes. Although Countrywide maintained a policy that discouraged loan officers from refinancing Countrywide loans within a short time period after the original loan funded (Countrywide often changed this time period, which was as low as three months for some loan products), loan officers boosted their loan sales by targeting the easiest group of potential borrowers to locate — Countrywide borrowers — as soon as that period expired.

146. Countrywide management at all levels pressured the employees below them to sell and approve more loans, at the highest prices, as quickly as possible, in order to maximize Countrywide's profits on the secondary market. Defendant Sambol, for example, monitored Countrywide's loan production numbers and pressured employees involved in selling loans or supervising them to produce an ever-increasing numbers of loans, faster. Regional vice presidents pressured branch managers to increase their branches' loan numbers. Branch managers pressured loan officers to produce more loans, faster, and often set their own branch-level production quotas.

147. Underwriters were also pressured to approve greater numbers of loans quickly and to overlook underwriting guidelines while doing so. Defendant Sambol pressured underwriters to increase their loan production and to increase approval rates by relaxing underwriting criteria. Regional operations vice presidents, branch operations managers, branch managers, and loan officers all pressured underwriters to rush loan approvals. Countrywide required underwriters to meet loan processing quotas and paid bonuses to underwriters who exceeded them.

148. Customer service representatives at Countrywide's Call Center also were expected to achieve quotas and received bonuses for exceeding them. Countrywide required service representatives to complete calls in three minutes or less, and to complete as many as sixty-five to eighty-five calls per day. Although three minutes is not sufficient time to assist the confused or distressed borrowers who contacted them, Countrywide required service representatives to market refinance loans or piggyback HELOCs to borrowers who called with questions - including borrowers who were behind on their monthly payments or facing foreclosure. Using a script, the service representatives were required to pitch the loan and transfer the caller to the appropriate Countrywide division. Service representatives also received bonuses for loans that were so referred and funded.

149. Countrywide employees from senior management down to branch

managers pressured the employees below them to sell certain kinds of products. Regional vice presidents, area managers, and branch managers pushed loan officers to sell Pay Option ARMs, piggyback HELOCs, and loans with prepayment penalties, primarily because such loans boosted branch profits, manager commissions, and Countrywide's profits on the secondary market.

150. If any of these employees, including branch managers, loan officers, loan processors, underwriters, and customer service representatives, failed to produce the numbers expected, Countrywide terminated their employment.

VIII. AS PART OF ITS DECEPTIVE SCHEME, COUNTRYWIDE COMPENSATED ITS BUSINESS PARTNER BROKERS AT A HIGHER RATE FOR MORE PROFITABLE LOANS, WITHOUT CONSIDERATION OF SERVICES ACTUALLY PROVIDED BY THE BROKERS

151. In California, a mortgage broker owes his or her client a fiduciary duty. A mortgage broker is customarily retained by a borrower to act as the borrower's agent in negotiating an acceptable loan. All persons engaged in this business in California are required to obtain real estate licenses and to comply with statutory requirements. Among other things, the mortgage broker has an obligation to make a full and accurate disclosure of the terms of a loan to borrowers, particularly those that might affect the borrower's decision, and to act always in the utmost good faith toward the borrower and to refrain from obtaining any advantage over the borrower.

152. Countrywide paid brokers compensation in the form of yield spread premiums or rebates to induce brokers to place borrowers in loans that would earn Countrywide the greatest profit on the secondary market, regardless of whether the loans were in the best interest of, or appropriate for, the borrowers. In fact, the mortgages that earned Countrywide the highest profit, and therefore would pay the highest rebates or yield spread premiums to brokers, often were not in the best interest of the borrower.

153. For example, Countrywide paid a yield spread premium to brokers if a loan was made at a higher interest rate than the rate for which the borrower qualified and without regard for the services actually provided by the broker. Countrywide paid a rebate to a broker if he or she originated or negotiated a loan that included a prepayment penalty. A three-year prepayment penalty resulted in a higher rebate to the broker than a one-year prepayment penalty. Countrywide would pay this higher rebate even in instances where the loan did not include a provision, such as a more favorable origination fee or interest rate, to counterbalance the prepayment penalty, and where brokers did not perform any additional services in connection with the loan.

154. Countrywide also would pay rebates in exchange for a broker providing an

adjustable rate loan with a high margin (the amount added to the index to determine the interest rate). Countrywide would provide an additional rebate to brokers if they were able to induce a borrower to obtain a line of credit.

155. Countrywide accepted loans from brokers in which the broker earned up to six points (i.e., six percent of the amount of the loan), whether in origination fees, rebates, or yield spread premiums. This high level of compensation was well in excess of the industry norm and encouraged brokers to sell Countrywide loans without regard to whether the loans were in their clients' best interest. In addition, the compensation paid by Countrywide to brokers was well in excess of, and not reasonably related to, the value of the brokerage services performed by Countrywide's business partner brokers.

156. In order to maximize their compensation from Countrywide, brokers misled borrowers about the true terms of Pay Option and Hybrid ARMs, misled borrowers about their ability to refinance before the rates or payments on their loans increased, misled borrowers about the cost of reduced and no document loans, and misled borrowers regarding the terms of HELOCs by engaging in the same kinds of deceptive practices alleged at paragraphs 58 through 64, 75 through 77, 108 through 117, and 119 through 135 above.

157. Borrowers often did not realize that their loans contained terms that were unfavorable to them and provided greater compensation to their brokers specifically as payment for those unfavorable terms. An origination fee or other charges imposed by a broker are either paid by the borrower or financed as part of the loan. In contrast, rebates and yield spread premiums are not part of the principal of the loan and instead are paid separately by Countrywide to the broker. Documentation provided to the borrower might indicate, at most, that a yield spread premium or rebate was paid outside of closing (often delineated as "p.o.c." or "ysp poc"), with no indication that the payment constituted compensation from Countrywide to the broker for placing the borrower in a loan with terms that were not in the borrower's best interest, such as a higher interest rate or lengthier prepayment penalty.

158. Countrywide closely monitored and controlled the brokers with whom it worked. Countrywide required brokers it accepted as "business partners" to cooperate and provide all information, documents and reports it requested so that Countrywide could conduct a review of the broker and its operations. In addition, Countrywide required the broker to warrant and represent that all loans were closed using documents either prepared or expressly approved by Countrywide.

IX. AS A RESULT OF DEFENDANTS' DECEPTIVE SCHEME, THOU-SANDS OF CALIFORNIA HOMEOWNERS HAVE EITHER LOST THEIR HOMES OR FACE FORECLOSURE AS THE RATES ON THEIR AD-JUSTABLE RATE MORTGAGES RESET

159. Due to Countrywide's lack of meaningful underwriting guidelines and risk-layering, Countrywide's deceptive sales tactics, Countrywide's high-pressure sales environment, and the complex nature of its Pay Option and Hybrid ARMs, a large number of Countrywide loans have ended in default and foreclosure, or are headed in that direction. Many of its borrowers have lost their homes, or are facing foreclosure, because they cannot afford the payment shock and their properties are too heavily encumbered for them to be able to refinance and pay prepayment penalties.

160. The national pace of foreclosures is skyrocketing. In the month of May 2008, approximately 20,000 Californians lost their homes to foreclosure, and approximately 72,000 California homes (roughly 1 out of 183 homes) were in default. This represented an 81% increase from May 2007, at which point the rate was roughly 1 out of every 308 households, while the May 2007 rate represented a 350% increase from May 2006.

161. Countrywide mortgages account for a large percentage of these delinquencies and foreclosures. Countrywide's 10-K filed in February, 2008, estimated that as of December 31, 2007, a staggering 27.29% of its non-prime mortgages were delinquent. As of that date, approximately 26% of Countrywide's loans were secured by properties located in California.

162. These numbers have only worsened. As of April, 2008, 21.11% of the mortgages owned by Countrywide Home Loans were in some stage of delinquency or foreclosure, including 47.97% of originated non-prime loans, and 21.23% of Pay Option ARMs.

163. In January and March, 2008, Countrywide recorded 3,175 notices of default in Alameda, Fresno, Riverside, and San Diego counties alone. Those 3,175 notices of default represented an aggregate total of delinquent principal and interest of more than 917 million dollars. An October 2007 report prepared by Credit Suisse estimated that Countrywide's delinquency and foreclosure rates are likely to double over the next two years.

164. This may well understate the extent of the crisis facing California homeowners with Countrywide mortgages, as more and more Pay Option ARMs go into delinquency. Approximately 60% of all Pay Option ARMs (made by any lender) were made in California, and many of these were made by Countrywide. Once the thousands of Pay Option ARMs sold by Countrywide to California borrowers reach their negative amortization cap or otherwise reset to

require fully indexed principal and interest payments, which will occur over the next two years for many such loans made between 2003 and 2006, the number of such loans in default is likely to skyrocket even above their current high delinquency rate.

FIRST CAUSE OF ACTION AGAINST ALL DEFENDANTS VIOLATIONS OF BUSINESS AND PROFESSIONS CODE SECTION 17500 (UNTRUE OR MISLEADING STATEMENTS)

165. The People reallege and incorporate by reference all paragraphs above, as though fully set forth in this cause of action.

166. Defendants have violated and continue to violate Business and Professions Code section 17500 by making or disseminating untrue or misleading statements, or by causing untrue or misleading statements to be made or disseminated, in or from California, with the intent to induce members of the public to enter into mortgage loan or home equity line of credit transactions secured by their primary residences. These untrue and misleading statements include but are not necessarily limited to:

a.) Statements that Countrywide was a mortgage loan expert that could be trusted to help borrowers obtain mortgage loans that were appropriate to their financial circumstances, as described in paragraphs 109 through 113, above;

b.) Statements regarding the terms and payment obligations of Pay Option ARMs offered by Countrywide, including statements that the initial payment rate was the interest rate, statements regarding the duration of the initial payment, statements regarding the duration of the initial interest rate, and statements obfuscating the risks associated with such mortgage loans, as described in paragraphs 58 through 64, 119 through 122, and 124 through 128, above;

c.) Statements regarding the terms and payment obligations of Hybrid ARMs offered by Countrywide, including statements regarding the duration of the initial interest-only payment, statements regarding the duration of the initial interest rate, and statements obfuscating the risks associated with such mortgage loans, as described in paragraphs 75 through 77, 119, and 123 through 128, above;

d.) Statements regarding the terms and payment obligations of HELOCs, as described in paragraphs 134 through 135, above; and

e.) Statements that borrowers with Pay Option and Hybrid ARMs offered by Countrywide would be able to refinance the mortgage loans before the interest rates reset, when in fact they most likely could not, as described in paragraphs 62, 76, 77, and 129 through 132, above;

f.) Statements regarding prepayment penalties on Pay Option and Hybrid ARMs offered by Countrywide, including statements that the mortgage loans did not have prepayment penalties, when in fact they did, and statements that prepayment penalties could be waived, when in fact they could not, as described in paragraphs 63, 64, 76, and 131 through 132, above;

g.) Statements regarding the costs of reduced or no documentation mortgage loans, as described in paragraph 133, above;

h.) Statements regarding the benefits or advisability of refinancing mortgage loans with Pay Option and Hybrid ARMs offered by Countrywide, as described in paragraphs 110 through 118, above; and

i.) Statements regarding the existence of prepayment penalties on mortgage loans being refinanced with Countrywide mortgage loans, as described in paragraph 117, above.

167. Defendants knew, or by the exercise of reasonable care should have known, that these statements were untrue or misleading at the time they were made.

SECOND CAUSE OF ACTION AGAINST ALL DEFENDANTS VIOLATIONS OF BUSINESS AND PROFESSIONS CODE SECTION 17200 (UNFAIR COMPETITION)

168. The People reallege and incorporate by reference all paragraphs above, as through fully set forth in this cause of action.

169. Defendants have engaged in, and continue to engage in, acts or practices that constitute unfair competition, as that term is defined in Section 17200 of the Business and Professions Code. Such acts or practices include, but are not limited to, the following:

a.) Creating and maintaining a deceptive scheme to mass produce loans for sale on the secondary market, as described in paragraphs 15 through 164, above;

b.) Making untrue or misleading representations that Countrywide could be trusted to sell borrowers mortgage loans that were appropriate to their financial circumstances, as described in paragraphs 109 through 113, above;

c.) Making untrue or misleading representations regarding the terms and payment obligations of Countrywide's Pay Option and Hybrid ARMs, including representations regarding the payment rate, the duration of initial interest rates, the duration of initial monthly payments, the inclusion of prepayment penalties, the waivability of prepayment penalties, the payment shock that

borrowers were likely to experience, and the risks associated with such mortgage loans, as described in paragraphs 58 through 64, 75 through 77, and 119 through 132, above;

d.) Making untrue or misleading representations regarding the terms and payment obligations of Countrywide's HELOCs, as described in paragraphs 134 through 135, above;

e.) Making untrue or misleading representations regarding the costs of reduced or no documentation mortgage loans, as described in paragraph 133, above;

f.) Making untrue or misleading representations regarding the true likelihood or circumstances under which borrowers would be able to refinance Pay Option or Hybrid ARMs offered by Countrywide, as described in paragraphs 62, 76, 77, and 129 through 132, above;

g.) Soliciting borrowers to refinance mortgage loans by misrepresenting the benefits of doing so or by misrepresenting or obfuscating the fact that in doing so the borrowers will incur a prepayment penalty, as described in paragraphs 110 through 118, above;

h.) Making mortgage loans and extending HELOCs without regard to whether borrowers would be able to afford monthly payments on those loans or HELOCs after the expiration of the initial interest rates on the mortgage loans, or the draw periods on the HELOCs, as described in paragraphs 85 through 107, above;

i.) Aiding and abetting the breach of the fiduciary duty owed by mortgage brokers to California borrowers, as described in paragraphs 151 through 158, above;

j.) Failing to provide borrowers with documents sufficient to inform them of their payment obligations with respect to fully drawn HELOCs, as described in paragraphs 81 through 84, above;

k.) Paying compensation to mortgage brokers that was not reasonably related to the value of the brokerage services they performed, as described in paragraphs 152 through 155, above; and

l.) Violating Section 17500 of the Business and Professions Code, as described in the First Cause of Action, above.

PRAYER FOR RELIEF

WHEREFORE, Plaintiff prays for judgment as follows:

1. Pursuant to Business and Professions Code section 17535, that all Defendants, their employees, agents, representatives, successors, assigns, and all persons who act in concert with them be permanently enjoined from making any untrue or misleading statements in violation of Business and Professions Codes section 17500, including the untrue or misleading statements alleged in the First Cause of Action.

2. Pursuant to Business and Professions Code section 17203, that all Defendants, their employees, agents, representatives, successors, assigns, and all persons who act in concert with them be permanently enjoined from committing any acts of unfair competition, including the violations alleged in the Second Cause of Action.

3. Pursuant to Business and Professions Code sections 17535, that the Court make such orders or judgments as may be necessary to prevent the use or employment by any Defendant of any practices which violate section 17500 of the Business and Professions Code, or which may be necessary to restore to any person in interest any money or property, real or personal, which may have been acquired by means of any such practice.

4. Pursuant to Business and Professions Code section 17203, that this court make such orders or judgments as may be necessary to prevent the use or employment by any Defendant of any practice which constitutes unfair competition or as may be necessary to restore to any person in interest any money or property, real or personal, which may have been acquired by means of such unfair competition.

5. Pursuant to Business and Professions Code section 17536, that Defendants, and each of them, be ordered to pay a civil penalty in the amount of two thousand five hundred dollars ($2,500) for each violation of Business and Professions Code section 17500 by Defendants, in an amount according to proof.

6. Pursuant to Business and Professions Code section 17206, that Defendants, and each of them, be ordered to pay a civil penalty in the amount of two thousand five hundred dollars ($2,500) for each violation of Business and Professions Code section 17200 by Defendants, in an amount according to proof.

7. That Plaintiff recover its costs of suit, including costs of investigation.

8. For such other and further relief that the Court deems just, proper, and equitable.

DATED: July 17, 2008

EDMUND G. BROWN JR.
Attorney General
ALBERT NORMAN SHELDEN
Senior Assistant Attorney General
RONALD REITER
Supervising Deputy Attorney General
KATHRIN SEARS
ROBYN SMITH
BENJAMIN G. DIEHL
LINDA HOOS
Deputy Attorneys General

By: _____
 BENJAMIN G. DIEHL
 Deputy Attorney General

"It is abundantly clear now that most mortgages
in this country from 1996 to 2008
were fraudulently induced."

A former Assistant Secretary of HUD

CHAPTER 2

The Conspiracy and the Fraud

The conspiracy to defraud homeowners was created during the derivatives explosion. To keep up with the market demand for mortgage backed securities, banks, investment banks, brokerages and Wall Street created predatory loans then engaged in fraudulent practices to sell and service them. The initial conspiracy was enlarged to include loan brokers, appraisers, realtors, builders, attorneys, insurers, title agents and credit rating agencies.

When first courting Wall Street, investment bankers were fastidious in qualifying assets to sell as derivatives. As the new kid on the block, derivatives were sweetened with falsely inflated credit ratings, overcollateralization and hype. This branding helped foster the misperception that derivatives were as valuable as their underlying assets.

In response, Wall Street lobbied the largest hedge and pension funds to invest in derivatives. The Federal Reserve got on board and predicted that sales of derivatives would exceed the growth of real currency. Market demand exploded, forcing Wall Street to think outside the box.

Mortgages were soon thrown into the derivative mix. Historically, mortgages were considered attractive debt assets. They adhered to strict underwriting standards based on excellent credit profiles. Their default rate was relatively low, as compared to credit cards, auto loans and the like.

Banks sold their mortgages to investment banks and loans were pooled and packaged as derivatives. Soon, mortgages were no longer funded in-house. Banks became nominal lenders who fronted the mortgage transaction for the investment banks who bought and securitized the mortgage loans. Then the notes were pooled, sliced, diced, rated and issued as shares of mortgage backed securities.

With the inclusion of mortgages, the derivatives market expanded. Banks were pressured by Wall Street to find new ways to enlarge their loan portfolios. But there was a limit of credit worthy borrowers and a finite number of first time homeowners who could afford the down payment on a new home. A bank could only do so much to feed the burgeoning pipeline.

So the House and Senate concluded the solution was to reduce lending standards. Couched in the sentiment of helping more minorities afford homes, this mandate had nothing to do with enhancing the lives of unqualified borrowers. It had everything to do with helping Wall Street sell derivatives by providing more loans that could be securitized.

Minorities, the elderly, immigrants and new home buyers were initially targeted. Neighborhoods were reverse-redlined as unscrupulous sweet-talking brokers, many of whom were former convicted felons, farmed the streets. Even after signing up first time unsuspecting borrowers, their efforts did not produce enough loans to meet the soaring demand.

So Wall Street created a line of "non-traditional" loan products to broadly expand the borrowing base. These products included hybrid adjustable rate mortgages, interest only loans, no documentation loans, no money down loans—even NINJA loans, based on no income, no job, and no assets. As we would learn later, less than fifty percent of borrowers understood these loans or their true terms.

Borrowers were encouraged to finance one hundred percent or

more against their equity with little or no money down. Refinances and equity lines were liberally granted based on falsified assets, credit scores and appraisals. The banks, being nominal lenders only, often did not take these loans on their balance sheets, acting in an originating capacity only.

Rather than banks making loans based on underwriting standards, Wall Street now dictated loan terms and production volumes. Since the lenders were paid at the closing, plus a profitable premium, there was no real risk in approving toxic loans. For the banks, pleasing Wall Street became more profitable than protecting Main Street. And Main Street cooperated, naively believing that lenders had their best interests at heart.

For Main Street, these new loan products were nothing short of a miracle. Main Street swiftly embraced them, taking comfort against the dire reality that existed outside its locked doors. As they say, home is where the heart is.

Initially, loan brokers, the first offensive line, were aggressively courted. Banks paid bonuses to them for steering innocent borrowers into higher profit toxic loans. These bonuses were passed onto borrowers as closing costs. Since higher interest loans paid handsome dividends to investors, unknowing borrowers were penalized for short-selling them and saddled with mandatory pre-payment penalties. These penalties paid the fees for predatory loan brokers.

What Wall Street knew that homebuyers and homeowners didn't, was that these unconventional loans were good for lenders and investment banks, but terrible for homeowners. They were based on false appraisals. They were hard to get rid of. They had initial teaser rates which would quickly and painfully reset. But not much concern was paid to borrowers or to the crisis that would inevitably erupt when loans would adjust and the real estate bubble would deflate.

Instead, the conspiracy's sole focus was on money changing hands to generate more and more fees. And as its sinister plan unfolded, the nation became bloated with leveraged debt that had insufficient and vaporous assets to back it up.

The initial conspiracy included loan brokers, banks, investment

banks and Wall Street. Its purpose was to provide a seamless loan closing. This was accomplished by the broker, posing as a correspondent lender, or the loan officer posing as the lender, pretending it was providing the funds.

In reality, the tail was decidedly wagging the dog. The loan had been pre-sold to an investment bank that actually provided the funds for the closing. The nominal lender did not take the loan on its balance sheet, either because it didn't provide the funds or it assumed the loan wouldn't be repaid. This fraud on the homeowner accomplished many objectives. It paid the broker a high yield spread premium. It originated fees and closing costs for the nominal lender. It kept the pipeline full for the investment bank that was in the business of churning loans. It kept Wall Street pumped up to sell the eventual securities. There were however, some fatal flaws in the seamless process, which would shortly bring the global economy to its knees.

Once the borrower was induced and the fraud was accomplished, the loan closing lacked transparency, as the real parties were not disclosed. Moreover, the homeowner was not informed that his mortgage was about to become a security. After the closing, the note went on a dizzying journey from the investment bank that placed it into a pool classified by credit worthiness and risk, beginning with "Triple A" and ending in "toxic waste." Each pool contained descriptions of its loans. The pools went to a depositor and then to a trust which issued shares of mortgage backed securities. At each step, the notes were required to be legally endorsed during the transfer, and the transfers were required to be legally recorded. The securities were sold to sophisticated investors, and the shares were re-sold and leveraged up to sixty times and then swapped.

Until the foreclosure crisis, not much thought was given to the exuberant haste in which this process unfolded. Not only did the separation of the mortgage and the note nullify the transaction, but the rapid re-assignments of notes went unendorsed and unrecorded, rendering them useless as security instruments in the underlying real estate property. Due to the lack of transparency, the closings had fatal defects. And while the nominal lenders kept the mortgage servicing

rights, the rights of the lenders to foreclose were denied by judges who demanded that lenders prove they had legal standing.

This would later prove to be the silver lining for defrauded home-owners who fought hard against foreclosure.

The conspiracy further encouraged brokers and lenders to conceal the true terms of toxic mortgages. Mortgage brokers and loan officers were trained to tout the initial teaser rate and refrain from mentioning the loan's toxic features. Brokers and lenders enthusias-tically participated in this fraud, qualifying borrowers on the teaser rate and not the fully amortized payment. They were incented to pro-mote that "quick cash out" was only a phone call or signature away.

Another common ploy lenders used was insisting that borrowers sign loan documents without review. This was accomplished by send-ing a notary to the borrower's home, ensuring the loan officer would-n't be available to answer questions. This perk was presented as an example of the lender's efficient albeit self-serving customer service. Borrowers were charged an excessive fee for this fraudulent courtesy.

But in reality, this tactic had nothing to do with customer service. The truth was there was an urgent need for the investment banker of the nominal lender to back up an already sold security with a mort-gage and title. Even loans that were rescinded were sold! It would be years before borrowers would learn they were in foreclosure on a mortgage they had cancelled for a home they never purchased. Florida lawsuits revealed some desperate lenders, backed into a legal corner, brought falsified assignments and forged notes to court.

According to plan, explosive sales of toxic loans expanded the mortgage backed securities market. The stock market soared and bank stocks hit an all time high. As more false wealth was created, more homes were purchased, translating into huge profits for builders, realtors, appraisers, attorneys, insurers and title agents.

They all joined the conspiracy, inflating home prices, appraisals, insurance premiums and fees. Lenders paid bonuses to builders who raised new home prices each quarter. They incented appraisers for falsifying home values. They incented real estate agents to over-list properties so that higher "comps" could justify inflated loan amounts.

Lenders paid brokers, appraisers and realtors illegal referral fees, rebates and kickbacks.

The cycle continued. Relying on fraudulent advice from corrupt brokers and lenders, borrowers upgraded into more house and more debt. While it seemed too good to be true, borrowers believed brokers and loan officers who claimed their initial teaser rate was fixed. They believed their homes' value had suddenly doubled. They believed their next refinance was just around the corner. Why wouldn't they? Most were homeowners who had prior traditional mortgages and were not used to being deceived or defrauded. More profound reasons are discussed in the next chapter.

To keep up with brisk loan production, banks re-organized to make room for inventive processing functions. One of the more creative vehicles to generate fraud was the "structured loan desk." Adopted by the largest lenders, this department's job was to ignore the normal underwriting standards and push toxic loans through the pipeline.

By now, it was commonplace for brokers and lenders to fill out pre-signed loan applications. While this seemed a strange custom to borrowers, brokers insisted the application was submitted online. Brokers particularly pushed "no doc" toxic loans. These were loans that required only a credit score and a statement of assets. They were the easiest loans to generate rapid approval.

But no loan was too challenging and no FICO credit score too low. When a borrower didn't have enough assets, assets of other borrowers were substituted. Bank statements and pay stubs were falsified. However, on the rare occasion when a toxic loan hit an unexpected and insurmountable snag, it was shuttled over to the structured loan desk for an "exception."

The structured loan desk was approval heaven. If a borrower didn't have sufficient income, the structured loan desk created assets. If a borrower had a credit problem, the structured loan desk removed it. If a borrower didn't have a job, the structured loan desk transferred the loan into the spouse's name. Exceptions were liberally granted in line with the demand for securities.

Lenders also demanded that underwriters approve over sixty loans per day. If they protested, they were shown the door. When an underwriter correctly denied a loan, a supervisor quickly overruled the decision. Branch managers were in on the fraud, and had final approval of their loans. Branch bonuses were tied to production volumes, not quality loans.

By 2008, the parallel fraud of borrowers and investors was nearly complete. Most fixed rate mortgages were converted and sales of toxic loans had grown by over one thousand percent. And what had the conspiracy accomplished? A real estate market on the verge of bulimia, poised to regurgitate a Sunday buffet of false equity. And a global credit market flying high on vaporous paper.

By inflating appraisals and home prices, real estate values were temporarily higher. By inflating credit ratings, derivative sales soared. Based on these illusions, the economy appeared stronger and the DOW hit an all time high. But home equity and derivative value were worth far less than their projected hype. Instead, the seemingly robust economy was temporarily pumped up by leveraged derivatives backed by securities tied to worthless paper.

Even the US government had gone along for the ride, ignoring repeated requests from Congress to examine the wild deregulation of financial service institutions. The government's lobbyist-generated belief, that the financial markets could regulate themselves, was music to Wall Street's ears. So the world kept surfing this crashing credit wave, oblivious to the rocky wipeout ahead.

Until the unthinkable happened. Toxic loans adjusted and borrowers could not make the adjusted payments. The financial market was hit first, symbolized by the collapse of Bear Stearns and the bankruptcy of Lehman Brothers. The crisis soon infiltrated the globe when credit default swaps came due. Ironically, the two largest conspiring and most creative perpetrators of the fraud—Wall Street and the Federal Reserve—acted the most surprised of all.

The first bailout engineered by the Bush government was a failure. Unconscious financial organizations reciprocated with lavish off sites and spa treatments for their management. Nonetheless, the

Obama administraton continued the bailouts while banks hoarded the capital. The "too big to fail" institutions cried they could get back on their feet with a little help from their friends at the Fed, while their stock continued to plummet. The failing automakers, fresh off their corporate jets, offered weak business plans and then blamed commodity prices for their myopia.

The credit markets crashed. Small businesses bellied up, unable to float payroll. Consumer confidence was shattered. The Fed's pathetic infusions did little to stimulate the battered, paranoid, traumatized, risk adverse economy. Even after the jubilant presidential election, Obama's plans to revitalize the shell-shocked economy were greeted with downturns and suspicion.

The globe's sense of false abundance quickly turned to scarcity and the layoffs began. Even the newly rich retreated, scarred by margin calls and portfolio wipeouts. The chain of blame, along with the chain of new poverty emerged, causing an immediate trickle-down effect. States and even nations, almost declared bankruptcy while entire industries were derailed.

And where has this catastrophe left you, the defrauded home-owner?

Out of luck and out on the street, saddled with judgments, bank-ruptcies, and bad credit. Unemployed and cash poor. Worse off than if you had kept your higher interest fixed rate loan and left the fleeting equity in your home. Emotionally, it has left you terrified, angry, hurt and mistrustful of the government and its cronies. And it has left holders of mortgage backed securities in the same boat as homeowners, holding worthless paper that has no legal connection to the real estate it represents.

The damage to homeowners has not only been financial.

Main Street has been afflicted with payment shock syndrome in addition to post traumatic stress disorder. Some elderly homeowners, displaced from their lifelong homes, have been forced into nursing homes. Homeless families have moved into their cars. Other trauma-tized borrowers have committed suicide. It will be years before America recovers from financial and psychological shock.

However, there is a silver lining in this cloud of deception and fraud.

Homeowners are fighting back. They have filed lawsuits across America, demanding their predators be punished. Lenders and their attorneys are getting a caning. Educated by borrowers and savvy litigators, judges are demanding lenders prove their standing before granting foreclosures. Ohio has even adopted a foreclosure readiness law, which requires attorneys to prove lenders' standing before they can file a foreclosure action.

Sheriffs have gotten on board, refusing to enforce eviction orders that would throw homeowners out on the street. Some cities have declared a "no foreclosure zone." Hardest hit states, including California, Florida, Michigan, Illinois, Missouri, Nevada, New Jersey, New York, North Carolina, Ohio, Pennsylvania, Texas, Virginia and Washington are not far behind. More and more, the country smells a rat and is joining forces to exterminate the rodent predators.

President Obama must come to terms with the millions of homeowners in distress, and the billions in loans soon to reset, forcing millions more into payment shock and foreclosure. How the government attempts to re-establish the American dream will be crucial to stabilizing the economy. The nation should adopt a national foreclosure readiness law, before more fraudulent lenders' attorneys clog up the courts with more illegal foreclosures.

The greed epitomized by the predators that created this demise, is nowhere more apparent than in the courtroom. Not only have the conspirators fraudulently induced borrowers into toxic loans and been paid in full plus a premium, they want to take their houses through illegal foreclosures! Judges are curtailing their windfalls by dismissing foreclosures and awarding damages to enraged borrowers.

Is there any way out of this mess? There is, but the conspiracy of predators isn't buying it.

These toxic loans, pushed down borrowers' throats in the name of greed, should be extinguished. That is the fastest route to returning wealth to the millions of damaged borrowers. It would spur an economic revolution on Main Street and help reverse the recession.

But will the conspiracy come clean? Not likely.

If, in an improbable and bold flight into health, the federal government decides to play Robin Hood, it would restore confidence in the country's political and financial systems. That in turn, would have a swift global impact. But if it doesn't, weighed down by the cronyism that rots like cancer in Washington, it will happen anyway, when enough homeowners take to the courts.

For instance, what happens when millions of homeowners rescind their toxic loans after reading this book? The final shoe will drop, as lenders will be forced to admit that their paperwork has been a little too shoddy.

Ohio has been a leader in advocating homeowner's rights. This law stops illegal foreclosures dead in their tracks and holds predatory lenders accountable. If adopted nationally, it could highlight millions of illegal foreclosures and stop millions more.

It is presented here in its entirety for your review.

CASE STUDY 2

Ohio Certificate of Readiness
For Foreclusre Actions

Case Study Two

IN THE COURT OF COMMON PLEAS
SUMMIT COUNTY, OHIO

IN RE:
CERTIFICATION OF READINESS FOR MISC. NO. 325
FORECLOSURE ACTIONS FILED IN THE
COURT OF COMMON PLEAS
GENERAL DIVISION **ORDER**

Due to the dramatic increase of foreclosure actions filed and the number of claims field by parties other than the original Mortgagee and Note Holder, the judges of the Common Pleas Court — General Division have determined that when a foreclosure case is filed the use of a certificate of readiness is necessary to allow that substantial justice be done and to ensure judicial efficiency. Current circumstances also require a modification of the time in which to file the preliminary judicial report, shortening the time to file such preliminary judicial from sixty days after filing the complaint to contemporaneous with the filing of plaintiff's complaint.

The court hereby incorporates, by reference, the attached certificate of readiness, which is required to be filed with the Clerk of Courts at the time the plaintiff's complaint n foreclosure is filed. The complaint in foreclosure, the preliminary judicial report and the certificate of readiness shall all be filed contemporaneously.

To adopt these procedures, the rules of practice and procedures of the court of Common Pleas — General Division, Rules 11.01 and 11.02 shall be amended to read in their entirety as follows (added or altered language in bold):

11.01 — Title Evidence; Preliminary Judicial Report and Certificate of Readiness

In actions for the marshaling and foreclosure of liens on real property or partition of real estate, a Preliminary Judicial Report shall be filed with the Clerk by the attorney for the plaintiff at the time of the filing of complaint. This shall serve as evidence of the state of the record title of the real property in question. Said report may be prepared by an attorney or a competent abstractor or title company. A copy, certified by the attorney or a photographic copy of the original evidence of title, may be filed with the Clerk in lieu of the original, and shall become and remain a part of the case file. Along with the

filing of the Preliminary Judicial Report, the attorney shall file a Certificate of Readiness and any required supporting documentation, demonstrating that plaintiff is the real party in interest and the matter is ready to proceed against all necessary parties. This shall be signed by the attorney. The complaint, the Preliminary Judicial Report and the Certificate of Readiness shall be filed as separately time-stamped with the complaint being filed first.

11.02 — Failure to Provide Evidence

If a Preliminary Judicial Report and the Certificate of Readiness, along with all supporting documentation, are not presented to be filed at the time of the filing of the complaint, the Clerk of Courts shall not accept such complaint for filing.

This order shall be effective June 1, 2008 and all foreclosure filings shall be bound by the amended local rules after this date.

IT IS SO ORDERED.

ELINORE MARSH STORMER, ADMINISTRATIVE JUDGE
PAUL J. GALLAGHER, PRESIDING JUDGE
PATRICIA A. COSGROVE, JUDGE
MARY F. SPICER, JUDGE
ROBERT M. GIPPIN, JUDGE
THOMAS A. TEODOSIO, JUDGE
JUDY HUNTER, JUDGE
BRENDA BURNHAM UNRUH, JUDGE
ANDREW J. BAUER, COURT EXECUTIVE OFFICER

IN THE COURT OF COMMON PLEAS
COUNTY OF SUMMIT, OHIO

Certificate of Readiness

Case Caption

I, _____, counsel for the Plaintiff, certify to the Court that I have reviewed the case file and my own records, and that all of the below statements are correct to the best of my knowledge and belief:

1. The complaint, the mortgage attached to the complaint, and the preliminary judicial report all contain the correct legal description(s) and permanent parcel number(s) relating to the subject property located in Summit County, Ohio.
2. The complaint and the preliminary judicial report both indicate the correct owners of the subject real estate (as shown on the mortgage, tax lien, mechanic's lien, or judgment lien) and signators (as shown on the note and mortgage), and that said owners and signators have been named as Defendants within the complaint.
3. The Plaintiff is the owner of the note and mortgage upon which the complaint is founded and as verified within the preliminary judicial report.
4. Should the Plaintiff be different from the designated owner of the original note and mortgage due to an assignment, copies of that assignment, and intervening assignments of such note and mortgage are attached to the complaint, and are similarly reflected within the preliminary judicial report.
5. Should the Plaintiff be different from the designated owner of the original note and mortgage due to a name change or corporate merger, copies of said name change or merger are attached to the complaint, or an affidavit attesting to the name change or merger along with the dates of the name change or merger is attached to the complaint.
6. Should there be more than one Plaintiff asserting a separate right of ownership in the mortgage and note, all necessary supporting documents establishing the separate chains of ownership are attached to the complaint.
7. The Plaintiff has in its custody and control the original note and mortgage, and said documents are available for inspection upon order of the Court.
8. All such assignments, name changes, or corporate mergers referred to above, and which are shown on the preliminary judicial report, bear a date prior to the filing date of the complaint in this matter.
9. None of the Individual Defendants named in this complaint has been adjudicated as incompetent or otherwise under guardianship and/or is a minor.
10. Any person named in their representative capacity (such as a guardian, an estate representative, statutory agent, trustee, or in any other representative capacity) has been correctly designated by name and duly appointed

by court order or other government designated, and copies of such appointment documents can be produced upon order of the Court.

11. None of the designated Defendants are currently under the protection of the Federal Bankruptcy Court; if relief from stay has been granted, then a copy of such relief from stay is attached to the complaint.

12. Should the complaint be based upon a judgment lien, mechanic's lien, or a tax certificate, the preliminary judicial report reflects said claim, and a copy of the lien or certificate, together with the affidavit stating the current balance due, is attached to the complaint.

13. Should the complaint be based upon a tax certificate, an affidavit is attached to the complaint describing the tax certificate numbers, the current amount due, and the real estate subject to the within foreclosure.

14. Should the complaint be based upon a mortgage and note, I have available for inspection upon order of the Court a statement showing the total amount due, with a separate itemized part showing the pay-off balance, interest, the interest rate, and any penalties or other charges, with specific reference identifying what the additional penalties and charges are based upon. A person responsible for maintaining such records for the Plaintiff shall certify this statement.

As counsel for the plaintiff, I acknowledge and otherwise understand that if any of the above requirements are not met or if the provided documents and information are inaccurate, the Court may cause this case to be dismissed without prejudice at the Plaintiff's cost.

Date:

Counsel for Plaintiff

Printed Name and Bar Number

Pursuant to Local Rule 11.09, this Preliminary Certificate of Readiness shall be filed with the Clerk of Court with the complaint and preliminary judicial report.

"It was the Wild West," said Steven M. Knobel,
a founder of an appraisal company that did business
with WAMU until 2007. "If you were alive, they would
give you a loan. Actually, I think if you were dead,
they would still give you a loan."

New York Times, December, 2008

How America Got Duped

It is worth examining how America, the strongest and most resilient superpower in the world, got duped by the conspiracy of predators that masterminded the downfall of the global financial markets, and in the process defrauded millions of homeowners. Americans, by nature, are both trusting and savvy. But in this case, they allowed themselves to be conned right into the financial slaughterhouse. Why?

For the answer, we must look to psychology and look no further.

Just like people have their own development and psyche, systems such as families, businesses, industries and nations have their own psyche. What is a psyche? It is the conscious and unconscious cerebral apparatus for making meaning in the physical world. On a conscious level, Americans value democracy, industry, peace and prosperity. On an unconscious level, America struggles to grow beyond its illusions to live those values with transparency.

If nothing else, Americans are growth junkies, always seeking to further their own development. On a conscious level, America's psyche is in transformation: transforming

from a country with prejudices into one which honors diversity; transforming from a society that carries the burden of the world into one seeking global partners; transforming from a nation threatened by terrorism into one which establishes power over terrorists, and so on.

However, transformation, by definition, is a biphasic unconscious process. So, on a daily basis, America ricochets from good to evil, from progress to regression, from awareness to denial, from illusion to truth; two steps forward, followed by one step backward, integrating new awareness and consolidating new learning along the way.

So in picking its leader, America generally roots for the growth junkie; a president who can push, cajole, inspire and prod the nation into its next level of consciousness. Unfortunately, such a leader often falls prey to a Gandhi effect, in which the minority fearing transformation attempts to derail him. But as we saw in the acquittal of President Clinton, the growth junkie majority often rights the ship in the nick of time.

From 1992 to 2000, America's thirst for growth resulted in the two term election of a transformational president who turned the economy around, and insisted on diversity and intimate global partnerships. Then the abundant and optimistic nineties were punctuated by a new millennium, symbolized by one big global bash. Together, Americans crossed the bridge to the 21st century and said an affectionate goodbye to their transformational leader.

America had no idea that financial Armageddon was rolling. Or that it would soon be led into a fraud zone.

The 2000 rigged presidential election began a ten year cycle of fraud. As the country uneasily accepted its new self-appointed president, terrorists attacked the Twin Towers and the Pentagon. The new president acted swiftly but incorrectly. Rather than hunt down Bin Laden, he focused instead on Iraq. In response to feeling unsafe within its borders, American contracted post traumatic stress disorder.

Post traumatic stress disorder (PTSD) is classified as an anxiety disorder caused by a catastrophic threat. Common to soldiers and battered children, it thrusts its victims into a paranoid state, characterized

by fight or flight behavior. It also has a self protective mechanism causing denial.

PTSD is characterized by the American Psychiatric Association as a condition resulting from "personal experience of an event or trauma that involves actual or threatened death or serious injury. Events include combat, being taken hostage, a terrorist attack, torture, manmade disasters and war. The disorder may be severe and long lasting. Symptoms include anxiety, depression, anger, intense fear, helplessness, horror, persistent avoidance and numbing of responsiveness; feelings of ineffectiveness, shame, despair, and a loss of previously sustained beliefs."

After the initial shock of 9/11, there were many incidents that deepened America's PTSD, starting with Homeland Security's color-coded daily threat index, followed by regular anthrax attacks and Katrina. Americans tiptoed around their borders and stayed put behind locked doors. And by the time the country was told of the imminent need for war, its learned helplessness was in full throttle.

Learned helplessness, a condition caused by post traumatic stress disorder, is defined as the inability to change one's circumstances no matter what action is taken. America felt helpless against the daily threat of terrorism. It also felt helpless to overturn the rigged election, stop the illegal wire tapping of American citizens, save victims from Katrina and cease the torture at GITMO. America was further helpless to stop the bloodshed inside Africa, prevent children from being sold into slavery, convict terrorists and stop gang-related killings.

Prior to this cycle of fraud, America had been empowered. The transformational thrust of the prior presidential administration had Americans feeling optimistic and industrious. But due to these unforeseen external forces, America was immobilized with anxiety and self doubt, and helpless in doing much about it.

Learned helplessness is a condition described by experimental behaviorists—the ones who torture innocent animals in the name of science—as a "no win consciousness." In a typical experiment, a laboratory dog receives a series of shocks, forcing him to run to the

opposite side of his cage, where he receives more shocks. Realizing there is no way to avoid the shocks; the defeated animal lies down on the shock apparatus and awaits death.

PTSD coupled with learned helplessness explains the country's passive acceptance of the premature need for war. If America couldn't elect a President without the Supreme Court overturning its will, how could it stop a fraudulent war?

America's distorted thinking went something like this: if in fact, Iraq had weapons of mass destruction, and if in fact, Suddam Hussein planned to deploy them, then given 9/11, America would be completely self-destructive not to stop him. And truth be told, while America could not easily link Saddam with Bin Laden and his fraternity of terrorists, it didn't much like the guy: look what he did to the president's daddy!

America embraced the war with the same suspicion it felt toward the new president and remained cautiously pessimistic. When Americans learned that there were no weapons of mass destruction found in Iraq and the war escalated, their post traumatic stress disorder deepened. Yet they were helpless in curing themselves, much less the nation.

The silver lining in this cloud was, ironically, the buoyant economy, bolstered by the derivatives explosion. The American psyche, seeking comfort from these recent and traumatic events, sought sanction in the one place Americans had always found their refuge: inside their homes.

The predators had found the prey. Offering easy credit and cheap money to upgrade or improve their homes was an offer America could not resist. It had the nation at "hello".

Under better circumstances, America could have mustered the momentum to fight back against the war, but given its PTSD, it just limped along, watching the war on TV as it did the Superbowl. So the war dragged on despite America's distaste for it, and its growing dislike of its president. And along with the war, the predatory conspiracy was growing and spitting out foreclosure casualties without much of a response from the government.

To some, the explosive growth of the mortgage market felt like a lifeline. And things that are too good to be true often are. But given America's trauma and fixation on its homes as a source of comfort, it embraced the con, believing it was the silver cloud in a sky of darkening doom. Americans, who had never owned homes, bought them. Americans who loved their homes took out equity lines to improve them. And ironically, as America retreated deeper into its homes, the conspiracy dug deeper into building a vaporous global economy.

When the global financial crisis hit, it added insult to injury for America. The one place Americans craved was their homes. Now, stuck in a war they did not authorize, and stuck with a leader who didn't consult them, they soon found themselves, literally and figuratively, thrown out on the street. How did this happen, they wondered. Answers would be hard to find.

Other nations may have collapsed, but not America. When the proverbial going gets tough, America's tough gets going. So, in 2008, America elected a new leader more in keeping with its transformational paradigm and hoped for the best.

But the trauma remains and recovery looks uncertain. Clearly, part of the cure is to keep Americans in their homes and not punish them for falling prey to the conspiracy. Given special interest groups, lobbyists and politicians, this will be easier said than done.

But one thing is for sure: this is an unprecedented crisis, which carries with it, an unprecedented opportunity for both financial and psychological transformation. The question remains: is the new Administration up to the task of transformation?

A transformation of this magnitude is enormous. It includes a complete overhaul of the dynamics between the President and his Administration, between the President, Congress and the Senate, between the President and the Federal Reserve, and between all the above parties, plus special interest groups, lobbyists and Wall Street. To accomplish it, the President must be schooled in transformational process and dynamics to avoid a disastrous Gandhi effect.

As a former CEO of a global consultancy that specialized in corporate culture transformation, I can attest to the fact that most lead-

ers naively assume events will change because they say so. They are blithely unaware of the multitude of dynamics that a progressive vision triggers. They are mostly, and fatally, unaware of the accompanying regressive trend that takes hold. They also do not know how to calibrate the balancing act between top down and bottom up transformation. It will be fascinating to observe how the United States and the world are led toward a corrective course.

"Just two hours before her home was to be auctioned due to foreclosure, a Massachusetts woman shot and killed herself... psychological experts agree that this kind of financial stress is a primary factor in suicide."

Nowpublic.com

CHAPTER 4

Payment Shock Syndrome

The meltdown begins. Your heart pounds, your palms sweat and your ears ring. Your breath is labored as your central nervous system triggers a flight or fright response. You feel your whole being explode with rage.

In disbelief, you re-read your mortgage statement. As you stumble from your mailbox to your kitchen, you consider reaching for something more potent than coffee. With trembling hands, you read the statement again. It can't be right! How can your mortgage payment have tripled?

You grab the portable and call your broker, who is conveniently out of business. You call the customer service number on the statement. A man answers from a call center in Costa Rica. You barely understand a word he says. You demand to talk to a manager and are told managers don't accept calls. You leave a request for a callback within twenty four hours.

Then, spent from anxiety, you collapse into a chair. For a moment, you concentrate on your lack of calm. You take a deep breath and try to get a grip. If you are already ill, you reach for a pill. If you aren't, you might think about reaching for a drink or some chocolate.

You glance around your kitchen, noticing every knickknack, child's drawing and decorative touch. So much has happened in this kitchen, the heartbeat of your house! Although you attempt to repress your terror, you can't help bursting into tears. You are in big trouble and you know it. You are in danger of losing your home.

What to do? Who can help? You just don't know where to turn.

Welcome, battered borrower, to the disease known as payment shock syndrome. It begins with an anxiety attack. Its symptoms include helplessness, rage, denial, panic and depression. If not treated, payment shock syndrome can lead to other disorders including drug and alcohol abuse, hypertension, cancer, obesity and heart disease.

In its most severe manifestation, it can end in suicide.

Your first onslaught of payment shock syndrome begins when your toxic loan adjusts, causing your monthly payment to skyrocket. You realize the very home that brings you such comfort, safety, security and joy, is under siege. Your first reaction is shock, disbelief and panic. But you must get a grip on your galloping emotions.

While payment shock syndrome is a silent killer, you can be cured of it. First, you must stop blaming yourself for contracting it. You are not alone. It has grown into an epidemic, crippling millions of neighborhoods across America. You also must not give in to its sweet lull of denial. When confronted with payment shock, some 80% of Americans gave up their homes and took to the streets. A smaller percentage sought the empty sanctity of bankruptcy and lost their homes anyway.

So beware: payment shock syndrome will worsen if left untreated. It is time to mobilize and seek treatment in the form of deliberate and strategic action. You must take a deep breath, calm down and begin your investigation.

First, you must determine why your payment suddenly increased. Is it due to forced-placed homeowner's insurance? If it is, contact a local insurance broker and obtain your own policy. Then, contact your lender and fax a copy of the new policy immediately. You can demand the forced placed insurance be cancelled and your escrow account be reduced.

If your payment has escalated due to unpaid property taxes, you need to work out an escrow payment plan with your lender. Write to your mortgage servicer and ask for a work-out plan to pay back your lender who has already paid your taxes. In the current climate, many lenders will revise your monthly payment, and even add the amount owed on the back end of your loan. If your lender ignores your request, refer the matter to an attorney. Be aware, most attorneys will expect you to conduct a qualified audit of your mortgage. More on this in a moment.

Now if your payment has escalated due to an interest rate adjustment, you must certainly obtain a mortgage audit demanding an analysis of the life of your loan. Chapter Seven details the purpose, process and benefits of the mortgage audit. It also describes the most common predatory practices which are violations of federal laws.

Once retained, your mortgage auditor will request documents from your lender and study them for errors and predatory lending practices. Your auditor will first review your origination and closing documents, then review your lender's correspondence. If errors and violations have been identified, your auditor will demand that your lender restructure your loan and pay you damages. If the loan is found to be predatory, your auditor may advise you to rescind your mortgage. A full discussion of rescission (cancellation) is detailed in Chapter Eight.

The Real Estate Settlement Procedures Act, detailed in Chapter Eleven, is a federal law which allows your lender twenty business days to address your concerns, and sixty days to resolve them. If your lender doesn't respond within these parameters, your mortgage auditor may advise you to begin legal action against your lender.

If your lender doesn't respond to the Qualified Written Request, your auditor may send an Attorney's demand letter as the final step before advising you to begin litigation. This demand for settlement spells out the violations, what laws have broken, and what remedies are appropriate. Some lenders do not respond because they are aware they have no legal right to modify your mortgage. This is because your loan was securitized.

At this stage, many homeowners wonder if they should retain a competent attorney or attempt to go "pro se." While there are cases where homeowners were successful in representing themselves, it is not advisable to do so. Mortgage litigation involves contract law, real property law, consumer law and securitization law. It is impossible for a layperson to garner enough information to understand how to create and manage a winning lawsuit. Also, your lender will have retained competent counsel who can bury you in paperwork that you will not really understand.

To obtain competent legal counsel, you must interview several prominent litigators and see if any are interested in taking your case on a contingency basis. Review your city's "Book of Lists" to find qualified law firms. Ask your friends and family if they know anyone in these firms. If they do, you might be a step closer to retaining a good attorney. An appropriate contingency fee is between 1,500 and 5,000 dollars. Don't go from predatory lender to predatory lawyer. And stay away from attorneys who want a piece of your house or half your recovery. These ploys are beyond predatory; they are a malicious abuse of vulnerable homeowners in distress.

Also recognize that even excellent attorneys may not be up to speed on filing predatory lawsuits. Many have not been trained in securitization law. You will need to determine if your prospective attorney has the training and experience to adequately represent you. Don't be afraid to ask questions. You might even give your attorney of choice a copy of this book to bring him up to speed. You can go to my website www.yourmortgagewar.com for a referral to a qualified attorney.

Why is it crucial to hire an attorney who is familiar with these kinds of law?

For example, if you have an adjustable rate mortgage, there is a good chance that your loan has been securitized. If the securitization was done improperly or illegally, your mortgage transaction may be null and void. In this case, a judge would most likely extinguish your mortgage and note. You would then be awarded your home free and clear of debt.

But winning a "quiet title action" is not a given. The issues that arise during securitization are complex and varied. It is not as easy as just going to court and demanding that your lender prove it has a right to collect or foreclose. This issue will be dealt in detail in further chapters where foreclosure action is pending.

But for now, to investigate whether your loan was securitized, go online and print out your lender's Securities and Exchange Commission 10K filing and 8K filing for the year that you obtained your mortgage. These annual filings are sworn statements of fact. In them, your lender discloses its securitization process, how it buys loans, how it sells its own loans, and how these loans are converted into mortgage pools and shares of securities. While these reports are lengthy and difficult to follow, it is well worth it to study them. You'll be surprised to find a plethora of fraudulent misrepresentations your lender made to its own investors.

If your lender is one of the mortgage giants, there is a great likelihood that your loan was securitized. The question is: was the securitization done properly and legally? If so, your lender will have to prove that to the judge. If not, which is true in the majority of cases,there are powerful legal remedies at your disposal.

What is securitization? It is the process your loan went through from being a mortgage and note to becoming shares of mortgage backed securities. It may even have been pre-sold to Wall Street before you signed your loan documents. If this is the case, which will be determined through a legal process called "discovery", your mortgage and note may be null and void.

While you are waiting for the results of your audit, you may be advised to not pay your payment, or pay only the amount you were paying before the adjustment. Each case is different, and that is why you need a professional to guide you.

It is important to take immediate action when you are in payment shock. First, it is essential to protect your home. Second, it is therapeutic in alleviating your symptoms.

There are psychological remedies you can adopt. For example, it is helpful to "abreact" your thoughts, associations and feelings about

what is happening to a parent, spouse, partner or friend. Essentially, abreaction is the "talking cure" proposed by Sigmund Freud. It is the cornerstone of all good psychotherapy. During abreaction, you are not just talking about the event; you are ventilating your feelings about it, and comparing it to other painful events in your past. It is best to do this uninterrupted in a session with a sympathetic listener. The last thing you need is to be criticized or blamed for circumstances outside your control.

You will find, as your express your "word salad" you will begin to feel better. In the process, your anxiety will dissipate and you will be energized to forge ahead. Why? Because by abreacting, you are regressing yourself. During regression, you will take in energy from the person who is listening. This energy will fuel you to begin your next progression. Technically, this process is clinically termed "Progressive Abreactive Regression" and it is the basis for transformation.

Another psychological strategy is to meditate in order to calm your mind. As your mind calms, so will your body. Studies show that there is a direct link between meditation and the relaxation response. If you do not know how to meditate, try the following method:

Make sure you have about thirty minutes of uninterrupted alone time. Find a quiet spot and lie down. Take a deep breath through your nose and exhale it through your mouth. Do this five times. Pay attention to your breathing and respiration. Notice if your heart is pounding or your thoughts are racing. Ask your heart to slow down. Ask your breathing to deepen. Then imagine your favorite color. Picture it behind your closed eyes. Breathe it in and feel like filling your head, then exhale. Breathe it in to your throat and feel it warming your neck and shoulders. Breathe out any tension. Now breathe it in to your chest and feel it travel down to your stomach and around to your spine. Breathe out any tension. Now breathe it into your toes, feel it travel into your feet and ankles and up your calves and knees. Breathe out any tension. Breathe it into your thighs up to your sexual organs and buttocks, and then breathe out any tension. Picture yourself in your favorite place. It may be a beach or a forest. Now ask the universe to send you a helper. Visualize your helper. Ask him or

her for guidance. Listen to the advice without judging it. Thank your helper and say goodbye. Say goodbye for now to your favorite place. When you are ready, open your eyes. Sit up and re-orient yourself.

This meditation should be powerful enough to give you a peaceful reprieve. Use it twice a day, even if you shorten it to fifteen minutes. You will be quite surprised and delighted with the advice your "imaginary" helper dispenses.

Another psychological strategy is to force yourself to exercise twenty minutes a day. This could be as simple as taking a brisk walk. Not only will exercise increase your endorphins and calm your mind, it will help you sleep better at night. Exercise is a strong defense against the impulse to self destruct. Overeating, overdrinking and worse, will only impair your self esteem and ability to act deliberately and strategically. Don't let yourself fall into that pit.

Finally, if you follow the advice in this book, you will not lose your home. So don't awfulize any further. We will take this one step and a time and I will be with you. Hopefully, your lender will cooperate and agree to a restructure, that takes into account what damages you would be awarded in court if you litigate. If not, there are plenty of legal weapons to deploy in a court of law. And during litigation, you will remain in your home without having to make any mortgage payments.

So don't despair and don't give up. Don't make any plans to sell your home or move out. There is light at the end of the tunnel. Hang onto your optimism and hope and you will get through this with flying colors. And if your adjustable rate mortgage has been illegally securitized, you are literally home free!

Take a lesson from the Andrews, who sued Chevy Chase Bank for predatory lending practices. While their case has failed to date to reach the status of class action, their mortgage was extinguished and they own their home free and clear.

"We conclude that the Belinis' claim that they are entitled to damages because of Washington Mutual's failure to return their money and void the security interest on their home within twenty days of receiving their notice of rescission. We join the approach of four other circuits, and we know of no circuit which has held to the contrary."

Judge Lynch, US Court of Appeals,
First Circuit in the District of Massachusetts

CASE STUDY 3

Susan and Bryan Andrews
v.
Chevy Chase Bank

UNITED STATES DISTRICT COURT
EASTERN DISTRICT OF WISCONSIN

SUSAN AND BRYAN ANDREWS
AND A CLASS OF PERSONS SIMILARLY SITUATED,
PLAINTIFFS,

Case No. 05-C-0454

V.

CHEVY CHASE BANK, FSB
DEFENDANT.

Plaintiffs Combined Brief in Opposition to Defendant's Motion for Summary Judgment and in Support of its Own Motion for Summary Judgment on the Issue of Liability under TILA

Plaintiffs are filing this brief in opposition to Defendant Chevy Chase Bank's (hereafter referred to as "Defendant" or "Chevy Chase") Motion for Summary Judgment and in support of their own Motion for Summary Judgment on the issue of liability under the Truth in Lending Act ("TILA").

INTRODUCTION

Plaintiffs Bryan and Susan Andrews, on behalf of the class, seek a remedy under the *Truth in Lending Act* ("TILA"), *15 U.S.C. § 1601 et seq.*, to obtain the opportunity for rescission for each class member, statutory damages, attorneys' fees and other equitable relief against Defendant for engaging in unfair or deceptive acts or practices in violation of TILA, *15 U.S.C. § 1601 et seq.*, and its implementing *Regulation Z, 12 C.F.R. Part 226.*

The putative class in this case sues on a deceptively written truth in lending disclosure statement ("TILDS"). The TILDS is inconsistent with the underlying contractual document, the Adjustable Rate Note ("note"). These documents must be compared and considered by the Court objectively. Rather than address the inconsistencies between the TILDS and the note, Chevy Chase refers the Court to oral statements, which are not a part of TILA law. Chevy Chase manufactures a sideshow in an attempt to eclipse the underlying TILA violations.

TILA was created to prevent consumers, including the putative class members, from being misled with respect to the extension of credit. If the TILDS and the Adjustable Rate Note had been drafted forthrightly and honestly, there

would have been no opportunity for the type of oral broker fraud, which Chevy Chase acknowledges in its submissions and arguments to this Court. Chevy Chase puts forth only two substantive defenses. Neither of their defenses will carry the day under TILA law. The first is that the loan broker committed oral fraud, which relieves the lender from TILA responsibility. The second is Chevy Chase's Da Vinci Code defense, requiring the borrower to read through several deceptively written contract documents to determine that Chevy Chase was using code when it promised a "5 Year Fixed" teaser rate and provided a faulty payment schedule in the TILDS.

Regarding the first defense, Chevy Chase cannot shift the blame for its own failure to comply with TILA. Chevy Chase, as the principal, has the affirmative obligation to provide TILA disclosures. That obligation cannot be put on the Plaintiff borrowers or brokers. The Plaintiffs had no duty to pick over the several deceptive closing documents to ferret out that Chevy Chase was "teasing" when it stated a Note Interest Rate of 1.95% fixed for the first 5 years of the loan in the TILDS. The Plaintiffs similarly had no duty to calculate the monthly payment schedules that they would be charged under the Chevy Chase mortgage. Chevy Chase made illusory statements in their TILDS. Finger pointing cannot excuse Chevy Chase for misleading its borrowers.

Chevy Chase also puts forth a "Da Vinci Code" defense that fails at every turn. Chevy Chase mistakenly suggests that the consumer is at fault for failing to read around the teaser language in the TILDS and decipher the truth from the underlying loan documents, which are themselves written in code. TILA requires a clean disclosure statement that outlines the contractual obligations under the note. The Chevy Chase disclosure statement is inconsistent with the note. Moreover, the contract documents themselves contain additional illusory and teaser words, which have no inherent truth, further misleading the customer into believing that the program is fixed at the teaser rate for 5 years.

In order to understand Chevy Chase's defense, one must realize that, like the reader of the Da Vinci Code, "it is not sufficient to confine oneself exclusively to facts." Thus liberated, Chevy Chase concocts arguments that are not factual but clever. Parsed quotations are injected out of context in order to provide a legitimizing cushion for rank nonsense. Incredible misinterpretations (the premise that is okay to "preview" the APR with an "internal code" stating the "Note Interest Rate" at a teaser rate for "5 years fixed"; and, displaying a false payment schedule in the TILDS) are presented as conforming to established precedent. Established precedent strictly disallowing such shenanigans is ignored. Chevy Chase's theory is that "it is okay for us to lie outside the Federal box." Irrelevant testimony is microscopically scrutinized for inconsistencies that might shift the blame to anybody but Chevy Chase. Chevy Chase spins one gossamer strand of nonsense over another, forming a web dense enough to create the illusion of validity.

Chevy Chase ignores a cache of "teaser" terminology from its own misleading documents. Chevy Chase fabricated all of the critical written materials, including the TILDS, the Adjustable Rate Note, and the 1st Monthly Statement Coupon. This patently silly catalog of coded documents is paraded as "full disclosure." Chevy Chase could not produce any expert to explain its slew of misleading documents. Upon reading the critical documents, it becomes evident that Chevy Chase misleads its customers by using "code" terms. Chevy Chase's hoax is debunked by reading its own documents, but curiously enough, these documents do not prevent it from arguing the fantasy of "full disclosure." Ultimately the defense in this case must be rejected because it transforms the Truth in Lending Act to the equivalent of the Da Vinci Code.

STATEMENT OF THE FACTS

Chevy Chase sells loans with teaser[1] interest rates set forth in their TILDS that misrepresent to the Class of Plaintiffs that they are obtaining loans with note interest rates that are lower than the rate actually being imposed on their mortgage accounts. Chevy Chase further displays faulty payment schedules in the TILDS that fail to state the intervals of payments, and fails to calculate the fully amortized charges to the customer's account each month or make any reference to payment variations.

[1] *Chevy Chase describes the loan for its brokers as including a "teaser" interest rate in several places. See Doc. #34, verifying the document published by Defendant at the following website: http://chevychasewholesale.com/pdf/wrf802_cf_qa.pdf. The document was changed by Defendant after this lawsuit was filed to delete the use of the term "teaser." See also, Doc. #34, Exhibit C, Response to Requests for Admission.*

1. The Documents at Issue

Plaintiffs Bryan and Susan Andrews obtained a mortgage from Chevy Chase in June 2004. The TILA violations in this case are evident upon reviewing the following four documents:

- The TILDS. The TILDS presented to the Andrews at closing discloses a type of loan that is *"5-Year Fixed"* at a *"Note Interest Rate"* of *"1.95%"* and a payment schedule that fails to state the intervals at which payments are due and fails to calculate the fully amortized charges to the customer's account or make any reference to payment variations during the first 60 payments of the loan. (Exhibit 17, attached to the affidavits of Bryan Andrews and Susan Andrews, dated 2-24-2006, Doc. #s 29 and 30).

- *The Adjustable Rate Note.* The note, in detailed print, provides for a monthly adjustable loan beginning with the second month of the loan, but also contains teaser language, such as: *"I will pay interest at the yearly rate of*

1.95%"; and, *"5 Year Fixed."* (Exhibit 16, attached to the affidavits of Bryan Andrews and Susan Andrews, dated 2-24-2006, Doc. #s 29 and 30) and,

- *The 1st Monthly Statement Coupon.* The 1st Monthly Statement Coupon again discloses the teaser *"Interest rate: 1.95%"* and a monthly payment of $701.21 in the first month of the loan, but it fails to show the fully amortized payment on the loan. (Exhibit 33, attached to the affidavits of Bryan Andrews and Susan Andrews, dated 2-24-2006, Doc. #s 29 and 30).

- *The 2nd Monthly Statement Coupon.* The 2nd Monthly Statement Coupon, which for the first time shows: the monthly adjustable rate, the rate increase from the teaser rate of 1.95% to 4.375% and the fully amortized payment in the second month of the loan. (Exhibit 21 attached to the affidavits of Bryan Andrews andSusan Andrews, dated 2-24-2006, Doc. #s 29 and 30).

In reviewing the affidavits submitted by both parties, there is no factual dispute that the Andrews' documents (See: Doc. #s 29 and 30) and the Luisa Cordova-Holmes' documents (See: Doc. # 31) are typical and representative of those of the entire Class. Chevy Chase put forth no substantive evidence to dispute this issue.

2. The TILDS Misrepresents a Teaser Rate for 5 Years
The TILDS issued to the Class misrepresents that the loan has a "fixed" interest rate feature at an initial teaser rate for 5 years. (See Doc.s #s 29 and 30, Exhibit 17, upper right-hand corner of the document; See also: Doc. # 31, Affidavit of Luisa Cordova Holmes, with attachments). In fact, the annual loan interest rate was increased by more than double the rate, to 4.375%, in the second month of the loan for the Class representatives. (Doc.s #s 29 and 30, Exhibits 33 and 21).

TILA requires a creditor to accurately disclose the finance charge as an annual percentage rate. *15 U.S.C. § 1638(a)(4)*. Defendant is misrepresenting that the loan interest rate is "Fixed" at "1.95%" for 5 years in the TILDS. Defendant has added deceptive language to the TILDS issued to the Plaintiff (and similarly to the Class, as will be discussed below), that violate the TILA requirements that added language be both "clear and conspicuous" and that such added language not be misleading. *15 U.S.C. 1632(a); Reg. Z sec. 226.17(a); Official Commentary Sec. 226.17(a)(1)-1*. The teaser information that Chevy Chase added above the "Federal box" in the TILDS is so glaringly false that it renders the annual percentage rate information "inside the box" to be both unclear and confusing. (Doc. #s 29 & 30, Exhibit 17).

For example, in the final "Truth In Lending Disclosure Statement" for the Andrews' loan, Defendant added the following language on the top right-hand side of the form wherein the Type of Loan is stated as follows:

**"WS Cashflow 5-Year Fixed
Note Interest Rate: 1.950%"**

See: Doc. #s 29 & 30, Exhibit 17.

The plain meaning and implication of the above language is that the Plaintiffs were to receive a loan at a fixed interest rate of 1.95% for the first five years. In truth, Chevy Chase has never offered or provided such a loan. A detailed examination of the Adjustable Rate Note issued to Representative Plaintiffs shows that it was a loan for a mortgage that imposed 1.95% interest for only one month. After one month, the rate of interest more than doubled and has adjusted to a much higher interest rate each and every month thereafter. This has caused the loan of the Representative Plaintiffs to negatively amortize and is causing them to pay a substantially higher interest rate than represented in the Truth in Lending Disclosure Statement. The current rate on the Andrews loan is above 7%. (See: Doc. #s 29 & 30, Exhibits 17, 16, 33 and 21. See: Doc. # 34, Attach. #3, Doc. #34, Exhibit B, for current Monthly Statement Coupon.). Thus, Chevy Chase Bank did not comply with the TILA requirement to disclose the finance charge as an annual interest rate because it added information that confuses the annual percentage rate disclosed in the Federal box. *15 U.S.C. § 1638(a)(4).*

Approximately two months after the filing of this lawsuit, on June 24th, 2005, Chevy Chase changed its TILDS form for newly issued loans, so that it deleted the teaser "Note Interest Rate" and the term "5 Year Fixed." The term "Monthly Adjustable ARM" was substituted. These facts are not disputed in the discovery responses. (See: Doc. # 34, Attach. #4). Thus, the Court may infer from the change in the TILDS that Chevy Chase could have easily drafted the form so as to be less misleading.

3. The Payment Schedule Is Faulty
The Truth in Lending Disclosure Statement (See: Doc. #s 29 & 30, Exhibit 17; Doc. #31) for each class member further contains a defective payment schedule, in two respects.

A. Payment Intervals are Missing For All Class Members
The payment schedule on the TILDS fails to describe the interval of payment due dates, which is "monthly" under the terms of the note, in the space provided in column 3 of the model form. (See: Doc. #s 29 & 30, Exhibit 17; Doc. #31) Thus, for example, in the Andrews' TILDS, the schedule literally calls for:

Number of Payments	Amount of Payments	Payments Beginning
60	701.21	08/01/2004
300	983.49	08/10/2009

When read literally the borrower only has two payment dates, with multiple payments (60 and 300) due on the stated dates. The Declaration of T. Banks Gatchel[2], at paragraphs 9 through 13, misstates the payment schedule in the TILDS. Although Mr. Gatchel alleges that the payment schedule is "monthly," when the TILDS is actually read, there is no indication that payments are due "monthly." See: Affidavit of Mark Vandeventer dated 5/12/2006 and Affidavit of Nicole Walber, filed with this motion. The space where the term "monthly" should appear from the model form is left completely blank. In the entire sample of 132 class member loan files reviewed for purposes of these Motions, the TILDS always leaves out the payment interval. See: Affidavit of Mark Vandeventer dated 5/12/2006 and Affidavit of Nicole Walber, filed with this motion. The same is true with respect to the TILDS issued to Class Member Ms. Louisa Cordova-Holmes. See: Doc. # 31. The authenticity of these TILDS documents is not disputed. All of the loans in the class have the same mistaken TILDS. Thus, there is no factual issue that the payment schedule is defective. The TILDS for each class member is fatally flawed because it is missing the interval for payment under the Adjustable Rate Note. The mistake is universal to all of the loans sampled and readily apparent from reading each TILDS produced in this case. See: Affidavit of Mark Vandeventer dated 5/12/2006 and Affidavit of Nicole Walber.

[2] *Plaintiffs object to the Declaration of T. Banks Gatchel as being inadmissble. It lacks foundation. Mr. Gatchel says that he was hired in 2005, after the operative facts, and he has established no personal knowledge of the facts. His Declaration raises credibility issues, as will be discussed in this brief.*

B. The Payment Schedule Fails to Calculate the Fully Amortized Charges to the Customer's Account or Make Any Reference to Payment Variations During the First 60 Payments of the Loan.

The payment schedule also and fails to calculate the fully amortized charges to the customer's account or make any reference to payment variations during the first 60 payments of the loan. See: Doc. #s 29 & 30, Exhibit 17; Doc. #31. This supports and buttresses the false representation at the top of the TILDS as to the loan being "5 Year Fixed" at a "Note Interest Rate" of "1.95%." The payment schedule shown on the TILDS shows a fixed payment at the teaser rate for the first 60 payments of the loan. The calculation prepared by Chevy Chase is done on the misleading basis that the interest rate is fixed at an annual rate of 1.95% for the first five years of the loan. In fact, the interest rate jumps to 4. 375% in just the second month of the loan. See: Doc. #s 29 & 30, Exhibits 17 & 21.

A payment schedule, when included in a TILDS, must display the entire fully amortized principal and interest being imposed (whether directly or indirectly) upon the consumer each month, according to the definition of pay-

ment in the TILDS form and the related regulations. The Chevy Chase payments schedule does not point out to the borrower that the interest rate being charged in month two of the loan will change, and in fact, will change even if there is no change in the index rate. See: Doc. # 32, Vandeventer Report at pages 6-7.

The payment schedule on the Andrews TILDS misrepresents that a payment of $701.21 for the first 60 months will fully amortize the loan. In fact, with the automatic interest rate increase in the second month of the loan, the payment necessary to fully amortize the loan as of 8-9-2004 was already $952.47, a monthly increase of $251.26. See: Doc. #s 29 & 30: Exhibit 21 — upper right-hand corner entry for fully amortized payment; Compare with the 1st Monthly Statement Coupon, Exhibit 33, which fails to disclose the fully amortized payment.

The second page of the TILDS (Doc. #s 29 & 30, Exhibit 17, at p. 2) states the following:

"DEFINITION OF TRUTH IN LENDING TERMS"

PAYMENT SCHEDULE
The dollar figures in the Payment Schedule represent principal, interest, plus Private Mortgage Insurance (if applicable)."

The payment schedule on the TILDS for the Plaintiffs and the Class members is inaccurate under the definition articulated in the TILDS form and under Regulation Z standards (as will be discussed later in this brief)[3]. The payment schedule does not include all of the fully amortized principal and interest being imposed each month of the loan. The payment schedule only discloses the minimum payment required to avoid immediate foreclosure, which has the effect of misleading the ordinary borrower as to the true monthly cost of the loan provided by Chevy Chase.

[3] *Similarly, the Federal Reserve Board's Truth in Lending Official Staff Commentary to* **Reg. Z, 226.18(g) says:**
"*Payment schedule. 1. Amounts included in repayment schedule.* **The repayment schedule should reflect all components of the finance charge**, *not merely the portion attributable to interest.*"

Reg. Z, 12 CFR § 226.4 states:
"**Finance charge.**
(a) *Definition. The finance charge is the cost of consumer credit as a dollar amount.* **It includes any charge payable directly or indirectly by the consumer and imposed directly or indirectly by the creditor as an incident to or a condition of the extension of credit......**"

Although the Gatchel Declaration suggests in paragraph 14 that somebody could theoretically choose an initial rate higher than the first month's note rate, and therefore an initial payment that is higher than the fully amortizing payment, Mr. Gatchel is attempting to mislead the Court. Mr. Gatchel cannot point to a single situation in the Class of 7,000+ loans where that occurred. None of the 132 sampled loans in the class had an initial rate exceeding the note rate.[4] See: Affidavit of Mark Vandeventer dated 5/12/2006 and Affidavit of Nicole Walber. Chevy Chase's website description of the loan program to brokers confirms that the initial rate is a "teaser" rate. See: Doc. # 34. This is uncontested in the record. Thus, Gatchel's Declaration is a smokescreen.

The payment schedule does not include a reference to variations in the payment series. See: Doc. # 32, Vandeventer Report. The transaction is represented as fixed in the payment schedule for the first 60 months in the TILDS but it is really not fixed. Chevy Chase had a duty to adapt the model form to explain the transaction to the borrower. The Chevy Chase form is misleading as to the amount the consumer is charged in months 2-60.

In view of each of the foregoing defects, there is no factual issue that the TILDS issued in connection with the loans made to the Plaintiffs and the Class do not accurately reflect the terms of the legal obligations between the parties.

[4] *If the initial rate was higher, the payment schedule 4 for the second series of payments would be lower than the first series. In all of the loans sampled, the second series of payments is higher than the first. See: Vandeventer Affidavit dated 5/12/2006 at para. 7. Mr. Gatchel obviously knew that paragraph 14 of his Declaration was misleading the Court.*

4. The Other Loan Documents Presented are Misleading
Chevy Chase has put up what is in essence a Da Vinci Code defense. Chevy Chase points to certain terms in the loan documents and Monthly Statement Coupons in an attempt to manufacture disclosure that was missing in the TILDS. This violates the standard of TILA law requiring a segregated TILDS.[5] However, even if the Court were to consider these items, the Court must also keep in mind that several of the contract documents are themselves deceptive, further inviting the borrower to be misled by Chevy Chase's "teaser" rate scheme.

Chevy Chase, in putting forth these documents, demonstrates that additional deceptive statements are being made in the transaction. Virtually every document that the borrower is presented or signed in connection with this loan program prominently dangles the teaser rate or the term "5 Year Fixed." See, e.g., Deposition of Bryan Andrews, at pages 191-195. These teaser terms are not used accidentally. See: Vandeventer Report (Doc. #32) and Groble Report (Doc. #33). If the Court, for any reason, considers the entire document

trail from Chevy Chase, the facts look even more egregious for Chevy Chase. Consider the following, as examples of deceptiveness in Chevy Chase's paper trail:

The Andrews' Uniform Residential Loan Application and Good Faith Estimates mislead the borrower.

The Andrews' loan Application and Good Faith Estimates (Gatchel Declaration, at Exhibit 3, Defense Exhibit 2 and others), both clearly state that the loan applied for is "1.95%" for "360" months, and "Fixed Rate." This clearly puts Chevy Chase underwriting on notice at the time of application that borrowers are being scammed.[6]

[5] *See, for example:* ***Clay v. Johnson****, 22 F.Supp.2d 832 (N.D. IL 1998)(TILA disclosures are not to be made in the underlying contract documents);* ***Sneed v. Beneficial Co. of Hawaii****, 410F. Supp. 1135 (D.Ha. 1976).*
[6]*Although Chevy Chase seeks to distance itself from the broker, Article IX of the Uniform Residential Loan Application (several are contained in the Exhibits to the Gatchel Declaration) makes it very clear that the broker is working on behalf of the lender in all loan transactions. Chevy Chase is the principal in the transaction.*

The preliminary TILDS from Chevy Chase misleads the borrower.

Even the preliminary TILDS, which is at the top of the packet shipped by Chevy Chase to the borrowers during underwriting, contains all of the false representations that are contained in the final TILDS, as discussed above. (Gatchel Declaration, Exhibit 3, Defense Exhibit 10). In addition, it contains an additional fraudulent statement, wherein Chevy Chase states:

"If you pay off the loan early, you will not have to pay a penalty."

Notwithstanding that false statement in Chevy Chase's preliminary TILDS, there is a prepayment penalty. Thus, the preliminary TILDS contains is even more false than the final TILDS. See: Susan Andrews Deposition, at page 80-81.

The Adjustable Rate Note misleads the borrower.

A cursory review (which is presumably what most borrowers do at closing) of the Adjustable Rate Note (Doc. #s 29 &30, Exhibit 16), shows the following term set off near the top of the note:

"5 Year Fixed"

That language is followed by an internal code which Chevy Chase suggests that the borrowers should be able to decipher:

"Pay/1 Month LIBOR Index/Payment Rate Caps"

This is just another Da Vinci Code defense, wherein Chevy Chase suggests that the above internal codes and abbreviations constitute "full disclosure." Chevy Chase then mocks the borrowers for failing to translate these codes to decipher the meaning of the contract. In section 2, under the caption INTEREST, the note plainly states that:

"I will pay interest at the yearly rate of 1.95%."

It is only with a more exhaustive reading that the reader discovers the truth: there simply is no year in which the 1.95% yearly rate applies. The 1.95% applies for 1 month, and only 1 month.

The Adjustable Rate Rider misleads the borrower.

Even the Adjustable Rate Rider (Gatchel Declaration, Exhibit 3, at Defense Exhibit 15), shows the following false term set off near the top of the note:
"5 Year Fixed"

In section 1, under the caption INTEREST, the note plainly states that:

"I will pay interest at the yearly rate of 1.95%."

Again, only later does the reader discover there is no year in which this "yearly rate of 1.95%" is even applicable.

The Notice of Right to Cancel misleads the borrower.
(Gatchel Declaration, Exhibit 3, Defense Exhibits 18 and 20).

This document contains the term **"5 Year Fixed Pay,"** again misleading the unknowing borrower into thinking the loan is fixed for five years. Susan Andrews testified as follows about this document:

"And obviously you have to have someone that's looking at every single word to see who's trying to scam you."

(Susan Andrews Deposition at page 107.)

The 1st Monthly Statement Coupon misleads the borrower.

Chevy Chase, on page 5 of its Brief, points out that the borrower receives a statement each month on the mortgage. Chevy Chase fails to point out that the 1st Monthly Statement Coupon does not show the fully amortized payment and does not show the Note Interest Rate; Chevy Chase only shows the mini-

mum payment. In addition, the 1st Monthly Statement Coupon states the teaser interest rate of **"1.95%"** with no explanation that the note rate is monthly adjustable and will increase the next month. Doc. #s 29&30, Exhibit 33. Chevy Chase unscrupulously leaves out the 1st Monthly Statement Coupon, Exhibit 33, from its submissions. Chevy Chase also attempted this stunt at the depositions of Bryan and Susan Andrews, misrepresenting on the record that Exhibit 21 was the 1st Monthly Statement Coupon. It is improper to mislead the Court and the parties by suggesting that Exhibit 21 is the 1st Monthly Statement Coupon when it is obviously the 2nd Monthly Statement Coupon (and in fact displays the earlier payment on the mortgage). The actual 1st Monthly Statement Coupon, Exhibit 33, is very misleading. It is only after the borrowers are hooked into the program for 2 months that they receive the truthful, 2nd Monthly Statement Coupon, stating the fully amortized payment and the true monthly adjustable note rate. Doc. #s 29 &30, Exhibit 21.

<div style="text-align:center">

**The Variable Rate Disclosure[7] fails to advise the borrower
that the initial rate is discounted.**

</div>

Even the variable rate disclosure that Chevy Chase alleges it provided to all borrowers8 fails to inform the borrowers that the initial rate on the loan is discounted. See: Affidavit of Mark vandeventer dated 5/12/2006, at para. [8]. Additionally, contrary to the allegation of T. Banks Gatchel in paragraph 6 of his Declaration, 105 of the 132 loan files reviewed did not contain any variable rate disclosures at all. See: Affidavit of Mark Vandeventer dated 5/12/2006 and Affidavit of Nicole Walber. Here again, Mr. Gatchel attempts to mislead the Court as to both the content of the disclosure and the fact that most of the loan files do not even contain the document.

Taken in combination, all of these other documents, which Chevy Chase submits as their "Da Vinci Code" defense, contain further illusory language. In footnote 6 of their brief, Chevy Chase complains that the terms from their documents are highlighted by the Plaintiffs. Chevy Chase is apparently troubled that its own words, the teaser terms, are being highlighted to the Court. The Chevy Chase documents are replete with references to a "1.95% yearly rate" and the term "5 Year Fixed."[9] The prominent placement of illusory terms in the Chevy Chase documents are suspicious. These documents, taken in their entirety show a pattern of attempting to "tease" the borrower by dangling an illusory benefit, "1.95%" yearly interest for "5-Year Fixed," that is never available. It is only because of the faulty TILDS that the deception is able to occur. The related documents received by the borrower, including the actual contract documents, only buttress and support the misleading statements in the TILDS.

[7] *The Andrews did not recall receiving a variable rate disclosure or a consumer handbook on ARMS. Susan Andrews testified that she never received a thick packet of information from Chevy Chase prior to the loan closing. See: Susan Andrews deposition at page. 79-80.*

[8] *Of the 132 loan files sampled, 105 did not contain variable rate disclosures. See: Affidavit of Mark Vandeventer dated 5/12/2006, at para. 8 and Affidavit of Nicole Walber.*
[9] *Even the BOLDFACED statement in the 9 Rider, referred to at page 10 of the Chevy Chase Brief, never tells the borrower in plain English that the loan is a "MONTHLY ADJUSTABLE RATE MORTGAGE."*

5. A Federal Charter is Not a License to Cheat

Chevy Chase seeks deference because they are a Federally chartered institution. However, the Federal charter goes to the heart of how the Andrews and so many other borrowers were misled. Susan Andrews testified that she was more confident because the paper work was coming from a big bank, stating:

" — they weren't some crazy company I never heard of."

(Susan Andrews Deposition, at page 39)

The Andrews testified that, prior to this loan, they had a fixed rate mortgage with a local bank, Port Washington State Bank, at a fixed rate of 5.375%. See: Deposition of Bryan Andrews, at p. 41. Thus, a TILA compliant lender lost the Andrews' loan in a refinancing to a noncompliant lender peddling a teaser loan. Any suggestion that the Federal charter allows Chevy Chase to make misleading TILA disclosures is misplaced. The Andrews are paying interest substantially higher than the fixed rate on their prior mortgage, and have clearly suffered harm.

6. Chevy Chase's Documents Invite Fraud

The Defendant cites a litany of acts suggesting, in essence, that because the borrowers were misled by the broker prior to the loan closing, that somehow excuses the violations of the TILA by Chevy Chase. The factual recitation supports the position of the plaintiffs, rather than detracts from it. It certainly appears from the terms of Article IX of the Uniform Residential Loan Applications signed by all of the Class members, that the broker is the underwriting agent of Chevy Chase, and that was the testimony of Susan Andrews at page 134 of her deposition:

```
1   Q:  Was your understanding from reading this document
2       that the information was being taken on your
3       behalf or on behalf of the lender?
4   A:  Say that again.
5   Q:  Was the broker — was it your understanding the
6       broker was working for you or for the lender?
7   A:  He was working for the lender.
```

(Susan Andrews Deposition, at p. 134)

Likewise, the President of the brokerage firm, David Rehberg, admitted that his firm was acting on behalf of Chevy Chase:

25 Q: Do you feel you are performing any services for the
1 investor?
2 A: Yes.
3 Q: And what service is that?
4 A: Packaging the deal. Getting them the deal and
5 packaging it for them.
6 Q: So do you feel you are working for both of them to
7 some extent?
8 A: Yes.

(David Rehberg Deposition, at pp. 46-47).

There is no contrary testimony in the record.

7. Broker Admits the TILDS is Defective

Moreover, it must also be noted for David Rehberg, the owner of the mortgage broker firm, admitted in his testimony that the Andrews' TILDS suggested a 1.95% interest rate for 5 years and that it failed to explain that the interest rate would change in the second month of the loan:

16 Q: Does it indicate that there's an interest rate?
17 A: Yes.
18 Q: What does it indicate the interest rate is?
19 A: At 1.95. Also at an annual percentage rate.
20 Q: Why wouldn't that language indicate that it was
21 fixed at five years at 1.95 percent?
22 A: I have no idea.
23 Q: So there's nothing in that language in the upper
24 right-hand corner that indicates that the interest
25 rate is going to change, is there?
1 A: In the upper right-hand corner?
2 Q: In the first five years — In the first five years
3 is there any language in the upper right-hand
4 corner that indicates the interest rate is going to
5 change during that five-year period?
6 A: No, not that I can see.
7 Q: Then drop down to the payment schedule.
8 A: Yes.
9 Q: And that shows a payment in the amount of $701.21
10 for the first 60 months?
11 A: That's correct.
12 Q: Is there any indication there that interest

```
13      rate is going to vary?
14      MR. HANDOO: Objection. Form.
15      BY MR. DEMET:
16   Q: Is there any --
17   A: The annual percentage rate.
18   Q: All right. I am asking in the Payment Schedule
19        portion --
20   A: Right.
21   Q: —which is where that box — where it says Number
22        of Payments, Amount of Payments?
23   A: Yes.
24   Q: Is there any indication there that the interest
25        rate is going to change during the first five years
1        of the loan?
2    A: Not in that box.
```

(David Rehberg Deposition, at pp. 60-62)

The Chevy Chase documents are so deceptively drafted, even the broker cannot explain the defects. If the Truth in Lending disclosures were properly drafted, there would be little opportunity for oral broker fraud.

8. There is No Factual Dispute that Chevy Chase's TILDS Violated TILA
Thus, Chevy Chase's purported defenses, while lengthy, cumbersome and time consuming to discuss, demonstrate the utter disregard of TILA. Chevy Chase's documents fail to reflect an honest attempt to comply with TILA.

Likewise, the Court must take notice that Chevy Chase refused to provide any discovery on the complaints of other borrowers about this loan program. (See Doc.#34, Attach. 4). The Court should therefore infer that the discovery, if produced, would have been adverse to Chevy Chase.

Plaintiffs submit the entire depositions of Bryan and Susan Andrews so the record of their testimony is not cleverly parsed and misrepresented without reading the context in which statements were made. See: Depositions of Bryan Andrews and Susan Andrews.

Finally, while ultimately the Court must decide whether the TILDS is misleading, all of the Affidavits and testimony submitted in this case, including the statements of the Andrews, indicate that TILDS was misleading as to the items claimed by the Plaintiffs. Chevy Chase acknowledges that the TILDS was programmed to include the optional language that the Plaintiffs' complain about, "5-Year Fixed," and the teaser "Note Interest Rate," above the Federal disclosures. Mr. Gatchel fails to suggest any alternative meaning for the offending language than the reading given by the Plaintiffs, Ms. Cordova-

Holmes, Mr. Rehberg, and the Plaintiffs' experts, Mr. Groble, and Mr. Vande-venter. The optional language in the TILDS suggests that the loan is "5-Year Fixed" at the teaser rate. Mr. Gatchel's Declaration falsely suggests in paragraphs numbered 9-13 that the TILDS contains a "monthly" payment schedule; clearly the 132 sampled loans do not contain any monthly language as to the intervals for payments. See: Affidavit of Mark Vandeventer dated 5/12/2006, at para. 5 and Affidavit of Nicole Walber. Mr. Gatchel acknowledges that the payment schedule is not fully amortized in months 1-60. Mr. Gatchel misleads the Court in paragraph 14 of his Declaration by suggesting that a minimum monthly payment schedule on some loans could meet or exceed the fully amortized payment, when none of the sampled loans contains such a payment schedule. See: Affidavit of Mark Vandeventer dated 5/12/2006 at para. 7 and Affidavit of Nicole Walber. They all involve a teaser rate.

In moving for summary judgment herein, Chevy Chase has put forth no expert witness to opine that the loan documents comply with the requirements in TILA, in spite of the fact that the case has been pending for over one year and they had ample ability to obtain such an opinion. Plaintiffs have put forth the Affidavits of Susan Andrews, Bryan Andrews, Luisa Cordova Holmes, and the two experts, Mark Vandeventer and Thomas Groble. All of them concluded that the TILDS is misleading. Therefore, the essential facts are undisputed.

SUMMARY JUDGMENT STANDARD

TILA is designed to make credit contract terms comprehensible; *Williams v. Blazer Financial Services, Inc.*, 598 F.2d 1371, 1374 (5th Cir. 1979); and to prevent predatory creditor practices. *James v. Ford Motor Credit Co.*, 638 F.2d 147 (10th Cir. 1980). It must be liberally construed to effectuate this purpose. *Id.* Ambiguities in the disclosure are construed against the lender; *Sneed v. Beneficial Co. of Hawaii*, 410 F. Supp. 1135 (D.Ha. 1976); and strictly in favor of the consumer. *Frazee v. Seaview Toyota Pontiac, Inc.*, 695 F. Supp. 1406 (D.Conn. 1988). Summary Judgment is appropriate in TILA cases because of the record produced by the loan documents. *Pearson v. Easy Living, Inc.*, 534 F. Supp. 884 (S.D.Oh. 1981). When the disclosure is so clearly confusing, misleading, and inaccurate that it cannot reasonably be disputed, summary judgment for the plaintiff is appropriate. *Griggs v. Provident Consumer Discount Co.*, 503 F. Supp. 246 (E. D. Penn. 1980); See also: *Hemauer v. ITT Financial Services*, (W.D.Ky. 1990). Since any violation of TILA is sufficient to activate civil remedies of *Sec. 1640*, it is clear that no matter how many violations are found in one loan transaction, only one recovery can be had and thus only one violation need be shown to trigger recovery. *Sneed v. Beneficial Finance Co. of Hawaii*, 410 F. Supp. 1135, 1138 (D. Hawaii 1976).

DISCUSSION

1. MISLEADING STATEMENTS IN THE TILDS VIOLATE TILA

When a lender provides additional information that either obscures, confuses or misleads the borrower as to its TILA disclosures, it creates a valid class action claim under TILA. *Smith v. The Cash Store Management*, 195 F.3d 325, 327-28 (7th Cir. 1999), 1999 U.S. App. LEXIS 27378; See also: *Adams v. Nationscredit Financial Services Corporation*, Case No. 03 C 3857, (N.D.Ill. 2004).

Thus, Courts have held that conflicting interest rate and payment disclosures justify rescission under TILA. *In re Ralls*, 230 B.R. 508 (E.D. PA 1999). *Friend v. Termplan, Inc.*, 651 F.2d 1012 (5 Cir. 1981) (State mandated in th terest rate disclosures must not conflict with Federal APR disclosures); *In Re Orr*, 697 F.2d 1011 (11th Cir. 1983) (Inconsistent state rate disclosures justify rescission); *Mason v. General Finance Corp. Of Virginia*, 542 F.2d 1226 (4th Cir. 1976) (A state mandated note rate disclosure that is different than the APR misleads the borrower); *Fairley v. Turan-Foley Imports, Inc.*, 65 F.3d 475 (5th Cir. 1995) (Conflicting interest rate disclosures mislead the borrower). See also: *Roberts v. Fleet Bank*, 342 F.3d 260, 269 (3rd Cir. 2003)(Alito, J., Fuentes, J. And Oberdorfer, J.) (Representing the loan rate as "fixed" misleads the borrower).

In addition, a defective payments schedule is a violation of TILA that justifies a rescission action. *Jones v. Ameriquest Mortgage Company*, Case No. 05-CV-0432 (N.D. IL 2006), 2006 U.S. Dist. LEXIS 3788. When a lender provides information that confuses a TILA mandated disclosure, it violates TILA by interfering with the right to receive "clear and conspicuous" notice in a reasonably understandable form. *See: 15 U.S.C. 1632(a); Reg. Z sec. 226.17(a); Official Commentary Sec. 226.17(a)(1)-1; Rodash v. AIB Mortgage Co.*, 16 F.3d 1142, 1146-47 (11th Cir. 1994); *Latham v. Residential Loan Ctrs. of America*, No. 03 C 7094, 2004 WL 1093315, at *4 (N.D. Ill. 2004); *Pulphus v. Sullivan*, No. 02 C 5794, 2003 WL 1964333, at *15-16 (N.D. Ill. Apr. 28, 2003) (same); *Wiggins v. AVCO Fin. Servs.*, 62 F. Supp. 2d 90, 93-97 (D.D.C. 1999) (granting plaintiff's motion for summary judgment because requiring borrower to sign two forms at the closing was inherently confusing and violated TILA's "clear and conspicuous" notice requirements); *Mount v. Lasalle Bank Lake View*, 926 F. Supp. 759, 765 (N.D. Ill. 1996); see also *Smith v. The Cash Store Management,* 195 F.3d 325, 327-28 (7th Cir. 1999), 1999 U.S. App. LEXIS 27378 (noting that "when a lender informs a borrower of his right to rescind, but also contradicts this notice by telling the borrower that he had waived his right to rescind, the borrower may state a claim under [TILA]").

Courts have consistently interpreted TILA to prohibit misleading disclosure statements, holding that "a misleading disclosure is as much a violation of TILA as a failure to disclose at all." *Smith v. Chapman*, 614 F.2d 968, 977 (5th Cir. 1980). TILA disclosures must be accurate, *Gibson v. Bob Watson Chevrolet-*

Geo, Inc., 112 F.3d 283, 285 (7th Cir. 1997)(Failure to disclose existence of an up-charge violates TILA.) Lenders are generally strictly liable under TILA for inaccuracies, even absent a showing that the inaccuracies are misleading. *Brown v. Marquette Savings and Loan Assoc.*, 686 F.2d 608, 614 (7th Cir. 1982). Where a disclosure is capable of more than one meaning, it is not "clear." See, e.g., *In re Madel*, Case No. 04-2060 (Bankr. E.D. WI 2004) (Conflicting disclosures justify rescission), citing *Williams v. Empire Funding Corp.*, 109 F.Supp.2d 352 (E.D. PA 2000) (A disclosure with two paragraphs, one giving a 3 day right to cancel and another giving a 1 day right to cancel, violates TILA).

All of the information provided in a TILA disclosure statement, including added information, must be *accurate. See: Goldman v. First Nat. Bank of Chicago*, 532 F.2d 10, 22 (7th Cir. 1976, Opinion by J.P. Stevens) ("Congress clearly sought to compel accurate disclosure . . ."), *cert. denied*, 429 U.S. 870, 97 S.Ct. 183, 50 L.Ed.2d 150 (1976). In rearranging the format of the model forms the creditor is not permitted to "affect the substance, clarity or meaningful sequence of the disclosure." *15 U.S.C. 1604(b)*.

In *Taylor v. Quality Hyundai, Inc.*, 150 F.3d 689, 692 (7th Cir. 1998), the 7th Circuit decided that misleading TILA disclosures were actionable when the creditor put added information into the TILDS stating that it was paying on behalf of a consumer to a third party insurance company more premiums than were actually being paid for an extended warranty. A creditor must disclose truthful information when optional information is added to a TILDS. *Alexander v. Continental Motor Werks, Inc.*, No. 95 C 5828, 1996 US Dist. LEXIS 1849 (ND Ill. Feb. 16, 1996) (Kocoras, J.) (Added information about amount being paid toward an extended warranty must be truthful).

The purpose of the TILA is to assure "meaningful" disclosures. *15 U.S.C. Sec. 1601 et seq., and 1604(b)*. See also: *15 U.S.C. 1638(a)(6)*. Consequently, the issuer must not only disclose the required terms, it must do so accurately. The accuracy demanded excludes not only literal falsities, but also adding misleading statements. *Smith v. The Cash Store Management*, 195 F.3d 325, 327-28 (7th Cir. 1999), 1999 U.S. App. LEXIS 27378 (Stapling a partially obscuring receipt on top of the TILA disclosure violates TILA); *Fairley v. Turan-Foley Imports, Inc.*, 65 F.3d 475 (5th Cir. 1995) (Conflicting interest rate disclosures mislead the borrower). See also: *Roberts v. Fleet Bank*, 342 F.3d 260, 269 (3rd Cir. 2003)(Alito, J., Fuentes, J. And Oberdorfer, J.) (Representing the loan rate as "fixed" misleads the borrower).

The two cases cited by Chevy Chase for the proposition that they can add misleading statements to the TILDS are not on point. *Johnson v. Banc One Acceptance*, 278 F.Supp. 2d 450, 455 (E.D. PA 2003) involved a situation where the payment schedule on the loan was found by the Court to be accurate. The issue in *Johnson* was failure to provide a more detailed itemization of title

charges, not the addition of misleading information into a TILA disclosure. The lender had offered the itemization in the disclosure, as *Regulation Z* allows, but the borrower did not request it. Thus, the form was not misleading. *Id.*

Another case cited by Chevy Chase for the proposition that they can add misleading information into the TILDS is the unpublished opinion in *Stutman v. Chemical Bank*, No 94 Civ . 5013 (MBM), 1996 WL 539845 (S.D.N.Y. , September 24, 1996). This case is also misconstrued. In *Stutman*, the issue was whether a lender issuing a new mortgage had to disclose on the TILDS an attorney fee that was incurred to release a past loan that was being paid off. Fees imposed relating to the extinguishment of prior debt are not considered finance charges or penalties for prepayment incident to the extension of the new loan under TILA. This was explained in the subsequent published decisions involving the same dispute in New York State Court. See: *Stutman v. Chemical Bank*, 690 N.Y.S.2d 8, 9 (A.D. 1 Dept. 1999); and, *Stutman v. Chemical Bank*, 731 N.E.2d 608, 610-11 (N.Y. 2000). *Stutman* really does not have anything to do with the case at hand, as it involves charges relating to the payoff of a prior loan, not disclosures of charges for new financing under TILA. The Federal Reserve Board commentary that Chevy Chase recites on page 16 of its Brief even acknowledges that the regulation on "added information" in a TILA form for "open ended" loans was abandoned in favor of the "general requirement" that information on the TILDS be "clear and conspicuous." *Truth in Lending: Revised Regulation Z*, 46 Fed. Reg. 20848, 20857 (April 7, 1981); *15 U.S.C. 1632(a); Reg. Z sec. 226.17(a); Official Commentary Sec. 226.17(a)(1)1*.

Notwithstanding Chevy Chase's ambitious argument, the regulatory change did not involve any authorization by the Federal Reserve Board to put misleading information in the TILDS. There was no statutory change. Chevy Chase is wrong to suggest that it can insert misleading interest rate information above the Federal box in a TILA disclosure statement. *15 U.S.C. 1632(a); Reg. Z sec. 226.17(a); Official Commentary Sec. 226.17(a)(1)-1*. See also: *15 U.S.C. 1604(b)* (the creditor is not permitted to "affect the substance, clarity or meaningful sequence of the disclosure.")

2. CHEVY CHASE MISREPRESENTS THE INTEREST RATE IN THE TILDS

In this case, the inaccurate rate representations in the TILDS are glaring. The added information on the top of the TILDS form misleads the borrower as to the meaning of the annual percentage rate disclosed in the Federal box. The TILDS states that the loan is a "5-Year Fixed" product with a teaser "Note Interest Rate." The Adjustable Rate Note, however, provides that the rate is monthly adjustable. Defendant, in its own web site explaining the mortgage to its brokers, conceded this when they stated that the loan has a "teaser" initial rate. The Defendant also acknowledged in answering discovery that the initial rate was a "teaser." See: Doc.#34, Attach.#4. In the second month of the Ad-

justable Rate Note, the interest rate more than doubles. Thus, the TILDS materially misrepresents the interest rate for 59 of the first 60 payments on the loan. The payment shown on the payment schedule for payments 2 through 60 of the loan are also glaringly false. The disclosed payment of $701.21 is at least $250.00 lower than the real self-amortizing payment imposed under the terms of the note. (See Exhibits 16, 17, 21 & 33 of the Doc. #s 29 &30). Moreover, the payment schedule does not even disclose the interval of payments.

The added language misleads the borrower as to the meaning of the APR information contained in the Federal box. Where information is presented that is substantively misleading, it invokes rights of rescission. Where a disclosure is capable of more than one meaning, it is not "clear." See, for example: ***Williams v. Empire Funding Corp.***, 109 F.Supp.2d 352 (E.D. Pa. 2000); ***In re Madel***, Case No. 04-2060 (Bankr. E.D. WI 2004).

In ***Roberts v. Fleet Bank***, 342 F.3d 260, 269 (3rd Cir. 2003)(Alito, J., Fuentes, J. And Oberdorfer, J.)[10], the 3rd Circuit found that where an annual percentage rate was adjustable at any time but was represented as a "fixed rate" product, a TILA class action was allowed because it violated the "clear and conspicuous" TILA guidelines. The substantive misrepresentation in this case of a "fixed" rate is quite similar to the one made by the lender in the ***Roberts*** case. The fact that the misrepresentation is made in the TILDS form itself, makes the misrepresentation substantially more egregious than in the ***Roberts*** case, where the misrepresentation occurred in an advertisement.

[10] *Plaintiffs cite two cases in this brief involving false advertising, the **Roberts** case and the **Rossman** case, both out of the 3rd Circuit. Plaintiffs are not alleging false advertising as a cause for rescission in this case. We are merely pointing out cases are analogous because, they involve the "clear and conspicuous" regulatory requirements, and they involve similar substantive misrepresentations. Here, the false representations are in the TILDS itself, not in general advertising, thus invoking **Regulation Z. Sec. 226.23(a)(3)** rescission for failure to deliver all material disclosures. The fact that the Chevy Chase's misrepresentations are in **Reg. Z** disclosures makes them substantially more egregious than if they were placed in false advertising, as in the **Roberts** and **Rossman** cases.*

Likewise, in ***Fairley v. Turan-Foley Imports, Inc.***, 65 F.3d 475 (5th Cir. 1995), the 5th Circuit found that disclosing more than one interest rate violates TILA, stating:

"Regulation Z sets out certain guidelines for creditors to follow when disclosing the amount financed, the finance charge, and the annual percentage rate to the consumer and demands that these disclosures be accurate." Id.

The borrower in ***Fairly*** was able to proceed under TILA because the lender

suggested a lower rate (8.5%) than was actually being provided under the contract (11.75%). Similarly in the present case, Chevy Chase's TILDS suggested a lower teaser rate than was actually being provided under the terms of the contract.

Likewise, in *Mason v. General Finance Corp. Of Virginia*, 542 F.2d 1226 (4th Cir. 1976), the Court found that disclosing a contract rate that was different than the Federally mandated "annual percentage rate" in the TILDS would mislead the borrower and therefore violated TILA. See also: *Friend v. Termplan, Inc.*, 651 F.2d 1012 (5th Cir. 1981). The only known reported case wherein the statement of the note interest rate was permitted is *Lewis v. Delta Funding*, 290 B.R. 541 (E.D. Pa 2003). *Lewis* is easily distinguished from this case. The *Lewis* Court was very careful to point out that the note interest rate was disclosed below the Federal disclosures in a footnote that did not in any way conflict with the Federal disclosures. Nor did it confuse the borrower as to the rate that would actually be charged under the note. *Id.* Whereas in this case, the teaser Note Interest Rate is placed before the Federal disclosures obviously confuses the borrower with an illusory *"5 Year Fixed"* teaser *"Note Interest Rate"* that exists for only a month. See: *Roberts*, cited above.

In *Rossman v. Fleet Bank Nat'l Ass'n, 280 F.3d 384, 394* (3d Cir. 2002 Scirica, J., Alito, J. and Barry, J.), a lender violated the "clear and conspicuous" requirement of TILA by stating that "no annual fee" would be charged when an annual fee was chargeable during the first year of the contract. A lender cannot disclose differing interest rates or conflicting loan documents and avoid liability under TILA. See: *England v. MG Investments, Inc.*, 93 F.Supp.2d 718 (S.D. W. Va. 2000) (Loan documents stating differing interest rates and a bad payment schedule justify rescission). See: *Roberts*, cited herein.

In each of the foregoing cases, the misleading statement of the lender was inconsistent with the legal obligations of the borrower under the terms of the note, thereby invoking TILA liability.

In this case, the disclosure is significantly more egregious than in the foregoing cases because the rate quoted is false for 59 of the first 60 payments, and there exists no good faith attempt to comply with any state mandated disclosure requirement. The **"5 Year Fixed"** initial **"Note Interest Rate"** is obviously put in the TILDS by Chevy Chase to tease borrowers.

The disclosures should reflect the credit terms to which the parties are legally bound at the time of giving the disclosures. *12 C.F.R. Sec. 226.17(c)(1)*. See: *In re Ralls*, 230 B.R. 508, 515 (Bankr. E.D. PA 1999). Chevy Chase's false statement in the TILDS that the loan was **"5 Year Fixed"** and **"Note Interest Rate: 1.95%"** was lawful, therefore, only if it met two conditions. First, it must have disclosed all of the information required by the statute. And second, it

must have been true, i.e., an accurate representation of the legal obligations of the parties at that time when the TILDS was prepared and presented to the borrower. Chevy Chase's statements satisfied neither of these requirements. The language obscured, rather than enlightened a borrower as to the true interest rate being imposed on the note. Review of the TILDS leads a reasonable borrower to believe that the interest rate was fixed for 5 years. In fact, this was not true. Secondly, the TILDS was not an accurate representation of the legal obligation of the parties. The details of the loan documents, in fact, provided that the interest rate was fixed for only one month, not 5 years.

A lender simply cannot suggest that a rate is "fixed" when it is adjustable at any time. See: **Roberts v. Fleet Bank**, 342 F.3d 260, 269 (3rd Cir. 2003)(Alito, J., Fuentes, J. And Oberdorfer, J.) (Using the term "fixed" is inappropriate when the rate can be varied at any time).; **Rossman v. Fleet**, 280 F.3d 384 (3rd Cir. 2002 Scirica, J., Alito, J. and Barry, J.) (Barring the statement "no annual fee" for a note that allows the lender to charge an annual fee within the first year). Likewise, the lender cannot put the teaser "contract rate" of interest on the TILA form that would differ from the APR and confuse the customer. See: **Mason v. General Finance of Virginia**, 542 F.2d 1226 (4th Cir. 1976); See also: **England; Friend; Ott; Ralls**; and **Fairley**, cited above.

In view of the purpose of TILA, which is meaningful disclosure, the added information that Chevy Chase put into the TILDS form causes a reasonable borrower to be misled about the terms of the note obligation. The representations are so egregious that they render the entire TILDS to be deceptive.

3. PUTTING CODE WORDS "PAY" OR "PA" OUTSIDE THE MARGIN IS AN OBSCURED DISCLOSURE THAT ADDS NOTHING

One of the arguments raised by the Defendant is that they stated the word "pay" or "pa" followed the term "5-Year Fixed" in the TILDS for half of the sampled loans. The Defendant apparently argues that this was an abbreviated or "Chevy Chase Code" method of telling the customer that only the loan "payment" was "fixed" during the first 5 years of the note, and that the rate was "monthly adjustable."11 See: Doc. #33, Groble Report. To the extent that the statement was made, it is obscured and invalid disclosure. Moreover, it adds nothing to explain or modify the teaser interest rate placed below.

11 **Susan Andrews testified as follows 11 at her Deposition, p. 107:**
19 Q **Did you have an understanding as of the date of**
20 **closing what the term "fixed pay" meant in**
21 **relation to your mortgage?**
22 A **Fixed pay to me was that it was a five year, and**
23 **the first five years, the payment wasn't going to**
24 **raise up and the interest rate wasn't going to**
25 **raise either.**

In *Smith v. The Cash Store Management*, 195 F.3d 325, 327-28 (7th Cir. 1999), 1999 U.S. App. LEXIS 27378, the Court found that a stapled receipt obscured the TILA disclosures and that the printed contents of the receipt were confusing or misleading, thus creating a valid legal claim under TILA. The purpose of TILA is to "assure a meaningful disclosure of credit terms so that the consumer will be able to compare more readily the various credit terms available to him and avoid the uninformed use of credit, and to protect the consumer against inaccurate and unfair credit billing and credit card practices." Id. *See: 15 U.S.C. Sec. 1601(a)*. Under TILA and *Regulation Z*, lenders are required to make disclosures to consumers regarding the charges and fees that accompany the extension of credit"). See: *O'Brien v, J.I. Kislak Mortgage Corp.*, 934 F. Supp. 1348, 1356 (S.D. Fla. 1996). Accordingly, lenders must disclose finance charges to ensure that the costs of securing credit are not obscured or hidden. See *Id*. Where a lender does not accurately disclose finance charges, a plaintiff may bring a TILA action for the equitable remedy of rescission. See *Quinn v. Ameriquest Mortgage Co.*, 03 C 5059, 2004 WL 316408, at *4 (N.D. Ill. Jan. 26, 2004).

Adding the abbreviated term of "pa" or "pay" after the misleading statements in the TILDS simply did not clarify the TILDS for a reasonable borrower reading the Chevy Chase form. The information is outside the margin, is incomplete, is written in a code, and does not nullify the prior statement that the initial note rate is "5 Year Fixed."

4. NOWHERE DOES CHEVY CHASE EXPLAIN WHY IT CHANGED THE FORM AFTER THIS LAWSUIT WAS FILED TO DELETE THE OFFENDING LANGUAGE

It also must be pointed out that Chevy Chase never explains why, two months after this lawsuit was filed, it changed its TILDS form to delete the term **"5 Year Fixed"** and the teaser **"Note Interest Rate"** from its TILDS. The term **"Monthly Adjustable ARM"** was substituted. The significance of this change is that it shows that the TILDS could have easily deleted the language in a manner that would be less misleading to the borrower.

5. THE PAYMENT SCHEDULE IS INVALID

A bad payment schedule renders the lender liable under TILA. *15 U.S.C. 1638(a)(6), Regulation Z Sec. 226.18(g)*. See: *Williams et al. v. Chartwell Financial Services, Ltd.* 204 F.3d 748, 753-54 (7th Cir. 2000), 2000 U.S. App. LEXIS 1651. Chevy Chase's listing of the total number of payments in the TILDS does not sufficiently comply with TILA. The District Court for the Northern District of Illinois recently held that a Truth in Lending disclosure statement that listed the number of payments to be made over the life of a loan and the due dates for the first and last payments nonetheless violated the Federal Truth in Lending Act, *15 U.S.C. § 1601 et seq.*("TILA"), because the statement did not list the payments' intervals or frequency. In *Jones v. Ameriquest*

Mortgage Company, Case No. 05-CV-0432 (N.D. IL 2006), 2006 U.S. Dist. LEXIS 3788, the plaintiff borrower obtained a thirty-year loan from the defendant lender in March 2002. At loan closing, the borrower was presented with a Truth in Lending disclosure statement stating that payments would be due beginning on March 1, 2002. The disclosure statement also indicated the total number of payments (360) and that the due date of the final payment would be on April 1, 2032. Finally, the statement indicated that the borrower was to make 359 payments of $480.01 beginning March 1, 2002, and one payment of $462.79 on April 1, 2032. In January 2005, the borrower brought suit against the lender, alleging that the TILDS she received at closing failed to fully disclose her loan's repayment schedule in the manner required by TILA, and seeking rescission of the loan and statutory damages. The lender subsequently moved for summary judgment arguing that the TILDS properly disclosed the repayment schedule and that the borrower's right to cancel had been adequately disclosed. In January 2006, the *Jones* Court issued its opinion. The Court observed that the Federal Reserve Board's Official Staff Commentary requires creditors to disclose the repayment amounts and intervals, using words such as "monthly" or "bi-weekly" or, alternatively, listing all of the consumer's payment dates. The lender argued that it had disclosed the fact that monthly payments were to be made because the disclosure statement listed 359 plus 1 payments, thereby implying that the payments on the thirty-year loan would be due on a monthly basis. The Court rejected this argument, stating that "[n]othing in the Federal Reserve Board's commentary or model forms (all of which use the phrases 'monthly beginning' or 'monthly starting'), suggests that numbers alone, not words, be used to disclose the frequency of payments unless, of course, the creditor lists all of the payment due dates." The *Jones* Court next rejected the argument that because the borrower had admitted to understanding that her payments were to be made monthly, there was no actionable injury. Relying on prior decisions from the Seventh Circuit Court of Appeals, the *Jones* Court found that a borrower in this Circuit need not have been misled or have suffered any actual damages from a TILA violation to recover under the act. Finally, the Court declined to follow a September 2005 decision reached in *Hamm v. Ameriquest Mortgage Company*[12], No. 05-C-227, 2005 WL 2405804 (N.D. IL, Sept. 27, 2005) a case in front of a different judge in the Northern District of Illinois. Examining facts virtually identical to those presented in *Jones*, the *Hamm* Court had concluded that an ordinary consumer would understand from the Truth in Lending disclosure statement that her payments would be monthly. The *Jones* Court expressly disagreed with that conclusion, stating that *Hamm* ignores the rule that a borrower need not have been misled by the missing Payment Intervals. A borrower in the 7th Circuit need not have been misled or have suffered any actual damages from a TILA violation to recover under the act. *Id.* The overwhelming authority is that a defective payment schedule entitles the borrower to rescind the loan. *Clay v. Johnson*, 22 F. Supp.2d 832 (N.D. IL 1998) (An ambiguous payment schedule is a material non-disclosure that entitles the borrower to rescission); *Graves v. Tru-Link Fence Co.*, 905 F.Supp. 515 (N.D. IL 1995).

[12] *Defendant cites* **Hamm** *in their Brief without notifying this Court that the decision was roundly rejected by the* **Jones** *case, in the same District, for failing to follow the terms of* **Regulation Z**. *See:* **Jones v. Ameriquest Mortgage Company**, *Case No. 05-CV-0432 (N.D. IL 2006), 2006 U.S. Dist. LEXIS 3788. Hamm is inconsistent with all of the other cases out of the same District and is simply not a well reasoned opinion. See, e.g.:* **Clay v. Johnson**, *22 F. Supp.2d 832 (N.D. IL 1998).*

Chevy Chase does not deny in other parts of its Brief that, to the extent the payment schedule was bad, it is strictly liable for rescission under TILA. For the reasons stated below, it is undisputed that Chevy Chase in this case put out a defective payment schedule. The payment schedule is defective in at least two respects. First, it fails to state the interval of payments in the model form blank, which is "monthly" under the terms of the note. Second, the mortgage fails to disclose the full amount of monthly principal and interest charges that are being made to the customer's account during the first 60 payments of the loan.

A. Payment Intervals are Undisclosed

The payment schedule in the TILDS (Andrews' Affidavits, Exhibit 17) is invalid. See: Affidavit of Mark Vandeventer dated 5/12/2006 at para. 5 and Affidavit of Nicole Walber (and related attachments, submitted under seal). In no loan file in the sample does the TILDS state that payments are to be made on a "monthly" basis as required in column 3 of the payment schedule. *12 C.F.R. sec. 226, App. H-15*. Failure to disclose the intervals of payments is a direct violation of TILA that creates a summary judgment liability against the lender. See: **Jones v. Ameriquest Mortgage Company**, Case No. 05-CV-0432 (N.D. IL 2006), 2006 U.S. Dist. LEXIS 3788; **England v. MG Investments, Inc.**, 93 F.Supp.2d 718 (S.D. W. Va. 2000) (A bad payment schedule would justify rescission).

An illustrative case is *Jeanty v. Washington Mutual Bank F.A.*, Case No. 03-C-0648 (E.D. WI 2004), wherein this Court found that the model form payment schedule, if used, must be modified to fit the circumstances of the loan transaction so that the form is not misleading under *15 U.S.C. Sec. 1604(b)*. See also: *15 U.S.C. 1638(a)(6)*, *Regulation Z Sec. 226.18(g)*. The Official Commentary to *Regulation Z, Sec. 226.18(g)* issued by the Federal Reserve

Board on April 6, 1998, reads as follows:

Section 226.18(g) requires creditors to disclose the timing of payments. To meet this requirement, creditors may list all of the payment due dates. They also have the option of specifying the "period of payments" scheduled to repay the obligation. As a general rule, creditors that choose this option **must disclose the payment intervals or frequency, such as "monthly"** or "bi-weekly," and the calendar date that the beginning payment is due. For example, a creditor may disclose that payments are due "monthly beginning on July 1, 1998." This information, when combined with the number of payments, is necessary

to define the repayment period and enable a consumer to determine all of the payment due dates. ii. Exception. In a limited number of circumstances, the beginning payment date is unknown and difficult to determine at the time disclosures are made. For example, a consumer may become obligated on a credit contract that contemplates the delayed disbursement of funds based on a contingent event, such as the completion of home repairs. Disclosures may also accompany loan checks that are sent by mail, in which case the initial disbursement and repayment dates are solely within the consumer's control. In such cases, if the beginning-payment date is unknown the creditor may use an estimated date and label the disclosure as an estimate pursuant to Sec. 226.17(c). Alternatively, the disclosure may refer to the occurrence of a particular event, for example, by disclosing that the beginning payment is due "30 days after the first loan disbursement." The information also may be included with an estimated date to explain the basis for the creditor's estimate.

See: *Comment 17(a)(1)-5(iii). Official Staff Interpretations of Regulation Z*, 63 Fed. Reg. 16669, 16677 (1998) (now codified at *12 C.F.R. pt. 226, supp. I, comment 18(g)-4*). This comment went into effect on March 31, 1998. 63 Fed. Reg. at 16669. The Federal Reserve Board is the primary authority for interpreting and applying TILA. *Ford Motor Credit Co. v. Milhollin*, 444 U.S. 555, 566, 100 S.Ct. 790, 797, 63 L.Ed.2d 22 (1980). Acquiescence to administrative expertise is particularly apt under TILA, because the Federal Reserve Board has played a pivotal role in "setting the statutory machinery in motion." *Norwegian Nitrogen Products Co. v. United States*, 288 U.S. 294, 315, 53 S.Ct. 350, 358, 77 L.Ed. 796 (1933). As emphasized in *Mourning v. Family Publications Service, Inc.*, 411 U.S. 356, 93 S.Ct. 1652, 36 L.Ed.2d 318 (1973), Congress delegated broad administrative lawmaking power to the Federal Reserve Board when it framed TILA. The Act is best construed by those who gave it substance in promulgating regulations thereunder. *Milhollin*, 444 U.S. at 566, 100 S.Ct. at 797. Courts defer to Board interpretations of TILA and its accompanying regulations. These interpretations can be found in the commentary on *Regulation Z, 12 C.F.R. Sec. 226, App. C*.

Likewise, in *Smith v. Chapman*, 614 F.2d 968, 977 (5th Cir. 1980), the Court found a violation of TILA in part because the failure to list the sales tax figure in the space allotted for that figure on the contract form was misleading. Similarly in this case, the payment interval is left out of the model form blank where it could have been inserted in the TILDS. *12 C.F.R. sec. 226, App. H-15*. A literal reading of the payment schedule is that all of the first 60 payments are due upon the first scheduled payment date under the TILDS.

Likewise, in *Clay v. Johnson*, 22 F.Supp.2d 832 (N.D. IL 1998), the Court found that a payment schedule was an essential element of the disclosure requirement under TILA and that an inaccurate payment schedule would be

the grounds to rescind the transaction. The Court found that adding the payment schedule to the underlying instrument was an ineffective means of providing an accurate payment schedule under TILA, because the consumer could not, with easy reference to the TILDS form, determine when payments were due.

In the case at hand, Chevy Chase left out the interval for the payment schedule in all of the 132 sampled TILA disclosures. See: Andrews' Affidavits; Affidavit of Mark Vandeventer dated 5/12/2006 at para. 5 and Affidavit of Nicole Walber. Therefore, the defect is uniform for the entire class.

B. The Payment Schedule Does Not Show the Full Principal and Interest Being Charged Each Month, nor any Reference to Payment Variations

The Truth in Lending Disclosure Statement (Exhibit 17) further contains an inaccurate payment schedule, which supports and buttresses this false representation, since it does not represent the total, fully amortized, principal and interest being imposed on the loan each month, nor a reference to variations in the series of payments.

The TILDS must contain an accurate payment schedule. *15 U.S.C. 1638(a)(6), Regulation Z Sec. 226.18(g)*. The payment schedule shown on the TILDS shows payments at the teaser rate for the first 60 payments of the loan. *Regulation Z Sec. 226.18(g)(2)* requires, in a variable rate transaction, "a reference to the variations in the other payments in the series." The calculation prepared by Chevy Chase is done on the misleading basis that the interest rate is fixed at an annual rate of 1.95% for the first five years of the loan. In fact, the interest rate jumps to 4.375% in just the second month of the loan. See: Affidavits of Bryan and Susan Andrews, Doc. No.s 29 &30, Exhibits 17, 33 & 21.

A payment schedule, when included in a TILDS, must display the entire fully amortized principal and interest being imposed (whether directly or indirectly) upon the consumer each month, according to the definition in the TILDS form and the related regulations. The Chevy Chase payments schedule does not point out to the borrower that the interest rate in month two of the loan will change, and in fact, will change even if there is no change in the index rate. See: Vandeventer Report, Doc. #32, at pages 6-7. The payment schedule on the Andrews TILDS misrepresents that a payment of $701.21 for the first 60 months will fully amortize the loan. In fact, with the automatic interest rate increase in the second month of the loan, the payment necessary to fully amortize the loan as of 8-9-2004 was already $952.47, a monthly increase of $251.26. See Doc. #s 29 &30 Exhibit 21; upper right hand corner entry for fully amortized payment).

The second page of the TILDS (Exhibit 17) states the following:

DEFINITION OF TRUTH IN LENDING TERMS

PAYMENT SCHEDULE
The **dollar figures in the Payment Schedule represent principal, interest**, plus Private Mortgage Insurance (if applicable).

Similarly, the Federal Reserve Board's Truth in Lending Official Staff Commentary[13] to *Reg. Z, 226.18(g)* says:

"Payment schedule. 1. Amounts included in repayment schedule. **The repayment schedule should reflect all components of the finance charge, not merely the portion attributable to interest.**"

Reg. Z, 12 CFR § 226.4 states:

"Finance charge."

(a) Definition. The finance charge is the cost of consumer credit as a dollar amount. It includes any charge payable directly or indirectly by the consumer and imposed directly or indirectly by the creditor as an incident to or a condition of the extension of credit......

[13] *Federal Reserve Board regulations and commentary under the TILA are entitled to substantial deference.* **Szumny v. Am. Gen. Fin., Inc.**, *246 F.3d 1065, 1069 (7th Cir.2001). See earlier discussion in this memorandum.*

The payment schedule on the TILDS for the Plaintiffs and the Class members is inaccurate under *Reg. Z* standards and under the definition articulated in the TILDS form. The payment schedule does not include all of the fully amortized principal and interest being imposed each month of the loan. The payment schedule only discloses the minimum payment required to avoid immediate foreclosure, not the principal and interest being charged to the account each month, which has the effect of misleading the ordinary borrower as to the true cost of the loan provided by Chevy Chase.

The payment schedule does not include a reference to variations in the payment series. *12 C.F.R. 18(g)(2)(ii)* caused by changes in the interest rate. See: Doc. #32, Mark Vandeventer Report. One of the difficulties presented is that transaction is represented as fixed for the first 60 months in the TILDS but it is really not fixed. Chevy Chase had a duty to adapt the model form to explain the transaction to the borrower. An illustrative case is *Jeanty v. Washington Mutual Bank F.A.*, Case No. 03-C-0648 (E.D. WI 2004), wherein this Court found that the model form payment schedule, if used, must be modified to fit the circumstances of the loan transaction so that the form is not misleading under *15 U.S.C. Sec. 1604(b)*. See also: *15 U.S.C. 1638(a)(6), Regulation Z Sec.*

226.18(g). This Chevy Chase form is misleading as to the amount the consumer is charged in months 2-60.

Defendant's conduct, as set forth above, violates TILA, *15 U.S.C. 1601 et seq., 15U.S.C. § 1638(a)(6)*, implementing **Regulation Z, 12 C.F.R. Part 226.18(g)**. The TILDS issued in connection with the loans made to the Plaintiffs and the Class do not accurately reflect the terms of the legal obligations between the parties as to the amounts the customer is being charged in the first 60 payments of the loan.

6. THE VARIABLE RATE DISCLOSURE IS NONCOMPLIANT WITH REG. Z

A. The Variable Rate Disclosure, Given Earlier, Does Not Excuse Subsequent Misstatements in the TILDS.

The variable rate disclosure is given earlier and it conflicts with the terms of the final disclosure document provided, the TILDS. Thus, the last document the borrower is given is false, rendering the earlier disclosures invalid. *England v. MG Investments, Inc.*, 93 F.Supp.2d 718 (S.D. W. Va. 2000) (Loan documents stating different interest rates and a bad payment schedule justify Rescission). *Williams v. Rizza Chevrolet-Geo, Inc.*, (N.D.Ill. 2000) Case No. 99 C 2294, March 1, 2000. Chevy Chase cannot make a false statement in the final TILDS.

B. The Variable Rate Disclosure Fails to Tell the Borrowers That the Initial Rate Is Discounted, and is Noncompliant.

According to *Regulation Z*, variable rate disclosures must tell the consumer when the initial rate is discounted, the following disclosures, as applicable, shall be provided:

(v) **The fact that the interest rate will be discounted, and a statement that the consumer should ask about the amount of the interest rate discount. 12 C.F.R. Sec. 226.19(b)(2)(v)**.

The variable rate disclosures Chevy Chase provided do not tell the consumer that the initial rate is "discounted." See: Declaration of T. Banks Gatchel; Affidavit of Mark Vandeventer dated 5/12/2006 at para. 8, Vandeventer Report, Doc. #32, and Affidavit of Nicole Walber.

Even the Declaration of T. Banks Gatchel, at para. 14, fails to honestly disclose to the Court that the loan is discounted. While Mr. Gatchel alleges that some borrower might have theoretically chosen an initial rate greater than the monthly adjustable rate, he fails to show an example of such a loan out of the 8,000 loans in the applicable class. Indeed, none of the sampled loans contained

such a rate or payment schedule. See: Declaration of T. Banks Gatchel; Affidavit of Mark Vandeventer dated 5/12/2006 at para. 7 and Affidavit of Nicole Walber.

The variable rate disclosures are inadequate because they fail to tell the consumer that the initial rate is discounted. *12 C.F.R. Sec. 226.19(b)(2)(v)*. For this particular loan program, failing to tell the borrower that the initial rate disclosure is discounted makes the variable rate disclosure grossly inadequate.

7. LANGUAGE IN THE LOAN DOCUMENTS DOES NOT ENTITLE THE LENDER TO RELIEF FROM TILA, AND IN THIS CASE IT SUGGESTS INTENTIONAL DECEPTION.

Chevy Chase argues that certain statements in the loan documents are a form of compliance. Disclosures must be "segregated from everything else." *12 C.F.R. sec. 226.17(a)*. See: *England v. MG Investments, Inc.*, 93 F.Supp.2d 718 (S.D. W. Va. 2000) (Loan documents stating different interest rates and a bad payment schedule would justify rescission); *Clay v. Johnson*, 22 F.Supp.2d 832 (N.D. IL 1998)(TILA disclosures are not to be made in the underlying contract documents); *Sneed v. Beneficial Co. of Hawaii*, 410 F. Supp. 1135 (D.Ha. 1976). Chevy Chase cannot point to the underlying loan documents as a form of disclosure when the regulations require segregated disclosure. *12 C.F.R. sec. 226.17(a)*.

Likewise, Defendant argues that the class members had an affirmative duty to make further inquiries into the contract documents to determine whether the TILDS was accurate and truthful. This is incorrect. TILA mandates disclosure by the lender; it does not place any duty of inquiry on the borrower. Defendant's argument in this regard would eviscerate TILA. Under Defendant's reading of TILA, a borrower would have an affirmative obligation to verify the truthfulness of the TILDS. Such affirmative inquiry is not required by TILA. See, e.g.: *Sneed v. Beneficial Finance Co. of Hawaii*, 410 F. Supp. 1135, 1145, (D. C. Hawaii 1976); : *Clay v. Johnson*, 22 F.Supp.2d 832 (N.D. IL 1998)(TILA disclosures are not to be made in the underlying contract documents). To the extent the Defendant has cited any authority for this theory, it is bad law.

Moreover, this defense, even if it were maintainable as a legal theory, is unsupported by the documentary evidence. Chevy Chase loan documents are drafted in such a way that they suggest that Chevy Chase intended to deceive borrowers. For example, in the Adjustable Rate Note agreement the **"5 Year Fixed"** term is stated at the top of the document and **"I will pay interest at a yearly interest rate of 1.95%"** is stated in the "INTEREST" section. A borrower quickly reading these documents at a real estate closing is unlikely to read far enough to determine later in the document that the rate adjusts monthly. Chevy Chase agrees that was the case with the Andrews and accepted their testimony on this point in the Brief. That was also the conclusion reached

by Plaintiffs experts, Vandeventer and Groble, and also the testimony of Luisa Cordova-Holmes. Their testimony is unrefuted.

An analogous case is ***Rossman v. Fleet Bank Nat'l Ass'n***, 280 F.3d 384, 394 (3d Cir. 2002 Scirica, J., Alito, J. and Barry, J.). In that case the lender advertised that there was no annual fee on a credit card. However, the terms of the actual note allowed the lender to charge a fee during the first year. During the first year of the note the lender charged an annual fee. The 3rd Circuit stated:

> "And because the statement "no annual fee" was misleading with respect to the duration of the offer, further clarification was necessary for it to meet the requirements of the TILA, assuming the terms of the cardholder agreement actually permitted Fleet to dispense with its no-annual-fee promise mid-year."

Rossman v. Fleet Bank Nat'l Ass'n, 280 F.3d 384, 394 (3d Cir. 2002 Scirica, J., Alito, J. and Barry, J.).

Likewise, in ***Jackson v. Check N Go of Illinois***, No. 99-C-7319 (N.D. IL 2000), the Court confronted a similar attempt to sidestep TILA disclosures by pointing the borrower to the underlying contract. In ***Jackson***, the Court stated:

> "The defendants failed to make the § 1638(a)(9) disclosure not merely because they placed the statement about the check as security outside the Federal box and above the 'Our Disclosures to You' line, but also because the statement could not have been less accessible to the average person if it had been written in Sanskrit. The statement on the back makes up for being more accessible by being misleading.

The meaning of "disclosure" is "opening up to view, revelation, discovery, exposure." ***United States and Mathews v. Bank of Farmington***, 166 F.3d 853, 860 (7th Cir. 1999) (citing 4 Oxford English Dictionary 738 (2d ed. 1989) (qui tam context)).

Finally, it would frustrate the purpose of the disclosure law to read the statute to bar statutory damages when a required disclosure is hidden in the fine print at the end of an indigestible chunk of legalistic boilerplate, and outside the Federal box, set apart from the defendants' own statement in that box about "Our Disclosures to You." That would give lenders a virtually free pass to violate the disclosure requirements by making them inaccessible to borrowers whom they might inadvertently mislead about what they were supposedly disclosing." ***Id***.

In this case, the lender states on the TILDS that the loan rate is fixed for the first five years. In the contract document, the language is also seriously mis-

leading. For example, the term **"5 Year Fixed"** is placed on the top of the Adjustable Rate Note. In the text of the first page, it states:

"I will pay interest at the yearly rate of 1.95%."

There is literally no year in which this rate is charged, thus; the contract itself is highly misleading with respect to the same illusory terms as are placed in the TILDS.

8. THE CONSUMER'S UNDERSTANDING IS NOT RELEVANT

Chevy Chase's argument about the consumer's substantive failure of the plaintiff to sort through the maze of false disclosures is irrelevant. The disclosures were not given in the proper form and that alone establishes liability. See, e.g., In *re Madel*, Case No. 04-2060 (Bankr. E.D. WI 2004). See also: *Jones v. Ameriquest Mortgage Company*, Case No. 05-CV-0432 (N.D. IL 2006), 2006 U.S. Dist. LEXIS 3788. Moreover, the actual knowledge in this record concerning the borrowers' understandings are consistent with the underlying TILA claims— that the TILDS forms are defective by any normal person's reading. See: Affidavits of Bryan Andrews, Susan Andrews; Luisa Cordova Holmes.

9. THE REMEDIES REQUESTED ARE PROPER

A. Summary of Requested Remedies
Plaintiff class is entitled to the following remedies under the Truth in Lending Act:

i. TILA Violation #1- ("5 Year Fixed"- Note Interest Rate 1.95%)

This is a violation of *15 U.S.C. Sec. 1638(a)(4)*. This gives rise to an award of statutory damages as set forth in *15 U.S.C. Sec. 1640(2)*. The maximum class award of statutory damages is $500,000.00 plus attorneys' fees and costs.

The Borrowers are also entitled to a right of rescission for the material nondiclosures under *15 U.S.C. Sec. 1635* and *12 C.F.R. Sec. 226.23*. In addition, costs and attorney's fees are to be awarded under *15 U.S.C. 1640(2)(B)(3)*.

ii. TILA Violation #2 (Failure to Specify an Interval of Payments in the Payment Schedule); and TILA Violation # 3 (The Payment Schedule Does Not Show the Full Principal and Interest Being Charged Each Month, nor any Reference to Payment Variations).

These are violations of *15 U.S.C. Sec. 1638(a)(4)*. Each count would also support an award of statutory damages as set forth in *15 U.S.C. Sec. 1640(2)*, however, only one award of statutory damages can be made in this action. The

Maximum total class award for damages is $500,000.00 as stated above, plus attorneys fees and costs.

The Borrowers are also entitled to a right of rescission on each of these material nondisclosures under *15 U.S.C. Sec. 1635* and *12 C.F.R. Sec. 226.23*. In addition, costs and attorneys' fees are to be awarded under *15 U.S.C. 1640(2)(B)(3)*.

B. The Opportunity for Rescission is an Appropriate Remedy

i. The Class Deserves a Fair Opportunity to Rescind

There are a few cases that hold that TILA claims seeking a declaration of the right to rescind under *§ 1635(b)* are inappropriate for class resolution. *See, e.g., James v. Home Const. Co. of Mobile, Inc.*, 621 F.2d 727, 730-31 (5th Cir. 1980) (agreeing with district Court in TILA case that rescission was a "purely personal remedy" and inappropriate for class action); *Gibbons v. Interbank Funding Group*, 208 F.R.D. 278, 285 (N.D. Cal. 2002) and *Jefferson v. Security Pac. Fin. Servs., Inc.*, 161 F.R.D. 63, 68 (N.D.Ill. 1995). None of those cases involve the numerous TILDS errors and deceptiveness employed by Chevy Chase in their documents in this case. Chevy Chase's documents are artfully tricky and indicate a pattern of predatory behavior.

There are many cases holding that class resolution is appropriate for claims seeking a declaration of the right to rescind under TILA. See: *McIntosh v. Irwin Union Bank & Trust, Co.*, 215 F.R.D. 26, 32-33 (D. Mass. 2003) (Young, C.J.) (discussing split among Courts regarding propriety of class resolution for TILA rescission claims and holding class action appropriate); *Williams v. Empire Funding Corp.*, 183 F.R.D. 428, 435-36 (E.D. Pa. 1998).

There is nothing in the language of TILA which precludes the use of the class action mechanism provided by Rule 23 to obtain a judicial declaration whether an infirmity in the documents, common to all members of the class, entitles each member of the class individually to seek rescission." *Williams*, 183 F.R.D. at 435-36. *Tower v. Moss*, 625 F.2d 1161, 1163 (5th Cir. 1980) (Class certified under TILA with option to rescind offered after settlement of common claims); *Hickey v. Great Western Mortgage Corp.*, 158 F R.D. 603 (N.D. Ill. 1994) (permitting certification of a 23(b) class seeking, inter alia, "a declaration that the class has a continuing right to rescind its transactions."). *Rodrigues v. Members Mortgage Co., Inc.*, Civil Action No. 03-11301-PBS, February 3, 2005 (D. Mass 2005) at page 15, a case in which a District Court allowed a class claim for rescission.

The *Williams* Court reasoned that the Plaintiffs were only seeking a declaration that the notices of rescission in the sales and financing contracts at

issue violated TILA, and thus that each member of the class is entitled to seek rescission. Were this Court to declare that, indeed, plaintiffs were entitled to seek rescission, then each class member, individually, would have the option to exercise his or her right to seek rescission. As to any member of the class who triggered the statutory right to rescission, the Defendant would have, in turn, the opportunity to exercise their rights to cure under TILA. Hence, the *Williams* Court saw the advantage in making a classwide decision on the common issue, the violation of TILA which gave rise to the right of rescission. Once a class member had that right, they were free to make their own decision whether to elect rescission. This avoided the necessity of the entire class having to come into Court and prove the same thing, the underlying TILA violation in the Defendant' loan documents.

The *Williams* Court pointed out that "there is nothing in the language of TILA which precludes the use of the class action mechanism provided by Rule 23 to obtain a judicial declaration whether an infirmity in the documents, common to all members of the class, entitles each member of the class individually to seek rescission." *Williams, Id* at 428, 435-36;

In *McIntosh v. Irwin Union Bank & Trust, Co.*, 215 F.R.D. 26, 32-33 (D. Mass. 2003) (Young, C.J.), the Massachusetts District Court, was also Court unpersuaded by the *Jefferson* Court's rationale that class actions seeking rescission under *Sec. 1635* are inappropriate because such actions would render *Sec. 1635* penal in nature. In agreeing with the holding in *Williams*, the *MacIntosh* Court pointed out that: "to achieve its remedial purpose, TILA is penal in nature and builds in incentives for litigation to protect classes of plaintiffs who, individually injured, would never sue to recover modest damages. It is that injury that resonates with this Court. Moreover, the Court agrees with the *Williams* Court's conclusion that the case for class certification is even stronger when, as here, the plaintiffs seek only declaratory relief." *Id*. With respect to the rescission claim, Plaintiffs in this action seek only declaratory relief of the right of rescission, not rescission itself. The decision to exercise the right of rescission is a decision each class member will make in turn, after the Court grants each class member the right to make such an election.

The United States District Court for the Northern District of Illinois recently cited and followed *Williams* and *McIntosh* in *Latham v. Residential Loan Centers of America, Inc.*, No. 03 C 7094, 2004 WL 1093315, (N.D. Ill. 2004). That case contains the best discussion of the status of this issue amongst trial Courts in the 7th Circuit. The *Latham* Court noted that:

"Courts are divided on whether TILA claims for rescission are appropriate for class action treatment. See *Williams v. Empire Funding Corp.*, 183 F.R.D. 428, 435 n. 10 (E.D. Pa. 1998) (listing cases in which Courts have both denied and granted class action status for rescission remedy under TILA). In *Jefferson*

v. Security Pac. Fin. Servs., Inc., 161 F.R.D. 63 (N.D. Ill. 1995), Judge Castillo denied a motion for class certification because he found that "rescission is a purely personal remedy for technical violations of TILA." *Id.* at 68. Particularly relevant to his conclusion was the language in section 1635(b) itself, which gives a creditor twenty days to act on a borrower's request for rescission before the claim can be filed in Court. He said: "This requirement cuts strongly in favor of treating rescission as a personal, rather than a class, remedy. Under Section 1635, individuals must choose to assert the right to rescind, on an individual basis and within individual time frames, before filing suit." *Id.* at 69. In concluding as he did, Judge Castillo relied in part on the decision in *James v. Home Constr. Co.*, 621 F.2d 727 (5th Cir. 1980), in which the Court found the twenty-day cure period persuasive evidence that rescission is a personal remedy and that a rescission class cannot be certified. See *James*, 621 F.2d at 731. Other Courts have found that rescission claims under TILA could be maintained as class claims. In *Hickey v. Great W. Mortgage Corp.*, 158 F.R.D. 603 (N.D. Ill. 1994), Judge Conlon granted a motion to certify a class seeking damages and a declaration that the class had a right to rescind its transactions under TILA. *Id.* At 613-14. She gave little weight to the *James* Court's argument that allowing a class action for rescission would conflict with the twenty-day cure period provided for in the statute. *Id.* at 613 n. 5 (noting that some authority suggests that a written complaint can serve as notice to a creditor that a borrower seeks rescission). In *Williams*, the Court found "nothing in the language of TILA which precludes the use of the class action mechanism provided by Rule 23 to obtain a judicial declaration whether an infirmity in the documents, common to all members of the class, entitles each member of the class individually to seek rescission." *Williams*, 183 F.R.D. at 436. It found significant the fact that plaintiff was not seeking to rescind each contract as a remedy. If the Court found in plaintiff's favor on the TILA claim, then each class member, as an individual, would have the option to seek rescission and defendant would have the opportunity to exercise its rights to cure under TILA. *Id.* at 435. The district Court of Massachusetts rejected the reasoning of the *James* and *Jefferson* Courts when it decided that class action status was available under TILA to seek a declaration of the right of rescission. *See McIntosh v. Irwin Bank & Trust Co.*, 215 F.R.D. 26, 33 (D. Mass. 2003). It was unpersuaded by the *Jefferson* Court's rationale that class actions under TILA seeking rescission were "inappropriate because it would render section 1635 penal in nature." *Id.* at 33. The Court said that to achieve its remedial purpose, TILA was penal in nature. It cited with approval the *Williams* decision and found that "the case for class certification is even stronger when . . . plaintiffs seek only declaratory relief." *Id.* With all due respect to the *Jefferson* Court, we agree with the latter line of cases holding that a class claim under TILA seeking a declaration of the right to rescind can be maintained and disagree with RLCA's position that, as a matter of law, Latham's class claim is untenable. At this stage in the litigation, we do not find that Latham's claim requires such an individualized inquiry as to preclude the possibility of proceeding as a class."

Latham at 5-7.

Plaintiffs urge the Court to follow the well reasoned *Latham* line of cases. Each class member who decides to be a class member will have the right to elect the remedy of rescission. If any putative class member does not want rescission, they are free to opt-out, or to elect not to rescind.

It must also be noted that, while TILA allows rescission regardless of fault on the part of the lender or reliance on the part of the customer, Chevy Chase is particularly ripe to respond to a rescission remedy in these proceedings due to the patently dishonest manner in which they have drafted their loan documents. Chevy Chase teases and ultimately deceives their customers with three glaring errors in their TILDS, any one of which is grounds for rescission. It is not fair for Chevy Chase to draft mortgage documents using what they admit are "internal codes," and then say "gotcha" when their phony loan documents are exposed. The Chevy Chase documents, which dangle illusory terms, reflect a predatory effort to evade TILA.

ii. The Demand for Rescission Is Made by the Filing of a Lawsuit

Courts across the Country have held that any written rescission notice, including a complaint, complies with the statute on notice of rescission. See *Taylor Domestic Remodeling, Inc.*, 97 F.3d 96, 100 (5th Cir. 1996) ("[T]he filing of the complaint constitutes statutory notice of rescission pursuant to *12 C.F.R. Sec. 226.23(a)(3).*"); *Fairbanks Capital Corp. v. Jenkins*, 225 F. Supp.2d 910, 913-14 (N.D. Ill. 2002) ("Defendants allege that they have made a demand for rescission . . . and even if they had not done so, their filing of an affirmative defense and counterclaim seeking rescission would be sufficient to constitute a demand for rescission under the TILA."); *McIntosh V. Irwin Union Bank and Trust, Co.*, 215 F.R.D. 26 (D. Mass. 2003). Filing a complaint against the Mortgagor serves as proper notice of rescission of a TILA/HOEPA mortgage, if timely filed, and if it specifically addresses recission. *Eveland v. Star Bank, NA*, 976 F. Supp. 721, 726 (S.D.Ohio 1997) (citing *Taylor v. Domestic Remodeling, Inc.*, 97 F.3d 96, 100 (5th Cir. 1996)). See also *Elliott v. ITT Corp* 764 F. Supp. 102, 105-6 (N.D.Ill. 1991). In *re Rodrigues*, 278 B.R. 683 (R.I. 2002), the Rodrigueses filed a complaint against U.S. Bank within three years from the date of the mortgage, and stated that they were "exercis[ing] their right of recission pursuant to *15 U.S.C. Sec. 1639* and *Regulation Z Sec. 226.23(a)(3)*. The filing of the complaint was timely, and effectively notified U.S. Bank that the Debtors were exercising their right of rescission. Pursuant to *Regulation Z*, "[t]o exercise the right to rescind, the consumer shall notify the creditor of the rescission by mail, telegram or **other means of written communication**." *12 C.F.R. Sec. 226.23(a)(2)* (emphasis added). In *re Rodrigues*, 278 B.R. 683 (R.I. 2002); *Pulphus v. Sullivan*, (N.D.Ill. 2003). [14] Chevy Chase knew the Class was seeking rescission from the initial complaint that was filed over one year ago. Chevy

Chase decided to roll the dice in this matter, probably hoping to overwhelm the Plaintiffs.

[14] *Two reported cases say that debtors must first request rescission of the TILA/HOEPA loan before there is standing to bring a complaint against the creditor. See* **Jefferson v. Security Pacific Fin. Servs.**, *162 F.R.D. 123, 126 (N.D.Ill. 1995);* **James v. Home Construction Co.**, *621 F.2d 727, 731 (5th Cir. 1980). These cases are the contrary to the rule under* **15 U.S.C. Sec.1635(b)**; *TILA merely requires written notice.*

iii. Rescission is Available Beyond the Three Day Period When Disclosure is Lacking

Defendant fails to acknowledge that its misleading and inadequate disclosures of the interest rate and the payment schedule extend the rescission period. When misleading or inadequate disclosures of the "annual percentage rate"[15] or the "payment schedule"[16] are given, as occurred in this case, the three day rescission period is tolled. When disclosures are inadequate, the recission period extends to three years from the date of the loan closing. *15 U.S.C. 1635(f), 12 C.F.R. Sec. 226.23(a)(3)*. See also: *Jones v. Ameriquest Mortgage Company*, Case No. 05-CV-0432 (N.D. IL 2006), 2006 U.S. Dist. LEXIS 3788. Plaintiffs should be permitted to rescind their loans on the basis of Chevy Chase's grossly inadequate TILA disclosures.

[15] *The APR disclosure is inadequate because the teaser r 15 ate disclosure is placed prominently above it on the TILDS and misleads the borrower as to the rate during the first 5 years.*
[16] *The payment schedule fails to state the interval of payments, fails to state the full principal and interest being charged each month, and does it make any reference to payment variations.*

CONCLUSION

For all of the foregoing reasons the Plaintiff Class is entitled to summary judgment of liability, for the following relief requested: (1) Declaration of a right of Rescission be provided for all class members; (2) Statutory Damages of $500,000, and (3) Attorneys fees and costs.

Respectfully Submitted,
Dated: May 15, 2006

DEMET & DEMET SC
Attorneys for the Plaintiffs
s/Kevin Demet
Kevin J. Demet

"Foreclosures will affect ten million homeowners over the next five years, estimates Moody's Economy.com."

The New York Times, December 2008

CHAPTER

Discover Fraud,
Forget Foreclosure

Fraud is defined as an intentional and deliberate conceal-
ment of facts in order to influence a material transaction.
The party conducting the fraud is attempting to be enriched
by the fraud. The defrauded party suffers real damages in the
inducement and enactment of the fraud. When false state-
ments are made in either the inducement or enactment, these
are considered fraudulent misrepresentations. These inten-
tional statements are made without any regard for the true
circumstances or facts. Fraud is a serious allegation and the
statute of limitation for alleging fraud is extended from the
date of discovery.

With regard to fraudulent lending, fraud can occur any
time in the solicitation, origination, processing, closing and
servicing of a mortgage. As discussed in Chapter Two, lenders
were encouraged by Wall Street to commit fraud in order to
sell toxic loans needed for securitization. Often the securiti-
zation process was fraudulent. Brokers were encouraged by
lenders to commit fraud by steering unknowing homeowners
into predatory loans because they paid higher interest and
fees. Appraisers were encouraged by lenders to fraudulently

inflate the value of homes to fraudulently increase loan amounts.

In addition to fraud in the inducement of toxic mortgages, there has been fraud in the execution or closing. Brokers have misrepresented themselves as "correspondent lenders" for mortgage giants. Major lenders have misrepresented themselves as cash lenders when in fact they were nominal lenders. Brokers, lenders and underwriters were encouraged to commit fraud during the application, qualification and approval process. Branch managers and executives were encouraged to commit fraud in order to meet loan production volumes.

Investment banks have concealed their true role as buyers and funders during the closing transaction. These fraudulent actions are serious enough to create fatal defects during the closing and render the mortgage and note null and void. Real property law demands complete transparency in financial transactions. Since the true parties involved in closings were intentionally not disclosed, those mortgages and notes failed to create a secured interest in the subject real estate linked to the loans.

There has also been fraud among the largest mortgage servicers. For example, if a loan was pre-sold prior to closing and funded by an undisclosed party (the investment bank) in order to securitize the loan, the mortgage and note were split, rendering them unenforceable. While the note was assigned to the investment bank, the mortgage servicing rights were sold or serviced by the nominal lender. The note was often improperly assigned and transferred. The servicer lost the right to modify the loan. Yet, unchallenged by homeowners, the servicers committed fraud in seeking and obtaining foreclosures.

Since many foreclosures were fraudulent, the evictions generated from these orders were fraudulent as well. In these cases, lenders' attorneys committed malpractice and fraud on the court by misrepresenting their client's legal standing to foreclose. The defrauded judges let the foreclosures proceed without an affirmative defense by homeowners' attorneys. The sheriffs then conducted illegal evictions based on lenders' frauds on the courts.

Investors were frauded as well. The accounting firms who helped prepare the SEC filings ignored the frauds perpetrated by the

lenders. The credit rating agencies frauded investors by inflating the value of mortgage backed securities.

As you can see, there is plenty of fraud to go around.

How can you, the homeowner, determine whether you have been a victim of mortgage fraud? As discussed in the last chapter, a mortgage audit is an essential tool in highlighting and identifying fraud. Fraud must be argued with specificity to the court. An audit can not only identify fraud, it can examine how it was planned and executed. Often, forensic auditors and attorneys can piece together the interconnected fraudulent actions of the parties in the conspiracy, including the broker, appraiser, lender, investment bank and the Trustee of the pool of mortgages, or Trustee assigned to foreclose. If you suspect that you have been defrauded, start by examining your loan documents.

Review your application and see if any information was falsified or if your signature was forged. Then look at your Good Faith Estimate. See if the estimated charges are the same as those on the Final Settlement HUD 1. If they aren't, examine why. If you were "baited and switched" at your closing, your lender conducted fraud.

Now read your mortgage and note. Pay particular attention to the language regarding interest rates and payment schedules. You may discover in the fine print that your payment schedule over the life of the loan was never disclosed to you. Or that your initial three years of payments were designed to skyrocket. Concealing these facts from you constitutes fraud.

Next, examine your title report and order a recent one. Identify all the parties listed on your title. Notice any assignments or transfers made on title. Many states require assignments and transfers be done on title as a matter of law. If you live in such a state, and your lender did not record assignments or transfers during its securitization process, it has broken the law.

The next chapter will detail all of the predatory practices that are routinely committed. But right now, review your documents in detail and get a feeling of whether or not you are a victim of fraud. If you believe that you are; write a letter to your prospective mortgage

auditor detailing what you have uncovered. Since good mortgage auditors are deluged by homeowners in various stages of distress, your letter will help your case get noticed.

To find a qualified mortgage auditor, start with your accountant. Do not fall prey to online auditing services. You need to meet your auditor and check references. And do not sign an agreement with an auditor who demands part of your recovery. You can also go to www.yourmortgagewar.com for a referral to a qualified auditor. More on mortgage auditing in Chapter Seven.

Many people wonder if they should confront their lender with examples of lender fraud. It is best to let a qualified auditor or attorney do this on your behalf. First, your lender will probably ignore your accusations or send you a threatening letter. Second, why tip your hand? It is best to let the professionals implement a strategic process.

If you have progressed from payment shock to delinquency or default, it is crucial that you retain a mortgage auditor immediately. This will delay any foreclosure action as your lender processes your auditor's "official written requests" as defined by the Real Estate Settlement Procedures Act. During this time, your lender is prohibited by law from reporting derogatory information about you to the three credit bureaus. And during this time, your auditor can build a case for your attorney against your fraudulent lender. If you do nothing, your lender will send you a foreclosure notice and sale date after ninety days of default.

If you are in foreclosure, you must get legal help immediately, even if it means borrowing the money from family and friends. If you are in a judicial state, your lender will serve you with a complaint and a lis pendens. The complaint will demand payment in full plus other charges, penalties and attorney's fees. The lis pendens prevents you from selling your home without the lender's permission. Your attorney will have a few weeks to respond with a counter claim, outlining your lenders predatory actions and violations of law.

If you live in a non-judicial state, your lender will appoint a Trustee to oversee the sale of your home and file a lis pendens on your title. Your attorney will have to confront your Trustee as to

whether it has any legal standing to bring about a foreclosure action, due to the securitization of your loan. This will often stop any foreclosure action temporarily. During that time, your attorney will ask the court for a Stay of Foreclosure until your complaint can be litigated and the outcome determined by a judge. This could take as long as two years.

If your foreclosure date is imminent, your attorney will file a Motion for An Emergency Hearing and raise "quiet title" as a crucial issue in determining if your Trustee or servicer has any legal right to foreclose. Quiet Title Action is discussed in detail in Chapter Twelve. Your attorney will also file a Motion to Stay Foreclosure pending the outcome of your litigation.

If you have been so immobilized by payment shock syndrome and have progressed to eviction, your attorney will file a Motion for an Emergency Hearing and a Stay of Eviction based upon a fraud committed on the court. If your lender had no legal right to foreclose, your foreclosure can be dismissed and your mortgage can be extinguished.

Why is it so hard to confront payment shock, delinquency, default and even foreclosure head on? The majority of people do not feel comfortable taking on authority figures, especially people who have had abusive parents. This trauma forces most people into a powerful "transference" with their lender, in which they attribute exaggerated power to the lender while minimizing their own power to act. These powerful and limiting "projections" inhibit many homeowners from fighting mortgage wars.

Don't become one of the casualties of foreclosure or eviction.

As dire as your circumstances seem, there are legal defenses, weapons and remedies at your disposal. Don't give up and don't move out.

Try to stay calm, take care of yourself, exercise and meditate. But force yourself to act. Without a signed order from a judge, your foreclosure and eviction can and will occur.

If you have medical conditions, you must seek a doctor who can help you deal with this monumental stress. If you don't have a family

physician, get a general physical and a stress test. Discuss your symptoms and seek temporary relief. Sometimes meditation and exercise aren't enough to drown out the panicked voices in your head.

Seeking either medical or psychological help is not a weakness. It is a strategy for self preservation. And if the stress is straining your family relationships, seek immediate help. Your family can weather this together with the right therapist leading the way. Do not give in to an impulse to divorce. While your situation may be agonizing, it is only temporary.

How do you find the right psychotherapist or psychiatrist? A great psychotherapist practices an integration of psychoanalysis and action-oriented therapy. Call your state's board of Psychology or Psychiatry, explain your dilemma and ask for references. Many family physicians can recommend good therapists to whom they refer patients.

If you believe you need medical help or pharmaceuticals, seek the services of a psychiatrist. A good psychiatrist can assess your symptoms and prescribe temporary medication to help with stress and sleeplessness.

Also, it is important to embrace whatever brand of spirituality that you believe. If you are Christian, you might reach out to Arch Angel Michael, the most powerful angel that sits at the side of God. If you are Jewish, you might seek out Moses. Whatever faith you are, you can go directly to God and ask for guidance and support. You will quickly notice that the parable "seek and you will receive" is true following everyday prayer.

Finally, you must speak affirmations. My favorite one, which is very powerful, is: "I desire health, peace and abundance. And I am open and willing to be shown the way." Another affirmation you can speak is "I desire to remain in my home. I am open and willing to be shown the way."

Speak your affirmations several times a day. Then thank the universe for listening and responding. The Law of Attraction is quite real and you will soon experience it. To set it in motion, take extra special care of your beloved home. Plant some flowers in your garden. Hang some of your favorite pictures on the walls. Buy small, inexpensive

items to nurture your home, like candles, incense and bath towels. Go the local swap meets where you can purchase home goods for a few dollars. These acts demonstrate your strong intention to stay in your home.

Remember you are not alone. You will survive this, grow from it and may prosper from it. Given your anxiety, I know you think that this seems impossible, so I have included the following opinion by Judge Boyko, who dismissed fourteen foreclosures due to lack of lender's standing. Another case study demonstrates a pleading to stop a foreclosure sale. The final case study is a judicial order which illustrates the power of challenging your lender on its standing to foreclose.

Other judges have followed suit. Bring these cases to your attorney's attention, or ask her to read this book. Quiet title is a crucial action to bring before the court in light of a foreclosure. Your attorney will have to get up to speed to file this action correctly.

"There is no doubt that every decision made by
a financial institution is driven by money. . . the institutions
worry less about jurisdictional requirements and more
about maximizing returns."

Judge Christopher A. Boyko

CASE STUDY 4

Order of Judge Boyko
United States District Judge

Case Study Four

UNITED STATES DISTRICT COURT
NORTHERN DISTRICT OF OHIO
EASTERN DIVISION

IN RE: FORECLOSURE CASES

CASE NO. NO.1:07CV2282
07CV2532
07CV2560
07CV2602
07CV2631
07CV2638
07CV2681
07CV2695
07CV2920
07CV2930
07CV2949
07CV2950
07CV3000
07CV3029

JUDGE CHRISTOPHER A. BOYKO
OPINION AND ORDER

CHRISTOPHER A. BOYKO, J.

On October 10, 2007, this Court issued an Order requiring Plaintiff-Lenders in a number of pending foreclosure cases to file a copy of the executed Assignment demonstrating Plaintiff was the holder and owner of the Note and Mortgage as of the date the Complaint was filed, or the Court would enter a dismissal. After considering the submissions, along with all the documents filed of record, the Court dismisses the captioned cases without prejudice. The Court has reached today's determination after a thorough review of all the relevant law and the briefs and arguments recently presented by the parties, including oral arguments heard on Plaintiff Deutsche Bank's Motion for Reconsideration. The decision, therefore, is applicable from this date forward, and shall not have retroactive effect.

LAW AND ANALYSIS

A party seeking to bring a case into federal court on grounds of diversity carries the burden of establishing diversity jurisdiction. *Coyne v. American Tobacco Company*, 183 F. 3d 488 (6th Cir. 1999). Further, the plaintiff "bears the burden of demonstrating standing and must plead its components with specificity." *Coyne*, 183 F. 3d at 494; *Valley Forge Christian College v. Americans United for Separation of Church & State, Inc.*, 454 U.S. 464 (1982). The minimum constitutional requirements for standing are: proof of injury in fact, causation, and redressability. *Valley Forge*, 454 U.S. at 472. In addition, "the plaintiff must be a proper proponent, and the action a proper vehicle, to vindicate the rights asserted." *Coyne*, 183 F. 3d at 494 (quoting *Pestrak v. Ohio Elections Comm'n*, 926 F. 2d 573, 576 (6th Cir. 1991)). To satisfy the requirements of Article III of the United States Constitution, the plaintiff must show he has personally suffered some actual injury as a result of the illegal conduct of the defendant. (Emphasis added). *Coyne*, 183 F. 3d at 494; *Valley Forge*, 454 U.S. at 472.

In each of the above-captioned Complaints, the named Plaintiff alleges it is the holder and owner of the Note and Mortgage. However, the attached Note and Mortgage identify the mortgagee and promisee as the original lending institution — one other than the named Plaintiff. Further, the Preliminary Judicial Report attached as an exhibit to the Complaint makes no reference to the named Plaintiff in the recorded chain of title/interest. The Court's Amended General Order No. 2006-16 requires Plaintiff to submit an affidavit along with the Complaint, which identifies Plaintiff either as the original mortgage holder, or as an assignee, trustee or successor-in-interest. Once again, the affidavits submitted in all these cases recite the averment that Plaintiff is the owner of the Note and Mortgage, without any mention of an assignment or trust or successor interest. Consequently, the very filings and submissions of the Plaintiff create a conflict. In every instance, then, Plaintiff has not satisfied its burden of demonstrating standing at the time of the filing of the Complaint.

Understandably, the Court requested clarification by requiring each Plaintiff to submit a copy of the Assignment of the Note and Mortgage, executed as of the date of the Foreclosure Complaint. In the above-captioned cases, none of the Assignments show the named Plaintiff to be the owner of the rights, title and interest under the Mortgage at issue as of the date of the Foreclosure Complaint. The Assignments, in every instance, express a present intent to convey all rights, title and interest in the Mortgage and the accompanying Note to the Plaintiff named in the caption of the Foreclosure Complaint upon receipt of sufficient consideration on the date the Assignment was signed and notarized. Further, the Assignment documents are all prepared by counsel for the named Plaintiffs. These proffered documents belie Plaintiffs' assertion they own the Note and Mortgage by means of a purchase which pre-dated the Complaint by days, months or years.

Plaintiff-Lenders shall take note, furthermore, that prior to the issuance of its October 10, 2007 Order, the Court considered the principles of "real party in interest," and examined Fed. R. Civ. P. 17 — "Parties Plaintiff and Defendant; Capacity" and its associated Commentary. The Rule is not *apropos* to the situation raised by these Foreclosure Complaints. The Rule's Commentary offers this explanation: "The provision should not be misunderstood or distorted. It is intended to prevent forfeiture when determination of the proper party to sue is difficult or when an understandable mistake has been made. ... It is, in cases of this sort, intended to insure against forfeiture and injustice ..." Plaintiff-Lenders do not allege mistake or that a party cannot be identified. Nor will Plaintiff-Lenders suffer forfeiture or injustice by the dismissal of these defective complaints otherwise than on the merits.

¹ Astoundingly, counsel at oral argument stated that his client, the purchaser from the original mortgagee, acquired complete legal and equitable interest in land when money changed hands, even before the purchase agreement, let alone a proper assignment, made its way into his client's possession.

Moreover, this Court is obligated to carefully scrutinize all filings and pleadings in foreclosure actions, since the unique nature of real property requires contracts and transactions concerning real property to be in writing. R.C. § 1335.04. Ohio law holds that when a mortgage is assigned, moreover, the assignment is subject to the recording requirements of R.C. § 5301.25. *Creager v. Anderson* (1934), 16 Ohio Law Abs. 400 (interpreting the former statute, G.C. § 8543). "Thus, with regards to real property, before an entity assigned an interest in that property would be entitled to receive a distribution from the sale of the property, their interest therein must have been recorded in accordance with Ohio law." *In re Ochmanek*, 266 B.R. 114, 120 (Bkrtcy.N.D. Ohio 2000) (citing *Pinney v. Merchants' National Bank of Defiance*, 71 Ohio St. 173, 177 (1904).1

This Court acknowledges the right of banks, holding valid mortgages, to receive timely payments. And, if they do not receive timely payments, banks have the right to properly file actions on the defaulted notes — seeking foreclosure on the property securing the notes. Yet, this Court possesses the independent obligations to preserve the judicial integrity of the federal court and to jealously guard federal jurisdiction.

Plaintiff's reliance on Ohio's "real party in interest rule" (ORCP 17) and on any Ohio case citations is misplaced. Although Ohio law guides federal courts on substantive issues, state procedural law cannot be used to explain, modify or contradict a federal rule of procedure, which purpose is clearly spelled out in the Commentary. "In federal diversity actions, state law governs substantive issues and federal law governs procedural issues." *Erie R.R. Co. v. Tompkins*, 304 U.S. 63 (1938); *Legg v. Chopra*, 286 F. 3d 286, 289 (6th Cir. 2002); Gafford v. General Electric Company, 997 F. 2d 150, 165-6 (6th Cir. 1993).

Plaintiff's, "Judge, you just don't understand how things work," argument reveals a condescending mindset and quasi-monopolistic system where financial institutions have traditionally controlled, and still control, the foreclosure process. Typically, the homeowner who finds himself/herself in financial straits, fails to make the required mortgage payments and faces a foreclosure suit, is not interested in testing state or federal jurisdictional requirements, either *pro se* or through counsel. Their focus is either, "how do I save my home," or "if I have to give it up, I'll simply leave and find somewhere else to live."

In the meantime, the financial institutions or successors/assignees rush to foreclose, obtain a default judgment and then sit on the deed, avoiding responsibility for maintaining the property while reaping the financial benefits of interest running on a judgment. The financial institutions know the law charges the one with title (still the homeowner) with maintaining the property. There is no doubt every decision made by a financial institution in the foreclosure process is driven by money. And the legal work which flows from winning the financial institution's favor is highly lucrative. There is nothing improper or wrong with financial institutions or law firms making a profit — to the contrary, they should be rewarded for sound business and legal practices. However, unchallenged by underfinanced opponents, the institutions worry less about jurisdictional requirements and more about maximizing returns. Unlike the focus of financial institutions, the federal courts must act as gatekeepers, assuring that only those who meet diversity and standing requirements are allowed to pass through. Counsel for the institutions are not without legal argument to support their position, but their arguments fall woefully short of justifying their premature filings, and utterly fail to satisfy their standing. And jurisdictional burdens. The institutions seem to adopt the attitude that since they have been doing this for so long, unchallenged, this practice equates with legal compliance. Finally put to the test, their weak legal arguments compel the Court to stop them at the gate the secondary mortgage market, nor monetary or economic considerations of the parties, nor the convenience of the litigants supersede those obligations. Despite Plaintiffs' counsel's belief that "there appears to be some level of disagreement and/or misunderstanding amongst professionals, borrowers, attorneys and members of the judiciary," the Court does not require instruction and is not operating under any misapprehension. The "real party in interest" rule, to which the Plaintiff-Lenders continually refer in their responses or motions, is clearly comprehended by the Court and is not intended to assist banks in avoiding traditional federal diversity requirements.2 Unlike Ohio State law and procedure, as Plaintiffs perceive it, the federal judicial system need not, and will not, be "forgiving in this regard."

CONCLUSION

For all the foregoing reasons, the above-captioned Foreclosure Complaints are dismissed without prejudice.

IT IS SO ORDERED.
DATE: October 31, 2007

CHRISTOPHER A. BOYKO
United States District Judge

CASE STUDY 5

La Salle Bank
v.
Marco Barraza and Maria Barraza

Case Study Five

IN THE CIRCUIT COURT OF THE 6TH JUDICIAL CIRCUIT
IN AND FORPINELLAS COUNTY, FLORIDA

LA SALLE BANK, N.A. AS TRUSTEE FOR
THE MLMI TRUST SERIES 2006-HE3
Plaintiff,　　　　　　　　　　　　　　CASE NO.: 08-003409-CI-13
vs.
MARCO BARRAZA and MARIA BARRAZA, et al,
Defendant(s).

**EMERGENCY PETITION TO STAY WRIT OF POSSESSION, MOTION
TO SET ASIDE FORECLOSURE SALE, TO SET ASIDE AND VACATE
DEFAULT AND FORECLOSURE FINAL JUDGMENT AND FOR LEAVE
TO CONDUCT STANDING DISCOVERY AND FILE A RESPONSE
UPON THE MERITS OF THE CASE**

Comes now, Defendants, MARCO BARRAZA and MARIA BARRAZA (hereinafter "THE BARRAZAS") by and through their undersigned counsel and pursuant to Rules 1.130, 1.140(h)(2), 1.190(a) and (e), 1.210(a) and 1.500(d), 1.540(b) of the Florida Rules of Civil Procedure moves this Court to stay the writ of possession, set aside and vacate the default, to set aside and vacate the foreclosure final judgment and to dismiss the case or in the alternative for leave to conduct standing discovery and file a proper response, with proper and meritorious affirmative defenses and counter-claims against LA SALLE BANK, N.A. AS TRUSTEE FOR THE MLMI TRUST SERIES 2006-HE3 (hereinafter referred to as "La Salle") and states:

1. As is more particularly set forth below there have been several instances of either fraud on the court, mistake, misrepresentation or other misconduct which occurred in this case leading up to the entry of the final judgment, including but not limited to:

a. Plaintiff's fraud on the court by misrepresenting in its Complaint that it had legal standing and thereby could file and maintain this action;

b. Plaintiff's failure to attach documents or instruments, contracts or other papers required;

c. The Barrazas' mistake as to Plaintiff's standing;

d. Plaintiff's failure to comply with federal laws on servicing, loss mitigation, or restructuring;

2. In today's landscape of asset-backed securities, the traditional lenders sold or assigned their rights, title and interests to the secondary finance market,

and other parties and entities now stand in the place of the traditional mort-gagee or lender. Nevertheless, those entities or parties claiming the right to foreclose must still satisfy the traditional requirements of standing for the Court to have subject matter jurisdiction and the power to proceed.

3. This Emergency Motion is filed pursuant to Fla. R. Civ. P. 1.540(b), which provides for relief from orders and judgments pursuant to mistake, in-advertence, surprise, excusable neglect, misrepresentation, fraud, misconduct of an opposing party, fraud on the court and newly discovered evidence if so challenged timely or under certain circumstances only within one year of the judgment.

4. In *Arrieta-Gimenez v. Arrieta-Negron*, 551 So. 2d 1184 (Fla. 1989), the Florida Supreme Court explained that fraud on the court exists when a judg-ment is void. *Id.* at 1186.

5. This Motion is timely filed as the summary judgment was only recently entered and it asserts that the judgment is void due to the plaintiff's lack of standing and subsequently this Court's lack of subject matter jurisdiction.

6. Fla. R. Civ. P. 1.120(a) provides that when a party desires to raise an issue as to the legal existence of any party, or the capacity of any party to sue or be sued, or the authority of a party to sue or be sued in a representative ca-pacity (which the Barrazas have raised), that party shall do so by specific aver-ment.

7. The instant Motion raises the threshold issues of legal standing by spe-cific averment.

8. Rule 1.140(h)(2) of the Florida Rules of Civil Procedure provides that the defense of lack of jurisdiction of the subject matter may be raised at any time. *Maynard v. The Florida Board of Education*, 2008 Fla. App. 2008 WL 1808523 (Fla. 2d DCA 2008) (subject matter jurisdiction is tantamount to standing and as long as the issue is raised in the trial court, standing may be raised even after a verdict or judgment is entered) (citing *Cate v. Oldham*, 450 So. 2d 224 (Fla. 1984)).

9. The Barrazas challenge La Salle's standing in this Motion, thereby ques-tioning this Court's subject matter jurisdiction. Thus, the Barrazas comply with Rule 1.140(h)(2) of the Florida Rules of Civil Procedure as well as the precedent set in *Maynard*, 2008 Fla. App. 2008 WL 1808523 (Fla. 2d DCA 2008).

10. Standing requires that the party prosecuting the action have a suffi-cient stake in the outcome and that the party bringing the claim be recognized in the law as being a real party in interest entitled to bring the claim. This en-titlement to prosecute a claim in Florida courts rests exclusively in those per-sons granted by substantive law, the power to enforce the claim. *Kumar Corp. v Nopal Lines, Ltd, et al*, 462 So. 2d 1178, (Fla. 3d DCA1985). A plaintiff's lack of standing at the commencement of a case is a fault that cannot be cured by gain-ing standing after the case has been filed. *Progressive Express Ins. Co. v. McGrath Community Chiropractic*, 913 So. 2d 1281, 1285 (Fla. 2d DCA 2005). *See also, Maynard, supra.*

11. Regarding standing, Rule 1.210(a) of the Florida Rules of Civil Procedure

provides that an action may be prosecuted in the name of the real party in interest.

12. Regarding documents that support the allegations in the Complaint, Rule 1.130 of the Florida Rules of Civil Procedure provides in relevant part that:

(a) Instruments Attached. All bonds, notes, bills of exchange, contracts accounts, or documents which action may be brought or defense made, or a copy thereof or a copy of the portions material thereof material to the pleadings, shall be incorporated in or attached to the pleading. [emphasis added].

13. The Florida Rules of Civil Procedure uses the broad designation of *"all...documents"* which are material to the case at issue as to what must be attached to a complaint. The attachment requirement is mandatory, not discretionary, as illustrated by the application of conventional maxims of statutory interpretation. Florida uses the commanding language of *"shall"* rather than the hortatory, or general, "will" or "may," in directing that the document or documents forming the basis of the cause of action be attached and made part of the Complaint.

14. The object of Rule 1.130 is to apprize the defendant(s) of the nature and extent of the cause of action alleged in the Complaint, in order that they may plead with the greater certainty.

15. Because a document or instrument is required to establish standing, parties may rely on the "relation back" rule when asserting standing. *Progressive, supra*. When applying the "relation back" rule, the party who did not have standing at the time the action was filed may amend their statement of claim to show that they acquired standing that "related back to the original statement of claim." *Id.* at 1285-1286; Fla. R. Civ. P. 1.190(c). However, this rule does not allow a party to establish the right to maintain an action retroactively by acquiring standing after the fact. *Progressive*, 913 So. 2d at 1285. If the party was without standing when the suit was filed then a new lawsuit must be filed. *Progressive*, 913 So. 2d at 1285 (citing *Jeff-Ray Corp. v. Jacobson*, 566 So. 2d 885, 886 (Fla. 4th DCA 1990) (finding that "the assignee of a mortgage could not maintain the mortgage foreclosure action because the assignment was dated four months after the action was filed, if the plaintiff wished to proceed on the assignment, it must file a new complaint.")).

16. Further, under *Meadows v. Edwards*, 82 So. 2d 733 (Fla. 1955), as cited in *Safeco*, supra, if the pleader does not have a copy of the writing involved, it should obtain the document through discovery and attach it to the appropriate pleading by amendment. As the 4th DCA explained in *Safeco*, supra, "in the case of a complaint based on a written instrument it does not state a cause of action until the instrument ... is attached to and incorporated in the pleading in question. *Id.* at 1130.

17. Additionally, when exhibits are inconsistent with the plaintiff's allegations of material fact as to whom the real party in interest is, such allegations cancel each other out. *Fladell v. Palm Beach County Canvassing Board*, 772 So.2d 1240 (Fla. 2000); *Greenwald v. Triple D Properties, Inc.*, 424 So. 2d 185, 187 (Fla.

4th DCA 1983); *Costa Bella Development Corp. v. Costa Development Corp.*, 441 So. 2d 1114 (Fla. 3rd DCA 1983). Because the facts revealed by La Salle's exhibits are inconsistent with its allegations as to its ownership of the subject note and mortgage, those allegations are neutralized and La Salle's complaint is rendered objectionable. *Greenwald v. Triple D Properties, Inc.*, 424 So. 2d 185, 187 (Fla. 4th DCA 1983).

18. La Salle's Complaint alleges in ¶ 7 that it is the owner and holder of the Mortgage Note and Mortgage. However, it does not support such allegation with any document or instrument. Indeed, the instruments attached to the Complaint are identified as a copy of the subject Mortgage Note which was executed by the Barrazas and made payable to Lenders Direct Capital Corporation (hereinafter referred to as "Lenders Direct"), dated February 14, 2006. Further, the Mortgage is actually between the Barrazas and Mortgage Electronic Registration Systems, Inc. (hereinafter referred to as "MERS") as nominee for Lenders Direct. There is no possible way that the Trust or La Salle could take an assignment or transfer of the mortgage note and mortgage from MERS or Lenders Direct. Moreover, the Complaint and documents attached thereto do not indicate La Salle or the MLMI Trust Series 2006-HE3 as the mortgagee or a party entitled to prosecute in the name of the real party in interest.

19. Additionally, there was no subsequent filing of the purported original Mortgage Note and Mortgage, nor production of an effective assignment, properly indorsed Note or allonge clearly identifying the chain of title transfer. Additionally, the Affidavit of Amounts Due and Owing filed in support of the Plaintiff's Motion for Summary Judgment states that Fidelity National Foreclosure Solutions, Inc. is an authorized agent for Wilshire Credit Corporation, the servicing agent for the Plaintiff. However, there is no allegation, pleading or document which indicates any tie between the Barrazas and these entities. Thus, the pleadings, documents, instruments and affidavits not only create issues of fact but also negate the plaintiff's standing *ab initio*, thereby indicating this Court does not have subject matter jurisdiction. The Barrazas should be entitled at the very least to conduct discovery to determine the veracity of this Affidavit.

20. In the mortgage foreclosure case of *WM Specialty Mortgage, LLC v. Salomon*, 874 So. 2d 680 (Fla. 4th DCA 2004), (citing *Jeff-Ray*), the trial court vacated default entered against the mortgagor and reversed and remanded the dismissal of the complaint in order for the trial court to consider whether the assignee's equitable interest in the mortgage transferred prior to filing. In *WM Specialty*, the assignment was executed after the date of filing but it indicated that it was transferred prior to date of filing. *WM Specialty*, 874 So. 2d 680. In *WM Specialty*, the homeowner failed to respond to the Complaint, thinking he had no recourse, and a default judgment was entered against him. Subsequently, the homeowner hired an attorney who moved to vacate the default and dismiss the action challenging the bank's interest based upon an invalid assignment. The assignment had been executed and delivered after the filing of the foreclosure action. The trial court in that case found that the default could

be vacated and also found that the complaint was *"void ab initio"*. *Id.* at 682. The District Court affirmed the default vacation, yet explained that an evidentiary hearing was the appropriate forum to address the conflict of standing to determine if the assignment showed a transfer of the mortgage and note with proper consideration and proof of purchase of the debt to vest equitable title and therefore authority to foreclose. *Id.*

21. In this case, there is simply no document or instrument showing La Salle's ownership or standing to sue on behalf of the unknown owner such as a pooling and servicing agreement, trust document or any document whatsoever between the Trust and La Salle, nor is there an Assignment of the Mortgage Note and Mortgage and properly indorsed Mortgage Note or allonge from MERS or Lenders Direct to any entity let alone the La Salle. Therefore, this Court should set aside and vacate the default, set aside and vacate summary judgment and dismiss this Complaint for lack of standing.

22. Additionally, in *Jeff-Ray*, supra, the 4th DCA, reversed final summary judgment and reversed and remanded for further proceedings. *Id.* In that case, the 4th DCA recognized that an apparent lack of due diligence in the defense may have influenced the trial court in its decision to deny the defendant a rehearing but explained that because of the likelihood that substantial prejudice would occur against the defendant if he was not permitted to show misrepresentation or mistake, said denial of the motion for rehearing was an abuse of discretion. *Id.* Further, in *Jeff-Ray*, the 4th DCA ruled that the trial court erred in denying defendant's motion to dismiss because the complaint was filed prior to an alleged assignment being produced some four months later. The District Court stated that pursuant to Rule 1.130 of the Florida Rules of Civil Procedure and *Safeco*, supra, the "complaint could not have stated a cause of action at the time it was filed, based on a document that did not exist until some four months later..." and that if the plaintiff intended to proceed on the assignment, they needed to file a new complaint. *Id.*

23. There is no indication that there was a transfer of ownership or right to sue on behalf of another. Thus, this Court should set aside and vacate the summary judgment and dismiss this case.

24. Until La Salle legally satisfies its threshold standing obligations to have initiated this action and maintain it, the foreclosure sale should be cancelled or stayed, the default vacated and the final summary judgment set aside and vacated, and the Complaint dismissed; or in the alternative the sale stayed and discovery conducted so that this Court may make a determination on the merits of the case.

25. Moreover, La Salle cannot meet the threshold requirements to re-establish a lost, stolen or destroyed note under Fla. Stat. § 673.3091. There is no document or instrument attached to the Complaint memorializing a transfer or assignment of the Mortgage Note or indicating actual or constructive delivery of the Mortgage Note to La Salle or the Trust in order for the Court to re-establish it.

26. Regarding Count I to Re-establish the lost Note, The Florida Fourth

District Court of Appeals decided an issue quite pertinent to today's foreclosure environment in the case of *StateStreet Bank and Trust Co., Trustee for Holders of Bear Stearns Mortgage Securities, Inc. Mortgage Pass-Through Certificates, Series 1993-12 v. Harley Lord, et al.*, 851 So.2d 790 (Fla. 4th DCA 2003). The Court held that *StateStreet* could not maintain a cause of action to enforce a missing promissory note or to foreclose on the related mortgage in the absence of proof that it or its assignor ever held possession of the promissory note. § 673.3091, Florida Statutes (2002).

27. *StateStreet* filed an action in the Circuit Court under § 71.011, Florida Statutes to reestablish the lost promissory note. The Court of Appeals upheld the lower court's decision and held that the right to enforce the lost instrument was not properly assigned to *StateStreet* where it was found that neither *StateStreet* nor its predecessor in interest possessed the note and *StateStreet* did not otherwise satisfy the requirements of § 673.3091, Florida Statutes (2002) which is Florida's version of the UCC's article on negotiable instruments. The court noted that it was undisputed that the note was lost before the assignment to *StateStreet* was made. (Although this case was pursued under § 71.011 of the Florida Statutes, Florida courts have determined that an action to re-establish a lost or destroyed note must be pursued under § 673.3091 of the Florida Statutes).

28. The Court also explained that pursuant to § 90.953, Florida Statutes, (2002), Florida's code of evidence, the plaintiff in a mortgage foreclosure must present the original promissory note as a duplicate of a note is not admissible. Otherwise, the plaintiff must meet the requirements of § 673.3091, Florida Statutes to pursue enforcement. *W.H. Downing v. First Na'tl Bank of Lake City*, 81 So.2d 486 (Fla.1955), *Nat'l Loan Investors, L.P. v. Joymar Assocs.*, 767 So.2d 549, 551 (Fla. 3d DCA 2000).

29. The 4th DCA further explained that although it and the Third District Court of Appeals have held that the right of enforcement of a lost note can be assigned, in *StateStreet*, there was no evidence as to who possessed the note when it was lost. See *Slizyk v. Smilack*, 825 So.2d 428, 430 (Fla. 4th DCA 2002), *Deakter*, 830 So.2d 124 (Fla. 3d DCA 2002). In *Slizyk*, the Court allowed the assignee of the note and mortgage to foreclose as the assignor of the note was in possession of the note at the time of the assignment and therefore the right to enforce the instruments was assigned to the assignee as well. In contrast, the 4th DCA explained, that the undisputed evidence in *StateStreet* was that the assignor never held possession of the note and therefore could not enforce the note under § 673.3091, Florida Statutes (2002). As the assignor could not enforce the lost note under § 673.3091, it had no power of enforcement which it could assign to *StateStreet*. The Court noted that it did not reach the question of whether *Slizyk* and *National Loan* could be applied to allow enforcement of a note if there was proof of possession by an assignor earlier than the most immediate assignor.

30. *StateStreet* was later cited with approval by *Dasma Investments, LLC v. Realty Associates Fund III, L.P.*, 459 F. Supp. 2d 1294 (S.D. Fla. 2006) (stating

that in Florida a promissory note is a negotiable instrument and that a party suing on a promissory note, whether just on the note itself or together with a foreclosure on a mortgage securing the note, must be in possession of the original of the note or reestablish the note pursuant to Fla. Stat. § 673.3091); *see also, Shelter Dev. Group, Inc. v. Mma of Georgia, Inc.*, 50 B.R. 588, 590 (S.D. Fla. 1985), *In re American Equity Corporation of Pinellas*, 332 B.R. 645 (M.D. Fla. 2005) (Court held that a party must comply with § 673.3091, Florida Statues in order to enforce a lost, destroyed or stolen negotiable instrument.). It is noteworthy that in *In re American Equity Corporation of Pinellas*, the Middle District of Florida found that the creditors' affidavits merely stated that the creditors had searched for the original promissory notes but were unable to find them and failed to state that the creditors ever received possession of the original promissory note.

Id.

31. In the case at bar, Count I to Re-establish the Note is proper under § 673.3091. However, Count I of the Complaint merely recites the language of the statute in positive form, as if the bald allegations are proof enough to meet the threshold requirements of the statute. La Salle actually contradicts it's own allegations, and misrepresents to this Court that it has the right to re-establish the Note as alleged in Paragraph 8 of the Complaint because it has not produced or provided any document whatsoever indicating any assignment or possessory rights of any kind with la Salle, the Trust or any purported assignee or predecessor.

32. As discussed several times throughout this Memorandum, the Complaint alleges that the Mortgage Note was assigned to La Salle or the Trust. However, La Salle fails to attach a copy of any document which purports to be an assignment of the Mortgage Note to the Trust or La Salle or to any person or entity. La Salle also fails to properly attach documents that prove that it received constructive delivery of the note as a proper assignee of the Mortgage Note. Although La Salle tries to withstand the issue in *In re American Equity*, by stating that it was in its predecessors or assignors were in possession of the Note in Paragraph 8 of the Complaint, such allegation is a clear misrepresentation and documents attached to the Complaint clearly indicate that the Plaintiff never had actual or constructive delivery of the Mortgage Note.

33. Therefore the Mortgage Note in this case should never have been re-established and the case should be dismissed.

34. Also, La Salle clearly is engaged in more than the enforcement of a security interest through a foreclosure in this foreclosure action. Specifically, La Salle is engaged in a broader scope of activity seeking judicial foreclosure as well as a personal judgment against the Barrazas, which additional activity qualifies its activity in this litigation as general consumer debt collection under federal and state law, rather than focused action against the security. *See* Compl., *see also McDaniel v. South & Associates, P.C.*, 325 F. Supp. 2d 1210 (D. Kan. 2004), cited in *Beadle v. Haughey*, 2005 WL 300060 (D. N. H. 2005). *See also* the ruling of the United States 11th Circuit Court of Appeals that found that the Federal Fair Debt Collection Practices Act applies to the service of a mortgage foreclosure

package including a summons, complaint and related items called for by Florida mortgage foreclosure law." 311 F.3d 1272 (11th Cir 2002) cited in *Heller v. Graf*, 488 F.Supp.2d 686 (N.D. Ill. 2007).

35. And, La Salle whether in its capacity as servicer or purported mortgagee, failed to comply with the forbearance, mortgage modification, and other foreclosure prevention loan servicing requirements imposed on Plaintiff and the subject mortgage by federal regulations promulgated by HUD, pursuant to the National Housing Act, 12 U.S.C. § 1709 and intended by HUD to require the plaintiff to provide special Foreclosure Prevention Loan Services to homeowners, including the Barrazas', whose federally insured loan is potentially in default due to circumstances beyond their control. *See* 12 U.S.C. § 1709.

36. As an additional alternative, recently, the Federal Government, enacted an emergency relief package bill of $700 billion, stated that a Federal Administrative Agency would be organized 60 days from the passing of the bill and that the purpose would be to provide help to individuals in foreclosure through government programs.

37. Because the Barrazas' loan is an FHA-insured loan, Plaintiff, La Salle, was required to comply with the payment forbearance, mortgage modification, and other foreclosure prevention loan servicing or collection requirements imposed on Plaintiff and the subject FHA mortgage by federal regulations promulgated by HUD, pursuant to the National Housing Act, 12 U.S.C. §1710(a). These requirements must be followed before a mortgagee may commence foreclosure. 24 C.F.R. Part 203(C), Servicing Responsibilities Mortgagee Action and Forbearance and Paragraph 9(a) of the subject mortgage. (Lender may, except as limited by regulations issued by the Secretary in the case of payment default....").

38. Plaintiff is required by HUD regulation to ensure that all of the servicing requirements of 24 C.F.R. Part 203(C) have been met before initiating foreclosure. 24 C.F.R.§203.606, published August 2, 1982, 47 FR 33252.

39. Plaintiff failed to carry out its federally-imposed duties which are owed to the Barrazas prior to filing this instant foreclosure lawsuit. According to the regulations and mortgage Plaintiff is required to adapt effective collection techniques designed to meet the Barrazas' individual differences and take account of their peculiar circumstances to minimize the default in their mortgage payments as required by 24 C.F.R. §203.600.

40. Plaintiff failed to make any reasonable efforts as required by federal regulation to arrange a face to face meeting with the Barrazas before three full monthly installments were unpaid to discuss their circumstances and possible foreclosure avoidance. 24 C.F.R. § 203.604, published June 16, 1986, 51 FR 21866.

41. Plaintiff failed to inform the Barrazas that it would make loan status and payment information available to local credit bureaus and prospective creditors, failed to inform the Barrazas of other assistance, and failed to inform them of the names and addresses of HUD officials to whom further communication could be addressed as required by federal law. 24 C.F.R. § 203.604.

42. Plaintiff is required under federal law to adapt its collection and loan servicing practices to the Barrazas' individual circumstances and to re-evaluate these techniques each month after default and Plaintiff failed to do this also. 24 C.F.R. § 203.605, effective August 2, 1996.

43. Plaintiff failed to perform its servicing duty to the Barrazas to manage the subject mortgage as required by FHA's special foreclosure prevention workout programs which must include and allow for the restructuring of the loan whereby the borrower pays out the delinquency in installments or advances to bring the mortgage current.

44. Plaintiff further denied the Barrazas access to repayment plan or special forbearance in the form of a written agreement that would reduce or suspend their monthly mortgage payments for a specific period to allow her time to recover from the financial hardship they were suffering through no fault of their own. Such a plan can involve changing one or more terms of the subject mortgage in order to help the Barrazas bring the claimed default current thereby preventing foreclosure.

45. Plaintiff's failure to comply with the FHA repayment plan or special forbearance workout programs denied the Barrazas the required access to explore alternatives to avoid foreclosure prior to the addition of additional foreclosure fees and costs.

46. Barrazas requested that Plaintiff provide them with options to help them save their home. Plaintiff was non-responsive and only answered with threats to foreclose if reinstatement in full with all claimed fees and costs was not paid right away.

47. Plaintiff failed to comply with its mortgage servicing responsibilities and the terms of the subject mortgage and as a proximate result, the Barrazas' delinquency has been improperly inflated by mortgage foreclosure filing, service and other fees and inspections and by foreclosure attorneys, amounts the Barrazas cannot afford to pay. Therefore, the Barrazas lost their home.

48. The Barrazas did not know they had the option of contacting an attorney or that the case had meritorious defenses. They only learned of this in the last few weeks and then needed time to save a little money to retain counsel. They have acted as quickly as possible.

49. As another note, the Plaintiff failed to join indispensable parties which also is fatal to its Complaint pursuant to Rule 1.140(b)(7).

50. The Barrazas' have demonstrated excusable neglect, mistake, fraud and fraud on the court in particular, and that they have meritorious and equitable defenses to this foreclosure action, and that they are entitled to receive a reasonable opportunity to appear and defend this action. *North Shore Hospital, Inc. v. Barber*, 143 So. 2d 849 (Fla. 1962) ("It is the rule that the opening of judgments is a matter of judicial discretion and in a case of reasonable doubt, where there has been no trial upon the merits, this discretion is usually exercised in favor of granting the application so as to permit a determination of the controversy upon the merits...(t)he courts are reasonably liberal in granting motions to set aside defaults..."); *All Mobile Video, Inc. v. Whitener*, 773 So. 2d 587

(Fla. 1st DCA 2000) ("The longstanding policy in Florida is one of liberality toward vacating defaults, and any reasonable doubt with regard to setting aside a default should be resolved in favor of vacating the default and allowing trial on the merits." citing *Allstate Insurance Co. v. Ladner*, 740 So.2d 42 (Fla. 1st DCA 1999).

51. The Barrazas' have established their qualification for relief requested herein. *Coastal State Mortgage Corp. v. Commonwealth S & L Ass'n of Florida*, 497 So. 2d 917 (Fla. 3rd DCA 1986);

52. Also, based on the actions of the La Salle prior to commencing this foreclosure action and after described herein, the Barrazas' have compulsory counterclaims to pursue against La Salle.

53. This motion is made in good faith and not for any purpose to delay and no prejudice has or will result to the Plaintiff by the granting of these motions. The Barrazas' have been prompt and diligent in pursuing this relief from the court.

54. This Motion is filed on an emergency basis due to the imminent and irreparable harm of being removed from their home based upon the writ of possession and is being filed as expeditiously as possible given the fact that undersigned counsel was just recently retained to represent the Barrazas in this matter.

WHEREFORE, the Defendants, MARCO BARRAZA AND MARIA BARRAZA respectfully requests that this Court enter an Order, on an emergency basis, cancelling or staying the writ of possession, setting aside and vacating the default, setting aside and vacating the Summary Judgment, dismissing the action or in the alternative allowing them to conduct discovery and pursue the merits of this case and for any other and further relief which is just and proper.

RAPOPORT LAW GROUP
1314 East Las Olas Blvd., Suite 121
Fort Lauderdale, Florida 33301
Phone: 754-235-7635
Facsimile: 954-337-3759
By:_____
Dawn M. Rapoport, Esq.
Florida Bar No. 13176

The Orsini & Rose Law Firm
By:
Scott T. Orsini, Esquire
Florida Bar No. 0855855
P.O. Box 118
St. Petersburg, Florida 33731
Tel. (727) 323 9633

FLORIDA FORECLOSURE OFFENSE AND DEFENSE
ATTORNEY, DAWN RAPAPORT, GIVES US THIS UPDATE:

"This case is currently on appeal and the homeowners and their
three children are still in their home. While the judge ruled that
standing could not be challenged post judgment, the Trust Agree-
ment was violated in that the note was never endorsed by any party
but the homeowners, as well as other issues. This case illustrates
the immediate need for judges to pay close attention to the mort-
gage securitization process."

CASE STUDY

United States Bankrupcy Court
Re: Kang Jin Hwang

Case Study Six

UNITED STATES BANKRUPTCY COURT
CENTRAL DISTRICT OF CALIFORNIA

In re:
KANG JIN HWANG,
Debtor.
Case No.: LA08-15337SB
Chapter 7

OPINION DENYING LIFT STAY FOR FAILURE TO JOIN REAL PARTY IN
INTEREST

Date: August 26, 2008
Time: 9:30 a.m.
Ctrm: 1575

I. INTRODUCTION

IndyMac Federal Bank ("IndyMac Federal") brings this motion for relief
from the automatic stay as the loan servicer for creditor Freddie Mac, and with
respect to real property belonging to debtor Kang Jin Hwang. IndyMac Fed-
eral, is the successor to IndyMac Bank F.S.E. ("IndyMac") formerly the holder
of the note, has sold the note to Freddie Mac, but continues to service the loan
for Freddie Mac — or whomever else invests in the note. Freddie Mac has not
joined and is not a party to this motion.

IndyMac now argues that as servicer on the loan, it is a party in interest
with standing to seek relief under § 362(d) of the Bankruptcy Code.

Although IndyMac may be a "party in interest" as contemplated by §
362(d) of the Bankruptcy Code, the court holds that IndyMac is not the real
party in interest pursuant to Rule 17 of the Federal Rules of Civil Procedure,
in that it lacks the legal right to enforce the obligation secured by this mortgage.
The motion cannot be granted, therefore, on procedural grounds. Pursuant to
Fed. R. Civ. P. 17(a)(3), the hearing on this motion is continued until August 26,
2008, to allow the real party in interest either to join in, ratify, or substitute
into the motion. This opinion explains the reasons for not granting relief at this
time, as well as the procedure required for loan servicers such as IndyMac to
successfully move for relief from the automatic stay.

II. RELEVANT FACTS

Kang Jin Hwang filed this chapter 7 case on April 22, 2008. Hwang's residence in Las Vegas, Nevada is encumbered by a first deed of trust, recorded on February 1, 2007, supporting a promissory note in the amount of $376,000. The lender on the deed of trust is identical to the payee on the promissory note, identified on both instruments as "Mortgageit, Inc." This note has since been endorsed over to IndyMac Bank, F.S.E., which has now been taken over by the Federal Insurance Depository Corporation and operates under the name IndyMac Federal. The deed of trust names MERS as "the beneficiary under this Security Instrument" and "a separate corporation that is acting solely as a nominee for Lender and Lender's successors and assigns.[1]" An Assignment of Deed of Trust dated January 29, 2008 is included with the motion, which indicates that MERS assigned and transferred to IndyMac all beneficial interest under the Deed of Trust.

III. DISCUSSION

Pursuant to Local Rule 9013-1(a)(13)(A), the court issued an order requiring that IndyMac bring to court each declarant for whom a declaration had been submitted in support of its motion, for the purpose of presenting testimony to support the declaration. A similar order has been issued by this court in other motions for relief from the automatic stay since the beginning of this year because this court has taken notice of recent cases and academic studies that reveal the inaccuracy of payment records in the mortgage industry.[2]

In addition, since January of this year — and for reasons entirely distinct from this court's concern over the accuracy of payment records — this court has required moving parties on relief from stay motions based on a promissory note to bring to court for inspection the original promissory note.[3] This requirement applies because developments in the secondary market for mortgages (and other security interests) have caused the court to lack confidence that presenting a copy of a promissory note is sufficient to show that a movant has the right to enforce the note, or that it otherwise qualifies as a real party in interest (as required by Rules 7017 and 9014).

The court held a hearing on this motion on July 15, 2008, in order for IndyMac to present the original note and present the testimony of Erica A. Johnson-Sect, a Vice President of IndyMac. While the court was satisfied with the declarant's testimony on the accuracy of the payment records, her passing mention of the note's "investors" led the court to inquire as to whether IndyMac had ever sold the note to a third party. It was in response to the court's question that Ms. Johnson-Sect admitted IndyMac no longer owned the note, but had sold it to Freddie Mac. Ms Johnson-Sect, evidently unaware that "owner" and "holder" are effectively synonymous, maintained that IndyMac is still the holder of the note, although Freddie Mac now owns it. Freddie Mac has not joined and is not a party to this motion.

A. The Real Party in Interest Requirement

A motion for relief from the automatic stay, must satisfy both substantive and procedural requirements. The substantive requirements are provided by § 362(d). The procedural requirements, on the other hand, are imposed by the United States Constitution and the Federal Rules of Bankruptcy Procedure (which mostly incorporate the Federal Rules of Civil Procedure).

In the context of relief from the automatic stay, these two sets of requirements are often confused because of the similarity in language between § 362(d) and Rule 17 of the Federal Rules of Civil Procedure. Section 362(d) provides that relief from stay shall be granted "[O]n request of a party in interest." § 362(d). This is a substantive requirement, and it is relatively broad: many parties are parties in interest for the purposes of § 362(d).

But a party that seeks relief from stay must also be "the real party in interest." The real party in interest requirement is imposed by Fed. R. Civ. P. 17(a)(1).[4]

The route to the real party in interest rule for relief from stay motions is complex. Rule 4001 provides: "A motion for relief from an automatic stay . . . shall be made in accordance with Rule 9014," which provides procedural rules for contested matters.

Rule 9014 provides, in turn that many of the rules for adversary proceedings apply (with exceptions not relevant here) to contested matters. Among the adversary proceedings rules incorporated by reference in Rule 9014 is Rule 7017, which provides: "Rule 17 F.R.Civ.P. applies in adversary proceedings" We thereby arrive at Rule 17, the first sentence of which states: "Every action shall be prosecuted in the name of the real party in interest."

Under Ninth Circuit law, the real party in interest is the party with the right to sue or enforce a claim under the applicable substantive law. *See, e.g., U-Haul Int'l, Inc. v. Jartran, Inc.*, 793 F.2d 1034, 1038 (9th Cir. 1986); *Allstate Ins. Co. v. Hughes*, 358 F.3d 1089, 1094 (9th Cir. 2004); *American Triticale, Inc. v. Nytco Services, Inc.*, 664 F.2d 1136, 1141 (9th Cir. 1981).

The term "real party in interest" is easy to confuse with the term "party in interest." "Party in interest" is a very broad concept in bankruptcy. It includes the debtor, creditors, employees, officers of a corporation, professionals active in the case, and many others. In general, a party in interest, in the bankruptcy context, is anyone who is entitled to express a view with respect to a matter before the court.

In contrast, a "real party in interest" is a far narrower group, and is usually limited to a single party. The real party in interest is "the person who, according to the governing substantive law, is entitled to enforce the right."

It is also important to distinguish the "real party in interest" requirement from standing. Standing is constitutional requirement, grounded in Article III.[5] The "real party in interest" requirement, on the other hand, is generally regarded as one of many "prudential" considerations that have been "judicially engrafted onto the Article III requirements for standing." *See, e.g., In re Village Rathskeller*, 147 B.R. 665, at 668 (Bankr. S.D.N.Y. 1992).[6] To seek relief in federal court, a

party "must meet both constitutional and prudential . . . requirements." *Morrow v. Microsoft Corp.* 499 F.3d 1332, 1339 (9th Cir. 2007); see also *In re Village Rathskeller, Inc.*, 147 B.R. at 668 (citing *Warth v. Seldin*, 422 U.S. 490, 498 (1975) for the proposition that "[t]he concept of standing subsumes a blend of constitutional requirements and prudential considerations"). To satisfy one does not necessarily mean that the other is satisfied: a party may have standing — having suffered an "injury in fact" — but this may not make it the real party in interest. *See, e.g., Whelan v. Abell*, 953 F.2d 663, 672 (D.C. Dir. 1992). Conversely, a party may be the real party in interest, but lack standing. *See, e.g., Davis v. Yageo Corp.*, 481 F.3d 661 (9th Cir. 2007).

B. The Right to Enforce a Note and Mortgage

Since the "real party in interest" is that party with the right to enforce a claim under the applicable substantive law, it is to that law that we must now turn. In particular, since a party that seeks relief under § 362(d) does so in order to enforce rights that have been stayed by § 362(a), it is also necessary to consider the substantive law that underlies those rights. This means that for relief from stay motions based on a promissory note, the court must look to the substantive law that governs promissory notes.

1. Who May Enforce the Note

The court assumes without deciding that the note here at issue is a negotiable instrument, as defined in California Commercial Code ("CCC") § 3104(a), (b) and (e). It is on a standard printed form that is used in the finance industry for notes that are freely bought and sold in a manner inconsistent with treating it is a non-negotiable note. In California, the substantive law that governs negotiable instruments, such as promissory notes, is CCC Article 3. *See id.* § 3-102(a).

It is important to distinguish between the "holder" of a note and the possessor of a note. A note may be in the possession of an agent, who has possession on behalf of a principal. For example, where an officer of a bank is in possession of a note on behalf of the bank, the bank is the holder of the note notwithstanding the possession by the officer.

In this case, IndyMac Federal is in possession of the note, and produced the original of the note at trial. Nonetheless, according to the testimony at trial, IndyMac Federal is the loan servicing agent for Freddie Mac, the owner, and thus the holder, of the note. IndyMac's possession of the note is the same as a bank officer's possession — it is on behalf of Freddie Mac, the owner of the note and its real holder.

The only person entitled to enforce a note (with minor exceptions not relevant to this case) is the "holder" of the note. See CCC § 3-301(a). Thus, the real party in interest rule requires the holder of the note to bring the motion for relief from stay.

Transfer of the note bears with it the right to enforce the note. Indeed, unlike the ownership of contractual obligations — which can generally be transferred by an assignment — the right of enforcement for a negotiable instrument is only transferable by delivery of the instrument itself. § 3-203. This follows from the principle that only the holder of a note is entitled to enforce the note.

2. The Mortgage Follows the Note

In the real estate context, it is typical for a promissory note to be secured by a mortgage on real property. The security is carried by a separate instrument — either a mortgage or, in California and some other states, a deed of trust — which must be recorded in the county records. The note represents the borrower's obligation on the debt, while the mortgage or deed of trust represents the security. The latter offers its bearer legal remedies in the event of default, while the former offers equitable remedies against the property. The two together may be referred to as a "mortgage loan."

In the primary mortgage market, a lender originates a loan to a borrower, who in turn issues the lender a note and deed of trust. This is the scenario in which the governing law developed, but is has become increasingly rare. More often now, the primary mortgage market gives way almost immediately to what is commonly termed the secondary mortgage market, in which the lender — having completed the primary transaction — immediately sells the loan to an investor. (Even more complex and sophisticated arrangements involve the pooling of loans into portfolios which are then securitized to form Mortgage Backed Securities — an alchemy that is little understood by the general public, much less the wizards who practice it these days, and which need not concern us here.)

Notes traded on the secondary mortgage market remain secured because the mortgage follows the note. Cal. Civ. Code § 2936 ("The assignment of a debt secured by mortgage carries with it the security"). California codified this principle in 1872, and this has long been the law in all the United States, too: when a note secured by a mortgage is transferred, "transfer of the note carries with it the security, without any formal assignment or delivery, or even mention of the latter." Carpenter v. Longan, 83 U.S. 271, 275 (1872). This is an equitable principle, in that "if [the security is] not assignable at law, it is clearly so in equity." Id. Clearly, the objective of this principle is "to keep the obligation and the mortgage in the same hands unless the parties wish to separate them." Restatement (Third) of Property (Mortgages) § 5.4 (1997). The principle is justified, in turn, by reasoning that the "the debt is the principal thing and the mortgage an accessory." Id. Consequently, "[e]quity puts the principal and accessory upon a footing of equality, and gives to the assignee of the evidence of the debt the same rights in regard to both." Id.[7]

3. The Mortgage Cannot Be Separated From the Note

Given that "the debt is the principal thing and the mortgage an accessory,"

the Supreme Court reasoned long ago that as a corollary, "the mortgage can have no separate existence." Carpenter, 83 U.S. at 274. (Hence the legal maxim cited by the Court: *accessorium non ducit, sequitur principalem*,[8] the accessory does not lead, but rather follows the principal. Id. at 276.) In arriving at this conclusion, the Court observed that "there is considerable discrepancy in the authorities," and cited from among these one holding of the Supreme Court of Ohio — "a case marked by great ability and fulness of research" — in which the Ohio court held that while notes are made negotiable by statute, "there is no such statutory provision as to mortgages, and that hence the assignee takes the latter as he would any other chose in action, subject to all the equities which subsisted against it while in the hands of the original holder." Id. at 275, citing Baily v. Smith et al., 14 Ohio State 396 (1863).

A *chose in action*, at first glance, does indeed appear similar to a mortgage, insofar as it is a "right to recover…personal property by a judicial proceeding," and insofar as it is transferable like personal property. Cal.Civ.Code § 953; see also McClain v. Buck, 73 Cal. 320 (1887) ("the right to take possession of personal property is a thing in action"); U.S. v. Stonehill, 83 F.3d 1156 (9th Cir. 1996) (chose in action is transferable personal property). The Supreme Court, however, disagreed, holding that "[t]here is no analogy between this case and one where a chose in action standing alone is sought to be enforced." Carpenter, 83 U.S. at 275. The "controlling consideration" that led the Court to this conclusion was its observation of the "dependent and incidental relation" that a mortgage has with the obligation it secures: "[w]hen the note is paid the mortgage expires. It cannot survive for a moment the debt which the note represents." Id. Consequently, a mortgage is unlike any other right to take possession of property that, like a *chose in action*, can stand alone, and "where no such relation of dependence exists." Id. at 276. For this reason, "an assignment of the note carries the mortgage with it, while an assignment of the latter alone is a nullity." Id. at 274. While the note is "essential," the mortgage is only "an incident" to the note. Id.

4. Only the Holder of the Note May Enforce the Mortgage

It follows further from this that "a mortgage may be enforced only by, or in behalf of, a person who is entitled to enforce the obligation that the mortgage secures." Restatement (Third) of Property (Mortgages) § 5.4 (citing Carpenter v. Longan). The Restatement supports this rule by analogy to the UCC's definition of a security interest as an "interest in personal property or fixtures which secures payment or performance of an obligation." UCC § 1-201(b)(35). As the Restatement notes, "[c]ase law construing the Code holds that a security interest is unenforceable in the absence of its underlying obligation." Id., citing Bank of Lexington v. Jack Adams Aircraft Sales, 570 F.2d 1220 (5th Cir. 1978); In re G.O. Harris Financial Corp., 51 B.R. 100 (Bankr. S.D.Fla. 1985) ("in order for a creditor to have lien rights in the property of a debtor, the creditor must hold an enforceable obligation against the debtor"); see also In re

Belize Airways Ltd., 7 B.R. 604, 606 (Bankr. S.D. Fla. 1980) ("[t]o allow the assignee of a security interest [who did not also acquire the note] to enforce the security agreement would expose the obligor to a double liability, since a holder in due course of the promissory note clearly is entitled to recover from the obligor").

5. Only the Holder of the Note is the "Real Party in Interest"

At the court's hearing on this motion, IndyMac argued that as the noteholder's loan servicer, it has the right to seek relief from stay under § 362(d). The court agrees that if IndyMac is duly authorized to enforce the note and mortgage as agent of the noteholder, IndyMac would have the right to enforce the mortgage on the holder's behalf. The authority to enforce the mortgage on the holder's behalf may be granted to an agent. Alternatively, if the noteholder's agent has been assigned the mortgage, the holder of the note may *cause* the holder of the mortgage to foreclose the mortgage, but only if the latter is an agent of the former. The authority can be express or implied, and the Restatement advises that "[c]ourts should be vigorous in seeking to find such a relationship, since the result is otherwise likely to be a windfall for the mortgagor" as well as a "frustration" of the mortgagee's "expectation of security." Restatement (Third) of Property (Mortgages) § 5.4, Comment e.

The right to enforce the mortgage on behalf of the noteholder does not, however, render the noteholder's agent into the real party in interest. "As a general rule, a person who is an attorney-in-fact or an agent solely for the purpose of bringing suit is viewed as a nominal rather than a real party in interest and will be required to litigate in the name of his principal rather than in his own name." Wright & Miller, 6A Federal Practice & Procedure Civ. 2d § 1553. Consequently, even if a court finds that a proper agency relationship exists between the holder of a note and the party seeking to enforce its security, this does not excuse the agent from the requirement that an action be prosecuted in the name of the noteholder, who is the real party in interest. Fed. R. Civ. P. 17(a)(1).

For the purpose of seeking relief from the automatic stay under § 362(d) of the Bankruptcy Code, this means that loan servicers may not seek relief from stay in their own name, if the relief sought is based on a promissory note, and if that note is held by another. Rather, only the holder of the note is the real party in interest. The loan servicer may still be a "party in interest" under § 362(d), and have suffered some injury in fact that would grant it standing to seek relief under § 362(d). There may be other parties, too - apart from the holder of the note — who suffer some injury in fact and constitute parties in interest when a homeowner defaults on a note's obligations and files for bankruptcy. Without ownership of the note, however, none of these parties possess the right to enforce either the note or the mortgage under the applicable substantive law. Only the holder the note possesses this right, and qualifies, therefore, as the real part in interest.

While some courts have held that a loan servicer is a real party in interest, none of these courts have based their holdings on an analysis of the law governing promissory notes. In some cases, the facts simply no not include a promissory note. In Greer v. O'Dell (In re O'Dell), for example, the Eleventh Circuit held that even prior to actual transfer, the purchaser of consumer credit card debt was a "real party in interest" for the purpose of filing a proof of claim pursuant to its Interim Servicing Agreement with the transferor. See O'Dell, 305 F.3d 1297, 1302-03 (11th Cir. 2002). Since the interim agreement delegated to the purchaser the responsibility for administering the accounts, the court held that the purchaser was the party entitled to enforce the right to payment, even though the purchaser did not yet possess the claim itself. Id. The credit card debt in this case, however, was not governed by the same law that governs promissory notes. It is for this reason that the court did not discuss the right to enforcement under UCC § 3-301, as would have been necessary in order to determine who the real party in interest is in a motion for relief from stay based on a promissory note. The O'Dell court's analysis, therefore, is distinguishable from the context of this case, because the substantive law that would determine the real party in interest is entirely different.

This distinction notwithstanding, the Greer court states in dicta that "other courts have held in similar contexts that mortgage servicers are real parties in interest," relying on Myers v. Citicorp Mortgage, Inc., 878 F.Supp. 1553, 1558 (M.D. Ala. 1995), aff'd 208 F.3d 1011 (11th Cir. 2000) (unpublished table decision) for this proposition. See O'Dell, 305 F.3d at 1303. But there is no basis for such a proposition in Myers. Rather, the holding in Myers is that the assignment of a mortgage, even if only for an instant, creates liability in the assignee under the Truth in Lending Act, although not to the same extent as other creditors. See Myers, 878 F.Supp. at 1558. Indeed, the Myers opinion contains no discussion of the real party in interest rule whatsoever.

The one other case on which O'Dell depends for the proposition that a mortgage servicer is a real party in interest is In re Tainan, 48 B.R. 250 (Bankr. E.D. Pa. 1985). O'Dell is the only case of which this court is aware in which a court has held that a mortgage loan servicer, though not the holder of the note, is nevertheless a real party in interest to a motion for relief from the automatic stay. In re Tainan, 48 B.R. at 252. The court in Tainan correctly opens its analysis by noting that "[w]hether a plaintiff is the real party in interest is to be determined by reference to the applicable substantive state law." Id. at 252 (citing Wright & Miller ¶ 1543). The Tainan court errs, however, in its identification of the applicable substantive law by failing to consider UCC Article 3 at all. Rather, the court ignores the substantive law that applies to promissory notes, and instead makes the the court makes the somewhat redundant observation that "[u]nder Pennsylvania law, a real party in interest must be in such command of the action as to be legally entitled to give a complete acquittal or discharge to the other party upon performance." Id. Moreover, the court's only rationale for holding that the servicer is a real party in interest is the servicer's "capacity as representative for collection purposes," id. But as this court has

already noted, this agency argument — the same argument advanced by Indymac at the hearing on this motion — fails as a matter of law. See Wright & Miller § 1553.[9]

IV. CONCLUSION

Consequently, if a loan servicer wishes to seek relief from the automatic stay, either as agent or nominee of the noteholder, the servicer may do so only if the noteholder either joins or ratifies the motion. Absent joinder or ratification, the noteholder must substitute into the servicer's place, and prosecute the motion on its own. Fed. R. Civ. P. 17(a)(3). If the servicer has mistakenly failed to seek relief in the noteholder's name, the court must allow a reasonable time for the noteholder to join or substitute into the action. Id.

IndyMac, by its own admission, is not the holder of the note on which this motion is based, and therefore lacks the authority to enforce the note. Since it lacks the authority to enforce the note, IndyMac also has no authority whatsoever to enforce the mortgage on Kang Jin Hwang's Las Vegas residence.

As the servicer on this loan, it is true that IndyMac may have suffered some "injury in fact" which would grant it standing to seek relief from stay. It is likely, moreover, that IndyMac is a "party in interest" under § 362(d). The fact remains, however, that IndyMac does not possess the rights necessary under Article 3 of the California Commercial Code to qualify as the real party in interest under Fed. R. Civ. P. 17(a).[10] If IndyMac wishes to prosecute this motion on behalf the note's current holder or holders, it may do so only if all real parties in interest join in this motion, or otherwise ratify it. Pursuant to Fed. R. Civ. P. 17(a)(3), the court continues this motion until August 26, 2008, to provide IndyMac a reasonable time for the real party in interest to either ratify, join, or be substituted into this motion.

Dated: September 2, 2008

Hon. Samuel L. Bufford
United States Bankruptcy Judge

Dated: September 2, 2008

HONORABLE SAMUEL L. BUFFORD
United States Bankruptcy Judge

PROOF OF SERVICE

I certify that a true copy of this **OPINION DENYING LIFT STAY FOR FAILURE TO JOIN REAL PARTY IN INTEREST** was served on _____, 2008.

Kang Jin Hwang
1635 4th Street
Los Angeles, California 90019

Robert K. Lee, Esq.
3435 Wilshire Boulevard
Suite 2741
Los Angeles, California 90010

William G. Malcolm, Esq.
Malcolm Cisneros, A Law Corporation
2112 Business Center Drive
2nd Floor
Irvine, California 92612

Sam S. Leslie, Trustee
6310 San Vicente Boulevard
Suite 320
Los Angeles, California 90048

U.S. Trustee
Department of Justice
725 South Figueroa Street
26h Floor
Los Angeles, California 90017

Dated:
DEPUTY CLERK

Footnotes

[1] MERS, Inc. is an entity whose sole purpose is to act as mortgagee of record for mortgage loans that are registered on the MERS System. This system is a national electronic registry of mortgage loans, itself owned and operated by MERS, Inc.'s parent company, MERSCORP, Inc.

[2] See Katherin M. Porter, *Misbehavior and Mistake in Bankruptcy Mortgage Claims*, (November 6, 2007), University of Iowa College of Law Legal Studies Research Paper Series Available at SSRN: *http://ssrn.com/abstract-102796.*

[3] Production of the note is excused only under circumstances such as those provided in Evidence Code Rule 1004 or Cal. Comm. Code § 3301 (as shown by competent evidence).

[4] Fed. R. Civ. P. 17 applies in all adversary proceedings pursuant to Fed. R. Bankr. P. 7017. Fed. R. Bankr. P. 7017, in turn, applies in all contested matters pursuant to Fed. R. Bankr. P. 9014. A motion for relief from stay is a contested matter, and therefore, must be brought by a real party in interest pursuant to Fed. R. Civ. P. 17(a)(1).

[5] "Article III of the Constitution limits the "judicial power" of the United States to the resolution of "cases" and "controversies." Valley Forge Christian Coll. v. Ams. United for Separation of Church and State, 454 U.S. 464, 484, (1982); see also Morrow v. Microsoft Corp. 499 F.3d 1332, 1339 (9th Cir. 2007). This constitutional restriction is enforced by the minimum requirement that a "party who invokes the court's authority…show that he suffered some actual or threatened injury," Matter of Village Rathskeller, Inc., 147 B.R. at 668 (citing Valley Forge, 454 U.S. at 464), that the injury be "fairly traceable to the defendant's allegedly unlawful conduct and likely to be redressed by the requested relief." Morrow, 499 F.3d at 1339 (citing Hein v. Freedom Religion Found., Inc., — U.S. —, 127 S.Ct. 2553, 2555-56, 168 L.Ed.2d 424 (2007)). "These requirements have been described as the injury in fact, traceability, and redressability inquiries." Id. "An actual or threatened injury exists when a party's pecuniary interest may be affected by the outcome of a determination." Matter of Village Rathskeller, 147 B.R. at 668 (citing United States v. Little Joe Trawlers, Inc., 780 F.2d 158, 161 (1st Cir. 1986).

[6] Of these considerations, two are of particular relevance to a party who invokes a court's authority to grant relief from the automatic stay under 11 U.S.C. § 362(d). See id. at 668-69. First, the party seeking relief "must assert his own legal rights and interests, and cannot rest his claim to relief on the legal rights or interests of third parties." Valley Forge, 454 U.S. at 760 (citing Warth v. Seldin, 422 U.S. 490, 501 (1975); Gladstone, Realtors v. Village of Bellwood, 441 U.S. 91, 100 (1979); Duke Power Co. v. Carolina Environmental Study

Group, Inc., 438 U.S. 59, 80 (1978); Singleton v. Wulff, 428 U.S. 106, 113-114 (1976)). Second, "the plaintiff's complaint [must] fall within 'the zone of interests to be protected or regulated by the statute or constitutional guarantee in question.'" Valley Forge, 454 U.S. at 475 (citing Association of Data Processing Service Orgs. v. Camp, 397 U.S. 150, 153 (1970); Gladstone, 441 U.S. at 100; Duke Power Co., 438 U.S. at 80). Both of these considerations are incorporated into Rule 17's requirement that an action be prosecuted "in the name of the real party in interest." See Ensley v. Cody Resources, Inc., 171 F.3d 315, 320 (5th Cir. 1999).

[7.] Some authorities have followed a similar rationale in holding that the transfer of the mortgage likewise transfers the obligation which it secures, if a court can infer the intent to keep the mortgage and the note together. See Restatement (Third) of Property (Mortgages) § 5.4 (1997). These authorities, however, predate the adoption of the Uniform Commercial Code in all fifty of the United States. Today, courts that would otherwise be inclined to follow this inverse rule will likely be forced to disregard it if they are to give effect to UCC §§ 3-203, 3-301(a). This is because mortgage obligations are almost universally negotiable notes, whose right of enforcement is available only to the holder, and only transferable by delivery of the note itself to the transferee, as mentioned above. Id.

[8.] Co. Litt. 152, a, 151, b. This maxim cited by the Supreme Court in Carpenter, is ancient, and arises from the principle of *accessio* in Roman Law. The principle appears in various forms throughout antiquity's legal sources. See, e.g., Dig. 34.2.19 (*accessio cedit principali*, the accessory gives way to the principal); other variations include *accessorium sequitur naturam sui principalem; res accessoria sequitur principalem; et in accessoriis, praestanda sunt quae in principali; sublato principali, tollitur et accessorium.*

[9.] There are other cases sometimes cited for the proposition that a loan servicer is a real party in interest, but in fact, these cases do not actually go so far as to decide the issue. For example, in Bankers Trust (Delaware) v. 236 Beltway Inv., 865 F.Supp. 1186, 1191 (E.D. Va. 1994), the trustee of a securitized pool of mortgages brought suit on one of the pooled notes, something which a trustee — quite apart from an agent — is fully capable of doing as a real party in interest. See Wright & Miller ¶ 1548 ("The trustee of an express rtust may sue in his own name as the real party in interest..."). Having acknowledged that the trustee was a real party in interest, the court goes on to merely speculate in dicta that "the servicer, as receiver and collector of moneys due under the mortgages, may also have standing to sue for deficiencies," even though the servicer was not a party to the action. See Bankers Trust, 865 F.Supp. at 1191.

In In re Woodberry, 383 B.R. 373 (Bankr. D.S.C. 2008), the court reached the right conclusion in holding that a loan servicer who was also the holder of the note was the real party in interest to move for relief from stay, but based its

holding on a flawed legal analysis. The court determined that ownership of the note could establish that the servicer was a "creditor" and therefore a "party in interest" under § 362(d), noting that "[t]he owner or holder of a note has a right to payment." In re Woodberry, 383 B.R. at 378. When considering whether the servicer was also a *real* party in interest, however, the court curiously ignored the substantive law that would determine this — despite having just cited it — and instead, concluded its discussion of real party in interest by conflating it with standing: "it seems the better view that a loan servicer, with a contractual duty to collect payments and foreclose mortgages in the event of default, has standing to move for relief from stay in the Bankruptcy Court." Id. at 379 (basing its holding on Tainan, Bankers Trust, and O'Dell). Regardless of its rationale, the movant in Woodberry was the actual noteholder, and therefore the real party in interest.

[10.] Rule 17(a)(3) provides:
The court may not dismiss an action for failure to prosecute in the name of the real party in interest until, after an objection, a reasonable time has been allowed for the real party in interest to ratify, join, or be substituted into the action. After ratification, joinder, or substitution, the action proceeds as if it had been originally commenced by the real party in interest.

HOW TO WAGE
MORTGAGE
WAR

"People were made false promises.
Borrowers were baited and switched into loans
they could not afford. It is fraudulent inducement."

Former Director of the Foreclosure Prevention Project

CHAPTER 6

Are You a Victim
of the Conspiracy?

Not everyone in delinquency, default, foreclosure or eviction is a victim of the conspiracy to defraud homeowners. There is a small minority of homeowners who have traditional fixed interest rate long term loans made by small or regional banks who have not sold their loans to the secondary market.

If you are in financial hardship, and your loan has not been securitized, there is good news. Your lender has the power and motivation to modify or restructure your loan. Believe me, your lender would much rather work out better payment terms than foreclose on your home. To make this a reality, make an appointment to see your branch manager. Explain your hardship and attempt to re-negotiate your mortgage. If your branch manager doesn't have the authority to do so, ask her whom you should negotiate with.

Send a hardship letter detailing your current predicament to the CEO of the bank, using language such as this:

"I am writing to you because there has been an unfortunate change in my financial status. I have recently become (unemployed or divorced or ill, etc.) and cannot make my monthly

payments as agreed. If you look at my financial history, you will find that I have been an excellent borrower and credit risk in the past. But due to these unforeseen circumstances, my hardship prevents me from meeting my obligations set forth in my mortgage and note.

I am requesting that you give me special consideration due to my hardship. This consideration may take the form of lowering my interest rate, reducing my monthly payments or adding several future payments to the back end of my loan.

My home is our family's sanctuary and we desperately do not want to lose it to foreclosure. It is also not possible for us to sell it at this time due to falling real estate values in our area. We also would not agree to a "short sale" as we would have no money to purchase or rent another home.

Please give this request your utmost and immediate attention. I understand that the current Administration is encouraging banks such as yours to make every effort to assist homeowners to stay in their homes.

I hope that I can be one of them.

Thanks you for your time, I remain,"

(Add your name).

A letter such as this will often result in a meeting or correspondence in which your lender offers you a loan modification or restructure. Review this offer with an attorney before you agree to it. Again, action is the winning strategy. Doing nothing will, in fact, result in you losing your sacred home.

The rest of homeowners mostly became victims of the predatory conspiracy. How do you know if you are a victim of predatory lending? Here is a checklist:

1. You were steered into a predatory loan. A predatory loan is simply one that hurts the borrower. A loan is predatory if you have no ability to pay it back over the life of the loan, were not qualified on the fully amortized payment, or given accurate disclosures regarding reset rates or adjusted interest payments. A broker or lender who induced you into such a loan is predatory, and has broken laws against

predatory lending, in addition to committing mortgage fraud. The Federal Truth in Lending Act prohibits lenders from charging excessive fees and requires them to give proper disclosures. The Real Estate Settlement Procedures Act demands that your lender notify you of all settlement costs and your mortgage servicer comply with proper notification and collection practices, as well as respond to your requests and concerns promptly.

2. You were not given certain disclosures demanded by law. The Truth in Lending Act allows for rescission and stiff fines and even jail if your lender doesn't disclose a loan's true terms or provide other information outlined in Chapter Ten in a timely manner.

3. You received a falsely inflated appraisal of the value of your home. If your lender paid excessive fees to an appraiser in order to falsely inflate the value of your property so that your lender could increase the loan amount, both your lender and appraiser have committed fraud. Fraud can be either a civil or criminal act, and carries punitive damages and even jail time.

4. You were not notified of changes in the servicing of your loan. The Real Estate Settlement Procedures Act demands that your lender notify you of any changes in escrow, payment terms or servicing rights. If your servicer doesn't respond to your request for information, or attempts to foreclose on you illegally, your servicer has not only broken this law, but has committed fraud in overstepping its standing on your mortgage.

5. You were forced placed into homeowners, mortgage or title insurance. If your broker or lender forced you to take its affiliate's insurance in order to make more profit, or you weren't aware of the relationships between your lender and its affiliates, your lender has broken The Truth in Lending Act and predatory lending laws.

6. Your Good Faith Estimate doesn't match your Final Settlement HUD 1. If your broker or lender did not give you a Good Faith Estimate of closing costs within three days of application, or your Good Faith Estimate changed between origination and closing, you were "bait and switched." This tactic is a violation of the Federal Truth in Lending Act law.

7. The true parties at your closing were not disclosed to you. If you were induced into a predatory, higher profit loan in order to meet your nominal (in name only) lender's quota for securitization, and your true lender was not disclosed to you, your nominal lender has broken real property and securitization laws which demand total transparency during financial transactions. If your mortgage and note were split at the closing, and your loan was bought and sold simultaneously, your mortgage and note are null and void.

8. Your mortgage broker, realtor, appraiser or builder accepted referral fees. While this will difficult to determine without "discovery" during a lawsuit, undisclosed rebates, referral fees and kickbacks are illegal. Your attorney can determine whom your lender paid in order to secure you as a customer and bring actions against the parties who accepted these bribes during the discovery process of your lawsuit.

9. You were not told that your mortgage was planned to be sold as a security. If your lender had pre-sold your loan to an investment bank that was planning to securitize it and this was not disclosed to you, then your lender has broken both real property and securitization laws, in addition to committing fraud. When your payments were allocated to cover shortfalls in other tranches, and not directly applied to your loan, it is illegal.

10. You were told you must pay off debts and accept pre-payment penalties to close your loan. If you were told by your broker or lender that credit cards, or other debts must be paid to close your loan, lenders did not pay these debts, but kept the money. If you were told you must pay pre-payment penalties in order to close your loan, your broker or lender broke predatory lending laws. Pre-payment penalties were designed to keep you from refinancing out of a predatory loan and given to investors and brokers as fees or profit.

11. Your loan application contains inaccurate or forged information or signatures. Many lenders required borrowers to sign blank loan applications. The purpose of this was to falsify information including employment, reserves, assets and income. Even signatures have been forged. This is a serious fraud which carries jail time. Forgery is a felony.

12. You were charged excessive origination and closing fees. If you were charged an application fee, or charged broker fees, these may be considered predatory, especially if your broker also received undisclosed fees from your lender. Other excessive fees include origination fees, filing fees, title fees, insurance fees, administrative fees or interest based on your credit score.

These excessive fees are violations of the Truth In Lending Act.

If you believe you are a victim of any of these predatory practices, it is time to hire a mortgage auditor, whether your payments are current or not. You must hold your broker and lender accountable for shirking their fiduciary responsibilities and return monies to you.

If your mortgage servicer refuses to do so within the sixty days required by the Real Estate Settlement Procedures Act, you may be advised by your auditor to rescind your toxic loan. In most cases, your servicer will ignore your rescission demand. Then it is time to go to court and seek justice.

You may be finding yourself quite angry right about now. You might be blaming yourself for being duped. Rage will not help you forge a path to victory. Look at it this way: at least you are in good company.

Instead, meditate on how lucky you are to have your home and how you will keep it. Focus on your plan to investigate your predatory loan, get it professionally audited, rescind it, then sue your lender in court.

"This investigation into Bear Stearns has uncovered abusive, fraudulent, illegal criminal schemes and predatory lending and servicing practices including;

fraudulently increasing principal balances,
misrepresenting the 'true ownership' of promissory notes,
misrepresenting the destruction of primary notes,
placing false charges and debts in escrow accounts,
placing forced insurance,
demanding overpayments on customer's accounts,
unlawfully modifying loan documents,
overcharging payoff amounts,
diverting payments,
holding money in suspense,
refusing to answer RESPA requests,
among others."

Private Investigation into Bear Stearns
Lending and Servicing Practices

CHAPTER

Your Forensic Mortgage Audit

One of the most important tools when waging mortgage war against your predatory lender is a mortgage audit. A mortgage audit is an investigation of your loan. It examines every transaction from the solicitation and origination of your loan to its closing and servicing. A thorough audit of your mortgage uncovers predatory practices and helps you build a case against your broker and lender.

It is possible to audit your own loan, but not advisable. A good auditor understands finance, forensic accounting, mortgage compliance and consumer law. An auditor is well versed in formulas for computing simple and compound interest, present and future values, nominal and effective interest rates, annual percentage rates and compounding and discounting of cash flows.

Some auditors are trained in forensics and investigative practices. Forensic auditors can provide a detailed report to your attorney and judge as part of a predatory lawsuit. They also can serve as an expert witness during your trial.

Qualified auditors have a firm grasp on the state and federal consumer protection statutes and regulations that govern

consumer real estate transactions. As mentioned, the two primary laws that protect homeowners are the Real Estate Settlement Procedures Act (RESPA) and the Truth in Lending Act (TILA).

RESPA addresses mortgage servicing, transfer procedures and billing complaints. How mortgages are sold, transferred and assigned comes under RESPA. TILA regulates disclosures to homeowners, fees and the right of rescission. Both RESPA and TILA are discussed in detail in Part Three of this book.

A typical fee for a qualified mortgage auditor is five hundred to one thousand dollars. A forensic auditor charges between one and two thousand dollars. Stay away from audit services promoted on the internet. You need to meet your auditor to check their references and determine a comfort level. You can go to www.yourmortgagewar.com for a referral to a qualified auditor or a forensic auditor.

Your auditor will provide you with a retainer agreement and a request for loan documents. This request is sent to your lender, notifying it that you have authorized your auditor to communicate on your behalf. The retainer agreement should not ask for a portion of any damages you receive based on issues uncovered in the audit. Your agreement with your auditor should be for a fee based audit and nothing more.

Once you have signed a retainer agreement, and notified your lender in writing, your auditor will examine your loan from application to closing, along with your loan servicing history. If you have already paid off a predatory loan, you can sue your lender based on the statutes of limitation in your state.

A competent auditor will be able to identify all predatory practices in the origination and closing of your loan including the loan's toxicity, excessive fees, forged or falsified qualifications, illegal kickbacks and rebates, pre-payment penalties and improper disclosures. A good audit can highlight:

■ Appraisal fraud
■ Bankruptcy code violation
■ Common law fraud
■ Embezzlement

- Equity stripping schemes
- Fair Credit Reporting Act violations
- Fair Debt Collections Practices Act violations
- Foreclosure rescue scams
- Forged loan documents
- Fraudulent inducement and misrepresentations
- Home Ownership and Equity Protection Act violations
- RICO claims
- National Housing Act violations
- Reverse redlining
- Quiet title
- Unjust enrichment
- Illegal foreclosure
- Unlawful eviction

The auditor will also track the accounting of your loan down to the penny, by replicating the interest rate formulas used in administering the loan. This is done to uncover errors, conflicts and omissions. This data highlights breach of contract and consumer rights violations.

The audit can uncover TILA violations including interest rate overcharges, bait and switch tactics, illegal HUD settlement charges, improper use of deposit funds and rescission (cancellation) rights.

With regard to loan servicing, the audit identifies breaches of contract, errors and omissions in payments, improper transfers of the note and rights to service the mortgage, interest rate adjustment errors, and discrepancies between year-end interest and your lender's statement. The auditor also examines whether your lender is in compliance with new RESPA rules, how suspense and disbursements are handled and whether improper fees were charged for forced place insurance.

A forensic auditor will communicate on your behalf with regulatory agencies, state authorities and state licensing boards. She will conduct legal research that can be later used as a brief in your case, and criminal research to determine if any criminal activity was committed by your broker and lender.

Essentially, the audit will determine if you are in a predatory loan that was sold to you to meet your lender's needs rather than your

own. It is suspected that the majority of foreclosures were conducted illegally, by trustees or servicers who had no standing to foreclose, based on toxic loans sold for the purpose of securitization. The audit is an important tool in your arsenal when waging mortgage war.

The results of your audit can be used to restructure your loan. Your auditor will write to your lender detailing all of the abuses, violations, errors and fraud found in your loan. He will then demand a restructure, including a lower loan amount and interest rate. This restructure is based on his estimation of what damages you would most likely be awarded by a judge. As an example, if your current predatory loan is 8% for $500,000, your restructure might be 2% for $200,000. Your lender may not agree to a restructure because it doesn't have the power to do so. Then it is time to rescind your loan and go to court.

In preparing your legal complaint, most attorneys will require a forensic audit. Following is a forensic mortgage questionnaire for your review.

SAMPLE AUDITOR'S INVESTIGATION QUESTIONNAIRE
QUAILIFIED WRITTEN REQUEST, COMPLAINT, DISPUTE OF DEBT, VALIDATION OF DEBT LETTER AND TILA REQUEST.

This letter is a "QUALIFIED WRITTEN REQUEST" in compliance with and under the Real Estate Settlement Procedures Act, 12 U.S.C. Section 2605(e).

Reference: Account #_____: Hereinafter the subject loan and is the reference for all questions and requests described below.

To Whom It May Concern:
I am writing about the accounting and servicing of this mortgage and clarification of various sale, transfer, funding source, legal and beneficial ownership, charges, credits, debits, transactions, reversals, actions, payments, analyses and records related to the servicing of

this account from its origination to the present date.

I hereby demand absolute firsthand evidence from you of the original uncertified or certified security regarding the above referenced account. In the event you do not supply me with the very security, it will be a positive confirmation on your part that you never really created and owned one.

I also hereby demand that a chain of transfer from you to wherever the security is now be promptly sent as well. Absent the actual evidence of the security, I have no choice but to dispute the validity of your lawful ownership, funding, entitlement right and the current debt.

By debt, I am referring to the principal balance; the calculated monthly payment; calculated escrow payment and any fees claimed to be owed by you or any trust or entity you may service or sub-service for.

To independently validate this debt, I will need to conduct a complete review and accounting of this mortgage from its inception through the present date. Upon receipt of this letter, refrain from reporting any negative credit information (if any) to any credit reporting agency until you respond to each of the requests. To do so would be in violation of the Fair Credit Reporting Act.

I also request that you conduct your own investigation and audit of this account since its inception to validate the debt you currently claim is owed. I would like you to validate the debt so that it is accurate to the penny.

Do not rely on previous servicing companies or originator's records, assurances or indemnity agreements. Instead, I demand that you conduct a full audit and investigation of this account.

In examining the loan documents, I suspect you may have engaged in predatory lending practices including:

- Inflating the appraisal of this property
- Increasing the amounts of monthly payments;
- Increasing the principal balance owed;
- Increasing escrow payments;
- Increasing the amounts applied and attributed toward interest on this account;

■ Decreasing the proper amounts applied and attributed toward the principal on this account; assessed, charged and/or collected fees, expenses and miscellaneous charges the borrower is not legally obligated to pay under the mortgage, note and/or deed of trust.

I request that you prove that my client has not been the victim of such predatory lending and servicing practices.

Since this is a Qualified Written Request under the Real Estate Settlement Procedures Act, codified as Title 12 section 2605(e) of the United States Code as well as a request under the Truth in Lending Act 15 U.S.C. section 1601, there are substantial penalties and fines for non-compliance, or failure to answer my questions within 20 business days of its receipt, and 60 business days to resolve my concerns.

In order to conduct the examination of this loan, I need to have full and immediate disclosure including copies of all pertinent information. **Please provide me with factual and detailed answers to the following questions:**

1. Was this loan originated in lawful compliance with all federal and state laws, regulations including, but not limited to Title 62 of the Revised Statutes, RESPA, TILA, Fair Debt Collection Practices Act, HOEPA and other laws?

2. Was the origination and/or any sale or transfer of this account or monetary instrument conducted in accordance with proper laws and was it a lawful sale with complete disclosure to all parties with an interest?

3. Please disclose whether the claimed holder in due course of the monetary instrument/deed of trust/asset is in compliance with statutes, state and federal laws and who is entitled to the benefits of payments.

4. Were all transfers, sales, Power of Attorney, monetary instrument ownership, entitlements, full disclosure of actual funding source, terms, costs, commissions, rebates, kickbacks, fees properly disclosed to the borrower; including but not limited to the period

commencing with the original loan solicitation until now and including any parties, instruments, assignments, letters of transmittal, certificates of asset backed securities and any subsequent transfer thereof?

5. Has each servicer and sub-servicers of this mortgage serviced this mortgage in accordance with statutes, laws and the terms of mortgage, monetary instrument/deed of trust, including but not limited to all accounting or bookkeeping entries commencing with the original loan solicitation until now and including any parties, instruments, assignments, letters of transmittal, certificates of asset backed securities and any subsequent transfer thereof?

6. Has this mortgage account been credited, debited, adjusted, amortized and charged correctly, commencing with the original loan solicitation until now and including any parties, instruments, assignments, letters of transmittal, certificates of asset backed securities and any subsequent transfer thereof?

7. Has interest and principal been properly calculated and applied to this loan?

8. Has any principal balance been properly calculated, amortized and accounted for?

9. Have charges, fees or expenses, not obligated in any written agreement, been charged, assessed or collected from this account or any other related account arising out of the subject loan transaction?

10. I also need answers, in writing, to various servicing questions. For each record kept on computer or in any other electronic file or format, please provide a paper copy of all information in each field or record from each computer system, program or database used by you that contains any information on this account.

As such, please send to me, at the address above, copies of the documents requested below as soon as possible. **Please also provide copies, front and back, of the following documents regarding this loan:**

1. Any certificated or un-certificated security used for the funding of this account;

2. Any and all "Pooling Agreement(s)" or "Servicing Agreements" between the nominal lender at the loan closing and any party or parties who could claim an interest in the loan closing or documents pertaining thereto and any government sponsored entity, hereinafter GSE or other party;

3. Any and all "Deposit Agreement(s)" between the nominal lender at the loan closing and any party or parties who could claim an interest in the loan closing or documents pertaining thereto and any GSE or other party;

4. Any and all "Servicing Agreement(s)" between the nominal lender at the loan closing and any party or parties who could claim an interest in the loan closing or documents pertaining thereto and any GSE or other party;

5. Any and all "Custodial Agreement(s)" between the nominal lender at the loan closing and any party or parties who could claim an interest in the loan closing or documents pertaining thereto and any GSE or other party;

6. Any and all "Master Purchasing Agreement(s)" between the nominal lender at the loan closing and any party or parties who could claim an interest in the loan closing or documents pertaining thereto and any GSE or other party;

7. Any and all "Issuer Agreement(s)" between the nominal lender at the loan closing and any party or parties who could claim an interest in the loan closing or documents pertaining thereto and any GSE or other party;

8. Any and all "Commitment to Guarantee" agreement(s) between the nominal lender at the loan closing and any party or parties who could claim an interest in the loan closing or documents pertaining thereto and any GSE or other party;

9. Any and all "Release of Document" agreement(s) between the nominal lender at the loan closing and any party or parties who could claim an interest in the loan closing or documents pertaining thereto and any GSE or other party;

10. Any and all "Master Agreement for Servicer's Principal and Interest Custodial Account" between the nominal lender at the loan

closing and any party or parties who could claim an interest in the loan closing or documents pertaining thereto and any GSE or other party;

11. Any and all "Servicer's Escrow Custodial Account" between the nominal lender at the loan closing and any party or parties who could claim an interest in the loan closing or documents pertaining thereto and any GSE or other party;

12. Any and all "Release of Interest" agreement(s) between the nominal lender at the loan closing and any party or parties who could claim an interest in the loan closing or documents pertaining thereto and any GSE or other party;

13. Any Trustee agreement(s) between the nominal lender at the loan closing and any party or parties who could claim an interest in the loan closing or documents pertaining thereto and trustee(s) regarding this account or pool accounts with any GSE or other party;

Please also send me copies, front and back, of:

1. Any documentation evidencing any trust relationship regarding the Mortgage/Deed of Trust and any Note in this matter;

2. Any and all document(s) establishing any Trustee of record for the Mortgage/Deed of Trust and any Note;

3. Any and all document(s) establishing the date of any appointment of Trustee for this Mortgage or Deed of Trust and any Note, including any and all assignments or transfers or nominees of any substitute trustees(s);

4. Any and all document(s) establishing any Grantor for this Mortgage or Deed of Trust and any Note;

5. Any and all document(s) establishing any Grantee for this Mortgage or Deed of Trust and any Note;

6. Any and all document(s) establishing any Beneficiary for this Mortgage or Deed of Trust and any Note;

7. Any documentation evidencing the Mortgage or Deed of Trust is not a constructive trust or any other form of trust;

8. All data, information, notations, text, figures and information contained in your mortgage servicing and accounting computer

systems including, but not limited to Alltel or Fidelity CPI system, or any other similar mortgage servicing software used by you, any servicers, or sub-servicers of this mortgage account, from the inception of this account to the date written above.

9. All descriptions and legends of all Codes used in your mortgage servicing and accounting system so the examiners, auditors and experts retained to audit and review this mortgage account may properly conduct their work.

10. All assignments, transfers or other documents evidencing a transfer, sale or assignment of this mortgage, deed of trust, monetary instrument or other document that secures payment to this obligation in this account from the inception of this account to the present date, including any such assignment on MERS.

11. All records, electronic or otherwise, of assignments of this mortgage, monetary instrument or servicing rights to this mortgage including any such assignments on MERS.

12. All deeds in lieu, modifications to this mortgage, monetary instrument or deed of trust from the inception of this account to the present date.

13. The front and back of each and every canceled check, money order, draft, debit or credit notice issued to any servicers of this account for payment of any monthly payment, other payment, escrow charge, fee or expense on this account.

14. All escrow analyses conducted on this account from the inception of this account until the date of this letter.

15. The front and back of each and every canceled check, draft or debit notice issued for payment of closing costs, fees and expenses listed on any and all disclosure statements including, but not limited to, appraisal fees, inspection fees, title searches, title insurance fees, credit life insurance premiums, hazard insurance premiums, commissions, attorney fees and points.

16. Front and back copies of all payment receipts, checks, money orders, drafts, automatic debits and written evidence of payments made by others on this account.

17. All letters, statements and documents sent by your company.
18. All letters, statements and documents sent by agents, attorneys or representatives of your company.
19. All letters, statements and documents sent by previous servicers, sub-servicers or others in your account file or in your control or possession or in the control or possession of any affiliate, parent company, agent, sub-servicers, servicers, attorney or other representative of your company.
20. All letters, statements and documents contained in this account file or imaged by you, any servicers or sub-servicers of this mortgage from the inception of this account to the present date.
21. All electronic transfers, assignments and sales of the note, asset, mortgage, deed of trust or other security instrument.
22. All copies of property inspection reports, appraisals and reports done on the property.
23. All invoices for each charge such as inspection fees, appraisal fees, attorney fees, insurance, taxes, assessments or any expense which has been charged to this mortgage account from the inception of this account to the present date.
24. All checks used to pay invoices for each charge such as inspection fees, appraisal fees, attorney fees, insurance, taxes, assessments or any expense which has been charged to this account from the inception of this account to the present date.
25. All agreements, contracts and understandings with vendors that have been paid for any charge on this account from the inception of this account to the present date.
26. All account servicing records, payment payoffs, payoff calculations, ARM audits, interest rate adjustments, payment records, transaction histories, account histories, accounting records, ledgers and documents that relate to the accounting of this account from the inception of this account to the present date.
27. All account servicing transaction records, ledgers and registers detailing how this account has been serviced from the inception of this account to the present date.

With regard to Account Accounting and Servicing Systems:

1. Please identify each accounting and servicing system used by you and any sub-servicers or previous servicers from the inception of this account to the present date so that experts can decipher the data provided.

2. For each accounting and servicing system identified by you and any sub-servicers or previous servicers from the inception of this account to the present date, please provide the name and address of the company that designed and sold the system.

3. For each accounting and servicing system used by you and any sub-servicers or previous servicers from the inception of this account to the present date, please provide the complete transaction code list for each system.

With regard to Debits and Credits:

1. Please detail each and every credit on this account from the date such credit was posted to this account as well as the date any credit was received.

2. Please detail each and every debit on this account from the date such debit was posted to this account as well as the date any debit was received.

3. For each debit and credit listed, please provide me with the definition for each corresponding transaction code utilized.

4. For each transaction code, please provide the master transaction code list used by you or previous servicers.

With regard to Mortgage and Assignments:

1. Has each sale, transfer or assignment of this mortgage, monetary instrument, deed of trust or any other instrument executed to secure this debt been recorded in the county property records in the county and state in which the property is located from the inception of this account to the present date? Please respond either, Yes or No?

2. If no, why not?

3. Is your company the servicer of this mortgage account or the

holder in due course and beneficial owner of this mortgage, monetary instrument and/or deed of trust?

4. Have any sales, transfers or assignments of this mortgage, monetary instrument, deed of trust or any other instrument executed to secure this debt been recorded in any electronic fashion such as MERS or other internal or external recording system from the inception of this account to the present date? Yes or No?

5. If yes, please detail the names of the seller, purchaser, assignor, assignee or any holder in due course to any right or obligation of any note, mortgage, deed of trust or security instrument executed securing the obligation on this account that was not recorded in the county records where the property is located, whether they be mortgage servicing rights or the beneficial interest in the principal and interest payments.

With regard to Attorney Fees:

In answering the questions below, assume attorney fees and legal fees to be one and the same.

1. Have attorney fees ever been assessed to this account from the inception of this account to the present date? Yes or No?

2. If yes, please detail each separate assessment, charge and collection of attorney fees to this account from the inception of this account to the present date and the date of such assessments to this account.

3. Have attorney fees ever been charged to this account from the inception of this account to the present date? Yes or No?

4. If yes, please detail each attorney fee to this account from the inception of this account to the present date and the date of such assessments to this account.

5. Please provide the name and address of each attorney or law firm that has been paid any fees or expenses related to this account from the inception of this account to the present date.

6. Please identify in writing the provision, paragraph, section or sentence of any note, mortgage, deed of trust or any agreement my client signed that authorized the assessment, charge or collection of attorney fees.

7. Please detail in writing each attorney fee assessed from this account and for what corresponding payment period or month such fee was assessed from the inception of this account to the present date.

8. Please detail in writing any adjustments in attorney fees collected and on what date such adjustment was made and the reason for such adjustment.

9. Has interest been charged on any attorney fees assessed or charged to this account? Yes or No?

10. Is interest allowed to be assessed or charged on attorney fees charged or assessed to this account? Yes or No?

11. Please send me copies of all invoices and detailed billing statements from any law firm or attorney that has billed such fees that have been assessed or collected from this account from the inception to the present date.

With regard to Suspense/Unapplied Accounts:

In answering these questions, treat the term suspense account and unapplied account as one in the same.

1. Has there been any suspense or unapplied transactions on this account from the inception of this account until the present date? Yes or No?

2. Please detail each and every suspense or unapplied transaction, including debits and credits, that have occurred on this account from the inception of this account to the present date.

With regard to Late Fees:

Please consider the terms late fees and late charges to be one in the same.

1. Have you reported the collection of late fees on this account as interest in any statement to the IRS? Yes or No?

2. Has any previous servicers or sub-servicers of this mortgage reported the collection of late fees on this account as interest in any statement or to the IRS? Yes or No?

3. Do you consider the payment of late fees as liquidated damages to you for not receiving payment on time? Yes or No?

4. Are late fees considered interest? Yes or No?

5. Please detail what expenses and damages you incurred for any payments made that was late.

6. Were any of these expenses or damages charged or assessed to this account in any other way? Yes or No?

7. If yes, please describe what expenses or damages were charged or assessed to this account.

8. Please describe what expenses you or others undertook due to any payments made that were late.

9. Please describe what damages you or others undertook due to any payments made that were late.

10. Please identify the provision, paragraph, section or sentence of any note, mortgage, deed of trust or any agreement my client signed that authorized the assessment or collection of late fees.

11. Please detail each late fee assessed to this account and for which corresponding payment period or month such late fee was assessed from the inception of this account to the present date.

12. Please detail any adjustments in late fees assessed and on what date such adjustments were made and the reason for such adjustments.

13. Has interest been charged on any late fee assessed or charged to this account? Yes or No?

14. Is interest allowed to be assessed or charged on late fees to this account? Yes or No?

15. Have any late charges been assessed to this account? Yes or No?

16. If yes, how much in total late charges have been assessed to this account from the inception of this account to the present date?

17. Please provide the payment dates you or other previous servicers or sub-servicers of this account claim my client has been late with a payment from the inception of this account to the present date.

With regard to Property Inspections:
Consider property inspection and inspection fee terms that apply to any inspection of property by any source and any related fee or expense charged, assessed or collected for such inspection.

1. Have any property inspections been conducted on this property from the inception of this account to the present date? Yes or No?

2. If yes, please tell me the date of each property inspection conducted on subject property that is the secured interest for this mortgage, deed of trust or note.

3. Please tell me the price charged for each property inspection.

4. Please tell me the date of each property inspection.

5. Please tell me the name and address of each company and person who conducted each property inspection on this property.

6. Please tell me why property inspections were conducted on subject property.

7. Please tell me how property inspections are beneficial.

8. Please tell me how property inspections are protective of subject property.

9. Please explain your policy on property inspections.

10. Do you consider the payment of inspection fees as a cost of collection? Yes or No?

11. If yes, why?

12. Do you use property inspections to collect debts? Yes or No?

13. Have you used any portion of the property inspection process on subject property to collect a debt, payment or obligation? Yes or No?

14. If yes, please answer when and why?

15. Please identify in writing the provision, paragraph, section or sentence of any note, mortgage, deed of trust or any agreement my client signed that authorized the assessment or collection of property inspection fees.

16. Have you labeled in any record or document sent to my client a property inspection as a miscellaneous advance? Yes or No?

17. If yes, why?

18. Have you labeled in any record or document sent to my client a property inspection as a legal fee or attorney fee? Yes or No?

19. If yes, why?

20. Please detail each inspection fee assessed to this account and for which corresponding payment period or month such fee was assessed from the inception of this account to the present date.

21. Please detail any adjustments in inspection fees assessed and on what date such adjustment was made and the reasons for such adjustment.

22. Has interest been charged on any inspection fees assessed or charged to this account? Yes or No?

23. If yes, when and how much was charged?

24. Is interest allowed to be charged on inspection fees charged or assessed to this account? Yes or No?

25. How much in inspection fees have been assessed to this account from the inception of this account to the present date?

26. Please forward copies of all property inspections made on subject property in this mortgage account file.

27. Has any fee charged or assessed for property inspections been placed into an escrow account? Yes or No?

With regard to Broker Price Opinions (BPO) Fees:

1. Have any Broker Price Opinions been conducted on subject property? Yes or No?

2. If yes, please tell me the date of each BPO conducted on subject property that is the secured interest for this mortgage, deed of trust or note.

3. Please tell me the price of each BPO.

4. Please tell me who conducted the BPO.

5. Please tell me why BPOs were conducted on subject property.

6. Please tell me how BPOs are beneficial.

7. Please tell me how BPOs are protective of subject property.

8. Please explain your policy on BPOs.

9. Have any BPO fees been assessed to this account? Yes or No?

10. If yes, how much in total BPO fees have been charged to this account?

11. Please identify the provision, paragraph, section or sentence of any note, mortgage, deed of trust or any agreement my client signed that authorized the assessment, charge or collection of a BPO fee.

12. Please send me copies of all BPO reports that have been done on subject property.

13. Has any fee charged or assessed for a BPO been placed into an escrow account? Yes or No?

With regard to Force-Placed Insurance:
1. Have you placed or ordered any force-placed insurance policies on subject property?
2. If yes, please tell me the date of each policy ordered or placed on subject property that is the secured interest for this mortgage, deed of trust or note.
3. Please tell me the price of each policy.
4. Please tell me the agent for each policy.
5. Please tell me why each policy was placed on subject property.
6. Please tell me how the policies are beneficial.
7. Please tell me how the policies are protective of subject property.
8. Please explain your policy on force-placed insurance.
9. Have any force-placed insurance fees been assessed to this account? Yes or No?
10. If yes, how much in total force-placed insurance fees have been assessed to this account?
11. Please identify the provision, paragraph, section or sentence of any note, mortgage, deed of trust or any agreement my client signed that authorized the assessment, charge or collection of force-placed insurance fees.
12. Do you have any relationship with the agent or agency that placed any policies on this property? If yes, please describe.
13. Do you have any relationship with the carrier that issued any policies on subject property? If yes, please describe.
14. Has the agency or carrier you used to place a forced-placed insurance on subject property provided you any service, computer system, discount on policies, commissions, rebates or any form of consideration? If yes, please describe.
15. Do you maintain a blanket insurance policy to protect your properties when customer policies have expired? Yes or No?
16. Please send me copies of all forced-placed insurance policies that have been ordered on subject property from the inception of this account to the present date.

With regard to Servicing:

1. Did the originator or previous servicers of this account have any financing agreements or contracts with your company or an affiliate of your company?

2. Did the originator or previous servicers of this account receive any compensation, fee, commission, payment, rebate or other financial consideration from your company or affiliate of your company for handling, processing, originating or administering this loan? If yes, please itemize each form of compensation, fee, commission, payment, rebate or other financial consideration paid to the originator of this account by your company or any affiliate.

3. Please identify where the originals of this entire account file are currently located and how they are being stored, kept and protected.

4. Where is the original deed of trust or mortgage and note my client signed located? Please describe its physical location and anyone holding this note as a custodian or trustee if applicable.

5. Since the inception of this account, has there been any assignment of this monetary instrument/asset to any other party? If the answer is yes, identify the names and addresses of each and every individual, party, bank, trust or entity that has received such assignments.

6. Since the inception of this account, has there been any sale or assignment of the servicing rights to any other party? If the answer is yes, identify the names and addresses of each individual, party, bank, trust or entity that has received such assignments or sale.

7. Since the inception of this account, have any sub-servicers serviced any portion of this mortgage account? If the answer is yes, identify the names and addresses of each individual, party, bank, trust or entity that has sub-serviced this mortgage account.

8. Has this mortgage account been made a part of any mortgage pool since the inception of this loan? If yes, please identify each account mortgage pool that this mortgage has been a part of from the inception of this account to the present date.

9. Has each assignment of this asset/monetary instrument been

recorded in the county land records where the property associated with this mortgage account is located?

10. Has there been any electronic assignment of this mortgage with MERS (Mortgage Electronic Registration System) or any other computer mortgage registry service or computer program? If yes, identify the name and address of each individual, entity, party, bank, trust or organization or servicers that have been assigned mortgage servicing rights for this account as well as the beneficial interest to the payments of principal and interest on this loan.

11. Have there been any investors (as defined by your industry) who have participated in any mortgage-backed security, collateral mortgage obligation or other mortgage security instrument that this mortgage account has ever been a part of from the inception of this account to the present date? If yes, identify the name and address of each and every individual, entity, organization and/or trust.

12. Please identify the parties and their addresses to all sales contracts, servicing agreements, assignments, alonges, transfers, indemnification agreements, recourse agreements and any agreement related to this account from the inception of this account to the present date.

13. How much were you paid for this individual mortgage? What premium was paid?

14. If part of a mortgage pool, what was the principal balance used by you to determine payment for this individual mortgage loan?

15. Who did you issue a check or payment to for this mortgage loan?

16. Please provide me with copies of the front and back of the canceled check.

17. Would any investor have to approve the foreclosure of subject property? Yes or No?

18. Has HUD assigned or transferred foreclosure rights to you as required by 12 USC 3754?

19. Please identify all persons who would have to approve foreclosure of subject property.

Please provide me with the documents I have requested and a detailed answer to each of my questions within the lawful time frame.

Upon receipt of the documents and answers, an examination will be conducted that may lead to a further document request and answers to questions under an additional RESPA Qualified Written Request letter.

Copies of this Qualified Written Request, Validation of Debt, TILA and request for accounting and legal records, Dispute of Debt letter are being sent to FTC, HUD, Office of Thrift Supervision, relevant state and federal regulators, other consumer advocates, State Congressman, State Senator and Attorney General. Please note that default provisions exist under this QUALIFIED WRITTEN REQUEST.

Lenders do not like this type of investigation, as it gets to the very heart of how the loan has been securitized and who the parties of interest actually are. In many cases, lenders will offer a modification or restructure rather than address these issues, even though not addressing them they are in violation of the Real Estate Settlement Procedures Act. These offers have been as high as an eighty percent reduction of the loan amount!

You would be better served suing your lender for quiet title and getting your home free and clear. If you receive such an offer, review it with an attorney. Keep in mind that if your lender is willing to offer a substantial reduction, it probably is not a current holder of your note and wants to avoid costly litigation which it will lose.

If your lender doesn't respond to a "qualified written request" your auditor will most likely advise you to rescind (cancel) your loan. How to do so is the subject of the next chapter.

Following is an example of a forensic mortgage audit for you to review.

"The forensic mortgage audit is a homeowner's most potent weapon in the mortgage war. Not only does it lay the foundation for litigation, it is a sure defense against foreclosure."

Marie McDonnell, Mortgage Fraud and Forensic Analyst

CASE STUDY 7

Forensic Mortgage Audit

Case Study Seven

Comprehensive Mortgage Audit

**IN THE UNITED STATES BANKRUPTCY COURT
FOR THE SOUTHERN DISTRICT OF TEXAS
HOUSTON DIVISION**

In the Matter Of
IN RE:
JAVIER PENA and
SANDRA PENA
Debtors

CASE NO. 03-45813-H4-13
CHAPTER 13

By Order of the Court
THE HONORABLE JEFF BOHM
Order Granting Motion To Set Aside
Notice Of Termination Of The Automatic Stay
March 8, 2007
Docket No. 68

July 9, 2007

Table Of Contents

DISCLAIMER

The opinions expressed herein do not constitute legal advice or conclusions but fall out logically from facts as they became known through the author's forensic analysis of the evidence. The author understands that the Court is the trier of fact and the arbiter of the law. This report is intended for the sole purpose of illuminating the facts so that the Court is better equipped to apply the law in this matter.

QUALIFICATIONS

My name is Marie Therese McDonnell. I am a Mortgage Fraud and Forensic Analyst located in Orleans, Massachusetts. I have twenty years experience in this emerging field and have, since 1991, specialized in auditing residential and commercial mortgage finance transactions on behalf of consumers and the attorneys who represent them.

The core of my practice involves crisis and foreclosure intervention, problem resolution, and mediation on behalf of consumers who are experiencing difficulties with their mortgage lenders and servicers. I rely upon the objective data produced incident to auditing these transactions as the basis for negotiating fair-minded solutions that avert litigation, preserve homeownership, and protect the bond holders who have an equal but opposite interest at stake.

A significant portion of my practice consists of providing litigation support services to attorneys who represent clients that have been negatively impacted by lender abuses in the origination and servicing of these complex transactions. My background and methodologies are more particularly

described in the Professional Profile attached hereto. (*See* Exhibit 1.- Professional Profile)

The information in this report is accurate, true and correct to the best of my personal knowledge given the documentary evidence provided to me for review as of this writing.

Methodologies

Over the past sixteen years, I have developed, extensively tested, and reliably employed a proprietary set of auditing tools and protocols that enable me to track with precision a lender's loan servicing system and determine with particularity whether a problem is the result of borrower failure, lender malfeasance, or whether it is technology and policy related.

My process begins by assembling documentation from borrowers, lenders, closing agents, loan servicers, and interested third parties so that I have a well rounded view of the entire history. I then integrate the data into a Microsoft Excel spreadsheet and map out each transaction by date in all contractual, fiduciary and collection accounts.

This mapping modality enables me to detect and quantify a lender's failure to disclose properly the material disclosures required under state and federal truth in lending laws; expose hidden devices that result in the gleaning of unearned interest; see how and when a loan servicer breaches its fiduciary duty in the handling of escrow and suspense accounts; uncover equity skimming schemes; and discover nefarious unfair and deceptive acts and practices as these are defined by the Federal Trade Commission.

I am also able to reconstruct lost or suppressed data through a variety of forensic accounting techniques, detect unconscionable loan terms, identify predatory lending schemes, cite violations of state and federal consumer protection statutes, and uncover fraud.

Reliability & Validity

My analysis here is based on loan documents that were generated by the originating lender, Summit Mortgage Corporation ("Summit"), and loan servicing histories maintained by Washington Mutual Bank, N.A. ("Washington Mutual") and Wells Fargo Home Mortgage ("Wells Fargo") in the regular course of business. In addition, I have incorporated proof of payment records supplied by Javier and Sandra Pena ("the Penas"), and have reviewed pertinent pleadings and evidence found in the Court's docket. I also examined, cross-referenced, and proved-out the Trustee's disbursement ledger for this claim, and independently verified tax payments made to the Harris County Tax Office as these were available online.

CASE HISTORY

On January 22, 1996, the Penas consummated the subject mortgage transaction with Summit in order to purchase 10318 Pimlico Court, Houston, Texas as their primary residence. Mr. Pena is solely obligated on the Note but both

he and Mrs. Pena executed the Deed of Trust. The loan was made pursuant to Section 203(b) of the National Housing Act and is insured by the Federal Housing Administration.

The Penas' Note provides for a principal advance of $45,436.00 in exchange for 360 monthly payments of $349.36 which amortizes the loan to a zero balance over thirty years at a fixed interest rate of eight and one half percent (8.50%). It also provides for a late charge amounting to four percent (4.0000%) of the total monthly payment consisting of principal, interest, and escrow items as required under the Security Instrument.

Section 203(b) loans place restrictions on lenders and loan servicers in the event of default to forego acceleration and foreclosure until they have complied with regulations of the Secretary of the Department of Housing and Urban Development. Paragraph 6(B) of the Penas' Note and paragraph 9(a) & (d) of the Deed of Trust contain these limitations.

Immediately after the closing on January 22, 1996, Summit assigned the Penas' mortgage obligation to Fleet Mortgage Corp. ("Fleet"). Due to a merger/acquisition, Washington Mutual assumed servicing the Penas' loan on or about December 31, 1997. From January 1, 1998 through November 31, 2006, Washington Mutual serviced the subject loan which was complicated by two bankruptcy filings and an Order Conditioning Automatic Stay issued on March 22, 2005. Thereafter, from December 1, 2006 to the present, Wells Fargo assumed servicing the Penas' loan.

COURT ORDER OF MARCH 8, 2007

During the past year, a dispute arose over the question of whether the Penas had defaulted on their monthly payment obligations pursuant to the March 22, 2005 Order. Washington Mutual sought relief from the automatic stay and filed Certificates of Default on July 11, 2006 and January 10, 2007. The Penas argued that they had made timely payments and that they could prove their case. A hearing was held on February 27, 2007 pursuant to which the Court found in favor of the Penas and, among other sanctions, ordered that Washington Mutual and/or Wells Fargo pay for an independent accounting to clear up a number of outstanding questions. Specifically, the Court ordered:

The accounting shall determine at the very least, the following non-exclusive list of issues:

a) Explain how late charges and other charges are calculated and applied;
b) Conduct an escrow analysis;
c) Determine if the Penas are current with their mortgage post-petition and if not, explain exactly which payments have been missed; and
d) Determine how payments from the chapter 13 trustee have been applied.

The following narrative and the attached exhibits will answer all of the Court's specific questions and beyond that, will address a number of serious issues that deserve further consideration.

FORENSIC ANALYSIS OF THE EVIDENCE PRESENTED

I have prepared a comprehensive translation of the loan servicing history from inception on January 22, 1996 through June 27, 2007. This accounting matches to the penny every single transaction recorded in the loan servicing histories maintained by Fleet, Washington Mutual and Wells Fargo ("the Servicers"). (*See* Exhibit 2. - Mortgage Map #1)

Exhibit "B" should be referred to frequently as the reader looks for validation in the record of my findings below. I begin this report by describing five distinct phases in the servicing of the Penas' loan spanning some eleven and a half years. Under the topic "Bankruptcy Compliant Servicing," I explain how the subject loan should be set up to conform to the "fresh start" provisions of the Bankruptcy Code. Following that, I address the Court's specific questions. Finally, I discuss the contractual and statutory options that FHA home loan borrowers like the Penas have under the National Housing Act that afford relief even while in bankruptcy.

PHASE I: 1/22/1996 TO 4/10/2001
Washington Mutual's Prepetition Servicing

The transaction histories supplied covering the period from consummation of the loan on January 22, 1996 through April 10, 2001 show that under Fleet's management, the Penas' monthly mortgage payments were timely made except for a 30-day delinquency that ran from February 1997 through August 1997. Washington Mutual took over servicing the Penas' loan on or about December 31, 1997 and their records show that all payments were made within the permissible grace period through and including April 10, 2001. Thus, the prepetition history is unremarkable.

PHASE II: 4/11/2001 TO 11/2/2003
First Bankruptcy

When Javier and Sandra Pena first filed for bankruptcy on April 11, 2001, their mortgage was current. Moreover, it appears that their mortgage payments were timely made, or considerably early, up until February 1, 2002. At that point in time, Washington Mutual virtually doubled the amount due for "escrow items" from $205.89 to $413.73.

Further investigation is required to ascertain precisely what happened here but it appears to be related to a 218% spike in homeowners insurance from $887.00 to $1,934.00 which was charged against the Penas' escrow account on January 1, 2002. Washington Mutual claims, and Mr. Pena has confirmed, that homeowners insurance rates soared that year due to fears of "black mold" from ex-tensive flooding in the region. On June 4, 2002, Washington Mutual again disbursed funds in the amount of $751.47 for force placed insurance after allegedly receiving notice from Allstate Insurance Company that the Penas' coverage had lapsed. This must have been a mistake after all because Washington Mutual redeposited those funds on August 12, 2002 when it reportedly learned that the Penas' policy had been reinstated.

I find Washington Mutual's explanation inconsistent and recommend that the Penas request a history of their insurance coverage and policy premiums spanning the life of their homeownership. One thing is obvious from looking at the transaction histories and that is the corresponding increase in the Penas' monthly payment obligation from $555.25 to $763.09 was so chilling that it caused them to default on their loan.

The Real Estate Settlement Procedures Act governs the handling of funds escrowed for payment of items necessary to protect the mortgaged property and the Mortgagee's lien position. When an account is current but an Annual Escrow Analysis reveals that a shortage will result in excess of one month's escrow account payment, the Servicer may either ignore the situation or require the borrower to repay the shortage in equal monthly payments over at least a 12-month period. [See 24 CFR § 3500.17(f)(3)(i). Escrow Accounts.]

In this instance, a shortage of $1,047.00 may have arisen which, when spread over twelve months, would increase the Penas' monthly payment obligation by $87.25 and not $207.84 as imposed by Washington Mutual. The consequences to the Penas of this breach of servicing duties was fatal in that it threw them hopelessly into default and foreclosure which forced the Penas to file a second bankruptcy one week after being discharged from their first bankruptcy.

PHASE III: 11/3/2003 TO 3/21/2005
Second Bankruptcy

Javier and Sandra Pena filed their second bankruptcy on November 3, 2003 to prevent fore-closure of their home at 10318 Pimlico Court, Houston, Texas. Washington Mutual submitted a Proof of Claim on December 8, 2003 asserting that as of November 4, 2003, the Penas were 13 in-stallments behind and due for the months of November 1, 2002 through November 1, 2003.

Accordingly, Washington Mutual claimed 13 payments of $621.47 each were due for a total of $8,079.11; plus late charges of $620.26; property inspection fees of $87.00; foreclosure attorney fees and costs of $1,481.17; and bankruptcy attorney fees and costs of $1,235.00. The total claim amounted to $11,502.54. (*See* Exhibit 3. - Proof of Claim)

In contrast, Washington Mutual's transaction history shows that as of November 3, 2003 the Penas were 19 months in arrears and were due for the months of May 1, 2002 through November 1, 2003. A total of $3,789.18 was held in the Penas' "suspense account" as a result of payments tendered that had not been disbursed to the appropriate sub-accounts. My analysis of Washington Mutual's Proof of Claim also shows that legal fees and costs were overstated by $226.19 when compared to their transaction history. (*See* Exhibit 4. - Analysis of Proof of Claim)

Approximately two weeks after the Penas had filed for bankruptcy, Washington Mutual debited the Penas' suspense account for the entire $3,789.18 and credited those funds to cover six installments due for May 1, 2002 thorough October 1, 2002. Thus, Washington Mutual portrayed the account status as of November 18th not November 4th in its Proof of Claim. (*See* Exhibit B. — Mortgage Map #1, p. 5)

Although one might argue that Washington Mutual's post-petition alterations are mathematically equivalent to reducing the 19-month prepetition arrearages by funds on deposit in the suspense account, handling the Penas' loan in this manner is improper for reasons more particularly described below under the topic "Bankruptcy Compliant Servicing."

Essentially, Washington Mutual failed to recalibrate the loan balance to bring the Penas' ac-count current as of the petition date and continued to service their loan in a perpetual state of default. Moreover, Washington Mutual failed to open the Trustee's suspense account with a debit for prepetition arrearages of $11,502.54 as claimed, which makes it extremely difficult to determine whether the Servicers have applied the Trustee's payments against prepetition or postpetition obligations.

The transaction histories for this period show that the Penas were correctly making postpetition payments in the amount of $572.05 as required by an Escrow Account Statement that Washington Mutual issued to them on November 13, 2003, ten days after the Penas had filed for bankruptcy. (*See* Exhibit 5. - Escrow Account Statement)

Notwithstanding its own computer-generated instructions, Washington Mutual placed the Penas' first postpetition payment, due for the December 1, 2003 installment, in their suspense account thus causing them to fall one month behind in their postpetition mortgage obligations. (*See* Exhibit B. — Mortgage Map #1, p. 5)

Thereafter, Washington Mutual subsidized the Penas' monthly payments due for January 1, 2004 through April 1, 2004 by drawing $49.42 from suspense which was added to the escrow portion of the installment effectively raising the required monthly payment from $572.05 to $621.47. The Penas were, no doubt, unaware that this was happening.

On April 23, 2004, Washington Mutual drained the Penas' suspense account by transferring the remainder of their first postpetition payment to settle $347.37 in prepetition late charges.

Washington Mutual repeated the above scenario on July 14, 2004 by depositing another of the Pena's monthly payments into suspense and subsidizing the next eight installments, five of which occurred after the Court issued its Order of March 22, 2005 conditioning the automatic stay.

Hence, Washington Mutual improperly serviced the Penas' loan during this entire period of time. Late charges of $366.08 were imposed as well as miscellaneous foreclosure fees, bankruptcy fees, and costs totaling $2,072.43.

PHASE IV: 3/22/2005 TO 11/30/2006
Court Order Conditioning Automatic Stay

For reasons unknown to this analyst, the Penas fell behind in making some of their postpetition payments and on March 22, 2005, the Court issued an Order Conditioning Automatic Stay ("Order") that allowed arrearages of $4,326.46 to be incorporated into the Penas' Plan; Washington Mutual was given leave to amend its Proof of Claim accordingly. The Order also instructed

the Penas to resume making timely postpetition payments in the amount of $572.05 beginning April 1, 2005 and monthly thereafter. As of this writing, the Penas' plan has not been modified, nor has Washington Mutual amended its Proof of Claim. Despite the administrative lag in perfecting the paperwork, all parties have otherwise complied with the Court's Order.

I do not have all of the Penas' canceled checks for this critical period of time, but among those I do have, I discovered that two payments were not credited in Washington Mutual's transaction history. The first of these, check number 2478, was issued on June 2, 2006 in the amount of $572.05; the second, check number 2518, was issued on November 6, 2006 in the amount of $632.68. (*See* Exhibit B. — Mortgage Map #1, p. 7)

In reading through the documentation provided to me by Washington Mutual I discovered a collection letter dated June 30, 2006 which explains what happened to check number 2478. The letter reads:

> Dear Mortgagor(s):
> The enclosed check number 2478 in the amount of $572.05 and dated 06/02/06 is being returned to you for the following reason(s):
> -Amount not sufficient to reinstate loan
> Please send your payment with the loan number clearly referenced to:
>
> Washington Mutual Bank
> Default Cash Operations
> 11200 W. parkland Ave
> Milwaukee, WI 53224
>
> If you have any questions or concerns, please call our Customer Service Representatives toll free at 1-866-926-8937.
> Sincerely,
> Default Cash Operations
> Washington Mutual Bank
> (See Exhibit 6. - FDCPA Letter, 6/30/06)

Subsequently, on July 11, 2006, Washington Mutual filed a Certificate of Default alleging that the Debtors had defaulted on this Court's Order of March 22, 2005 conditioning the automatic stay by failing to make or show proof of payments. The Certificate referred to a Default Letter of June 26, 2006 which is not in evidence.

My audit of Washington Mutual's transaction histories shows that the Penas had missed making the payment due on March 1, 2006 but payments were recorded and applied for April and May. Washington Mutual's collection notes do not indicate that any letters were sent or phone calls initiated to inquire as to whether there was a problem. Instead, Washington Mutual took the draconian step of returning the Penas' June payment on June 30, 2006; filed the

Certificate of Default on July 11, 2006; and instituted foreclosure on July 12, 2006. (*See* Exhibit 7. - Collection Log, 7/12/06)

The Penas' second, check number 2518, was issued on November 6, 2006 in the amount of $632.68 and appears to have been lost in the shuffle when Washington Mutual transferred the Penas' loan to Wells Fargo. This "lost" check no doubt triggered the initiation of Washington Mutual's second Certificate of Default which was filed on January 10, 2007.

The Penas should examine their bank statements to see if check number 2518 cleared their account. I also recommend that they research their records to see if they might have issued a mortgage payment in March 2006 as this "skip" is inconsistent with their payment history since the March 22, 2005 Order.

PHASE V: 12/1/2006 TO 6/27/2007
Servicing Transferred to Wells Fargo

Wells Fargo continued to service the Penas' loan in lock step with Washington Mutual, that is to say, in a perpetual state of default because it failed to recalibrate the loan according to the Bankruptcy Rules and to properly establish the Trustee's suspense account.

The Penas have been making timely payments to Wells Fargo during this period, the first three of which were in the amount of $632.68 which exceeded the scheduled payment of $572.05 by $60.63. On December 14, 2006, Wells Fargo placed the $60.63 overage in the Penas' escrow account; on January 15, 2007 and February 14, 2007, Wells Fargo placed the overage in the Penas' suspense account.

Wells Fargo hit a snafu when, on March 14, 2007, the Penas sent in a payment of $572.05 instead of $632.68. Wells Fargo placed that payment in the Penas' suspense account and then credited the payment on March 20, 2007. On April 3, 2007 Wells Fargo appears to have advanced $333.14 from the Penas' negative escrow account and credited those funds to principal and interest. To make up the shortfall, Wells Fargo debited the Trustee's suspense account by $16.22. This transaction is highly unusual. (*See* Exhibit B. — Mortgage Map #1, p. 8)

On April 3, 2007, Wells Fargo fouled up the Penas' account by crediting a lump sum payment of $4,767.00, which apparently, was somebody else's money. The erroneous postings were reversed on April 19, 2007, but in the meantime, the Penas sent in payments of $572.05 on April 13, May 17 and June 15, 2007 that Wells Fargo placed into their suspense account. Two of those payments were credited on June 27, 2007; but the third payment appears to be missing. (*See* Exhibit B. — Mortgage Map #1, p. 8)

BANKRUPTCY COMPLIANT SERVICING

Two seminal decisions have been handed down recently by bankruptcy court justices who believed that it was vital to the integrity of the system that mortgage servicing companies conform their accounting practices to the

Bankruptcy Code. The first of these important cases was decided by the Honorable Joel B. Rosenthal, United States Bankruptcy Judge, District of Massachusetts in the matter of *Jacalyn S. Nosek v. Ameriquest Mortgage Company*, A.P. No. 04-04517. Judge Rosenthal opined:

> Ameriquest next argued that "because Ameriquest cannot use its computer system to track bankruptcy payments and because no software exists to track such payments, Ameriquest must account for payments from Chapter 13 Debtors manually." *See Ameriquest's Reply Brief*, p. 16. Ameriquest offers this as an apparent excuse as to why Nosek's payment history was inaccurate. The Court is unpersuaded. Even if Ameriquest must manually account for these payments (though the Court is not convinced that a computer system could not be developed with the appropriate investment of time and money), Ameriquest is not excused from doing it right, even if it is an ad-ministrative burden. It is not sufficient that Ameriquest only internally accounted Nosek with having made the payments and internally considered her current. This must be reflected on Ameriquest's external payment history, which is shared with the debtor and the outside world and which is usually necessary for a refinancing, something a lender of Ameriquest's experience should recognize. In sum, Ameriquest is simply unable or unwilling to conform its accounting practices to what is required under the Bankruptcy Code, something this Court can encourage by assessing punitive damages under Section 105(a).
> (*See* Exhibit 8. - Rosenthal Memorandum on Remand)

The second case I have studied with particular care is *In re Jones*, No. 03-16518, Section A (Bankr.E.D.La. 4/13/2007) (Bankr.E.D.La., 2007). In Judge Elizabeth Magner's Memorandum Opinion she offers specific guidance and instructions as to how prepetition arrearages are to be satisfied under the auspices of the Chapter 13 Trustee. With regard to postpetition debt, Judge Magner explained:

> As for the postpetition debt, the confirmation of a plan recalibrates the amounts owed by Debtor as of the petition date. Because the prepetition arrearage is paid by the Trustee under the plan, Debtor's account gets a fresh start, free of all past due sums. [FN26] Thus, going forward, Debtor's balance should only reflect the principal amount due under the Wells Fargo Note as of the petition date, and all other charges, fees, or negative escrow balances should be zero.

In this Court's experience, few, if any, lenders make the adjustments necessary to properly account for a reorganized debt repayment plan. As a result, it is common to see late charges, fees, and other expenses assessed to a debtor's loan as a result of postpetition accounting mistakes made by lenders. If the lender does not recalibrate the loan to

reflect the terms of the plan, more likely than not, it will miscalculate the amounts due by a debtor. It appears to this Court that lenders refuse to make these adjustments because few debtors challenge their accounting and even less pay out their entire loan before discharge. There are also a sizeable number of debtors that default on their plans or the direct postpetition payments on their loans, resulting in the lifting of the automatic stay and a return to foreclosure. Thus, many lenders appear to take a "wait and see" attitude rather than provide the type of individualized administration that a reorganized debt requires.

Such was the case with Wells Fargo. Rather than recalibrate the loan as current on the petition date, Wells Fargo continued to carry the past due amounts contained in its proof of claim in Debtor's loan balance. Wells Fargo applied any amounts received, regardless of source or intended application, to pre and postpetition charges, interest and non-interest bearing debt. This resulted in such a tangled mess that neither Debtor, who is a certified public accountant, nor Wells Fargo's own representative could fully understand or explain the accounting offered. [FN27]

<div align="center">(See Exhibit 9. - Magner Memorandum Opinion)</div>

Before I could answer this Court's questions, I first had to translate the Penas' entire loan servicing history into a format that would allow me to analyze the data precisely as it was booked into the Servicers' accounting systems. This proved to be a monumental task as there are literally thousands of transactions that occurred over the life of this eleven and a half year old loan, each one of which had to be independently calculated, cross referenced, and verified. The result was the creation of Mortgage Map #1.

Next, I had to create a second version, Mortgage Map #2, wherein I followed Judge Magner's instructions on how to set up a bankruptcy compliant model. Mortgage Maps #1 and #2 are identical up until November 3, 2003 when the Penas filed their second bankruptcy petition. At that point Mortgage Map #2 departs from the actual servicing history in that I recalibrated the Penas' loan to bring it current, zeroed out all contractual and fiduciary accounts, and setup plan-approved arrearages in the Trustee's suspense account. I also zeroed out inappropriate transactions to maintain the integrity of the account. (See Exhibit 10. - Mortgage Map #2 — Bankruptcy Compliant Servicing)

Once accomplished, I found there are so many analogies between the Jones case and the Penas' case, that I constructed a "Similarities and Differences" schema to aid the Court in seeing some of the parallels. (See Exhibit 11. - Mortgage Servicing Abuses In Bankruptcy)

Briefly, the following transgressions can be verified by comparing Mortgage Map #1 with Mortgage Map #2:

1. The Servicers failed to recalibrate the loan to bring it current as of the bankruptcy petition date of November 3, 2003;
2. The Servicers failed to zero out escrow, late charge, corporate & foreclosure account balances to effect a fresh start;
3. The Servicers placed postpetition payments in a suspense account thereby manufacturing or deepening a default;
4. The Servicers kept the Principal balance artificially high by failing to credit payments that were placed in a suspense account and then stripped;
5. The Servicers applied postpetition payments to prepetition arrearages;
6. The Servicers imposed undisclosed legal fees post-petition but pre-confirmation;
7. The Servicers failed to notify debtor it was adding postpetition fees and costs;

ANSWERS TO THE COURT'S SPECIFIC QUESTIONS
Late Charges

Paragraph 6(A) of the Pena's FHA guaranteed Fixed Rate Mortgage Note addresses "Late Charges For Overdue Payments" and provides that for payments received after the fifteenth day past the due date, a late charge of four percent (4.0000%) of the "total monthly payment" may be imposed. Unlike most conventional loans, the total monthly payment in FHA cases includes both the installment due under the Note for principal and interest as well as for escrow items required pursuant to the Security Instrument.

I analyzed the late charges imposed on the subject loan and found that there were deviations between the escrow items "disclosed" in various Escrow Account Statements and the escrow items actually charged and collected which, in turn, affected late charges. Since the Servicers' computer automatically generates late charges based on the scheduled monthly payments, I can tell that Washington Mutual overcharged the Penas for escrow items from, at the very least, September 16, 2002 through December 13, 2003 during which time they were in bankruptcy. (*See* Exhibit 12. - Late Charge Analysis)

Immediately following the Penas' first bankruptcy filing, Washington Mutual wrongfully imposed late charges totaling $199.89 for the first nine payments due on April 1, 2001 through February 1, 2002 which were timely made. On April 23, 2004, Washington Mutual wrongfully diverted $374.37 from one of the Penas' postpetition mortgage payments to settle prepetition late charges.

Escrow Analysis

Mortgage Map #1 illustrates how the Penas' loan was actually serviced with respect to the escrow account. Mortgage Map #2 shows how the Penas' escrow account should have been maintained had the Servicers followed the bankruptcy rules. The difference is stark. In the first instance, Wells Fargo is currently reporting a negative escrow balance of $3,896.32 whereas, if the Servicers

had complied with the bankruptcy rules, the Penas would be both current and "in the black" with respect to their escrow account as of June 27, 2007. (*See* Exhibits B. & J.)

Other than my concern over whether or not the insurance payment of $1,934.00 made on January 1, 2002 and the $333.14 debited on April 3, 2007 which was applied to a monthly installment were proper, I believe that all other disbursements from the Penas' escrow account are valid.

Status of Account on June 27, 2007

As of June 27, 2007, Wells Fargo's loan history indicates that the Penas' outstanding principal balance is $40,033.92 and that they are contractually due for 17 monthly payments dating from February 1, 2006 through June 1, 2007. Past due arrearages for principal and interest total $5,939.12; past due arrearages for escrow items total $3,785.73. In addition, Wells Fargo is reporting a negative escrow advance balance of $3,896.32 which means that even if past due escrow items were brought up to date, there would still be a negative balance of $110.59. Late charges of $243.67 are outstanding along with $440.00 in recoverable costs. There should be $293.98 in the Trustee's suspense account according to my tracking of deposits and disbursements contained the Servicers' loan histories. (*See* Exhibit B. — Mortgage Map #1, p. 8-9)

In contrast, I find that when the Penas' loan is recalibrated as of November 3, 2003, the date of their second bankruptcy petition, and the Court's Order of March 22, 2005 is treated as fully implemented, the Penas should be current and in good standing as of June 27, 2007. Their outstanding principal balance should be $38,849.88; their escrow balance should be $0.00; their escrow advance balance should be $0.00; Court approved late charges should be incorporated into their modified plan as should legal fees and costs; in addition, the Penas should have $68.47 in their suspense account. The Trustee's suspense account should reflect an outstanding balance due of $9,290.07 which remains after Trustee payments of $6,541.93 are applied against arrearages totaling $15,832.00. Finally, the status of the Penas' loan may be further offset if certain missing checks were negotiated by the Servicers. (*See* Exhibit J. — Mortgage Map #2, p. 8)

For the Court's convenience, I have summarized the "Status of the Pena Loan as of 6/27/07" in a side-by-side comparison attached hereto as Exhibit "13." (*See* Exhibit 13. - Status of the Pena Loan)

Trustee Payments

One of the most troubling aspects of how the Penas' loan has been serviced throughout the course of their bankruptcy involves the Trustee's suspense account. To aide the Court on this topic, I constructed two exhibits that compare the way Washington Mutual and Wells Fargo should be handling the Trustee's payments versus the way they were/are handling them.

Exhibit "14." is a very simple accounting of how Washington Mutual should have booked the Penas' prepetition arrearages of $11,505.54, and postpetition

arrearages of $4,326.46 i.e., these are both "receivables" quantified in my illustration as negative items. Each Trustee payment tendered is a positive item that reduces the obligation *pro tanto* until the plan is fully funded and the arrearages are extinguished. (*See* Exhibit 14. - Bankruptcy Compliant Trustee Account)

In contrast, Exhibit "15." illustrates how the Servicers have allocated the Trustee's payments and shows that of the $6,541.93 paid to date $3,032.42 has been applied to postpetition payments in derogation of the Bankruptcy Code and the Penas' confirmed plan. The danger in handling the accounting this way, as Judge Magner admonished, is that the "in and out" transactions cloak what is really going on and make it extremely difficult for anyone to detect whether the Servicer is diverting Trustee payments to non-approved items. (*See* Exhibit 15. - Application of Trustee Payments)

LOSS MITIGATION RELIEF PURSUANT TO 24 CFR 203.355

Summit Mortgage Corporation made this loan pursuant to Section 203(b) of the National Housing Act, which promotes affordable home ownership opportunities to low and moderate-income persons such as the Penas by providing mortgage insurance that mitigates the risk for investors who ultimately provide the funding. Congress understood when it passed the National Housing Act that homeowners in this category were especially susceptible to life's vicissitudes and provided relief for those who fell upon hard times.[1]

Section 203(b) loans place restrictions on lenders and loan servicers in the event of default to forego acceleration and foreclosure until they have complied with regulations of the Secretary of the Department of Housing and Urban Development. Paragraph 6(B) of Mr. Pena's Fixed Rate Note and paragraph 9(a) & (d) of his Deed of Trust contain these limitations.

HUD Mortgagee Letter 00-05 clarifies HUD's policies and states in part: "Though lenders have great latitude in selecting the loss mitigation strategy appropriate for each borrower, it is critical to understand that Participation in the loss mitigation program is not optional." HUD is serious about enforcing these provisions of the National Housing Act and may impose treble damages on Servicers who fail to offer relief to homeowners desiring to avert foreclosure. (*See* Exhibit 16. - HUD Mortgagee Letter 00-05)

Part of my review in this matter involved reading through various collection letters and logs maintained by Washington Mutual. I did not see anything in those documents that indicated Washington Mutual inquired about the cause of the Penas' delinquency or offered loss mitigation relief pursuant to 24 CFR

[1] **12 USCS § 1715u. Authority to assist mortgagors in default**.
(a) **Loss mitigation**. Upon default of any mortgage insured under this title, mortgagees shall engage in loss mitigation actions for the purpose of providing an alternative to foreclosure (including but not limited to actions such as special forbearance, loss modification, and deeds in lieu of foreclosure, but not in-cluding assignment of mortgages to the Secretary under section 204(a)(1)(A) [12 USCS § 1710(a)(1)(A)]) as provided in regulations by the Secretary.

203.355. On the contrary, Washington Mutual renewed its attempts to fore-close upon the Penas at every opportunity, hampered only by the automatic stay imposed by Section 362 of the Bankruptcy Code.

Washington Mutual's collection log states that loss mitigation efforts were started on January 28, 2003, when Mr. Pena faxed a financial statement that was part of a workout package he had requested. The log goes on to say that the workout was approved on February 5, 2003 and the loan was reinstated. Mort-gage Map #1, page 4, shows that the Penas sent $1,500.00 on February 27, 2003 and resumed making regular mortgage payments of $763.09 which Wash-ington Mutual posted on March 21, April 3, and April 30, 2003. All of these funds were placed in the Penas' suspense account and were not credited to-wards the mortgage obligation. The collection log shows that Mr. Pena called Washington Mutual repeatedly between June and September 2003 to ask for an update on his workout plan. He was bandied about and unable to cut through Washington Mutual's chain of command until September 4, 2003 when the log indicates "WORKOUT FAILED, RESTART FCL."

In my opinion, Washington Mutual's collection log indicates that Mr. Pena was diligent in his efforts to communicate with Washington Mutual, in partic-ular, during the months leading up to the filing of his second bankruptcy. There appears to have been a breakdown in communication at Washington Mutual that made it impossible for Mr. Pena to get the information he needed. To un-derstand the Penas' mounting frustration in dealing with Washington Mutual, one need only read the collection log between January 28, 2003 and Novem-ber 3, 2003 when the exasperated couple were left with no alternative but to file for bankruptcy — one week after they had been discharged from their first bankruptcy — in order to save their home from foreclosure. (*See* Exhibit 17. - Collection Log, 11/9/01 to 11/10/03)

I had an opportunity to speak to Mr. Pena briefly about what led to his ex-tended period of delinquency and learned that he was involved in two serious motor vehicle accidents in 2001 and 2002 that put him out of work for a sus-tained period of time. In the first instance, a non-licensed, uninsured driver ran a stop sign on his way to an "AA" meeting. Mr. Pena hit him head-on totaling both vehicles which caused the toolbox in the trunk of his car to fly into the front seat injuring his spine and sandwiching him between the two crash points. The second accident occurred on June 23, 2002 when Mr. Pena was rear-ended while stopped at a traffic light. Mr. Pena's injuries were so debilitating he was out of work and in therapy for many months. Due to lack of adequate insur-ance, Mr. Pena was unable to afford back surgery, estimated to cost over $150,000.00, which would have restored him to health. No longer able to per-form his duties, Mr. Pena had to settle for a lower-paying job.

These circumstances are precisely what the Loss Mitigation provisions of the National Housing Act attempt to address. Washington Mutual had discre-tion to help the Penas stabilize their homeownership by offering one or more loss mitigation tools that would permanently lighten their load. Rather than force the Penas to file a second bankruptcy, for example, Washington Mutual

could have offered a "Partial Claim," which would have enabled the Penas to cure their default by making one monthly payment and deferring all remaining arrearages to the end of their loan under a non-interest bearing Note secured by a second mortgage.[2]

Wells Fargo has this same opportunity and could, if it had the will, repackage some or all of the Penas' outstanding arrearages of $9,290.07 as a partial claim thus reducing, not increasing, plan payments. In addition, this Court could find that the Servicers involved here may not be entitled, under the Penas' mortgage contract and Regulations of the Secretary, to recover collection costs and legal fees if it were to find they willfully failed to offer HUD-mandated loss mitigation relief.

RESERVATION OF RIGHTS

I am aware that additional research is necessary to resolve several outstanding questions. Accordingly, the opinions given here may change or further develop as more information becomes available. I am happy to answer any questions or be of further assistance as the Court requests.

Respectfully submitted,

Marie McDonnell
Mortgage Fraud and Forensic Analysts
TRUTH IN LENDING AUDIT & RECOVERY SERVICES, LLC
P.O. Box 2760, Orleans, MA 02653
Tel. (508) 255-8829 Fax (508) 255-9626

"The only person entitled to enforce a note is the 'holder' of the note. Thus, the real party in interest rule requires the holder of the note to bring the motion for relief from stay."

Judge Samuel A. Bufford

[2] **PARTIAL CLAIM**: "Under the partial claim option, a lender will advance funds on behalf of a borrower in an amount necessary to reinstate a delinquent loan (not to exceed the equivalent of 12 months PITI). The borrower, upon acceptance of the advance, will execute a promissory note and subordinate mortgage payable to HUD. Currently, these promissory or "partial claim" notes carry no interest and are not due and payable until the borrower either pays off the first mortgage or no longer owns the property." (See Mortgagee Letter 00-05, p. 24)

"Since the securitization process allows for more profit the more predatory (and therefore, illegal), the loan is, there is an inherent incentive to violate the borrowers' rights during the origination and servicing processes."

Ohio Attorney, Daniel L. McGookey

Rescission of Your Toxic Loan

After you have had your loan professionally audited, your auditor may recommend that you in rescind (cancel) your toxic loan and send it back to the predators that created it. The Truth in Lending Law requires that you, the borrower, exercise your right for rescission. However, under a special power of attorney, your auditor can rescind it on your behalf.

The right of rescission is normally granted for three days following your loan closing. As per the Truth in Lending Act (TILA), your lender includes a right of rescission notice in your closing documents. If you have "buyer's remorse" or get cold feet, you can cancel the transaction and get your money back.

The right to rescind can be expanded up to three years in the case of predatory lending practices. And if you detect fraud on the part of your lender, your right to rescind is extended further. The right to rescind is typically related to the refinancing of a primary dwelling used for personal, household and family use.

When you inform your lender of your wish to rescind your loan, your lender must return all monies and fees collected from you. You can demand that these monies be returned to

you, or you can set up an escrow account to hold the funds until your predatory lawsuit is concluded.

In order to rescind your loan, you must send a letter to your lender, stating "I wish to rescind my loan." However, it is best to fully document the reasons for your rescission. Rescission is also a defense against foreclosure.

Since the reasons you wish to rescind are complex, it is best to have your auditor or attorney write the rescission letter on your behalf. If you write it yourself, the chances are you will not receive a response from your lender, or you will receive a threatening letter.

Here is an example of a rescission letter sent by a qualified forensic auditor, who was operating under a "Special Power of Attorney" on behalf of the homeowners:

June 25, 2007
FIRST NATIONAL BANK OF ARIZONA, N.A.,
its Successors and/or Assignees
c/o Christopher DiCicco
Litigation Coordinator
GMAC ResCap, LLC
100 Witmer Road
Horsham, PA 19044
TEL. (215) 682-1307 FAX. (866) 340-3843

RE: NOTICE OF RESCISSION OF MORTGAGE TRANSACTION
OF JUNE 26, 2006
TIMOTHY K. KEEFER AND TIFFINI C. KEEFER
5061 Kahler Court, N.E., Albertville, Minnesota 55301
GMAC Loan No. 0360102513

Dear Attorney DiCicco:
Timothy and Tiffini Keefer ("The Keefers") have authorized and instructed me under the attached Special Power of Attorney to provide notice that they are hereby exercising their extended right to rescind the above referenced mortgage loan transaction. (See Exhibit 1. ~ Special Power of Attorney)

This Notice of Rescission is supported by and provided pursuant to the Federal Truth in Lending Act, 15 USC § 1635 and § 1640 ("TILA" or "Act"), and Regulation Z § 226.23 ("Reg. Z") which implements the purpose of the Act.

On information and belief, Residential Funding Corporation ("RFC") now holds the Keefers' mortgage obligation and you are authorized to accept and respond to this Notice of Rescission on their behalf. Please be advised that my delivery of the Keefers' Notice of Rescission voids the security interest held by RFC and is effective immediately regardless of your response to this notice. Additionally, the promissory note is also void because it is part of the transaction and the Keefers have no obligation to pay any finance or other charge concerning their transaction as those are now cancelled by operation of law.

Pursuant to the Regulation, RFC has twenty (20) days after receipt of this notice of rescission within which to return to the Keefers any money or property given as earnest money, down-payment, or otherwise, and to take any action necessary or appropriate to reflect the termination of any security interest created under the transaction. Accordingly, RFC must cancel and return the original Note and Mortgage to the Keefers and record a discharge of the latter at the Wright County Registry of Deeds. If RFC ignores this rescission notice, RFC will be liable to the Keefers for actual and statutory damages pursuant to 15 USC § 1640(a). Moreover, such inaction may cause the proceeds of the loan to vest in the Keefers without further tender.[1]

THE EXTENDED RIGHT TO RESCIND UNDER TILA

In a loan subject to rescission, the period within which a consumer may exercise the right to rescind runs for three business days from the last of three events: 1) of consummation of the credit transaction; 2) delivery of all material disclosures; 3) delivery to the consumer of the required rescission notice. [See 15 USC § 1635(a)]

Failure to deliver accurate material disclosures or to provide proper notice of the consumer's right to cancel the transaction suspends the triggering mechanism so that the three-day right never commences. Common violations occur when, for example, the creditor makes a

significant mathematical error in calculating the "material disclosures" contained in its federal Truth In Lending Disclosure Statement; fails to state the proper expiration date on the rescission notice; or fails to provide a Truth In Lending Disclosure Statement or the requisite number of rescission notices in a form that the consumer can take from the closing. In such circumstances, the timing bell is never sounded and the consumer's right of rescission will not expire until three business days after the correct disclosure is finally delivered; or until the earlier of three years after consummation, or the transfer of all of the consumer's interest in the property.

BACKGROUND

The Keefers have lived in the mortgaged premises as their primary residence since they purchased the property on December 17, 2002. Timothy Keefer is head of household and the sole wage earner for the family. He alone is obligated on the subject Adjustable Rate Note, but both he and his wife, Tiffini, are Mortgagors as they own their home jointly. The refinance here in question was for personal household and family purposes which makes this a consumer mortgage transaction subject to 15 USC §§ 1635 & 1640 and Regulation Z § 226.23.

To better understand why the Keefers wish to rescind this transaction it is important to know that their pre-existing first mortgage loan was taken out on March 31, 2004 with a local Minnesota bank they knew and trusted, Voyager Bank. The principal amount borrowed was $285,000.00 and was financed at a fixed rate of 5.50% for thirty years. Their monthly payments for principal and interest were an affordable $1,618.20. (See Exhibit 2. ~ Fixed Rate Note, 3/31/04)

Last year at about this time, the Keefers were contacted by Dan Vagts, a Senior Loan Officer with Source Lending Corp. of Brooklyn Park, Minnesota, who suggested the Keefers consolidate their first and second mortgage loans and refinance into an ostensibly more affordable "payment option" Adjustable Rate Mortgage loan that he told them would save the Keefers about $1,000.00 per month in mortgage payments. Mr. Vagts explained in various e-mails to Mr. Keefer that the loan product he was offering bore an interest rate of

1.50% that was "set for 10 years (does not change)." He went on to say that the Keefers would be saving $12,000.00 per year for a total of $120,000.00 over the course of the first ten years.

Mr. Keefer thought this offer sounded too good to be true and questioned Mr. Vagts both orally and in writing about his representations. In particular, Mr. Keefer wanted to know that if he made the "scheduled payments" would those, at the very least, cover the interest and not add to his loan balance. Mr. Vagts assured Mr. Keefer that they would and persuaded him that he had accurately described the loan; he even helped to lay out a strategy for using the savings the Keefers would enjoy on their first mortgage to pay off their Home Equity Line of Credit. For your reference, I have attached hereto Mr. Keefer's handwritten notes taken contemporaneously during a conversation with Mr. Vagts prior to applying for the subject loan. In addition, I am supplying Mr. Keefer's statement describing his under- standing of how this loan would operate. (See Exhibit 3. ~ Handwritten Notes & Statement)

Concerned about trading in his well-priced fixed rate mortgage loan for a variable rate product, Mr. Keefer moved forward with an application only after Mr. Vagts had convinced him that the Adjustable Rate Mortgage loan he was promoting would function just as he described. Having allayed their fears, Mr. Vagts processed the Keefers' loan which they consummated on June 26, 2006.

As soon as the ink was dry, the originating lender, First National Bank of Arizona, N.A., sold the loan to RFC and transferred the servicing rights to GMAC Mortgage, a related company. Several weeks later, GMAC Mortgage issued its first monthly mortgage statement which contained information contradicting everything Mr. Vagts had told the Keefers about how this loan would function.

Mr. Keefer immediately picked up the phone and called GMAC Mortgage. He spoke to a customer service representative who explained that if he made only the minimum payment scheduled, that would not be sufficient to cover the interest [now accruing at the fully indexed rate of 7.875%] and thus, negative amortization would result. Furious at this news, Mr. Keefer immediately contacted Mr.

Vagts and demanded that he issue a written statement reaffirming his earlier representations i.e., that if the Keefers made their scheduled payments, their loan balance would remain approximately level. Mr. Vagts complied and sent an e-mail to Mr. Keefer stating: "I Dan Vagts helped Tim Keefer complete a loan. If he makes the scheduled payments for the first five years, his loan amount will stay very close the same start balance." (See Exhibit 4. ~ E-mail of 7/24/06)

Feeling duped and betrayed, the Keefers were no sooner "into" this loan than they wanted "out." It was at this point that the Keefers realized they had unwittingly signed a prepayment penalty rider that would further strip their hard earned income and equity if they refinanced prematurely. Frustrated, and with nowhere to turn, Mr. Keefer began exploring the internet to see where help could be found. He happened upon "The Mortgage Professor"[2] who has a website devoted to educating consumers about mortgage financing. Professor Jack M. Guttentag referred Mr. Keefer to me.

FACTUAL BASIS FOR THE KEEFERS' RESCISSION

The federal Truth In Lending Act and its implementing Regulation Z require that each party entitled to rescind a consumer credit transaction shall receive two copies of the rescission notice in a form they can take from the closing.[3]

Failure to date the Notices at all, or improper disclosure of the date of the transaction or the expiration date for the three-day cooling-off period violates the regulations and gives rise to the extended right to rescind.[4]

When Mr. Keefer first contacted me, I asked him to send me a complete copy of the settlement file he was provided at closing. I was clear in my instructions that he should send me everything he had, including what may appear to be duplicates. In addition, I asked him to provide the "early disclosures" he should have received within three days of having submitted his loan application through Source Lending Corp. Finally, I asked to see the paperwork for the first and second mortgage loans that were paid off through the June 26, 2006 refinancing.

In response to my request, Mr. Keefer told me that he did not have any "early disclosures" for the subject loan. He reproduced the loan origination file and sent me copies of everything he was given at closing with respect to the subject transaction. I found only one (1) Notice of Right to Cancel which was defective in that it did not contain the date of the transaction or the date the re-scission period expired. Hence, the originating lender failed to deliver even one (four were man-dated) compliant Notice of Right to Cancel which, according to 15 USC § 1635(a); Reg. Z § 226.23(b), affords the Keefers an unequivocal extended right to rescind the subject transaction for up to three years from the consummation date which expires at midnight on June 25, 2009. (See Exhibit 5. ~ Notice of Right to Cancel)

MATERIAL DISCLOSURE VIOLATIONS

In light of the problematic history of this transaction, I find it particularly troubling that the Keefers could not produce any "early disclosures" which might have tipped them off to the fact that their mortgage broker was not accurately representing the terms and the cost of this highly complex Alternative Mortgage Transaction which Alan Greenspan branded "exotic" and Business Week labeled "toxic."

One thing is for certain, there is no way, short of full affirmative disclosure, that the Keefers could have known that their "scheduled payments" were established using a contrived "payment rate" of 1.49% but their monthly interest would accrue at the fully indexed rate of 7.625%.

The attached "Adjustable Rate Mortgage Loan Program Disclosure, Monthly Treasury Average Index-Payment Caps, All States Except New York" provided on the day of settlement is wholly inadequate to explain how this loan will operate. (See Exhibit 6. ~ ARM Disclosure)

The Truth In Lending Disclosure Statement, though compliant with respect to the material disclosure provisions of Regulation Z as presently written, is nevertheless in violation of the Truth In Lending Act for failing to "clearly and conspicuously" disclose: 1) how this loan would function; 2) that a deeply discounted "teaser rate" impacting

the setup of the loan was good only for one month; 3) that the true rate of interest was 7.625%; 4) that this loan was intentionally set up from inception to incur negative amortization that would bite into the Keefers' home equity; 5) the history of the Index used to calculate monthly interest rate changes; and 6) that depending on rising interest rates, the negative amortization ceiling could prematurely force amortizing payments sooner than expected thus placing a greater burden on the Keefers' income and ultimately, putting their home needlessly at risk. (See Exhibit 7. ~ Truth In Lending Disclosure Statement)

Had the Keefers the benefit of my counseling and the opportunity to see my Truth In Lending Analysis for this loan prior to settlement, they never would have refinanced away from their 5.50% fixed rate first mortgage for this volatile and costly negative amortization ARM loan whose rate sits presently at 8.375% and climbing. (See Exhibit 8. ~ Truth In Lending Analysis)

MINNESOTA PREDATORY LENDING LAWS

This spring, the Minnesota legislature enacted the strongest predatory lending laws in the country which passed the Senate unanimously and won by a huge margin in the House. In Minnesota the message is clear: if you prey on vulnerable homeowners, you will face tough civil and criminal penalties.

Specifically, the new law forbids equity stripping; flipping; churning; making loans without regard to the borrower's ability to pay; steering; giving a borrower a worse loan than what they qualify for; refinancing borrowers out of low-interest loans unless they have been counseled; making, facilitating, or receiving a loan through the use of deliberate misstatement, misrepresentation, or omission; criminal penalties are authorized for those who commit such acts.

On the affirmative side, mortgage brokers now have a duty to act in the borrower's best interest and in the utmost good faith towards borrowers; they must not compromise a borrower's right or interest in favor of another's right or interest, including a right or interest of the mortgage broker. Lenders must inform borrowers of whether or not their monthly payment includes taxes and insurance and to

inform them of the payment amount for those items. Lenders must ensure that in any refinance transaction, the borrower receives a net tangible benefit.

In the instant case, the Keefers' mortgage broker clearly steered them into a loan, bordering on subprime, that was not in their best interest and induced the Keefers to refinance out of a premium priced fixed rate first mortgage loan that cannot be duplicated in today's market. Source Lending Corp. was handsomely compensated for originating this loan through a yield spread premium of $9,660.00 paid behind the scenes by FNBA. In addition, Source Lending Corp. collected fees of $857.00 from the proceeds of the Keefers' loan bringing the total to $10,517.00.

It also appears that there is an affiliated business arrangement between Source Lending Corp. — the mortgage broker who originated the Keefers' loan; Source Title Agency, LLC — who closed the loan on behalf of FNBA; and Title & Closing, Inc. of Bloomington, Minnesota — the title insurance company who insured the lender. Notably, Source Title Agency, LLC and Title & Clos-ing, Inc. are located at the same address. (See Exhibit 9. ~ Registrations with MN Secretary of State & MapQuest)

Earlier this year, the Minnesota Department of Commerce announced a major crackdown on "Sham Affiliated Title Agencies" who created these entities to mask RESPA-prohibited kick-backs. Presently, the DOC has over 600 enforcement cases underway. (See Exhibit 10. ~ DOC Press Release & Chart)

Finally, I am very concerned about how First National Bank of Arizona is disclosing, or failing to disclose properly, its Payment Option Adjustable Rate Mortgage loans as critical material terms of this highly complex mortgage product are being withheld.

CONCLUSION

My delivery of this valid Notice of Rescission commences the 20-day period within which RFC must execute steps two and three of the statutory rescission process; therefore, time is of the essence as your 20-day deadline expires on July 16, 2007.[5]

To facilitate this rescission so that it goes by the book, I will arrange for a Minnesota Title Company in good standing to act as a fiduciary. The fiduciary will hold RFC's discharge of mortgage and remittance of funds in escrow until the Keefers are able to complete their tender obligation through a refinance of their property.

Should RFC fail to abide by the administrative procedures and 20-day deadline outlined in the statute it risks jeopardizing the Keefers' ability to consummate the refinance that will enable them to meet their tender obligation. The consequences of such noncompliance could result in a vesting of the outstanding principal in the Keefers, thus relieving them of their tender obligation altogether.

A necessary part of computing the amount of money RFC must return to the Keefers involves, on my part, an audit of their loan. Therefore, I ask that you kindly provide me at once with a life of loan history dating from the inception of this transaction as well as the name and contact information of a person in authority who can work with me through the rescission and tender processes.

Congress intentionally provided consumers with the right to rescind certain eligible mortgage transactions as a self-enforcement mechanism intending that they should be able to do so without having to litigate their claims. The Keefers have duly authorized me under a Special Power of Attorney to send you this Notice of Rescission, to outline the basis for their claim, and to see them through the administrative process under guidance of qualified TILA counsel.

The Keefers are ready, willing and able to meet their tender obligation and have already applied for a new loan which will enable them to tender in short order, but your performance must come first.

I look forward to working with you in the spirit of cooperation to see this process through to a successful conclusion. Moreover, the Keefers are willing to cooperate with RFC and GMAC Mortgage if it will help them to seek recourse for any losses incurred as a result of this rescission.

Kindly acknowledge receipt of this Notice at your earliest possible convenience as time is of the essence.

Sincerely yours,

Marie McDonnell
Attorney-in-Fact for Timothy K. Keefer
Attorney-in-Fact for Tiffini C. Keefer

ATTACHMENTS:
EXHIBIT – A ~ Special Power of Attorney
EXHIBIT – B ~ Fixed Rate Note, 3/31/04
EXHIBIT – C ~ Handwritten Notes & Statement
EXHIBIT – D ~ E-mail of 7/24/06
EXHIBIT – E ~ Notice of Right to Cancel
EXHIBIT – F ~ ARM Disclosure
EXHIBIT – G ~ Truth In Lending Disclosure Statement
EXHIBIT – H ~ Truth In Lending Analysis
EXHIBIT – I ~ MN-SOS Registrations
EXHIBIT – J ~ MN-DOC Press Release

COPIES: Timothy and Tiffini Keefer
 Professor Jack Guttentag
 Matthew P. Boyer, Senior Investigator Enforcement
 Division Minnesota Department of Commerce

SERVICE LIST

First National Bank of Arizona
MS AZ-4003-078
1665 W. Alameda Drive
Tempe, AZ 85282-3200
Fax: 602-636-7096

c/o Christopher DiCicco
Litigation Coordinator
GMAC ResCap, LLC
100 Witmer Road
Horsham, PA 19044
Tel. (215) 682-1307

Timothy K. Keefer
Tiffini C. Keefer

Matthew P. Boyer
Senior Investigator
Enforcement Division
85 7th Place East, Suite 500
St. Paul, MN 55101-2198
Phn: 651.296.5730

Jack Guttentag
jguttentag@mtgprofessor.com

As you can see from this rescission letter, the auditor is requesting the funds to be held in a third party account. If you are filing a legal complaint against your predatory lender, you can have your attorney hold these funds.

If your lender refuses to rescind your loan and chooses to break the law instead, your auditor may recommend that an attorney write a demand letter to your lender before beginning litigation.

A demand for settlement is a letter notifying your lender of your intention to sue if your demands are not met promptly. The letter outlines your lender's violations of law and your hardship as a result of them. It also discusses the issues that would be included in your legal complaint, and what damages you may be rewarded. It provides for a limited amount of time for your lender to respond, usually ten business days.

There are other alternatives being advertised daily in the media for "loan modifications" and "loan restructures." Be extremely careful of such service offerings. First, a securitized loan cannot be legally modified as the lender cannot produce the parties who actually own the note and must agree in writing to a modification. Second, a modification offered by your mortgage servicer will not significantly reduce your full principal and interest amount. Instead, your servicer will waive its 25% fee, which is all it can do by law.

If you have been a victim of fraud and illegal securitization, your best bet is to demand full loan extinguishment. This will require your attorney filing a complaint against your lender.

[1]See 15 U.S.C. § 1635 (b); Reg. Z § 226.23(d)(2); Official Staff Commentary § 226.23 (d)(2)-3)

[2] Jack M. Guttentag is Professor of Finance Emeritus at the Wharton School of the University of Pennsylvania. (http://www.mtgprofessor.com/Default.htm)

[3]See 15 USC § 1635(a); Reg. Z § 226.23(b)

[4]Jackson v. Grant, 890 F.2d 118 (9th Cir. 1989) (notice of right to cancel specified March 1 as expiration date, but event con¬stituting consummation did not occur until April 29, so a proper notice was never given): Riopta v. Amresco Resi-dential Mort¬gage Corp., 101 F. Supp. 2d 1326 (D. Haw. 1999) (closing actually occurred on Oct. 13, but documents said it occurred on Oct. 9 and that rescission period expired on Oct. 14). See also Smith v. Wells Fargo Credit Corp., 713 F. Supp. 354 (D. Ariz. 1989) (when creditor sent out corrected material disclosures, it should have sent new rescission no-tice showing that expiration date was three days from delivery of corrected disclosures).

[5]See 15 USC § 1635(b), Reg. Z § 226.23(d)(2); Official Staff Commentary 226.23 (d)(1)-1

"Citizens of the United States shall not
be deprived of life, liberty or prosperity
without due process of law."

The Constitution of the United States

CHAPTER 9

Suing Your Predatory Lender

Y ou have gathered a lot of crucial information regarding your toxic loan and your broker and lender's predatory practices. You have given your lender opportunities to restructure your loan. Your next step is to sue your lender in court by hiring an attorney to represent you and write your complaint. Your complaint is where you will document the facts of your case, allege wrongdoing, and demand relief from the court.

Some people have fought their mortgage wars acting as their own attorney, but it is not advisable. Your lawsuit touches on contract law, real property law, securities law and consumer law. It may even involve criminal allegations, such as racketeering or criminal fraud.

You don't want to personally tangle with your lender. It is common for lenders to forge documents, particularly assignments and transfers of notes. You need a skilled representative who can cut through these frauds and hold your lender accountable.

Your best bet is to cast a wide net in looking for a competent attorney, negotiate a contingency agreement, and get

working on your complaint. A contingency agreement makes your attorney your partner in your case. It cuts down on monthly legal bills. A good complaint can cost anywhere from ten thousand to thirty-five thousand dollars. If you lawyer is working on a contingency agreement, all you pay is an upfront retainer to cover filing fees. Your attorney writes your complaint and litigates your case in exchange for a percentage of damages. You can go to www.yourmortgage-war.com for a referral for a qualified attorney. Here is an example of a contingency agreement for you to review:

EXAMPLE OF CONTINGENCY AGREEMENT

Thank you for selecting our firm to represent you in the above referenced matter (hereinafter referred to as the "Dispute").

This letter, when countersigned by you, will constitute a written fee agreement and will apply to and cover all services provided by us or any law firm and/or attorneys hired by us, or associated with us, in pursuing your claim relating to the Dispute. We will provide you with all appropriate legal services including hiring or associating with any other law firm and/or attorneys deemed necessary by us or you in connection with the Dispute, but we do not undertake to provide advice in specialized areas such as tax or bankruptcy. We make no representation regarding nor do we warrant the probable outcome of the Dispute.

We have agreed to represent you on a contingency fee basis and you have agreed to pay to us for our professional services only a fee of thirty three and one third percent (33%) of damages awarded to you, obtained by us on your behalf in this matter. Damages include monies awarded to you based upon a judge's determination of violations committed by your broker/lender et al in this case. In addition, we will request reasonable attorney's fees and expenses from the court.

In addition to fees, you will be responsible for the payment of any unreimbursed costs incurred by our firm in acting on your behalf in the Dispute including; without limitation, the following costs: postage, photocopy, filing and court fees, service and process fees, investigation expenses, graphic artists and filming fees, interpreters fees,

expert witness fees, records copying fees, deposition costs, private investigator fees, travel costs, jury fees, computerized legal research fees, jury consultant fees, mail, messenger and delivery charges and any and all costs related to any arbitration or trial of the Dispute.

You hereby authorize our firm to incur all reasonable costs and to hire any investigators, consultants and/or expert witnesses deemed necessarily by our firm.

We make no representations regarding and do not warrant the total amount of the costs or expenses which will likely be incurred by you as a result of our representation of you in the Dispute except that they will not involve any portion of our office overhead or administrative costs, expenses or supplies or any costs incurred by us in associating with any other law firms or attorneys to act in this matter on your behalf.

You have agreed to pay to us a retainer in the amount of Two Thousand Five Hundred dollars ($2500) for the costs which will be incurred by us in acting on your behalf in the Dispute. It is understood and agreed that this initial retainer may be exhausted in connection with our representation of you in the Dispute. When the retainer has been exhausted, we may require an additional retainer. At the conclusion of our representation of you, any excess money paid by you to us as a retainer will be refunded to you.

We make no representation regarding nor do we warrant the total amount of costs or expenses likely to be incurred by you as a result of our representation of you in the Dispute.

You further agree that if you terminate this agreement and retain other counsel to act on your behalf in the Dispute that you will reimburse our firm for any and all costs advanced by our firm immediately upon you retaining substitute counsel.

You hereby grant our firm a lien on any claims or causes of action based thereon arising from the Dispute and on any sums received by you in settlement or in payment of any judgment pertaining to the Dispute for our firm's professional fees and any unreimbursed costs incurred by our firm in acting on your behalf in the Dispute.

If you discharge our firm prior to any offer being made to settle

your causes of action or claims being received by us on your behalf, our lien will be based on the number of hours expended by lawyers employed by, or associated with, our firm to the date of our discharge times an hourly rate of Six Hundred and Fifty Dollars ($650) per hour for time incurred by (Attorney's Name); Four Hundred and Seventy Five Dollars ($ 475) per hour for time incurred by (Staff Attorney); Three Hundred and Seventy Five Dollars ($375) per hour for time incurred by (Staff Attorney); Two Hundred and Seventy Five Dollars ($275) per hour for time incurred by (Staff Attorney)and One Hundred and Twenty Five Dollars ($125) for time incurred by legal assistants, paralegals or law clerks employed by, or associated with, our firm.

Should there be any dispute between you and our firm arising from or relating to this fee agreement which leads to litigation or arbitration, the prevailing party shall recover their reasonable attorney's fees and costs incurred in connection with any such dispute, including; without limitation, those incurred in any proceedings to enforce or collect on any award or judgment.

You have acknowledged that you have received, or have knowingly waived, the right to obtain independent legal advice regarding this agreement and that this agreement has been arrived at after a fair opportunity to negotiate its terms.

The provisions of this agreement are severable to the extent reasonably necessary to effectuate the party's intent in the event any provision or provisions of this agreement are held to be void, voidable or unenforceable. In that event, the remaining provisions shall remain in full force and effect.

As we have previously advised you, it is your responsibility to cooperate fully with us in assisting you in the Dispute by, among other things, providing us with all relevant information and documents and by making yourself or any other knowledgeable individual reasonably available for consultation, interviews and/or discovery.

Without limiting the generality of the foregoing, you will be responsible for providing us with any factual information that may be necessary for a consultant to conduct a forensic audit and for our firm to competently and professionally represent you in the Dispute, or

that we may otherwise request and confirming the completeness and accuracy of such information.

Would you please confirm your agreement to the terms and conditions of our engagement to act on your behalf in the dispute by signing and dating this letter in the space provided below and returning the signed original to us together with your check in payment of our retainer in the enclosed, self-addressed, stamped envelope.

We wish to thank you for placing your trust and confidence in our firm. We look forward to working together with you in our representation of you in the Dispute, and remain with kindest professional regards.

Yours very truly.

Stay away from predatory attorneys who want a piece of the "gross recovery" from the extinguishment of your loan. You want to keep your home. Therefore, you cannot enter into an agreement with an attorney that requires you to sell it in order to pay his bill.

Your legal complaint will be designed, not only to present your case, but to educate your judge as to the recent changes in foreclosure, bankruptcy and quiet title law.

A legal complaint is both a scientific document and an art form. A well written complaint reads like a novel: you can't put it down. You might want to review some of the complaints your attorney has written, or give him a copy of this book to get up to speed.

If you are forced to go pro se, you will have quite a bit of work to do to prepare and file your complaint. Starting with your natural fear of judges and courtrooms. When most people hear the word "lawyer" or "court," they cringe.

You need to stop viewing the courtroom as a torture chamber, and start viewing it as the battlefield on which you will wage and win your mortgage war.

If the courtroom is your battlefield, the judge is your commander in chief. Because unlike other laws, the laws regarding property, predatory lending and foreclosure, fall squarely on the side of the

consumer. These laws, summarized in the following chapters, consti-
tute your arsenal of legal weapons to use against the conspiracy.

To overcome your fear of the judge and the court, take an after-
noon and mosey down to your local courthouse. Sit in on a trial or
two. Get familiar with the players and the process. Observe the pro-
cedures and the rituals. Soon you will get absorbed by the drama of
procedures and rituals. You will intuit who is winning and losing, based
upon their skill, demeanor and comfort level in front of the judge.

You will also get a sense of the judge, who is supposed to be im-
partial. Judges are human, subject to prejudices, transferences and in-
fluence. That is why there is an appeals process. Analyze the judge's
behavior. Get a sense how open the judge is to evidence and oppos-
ing motions. This will help you plan your communication strategy
later on.

There is a psychology dedicated to the relationship between the
brain and language termed "neurolinguistic programming (NLP)."
This psychology pertains to how the brain processes language and
emotion. This psychology can be helpful in how your structure your
complaint and how you present yourself to a judge and jury. Percep-
tion is ninety percent symbolic. How you use time, space, energy,
power, affect and meaning will affect your performance in court. It is
advisable for you to review books related to body language and NLP
in preparing yourself for trial.

You may or may not want a jury to hear your case. Since your case
is technical, you may be better served by allowing only a judge to
reach a verdict. There is a theory in group psychology termed the
twenty-sixty-twenty rule of transformation. This means that twenty
percent of the jury will typically be watching the jury leader and the
judge for cues. Twenty percent will seek to defy a favorable verdict.
The middle sixty percent will be heavily influenced by the two groups.
When you are observing behavior in the courtroom, see if you can
determine which jury members fall into each group.

The purpose of the courtroom is to administer impartial justice.
The blindfold on "lady law" symbolizes that verdicts and orders are
not influenced by the personalities and character of those who seek

justice. Focus on organizing your facts and evidence in a logical way to make your case simple for a judge to understand.

The process of a trial is easy to understand. In a civil case like yours, opposing parties go before a judge to resolve a conflict. They may be represented by counsel, or they may go "pro se" and represent themselves. The party who brings suit is the "plaintiff" and the party who is being sued is the "defendant."

During a trial, oral statements, called "testimony" are heard from the parties and their witnesses. Facts of the case are called "evidence" and are presented. Both parties "argue" why they should win, citing similar cases and verdicts. Case precedents are provided as "briefs" for the judge to consider. Each party makes an opening and closing statement.

Each party presents witnesses who confirm the facts of the case. Expert witnesses testify about technical issues relevant to the case. Both parties can question each other's witnesses, through "direct" and "cross" examination. Upon closing statements, the judge will deliberate on the facts and merits of the case and reach a verdict.

Anyone can have access to the courts. There are some simple rules to follow. The first is jurisdiction, or the power of the court to rule based on the parties and complaint. You will need to determine which court in your city will hear your complaint. The second rule is a complaint must be filed before the case can be heard. The complaint must be served to all relevant parties. Then a trial date can be set.

A complaint details the parties in the case, the facts in question and alleges wrongdoing or "causes of action." The complaint seeks justice ("prayer for relief") from a judge's ruling. Along with the complaint, there is a summons which requires the defendants to respond to the complaint within a specified time (usually thirty days). If a jury trial is requested, it must be requested in the complaint.

The complaint must be filed with the court clerk, who will tell you the filing fees. Then a case number and a judge are assigned to the compliant. The court clerk enters the complaint on the court's calendar and a trial or motion date is set. Stamped copies are then served on all defendants by a process server or sheriff.

If the complaint is not answered, the plaintiff can file a default judgment, alleging everything in the complaint is correct. The defendant can request the judgment to be set aside and file a cross complaint. If the defendant does not set aside the judgment, a second hearing determines the amount of the judgment.

After all parties respond in writing to the complaint, a court date will be set to hear the case. Both parties will make a motion for "discovery" before trial. Discovery takes many forms: interviews based questions and sworn testimony (depositions); admissions of key facts and laws in the case; access to the premises of the parties; and written questions and answers (interrogatories). Discovery could take months, even years to complete.

Motions are filed and heard by the court. A motion requests the judge to sign an order for action. Frequent motions are motions to compel answers to interrogatories; to clarify or expedite discovery; to vacate default and to vacate judgment. Consider your motions as weapons to be used during discovery to soften the enemy. How you present your case is your missile attack.

When preparing for a case, great lawyers say they first write their closing argument. A case is won when you can prove each and every statement made in your complaint. This is done by presenting admissible evidence in the form of testimony from fact and opinion.

Testimonies are statements made in court under oath about the facts and perceptions of the case. Testimony can come from any person who has personal knowledge and experience with the facts, events and documents relevant to the case, and who swears to tell the truth under oath. Reluctant witnesses can be subpoenaed.

Another form of evidence is "judicial notice." This is a request for the court to pay particular attention to key documents in the case. Evidence is also expert testimony of witnesses who have specialized experience, knowledge or training. In predatory lending lawsuits, mortgage auditors are often used as experts. Another form of evidence is demonstrations of fact. These take the form of charts, graphs, video and audio testimony. These demonstrations can be dramatically presented to the court on oversized charts for effect.

The plaintiff puts on his case first. The plaintiff makes an opening argument, which details how the evidence will show why the plaintiff should win the case. The plaintiff then presents evidence, shows demonstrations, and questions witnesses and experts under oath.

During the trial, the opposing party may object to testimony, based on issues of competency (of the witness), relevance (of the evidence), materiality (to the importance of testimony) or foundation (based on a lack of facts). The judge listens to objections and rules to either "sustain" the objection (uphold it) or "overrule" it (disagree with it). The judge can also reserve ruling on an objection.

The opposing party also questions the witnesses ("indirect examination"). Then the plaintiff can "cross" examine the witness again.

At the end of the trial, the judge reaches a verdict. The verdict can be appealed. The purpose of the appeal is to determine whether the judge made errors during the trial. The Appeals Court may uphold the judge's order or overrule it. Appeals can progress all the way to the Supreme Court.

In a predatory loan case, the judge will rule on laws and violations which carry monetary damages. He will also rule on title, by determining whether the lender has standing on the note and mortgage to foreclose.

Use the cases in this book to familiarize yourself with complaints and causes of action. You can also go to a law library and read up on how to write a complaint. You might consider hiring a third year law student to teach you about the laws regarding predatory lending, if you choose to go pro se.

The following complaint illustrates many of the causes of action alleged in a predatory lawsuit. The facts of the case have been omitted to protect the litigant, a homeowner with a predatory loan. This case is currently in litigation.

Judges in at least five states have stopped foreclosure proceedings because the banks that pool mortgages into securities and the companies that collect monthly payments can't prove they own the mortgages. . . more than three trillion dollars of mortgages have been bundled into securities.

Bloomberg News, February 2009

CASE STUDY

Chevy Chase Predatory Lending Complaint

Case Study Eight

Robert Allan, Esq., (SBN 119010)
Martin B. Snyder, Esq. (SBN 78253)
Rod Rummelsbug, Esq. (SBN 201628)
ALLAN LAW GROUP P.C.
22917 Pacific Coast Highway, Suite 350
Malibu, CA 90265
Telephone: (310) 456-3024
Facsimile: (310) 317-0484

Attorneys for Plaintiff
SUPERIOR COURT OF THE STATE OF CALIFORNIA
COUNTY OF LOS ANGELES
PLAINTIFF'S NAME

vs.

PLATINUM CAPITAL GROUP, a California corporation; CHEVY CHASE BANK, F.S.B., a MARYLAND corporation; US BANK, a Delaware corporation and TRUSTEE FOR CCB LIBOR SERIES 2007 1 MIN NO.1000866-0011103912-1, status unknown; T.D. SERVICE COMPANY, a California corporation; MORTGAGE ELECTRONIC REGISTRATION SYSTEM, INC., a California corporation; MELMET DEFAULT SERVICES, INC., a California corporation; SECURITY UNION TITLE INSURANCE COMPANY, a California corporation; All Persons Unknown Claiming Any Legal or Equitable Right, Title, Estate, Lien, or Interest in the Property Described in the Complaint Adverse to Plaintiff's Title, or Any Cloud on Plaintiff's Title; and DOES 1 through 50, inclusive, Defendants.

CASE NO.
COMPLAINT FOR:
1. Intentional Misrepresentation
2. Negligent Misrepresentation
3. Fraudulent Concealment
4. Violations of Truth-In- Lending Act
5. Violation of Real Estate Settlement Practices Act
6. Violations of State Statutes
7. Quite Title
8. Violations of Business and Professions Code 17200
9. Injunctive Relief
10. Violations of Fair Credit Reporting Act

COMES NOW Plaintiff Name ("Plaintiff") and hereby alleges as follows:

SUMMARY OF ACTION

1. This is a predatory lending case involving deceptive, unlawful, fraudulent, and unfair residential real estate lending practices by Defendants. By this complaint, Plaintiff seeks rescission of her predatory loan, monetary and statutory damages for Defendants' violation of federal and state mortgage lending laws, monetary damages for Defendants' fraud, equitable and restitutionary relief for Defendants' violation of California *Business and Professions Code* Section 17200, statutory and contractual attorneys fee, and an order quieting fee simple title of Plaintiff's property to her. By this complaint, Plaintiff also seeks to enjoin Defendants' non-judicial foreclosure on her property.

PARTIES

2. Plaintiff is an individual residing in the City of Los Angeles, County of Los Angeles, State of California.

3. Plaintiff is informed and believes and thereon alleges Defendant PLATINUM CAPITAL GROUP ("Platinum") is a corporation organized and existing under the laws of the State of California, and at all times herein mentioned did business in the County of Los Angeles, State of California. Plaintiff is further informed and believes and thereon alleges that Defendant Platinum was, at the time of the loan transaction alleged herein, a licensed real estate broker and/or a licensed residential mortgage lender under California *Financial Code* Section 5000 *et. seq*, the California Residential Mortgage Lending Act. ("CRMLA.") Plaintiff is further informed and believes and thereon alleges that Defendant Platinum, under its residential mortgage lending license, provided "brokerage services" to home loan borrowers, including Plaintiff, as that term is defined in Section 50700 of the CRMLA. Plaintiff is further informed and believes and thereon alleges that on or about September 27, 2007, Defendant Platinum's residential mortgage lender license was revoked by the California Corporations Commissioner, pursuant to California *Financial Code* Section 50311.

4. Plaintiff is informed and believes and thereon alleges Defendant CHEVY CHASE BANK, F.S.B. ("Chevy Chase") is a corporation organized and existing under the laws of the State of Maryland and is a federally chartered and insured stock savings bank, and at all times herein mentioned did business in the County of Los Angeles, State of California.

5. Plaintiff is informed and believes and thereon alleges Defendant US BANK ("US Bank") is a wholly-owed subsidiary of US BANCORP, and the purported trustee for CCB Libor Series 2007-1 Min No. 1000866-0011103912 1, and is a corporation organized and existing under the laws of the State of Delaware, and at all times herein mentioned did business in the County of Los Angeles, State of California.

6. Plaintiff is informed and believes and thereon alleges Defendant T.D. SERVICE COMPANY ("T.D. Service") is a corporation organized and existing under the laws of the State of California, is a trustee in the business of conducting non-judicial foreclosures of real property in California, and at all

times herein mentioned did business in the County of Los Angeles County, State of California. Plaintiff is further informed and believes and thereon alleges T.D. Service was substituted as trustee under the deed of trust which is the subject of this complaint.

7. Plaintiff is informed and believes and thereon alleges Defendant MORT-GAGE ELECTRONIC REGISTRATION SYSTEM, INC. ("MERS") is a corporation organized and existing under the laws of the State of California, and at all times herein mentioned did business in the County of Los Angeles, State of California. Plaintiff is further informed and believes and thereon alleges MERS' corporate status has been suspended by the California Corporations Commissioner and that MERS is no longer a corporation in good standing in the State of California.

8. Plaintiff is informed and believes and thereon alleges Defendant MEL-MET DEFAULT SERVICES, INC. ("Melmet") is a corporation organized and existing under the laws of the State of California, and at all times herein mentioned did business in the County of Los Angeles, State of California.

9. Plaintiff is informed and believes and thereon alleges Defendant SE-CURITY UNION TITLE INSURANCE COMPANY ("Security Union") is a corporation organized and existing under the laws of the State of California, and at all times herein mentioned did business in the County of Los Angeles, State of California. Plaintiff is further informed and believes and thereon alleges Security Union is an agent for Defendant T.D. Service.

10. Plaintiff does not know the names or true capacities of Defendants identified as All Persons Unknown Claiming Any Legal or Equitable Right, Title, Estate, Lien, or Interest in the Property Described in the Complaint Adverse to Plaintiff's Title, or Any Cloud on Plaintiff's Title and DOES 1 through 50, inclusive, herein, and therefore sues these Defendants by fictitious name. (the "Fictitious Defendants.") The Fictitious Defendants are in some manner liable to Plaintiff, or claim some right, title, or interest in the property herein described that is subsequent to and subject to the interest of Plaintiff, or both. Plaintiff will amend this complaint to allege the true names, interests, rights, and capacities of the Fictitious Defendants when ascertained.

11. Plaintiff is informed and believes and thereon alleges at all times herein mentioned each of the Defendants was the agent, servant, or employee of each of the remaining Defendants, and in doing the things herein alleged was acting within the course and scope of such agency or employment. Plaintiff is further informed and believes and thereon alleges each Defendant approved, ratified, or affirmed the acts and conduct of each other Defendant or its officers or managing agents.

12. Except where otherwise alleged, Defendants US Bank, T.D. Service, MERS, Melmet, and Security Union are sued herein as nominal defendants only, so they will be bound by whatever order or judgment is issued by the court regarding the deed of trust and non-judicial foreclosure which is the subject of this complaint. Plaintiff reserves the right to propound discovery to said Defendants, and further reserves the right to amend this complaint to allege

substantive claims against said Defendants if discovery reveals said Defendants committed wrongful acts in the performance of their duties.

13. Each and every reference to "Defendants" in this complaint is intended and shall be deemed and construed to refer to all Defendants, named and un-named, including the Fictitious Defendants, against whom a cause of action is brought.

JURISDICTION AND VENUE

14. The events and transactions which form the basis of this complaint oc-curred in the County of Los Angeles, State of California, and within this judi-cial district.

15. Jurisdiction is proper in this court because the Defendants are located within this judicial district, do business within this judicial district, and the amount in controversy exceeds $25,000.

THE NATURE OF PREDATORY LENDING

16. There is no uniformly accepted definition of "predatory lending." How-ever, the United States Department of Housing and Urban Development ("HUD") has defined predatory lending as "involving deception or fraud, ma-nipulation of borrowers through aggressive sales tactics, or taking unfair ad-vantage of borrowers' lack of understanding about loan terms." *Curbing Predatory Home Mortgage Lending* (June 2000.) (HUD Report, at 1.) According to HUD, "[t]hese practices are often combined with loan terms that, alone or in combination, are abusive or make the borrower more vulnerable to abusive practices." Id.

17. Predatory lenders often target homeowners who have substantial equity in their homes.

18. HUD and the United States General Accounting Office ("GAO") have identified various lending practices as "predatory," including:

(a) engaging in aggressive, high pressure, and/or misleading sales tactics;

(b) lending without regard to borrowers' ability to repay;

(c) imposing excessive prepayment penalties that make prepayment diffi-cult if not impossible;

(d) offering to refinance borrowers' existing debt on more favorable terms and then, at closing, presenting loan documents with higher interest rates, points, and other charges than were originally disclosed ("bait and switch");

(e) failing to make accurate disclosures of points, prepayment penalties, interest rates, annual percentage rates, monthly payments, total loan amounts, and third-party costs;

(f) falsifying loan documents, including loan applications;

(g) charging excessive fees, points, and interest rates unrelated to borrow-ers' credit/risk profile ("packing");

(h) misleading borrowers about their credit/risk profile to steer borrowers to high cost loans not justified by borrowers' true credit/risk profile;

(i) making secured loans in amounts so high in relation to the value of borrowers' property such that the resulting debt-to-value ratio traps borrowers into a loan;

(j) inflating or falsifying property appraisals to justify the amount of loans. HUD Report, at 2; *Federal and State Agencies Face Challenges in Combating Predatory Lending* (January 2004, GAO Report at 3-4, 18 19);

(k) making loans based on the equity in borrowers' homes, whether or not borrowers have the ability to make payments. ("equity stripping.")

19. Loan brokers, such as Defendant Platinum, also victimize borrowers with predatory practices. A predatory loan broker acts as the agent of the lender, but abandons his fiduciary duties to the borrower. The predatory loan broker "preys" on borrowers to strip as much money in fees, costs, and commissions as possible from the equity in property, as Defendant Platinum did in this case. Predatory lenders engage in the same conduct, acting in concert with loan brokers and/or adopting a closed-eye posture to predatory loan brokers' fraudulent activities.

20. Plaintiff is informed and believes and thereon alleges Defendants engaged in the foregoing predatory practices in connection the loan made to Plaintiff.

SUBPRIME, NON-CONFORMING LOANS

21. Lenders traditionally made first trust deed home loans to highly credit worthy individuals. These "conforming" loans were and are safer from a credit perspective, in that such loans were easily sold to Fannie Mae and Freddie Mac, government-sponsored entities that provided liquidity to the market for home loans.

22. Beginning in the early years of this decade, and continuing into the time period encompassed by this complaint, lenders moved to originating "non-conforming" loans. Such practice exposed lenders to more risky loans with higher default rates. Moreover, these loans were typically sold into the secondary mortgage market to private institutional investors, as more fully alleged herein.

23. At the same time, lenders began to pursue a dramatic shift in strategic direction, away from traditional fixed-rate home loans to borrowers with high credit scores, in favor of a wide range of non-traditional, high risk home loans designed to allow borrowers from all credit models to borrow more money for home purchases and home refinancings than were available under traditional fixed-product lending guidelines. Since loan brokers are compensated on the volume of loans originated, and receive higher payments when selling non-traditional loan products than standard loans, lenders targeted borrowers who had to stretch, financially, to afford such non-conforming loans, many of whom had no realistic ability to repay such loans.

24. Non-conforming loan products include:

(a) hybrid adjustable rate mortgages ("HARMS"), which typically provide for a fixed, low, "teaser" interest rate for a predetermined introductory

time period, before resetting to higher rates which are typically tied to specified bench-marks or other criteria, as dictated by the fine print in the loan documentation. As a result, borrowers' monthly obligations often increase dramatically after the introductory period. Lenders deceptively market HARMs by aggressively promoting the teaser rate, often failing to distinguish between the "payment rate" and the "interest rate" on such loans, without any warnings about potential negative amortization. Borrowers, enticed by low teaser rates, do not understand the fine print of the loan documents or the financial implications of HARMs. Borrowers who obtain these loans face unaffordable monthly payments after the initial and often multiple rate adjustments, have difficulty paying real estate taxes and insurance that are not escrowed or impounded, and incur expensive refinancing fees, all of which do cause borrowers to default and potentially lose their homes;

(b) interest-only or negatively amortized loans, which allow borrowers to pay only the interest accruing on a loan on a monthly basis for a predetermined time period, or allow borrowers to pay an amount of interest that does not cover all of the interest due. As a result, the loan principal balance remains constant, or, in the case of negatively amortized loans, there is an interest shortfall that is added to principal, with additional interest charges placed upon any additions to principal;

(c) stated income loans, based on borrowers' representations about their ability to pay, with little or no documentation to substantiate those representations. In these loans, lenders typically do not inquire behind borrowers' represented income, leading many to call these products "liar loans";

(d) no documentation loans, in which borrowers' repayment capacity is not verified, proof of income is not required, and assets and liabilities are not confirmed. Without regard for underwriting standards, borrowers' income, expenses, assets, and liabilities are simply fabricated by the lender or loan broker.

25. In carrying out such non-conforming lending practices, lenders, and their affiliated and associated parties fail to comply with prudent underwriting and lending standards, leading to predatory lending practices. Lending decisions are not based upon all relevant factors, including borrowers' capacity to adequately service the debt. Borrowers' repayment capacity is not evaluated in terms of ability to repay the debt by its final maturity at a fully indexed rate, assuming a fully amortizing repayment schedule. Borrowers are not qualified based upon the quantification of repayment capacity by a debt-to-income ratio which should include an assessment of borrowers' total monthly housing related payments (*e.g.*, principal, interest, taxes, and insurance as a percentage of gross monthly income.) This is not done even where there are additional risk-layering factors, such as reduced or no documentation, or simultaneous second trust deed mortgages.

26. Lenders' shift towards the relaxation of underwriting and prudent lending standards was brought about to facilitate an increase in lenders' market

share of the residential mortgage business. Lenders pushed one goal above all others — originating loans and selling them into the secondary mortgage market as fast as possible.

27. Plaintiff is informed and believes and thereon alleges Defendants engaged in the foregoing predatory practices in connection with the loan made to Plaintiff.

THE SECONDARY LOAN MARKET, THE SECURITIZATION OF LOANS, AND MORTGAGE BACKED SECURITIES

28. Over the years, the residential loan business evolved from one in which lenders originated loans for retention in their own portfolios to one in which lenders originated loans for resale into the secondary mortgage market. Loans are sold by the "originating lenders" (for purposes of this complaint, "originating lender" refers to the named lender on a borrower's promissory note, although such named lenders are often nominal only, never actually providing funds for a loan) into the secondary mortgage market, primarily in the form of securities known as Mortgage Backed Securities. ("MBS.")

29. The process for creating an MBS begins when the originating lender sells, or pre-sells even before a loan is consummated, a borrower's note and the security for the note (a mortgage or deed of trust) to a third-party arranger, generally an investment bank or other financial institution, who packages mortgage loans — generally thousands of separate loans — into a pool and then transfers the mortgage loans to a trust (the "MBS Trust") that issues securities to investors typically large institutional investors such as pension plans, insurance companies, or hedge funds, collateralized by the pool of loans. The MBS Trust purchases the loan pool and acquires the right to borrowers' loan payments. The MBS Trust finances the purchase of the loan pool through the issuance of MBS's to investors. Borrowers' monthly payments, now funneled into the loan pool, are used to make monthly interest and principal payments to the investors in the MBS Trust. In order to qualify as an MBS under federal securities law (15 U.S.C. Section 78(c)(a)(41)), an MBS must be rated in one of the two highest rating categories by at least one nationally recognized statistical rating organization, such as Standard & Poors, Moody's, or Fitch. The accuracy of such organizations' credit ratings of MBS' generally, as well as the integrity of the ratings process as a whole, has been seriously questioned by the SEC. *Summary Report of Issues Identified in the . . . Examinations of Select Credit Rating Issues*, July, 2008.

30. Upon the sale of a loan, the originating lender is paid the full principal amount of the loan, plus an additional fee based on a percentage of the loan amount. The originating lender either transfers the responsibility to collect borrowers' monthly payments on a loan to a loan servicing company, or retains such loan servicing (collection) functions for an additional fee. The loan servicer remits borrowers' monthly loan payments to the MBS Trust.

31. Plaintiff is informed and believes and thereon alleges that loan servicing functions for Plaintiff's loan were acquired by and transferred to Defendant

Chevy Chase and/or to one or more MBS Trusts, without written notice to Plaintiff as required by RESPA and California *Civil Code* Section 2937, and without a recorded assignment as required by California *Civil Code* Section 2932.5 in order for a purported assignee to exercise a power of sale, non-judicial foreclosure.

32. An MBS Trust typically issues different classes of MBS's known as "tranches," which offer a sliding scale of coupon rates based on the level of credit protection afforded to the security. Credit protection is designed to shield the tranche securities from the loss of interest and principal due to defaults of the loans in the pool. The degree of credit protection afforded a tranche security is known as its "credit enhancement" and is provided through several means.

33. The primary source of credit enhancement is subordination, which creates a hierarchy of loss absorption among the tranch securities. For example, if an MBS Trust issues securities in 10 different tranches, the first or senior tranche has nine subordinate tranches, the next highest tranche would have eight subordinate tranches and so on down the capital structure. Any loss of interest and principal experienced by an MBS Trust from delinquencies and defaults on loans in the pool are allocated first to the lowest tranche, until it loses all of its principal amount and then to the next lowest tranche and so on up the capital structure. Consequently, the senior tranche does not incur any loss until all the lower tranches have absorbed losses from the underlying loans. As a result, senior tranche securities, having less risk, pay less interest; lower tranche securities, bearing a greater risk of loss, pay higher rates of interest.

34. A second form of credit enhancement is over-collateralization, which is the amount that the principal balance of the mortgage pool exceeds the principal balance of the tranche securities issued by the MBS Trust. This excess principal creates an additional "equity" tranche below the lowest tranche security to absorb losses. In the example above, the equity tranche sits below the tenth tranche security and protects it from the first losses experienced as a result of defaulting loans.

35. A third form of credit enhancement is excess spread, which is the amount that the trust's monthly interest income exceeds its monthly liabilities. Excess spread is comprised of the amount by which the total interest received on the underlying loans exceeds the total interest payments due to investors in the tranche securities, less administrative expenses of the MBS Trust, such as loan servicing fees, premiums due on derivatives contracts, and bond insurance. This excess spread can be used to build up loss reserves or pay off delinquent interest payments owed to a tranche security.

36. Ultimately, the monthly principal and interest paid into a loan pool must be enough to satisfy the monthly payments of principal and interest owed by an MBS Trust to the investors in each MBS tranche, as well as enough to cover expenses of the MBS Trust.

37. Plaintiff is informed and believes and thereon alleges that the sale of borrowers' loans from an original lender into the secondary market is not disclosed to borrowers.

38. Plaintiff is informed and believes and thereon alleges the loan made to her by Defendants was sold into the secondary mortgage market, without her knowledge, in the manner alleged above.

THE ASSIGNMENT OF LOANS TO THE MBS TRUST

39. At or about the time an MBS Trust issues securities to an investor, the originating lender typically transfers, conveys, and assigns to the MBS Trust all of its right, title, and interest in the underlying loan. In turn, the MBS Trust will transfer, convey, and assign some or all of an underlying loan to one or more additional MBS Trusts. The assignment includes the transfer to the MBS Trust of all principal and interest due by a borrower with respect to the loan. The MBS trustee will then, with such assignment in hand, execute and deliver the MBS to investors.

40. As part of the assignment, the originating lender will, typically, as to each loan transferred to the MBS Trust, deliver to the MBS trustee a borrower's note, negotiated without recourse to the order of the MBS trustee by endorsement on the note or by a separate "allonge," or deliver in blank, without endorsement or allonge, the original mortgage, deed of trust, or similar security instrument, together with an assignment of the mortgage, deed of trust, or similar security instrument. The MBS trustee will hold such documents in trust for the benefit of the investors in the MBS Trust.

41. In lieu of actual delivery of a borrower's note, mortgage, deed of trust, or similar security instrument, and an assignment of such instrument to the MBS trustee, for any loans registered in the MERS system, the originating lender will cause the MBS trustee to be recorded as the beneficial owner of loans pursuant to MERS' rules for electronically tracking changes in ownership rights.

42. Plaintiff is informed and believes and thereon alleges that all right, title, and interest in the loan she obtained from Defendants was transferred, conveyed, and assigned to Defendant Chevy Chase and then to one or more MBS Trusts. Plaintiff is further informed and believes and thereon alleges that the actual promissory note and deed of trust she executed when she obtained her loan from Defendants were delivered to one or more MBS Trusts, with or without a written assignment or, in the case of the note, with or without written endorsement or allonge, or, in lieu of actual delivery to an MBS Trust, Plaintiff's loan, and the transfer, conveyance, and assignment thereof, was registered in the MERS system pursuant to the rules for electronically tracking changes in ownership rights, with an MBS trustee recorded in the MERS system as the beneficial owner of Plaintiff's loan.

THE FORECLOSURE PROBLEM

43. The sale of borrowers' loans into the secondary mortgage market, in the manner alleged herein, creates an insurmountable problem when the originating lender, or its affiliates, such as Defendants herein, attempt to foreclose, judicially or non-judicially, on defaulting borrowers' property.

44. First, the originating lender has been paid in full by the third-party arranger and/or the MBS Trust to whom the loan has been sold, such that there is no delinquency or default as to the originating lender. A borrower is not made aware of such pay-off.

45. Second, the originating lender has transferred, conveyed, and assigned to the MBS Trust all of its right, title, and interest to a borrower's loan, including the right to receive payments of interest and principal, which principal and interest, the payment stream, is collateral for the securities issued to investors by the MBS Trust.

46. Third, as a result, the originating lender has no standing to foreclose, judicially or non-judicially, as that right is now owned by the MBS Trust or by the investors who hold the securities issued by the MBS Trust.

47. Fourth, having delivered and/or assigned a borrower's loan documents to the MBS Trust in consideration for being paid in full, or having registered a borrower's loan documents through MERS, an originating lender or its affiliates who initiate a foreclosure, judicially or non-judicially, cannot prove the ownership of or even the existence of a promissory note and security instrument upon which a foreclosure is premised.

48. Plaintiff is informed and believes and thereon alleges, for the reasons alleged herein, that Defendants have no standing or right to non-judicially foreclose on Plaintiff's property, as they have done, as more fully alleged herein.

GENERAL FACTUAL ALLEGATIONS

49. Plaintiff does not have any knowledge or experience with loan practice procedures or terms beyond that of a typical homeowner who does not work in or has not studied the home loan industry. At all times herein mentioned, Plaintiff had no knowledge, information, or belief regarding predatory lending practices.

50. In December, 2003, Plaintiff purchased a single family residence located at (the "Property.") Plaintiff viewed the Property not only as a place to live, but as an investment for her retirement. At the time of the loan transaction alleged herein, the Property was encumbered by two trust deed loans.

51. In December, 2006, Plaintiff sought to refinance the existing trust deed loans on her Property through Defendant Platinum, who was represented to Plaintiff to be a loan broker. At no time during the loan transaction alleged herein did Plaintiff know or understand that Defendant Platinum was also an originating, though nominal only, home loan lender.

52. Plaintiff learned about Defendant Platinum through a friend's daughter, loan broker Carol Katzman. ("Katzman.") Plaintiff is informed and believes and thereon alleges that at all times herein mentioned Katzman worked for Defendant Platinum. At no time during the loan transaction alleged herein did Plaintiff have any reason to distrust Defendant Platinum, Katzman, or any of Defendant Platinum's agents or employees. At no time during the loan transaction alleged herein was Plaintiff aware of Defendant Platinum's predatory and unlawful lending practices.

53. The new home loan which Plaintiff obtained from and/or through Defendant Platinum (the "Platinum Loan") was the only first trust deed loan which Katzman or anyone associated with Defendant Platinum presented to Plaintiff. At the time of the loan transaction alleged herein, Plaintiff had excellent credit with a FICO score of approximately 771. Plaintiff is informed and believes and thereon alleges that her credit profile made her eligible for a variety of loan products.

54. At the time Plaintiff applied for the Platinum Loan, she had no income. Plaintiff so advised Katzman of this fact. Plaintiff also advised Katzman of her illness and of her work limitations. Plaintiff had maintained her existing home loan payments by drawing on her retirement savings. At the time of the Platinum Loan, neither Katzman nor any agents or employees of Defendant Platinum requested Plaintiff to provide any written information regarding her past, present, or future income, nor did Katzman nor any agents or employees of Defendant Platinum request Plaintiff to provide any written information regarding her expenses, assets, or liabilities. Neither Katzman nor any agents or employees of Defendant Platinum requested Plaintiff to provide tax returns or any written personal financial information. At the time Plaintiff applied for the Platinum Loan, Katzman stated to Plaintiff that Plaintiff's savings, her excellent credit rating, and the value of the Property were all that was necessary in order for Plaintiff to obtain the Platinum Loan. The Platinum Loan was a no documentation loan.

55. At Katzman's request, Plaintiff signed a blank Uniform Residential Loan Application. (the "Loan Application.") Plaintiff is informed and believes and thereon alleges Katzman and/or one of Defendant Platinum's agents or employees fabricated Plaintiff's income and expense information on the Loan Application. More particularly, Katzman and/or one of Defendant Platinum's agents or employees falsely stated on the Loan Application that Plaintiff's total gross monthly income was $181,000 and that Plaintiff's estimated combined monthly living expenses, excluding the anticipated monthly payment on the Platinum Loan, was $16,886. The falsification of Plaintiff's Loan Application constitutes a violation of the federal Truth-In-Lending Act. ("TILA.")

56. As part of the loan transaction alleged herein, Defendant Platinum selected and sent an appraiser to the Property. The appraiser valued the Property at significantly more than the existing loans on the Property. The appraisal also grossly inflated the true market value of the Property. Plaintiff is informed and believes and thereon alleges that Defendant Platinum directed the appraised valuation of the Property in order to justify the amount of the Platinum Loan and to increase its fees, which were based on the loan amount. Plaintiff is informed and believes and thereon alleges that the true market value of the Property is presently less than the Platinum Loan amount.

57. Prior to signing the Platinum Loan documents, Katzman refused to meet with Plaintiff to review or to discuss the Platinum Loan documents or any of the terms of the Platinum Loan. Plaintiff was leaving the country and Katzman placed extreme and undue pressure on Plaintiff to sign the Platinum Loan

documents immediately. To facilitate such immediate signing, Katzman advised Plaintiff that a notary public would bring the Platinum Loan documents to Plaintiff's home and that Plaintiff should execute the Platinum Loan documents in the presence of the notary public.

58. Plaintiff is informed and believes and thereon alleges that the Platinum Loan documents which she executed were postdated by a number of days.

59. On or about December 14, 2006, Plaintiff did execute an Adjustable Rate Note (the "Platinum Note") and a first Deed of Trust (the "Trust Deed") securing the obligation evidenced by the Platinum Loan. The Platinum Loan amount was $3,850,000. (the "Loan Amount.") Copies of the Platinum Note and Trust Deed are attached hereto, respectively, as Exhibits 1 and 2. The Platinum Note identifies Defendant Platinum as the "lender."

60. At the time Plaintiff executed the Platinum Loan documents, Plaintiff did so under pressure from Katzman and the notary public to do so as quickly as possible. Plaintiff did not have, nor was she given, time to review the Platinum Loan documents. Plaintiff did not receive any copies of the Platinum Loan documents at the time of execution. Only some time after the close of escrow did Plaintiff finally receive unsigned copies of the Platinum Loan documents.

61. At no time did Defendant Platinum nor any agents or employees of Defendant Platinum provide Plaintiff with a Good Faith Estimate of Closing Costs Statement, in violation of the federal Real Estate Settlement Procedures Act ("RESPA") and California *Business and Professions Code* Sections 10240 *et. seq.* At no time did Defendant Platinum nor any agents or employees of Defendant Platinum advise Plaintiff of the type or amount of fees and charges for the Platinum Loan, in violation of TILA and RESPA. At no time did Defendant Platinum nor any of Defendant Platinum's agents or employees advise Plaintiff of the terms of the Platinum Loan, other than the initial amount of the monthly payment on the Platinum Note, in violation of TILA and RESPA. At no time did Plaintiff and Defendant Platinum enter into a written brokerage agreement, in violation of Sections 50700 and 50701 of the CRMLA. Plaintiff is informed and believes and thereon alleges that neither Defendant Platinum nor any agents or employees of Defendant Platinum provided Plaintiff with written notice of her right to rescind the Platinum Loan within 3 business days of the close of escrow, in violation of TILA.

62. Sometime after December 21, 2006, the purported date of close of escrow, Plaintiff received a Closing Settlement Statement for the Platinum Loan, setting forth, in a manner that was not clear and conspicuous and therefore in violation of TILA and RESPA, the fees and charges for the Platinum Loan that had never previously been disclosed to Plaintiff. From the Platinum Loan proceeds, Defendant Platinum was paid $53,103, for purportedly brokering and/or originating the Platinum Loan, as follows: an underwriting fee of $395; a flood certification fee of $15; a tax service fee of $79; a wire fee of $50; a document preparation fee of $350; an administration fee of $99; a processing fee of $595; points in the sum of $48,125; and an additional processing fee of $395; and a mortgage broker fee of $3,000.

63. Plaintiff is informed and believes and thereon alleges that the foregoing fees and charges constituted undisclosed "finance charges", as defined under TILA. The failure to disclose such hidden finance charges as part of Plaintiff's cost of credit constituted a violation of TILA and RESPA.

64. Plaintiff is informed and believes and thereon alleges that the foregoing fees and charges, including Defendant Platinum's "points" (also known as the "yield spread premium"), were excessive and extraordinarily high and therefore constituted a violation of TILA. Plaintiff is further informed and believes and thereon alleges that some or all of the foregoing fees and charges did not reflect fees and charges for genuine "settlement services" (as that term is defined in RESPA) rendered by Defendant Platinum or any agents or employees of Defendant Platinum and therefore constituted an illegal "kickback," "unearned fee," and "fee split" in violation of RESPA.

65. Until Plaintiff received the unsigned copies of the Platinum Loan documents, Plaintiff did not know nor understand the material terms and conditions of the Platinum Loan.

66. The Platinum Note and Trust Deed included predatory terms and conditions which were not disclosed to Plaintiff prior to her execution of same. The written terms and conditions of the Platinum Note and Trust Deed were not clearly, conspicuously, and accurately set forth and were stated in a manner so confusing as to be incomprehensible to a layperson, in violation of TILA. The relevant terms and conditions of the Platinum Note and Trust Deed included the following:

(a) the starting monthly payment under the Platinum Note was $11,357.17, approximately $3,000.00 more per month than the monthly payment Plaintiff was making under her existing trust deed loans. Plaintiff was not aware and was not informed that the $11,357.17 monthly payment was insufficient to cover the monthly interest due;

(b) within twenty-four (24) months, Defendant's monthly payment on the Platinum Note adjusted to $34,246.48, an increase of over 300%;

(c) the initial interest rate under the Platinum Note was 8.8%, with the interest rate after the first month and one-half adjusting monthly based on the London Interbank Offered Rate ("LIBOR"), plus 3.450 percentage points. The adjustable rate feature of the Platinum Note was not clearly and conspicuously set forth in the Platinum Note;

(d) the term of the Platinum Note was 40 years, with a balloon payment at term's end for all outstanding principal and interest due;

(e) the Platinum Note misleadingly stated that Plaintiff's minimum payments would be adjusted annually, but would never be more than 7.5% greater or less than the last minimum payment;

(f) under the Platinum Note, the initial interest rate of 8.8% and the initial monthly payment of $11,357.17 did not cover all of the interest due, resulting in negative amortization. Even at its inception, there was a $16,875.83 monthly interest shortfall, giving rise to an annual interest shortfall of approximately $202,509.00. (the "Interest Shortfall.") Under

the Platinum Note, the Interest Shortfall was added to the principal balance, with interest charges placed upon any additions to principal. Under the Platinum Note, when the principal balance of the loan exceeded 110% of the loan amount, a re-amortization of the new balance occurs, thereby increasing Plaintiff's monthly to an amount in excess of $34,346.98;

(g) in language that is not clearly and conspicuously set forth, the Platinum Note provided for a prepayment penalty for any partial or full prepayment of the principal due made during the first year of the loan term. The amount of the prepayment penalty was so exorbitant as to make it economically impossible for Plaintiff to prepay the Platinum Loan.

67. Plaintiff is informed and believes and thereon alleges that neither Defendant Platinum nor any agents or employees of Defendant Platinum ever disclosed to Plaintiff the negative amortization and prepayment features of the Platinum Note. Plaintiff is further informed and believes and thereon alleges that neither Defendant Platinum nor any agents or employees of Defendant Platinum ever disclosed to Plaintiff the adjustable rate features of the Platinum Note. In that regard, and in violation of RESPA, neither Defendant Platinum nor any agents or employees of Defendant Platinum provided Plaintiff with the booklet entitled *Consumer Handbook on Adjustable Rate Mortgages*, published by the Board of Governors of the Federal Reserve System, or with a required loan information booklet.

68. Plaintiff would not have agreed to the terms and conditions of the Platinum Note and Deed of Trust, nor would she have executed the same, had the terms and conditions of the Platinum Note and Deed of Trust been disclosed and explained to her.

69. Plaintiff is informed and believes and thereon alleges that at or about the time she executed the Platinum Loan documents, or shortly thereafter, Defendant Platinum, without Plaintiff's knowledge, assigned, sold, or transferred the Platinum Loan to Defendant Chevy Chase and/or to Defendant US Bank as the purported trustee for CCB Libor Series 2007-1 Min No. 1000866-0011103912-1.

70. At no time did Defendant Platinum, as transferor, or Defendant Chevy Chase and/or Defendant US Bank as the purported trustee for CCB Libor Series 2007-1 Min No. 1000866-0011103912-1, as transferees, notify Plaintiff in writing of such assignment, sale, or transfer, in violation of RESPA and California *Civil Code* 2937.

71. Plaintiff is informed and believes and thereon alleges that Defendant Platinum and/or Defendant Chevy Chase and/or Defendant US Bank as the purported trustee for CCB Libor Series 2007-1 Min No. 1000866-0011103912-1 further assigned, sold, or transferred the Platinum Loan to one or more MBS Trusts. Plaintiff was not provided written notice of any such subsequent assignments, sales, or transfers, in violation of RESPA and California *Civil Code* 2937.

72. Plaintiff is informed and believes and thereon alleges that with regard to any assignment, sale, or transfer of the Platinum Note, there was no proper

assignment of the Platinum Note, either by way of written endorsement, al-longe, or actual delivery. Plaintiff is further informed and believes and thereon alleges that any assignment, sale, or transfer of the Platinum Note and Deed of Trust was made without any recorded assignment as required by California Civil Code Section 2932.5 in order for a purported assignee to exercise a power of sale, non-judicial foreclosure.

73. Plaintiff is informed and believes and thereon alleges that notwith-standing any assignment, sale, or transfer of the Platinum Loan, Defendant Chevy Chase Bank continued to service the Platinum Loan.

74. Pursuant to TILA, any assignee, purchaser, or transferee of the Plat-inum Loan is liable for any and all claims and causes of action alleged by Plain-tiff herein with regard to the Platinum Loan.

75. Beginning in or about September, 2007, Defendant Chevy Chase com-menced a campaign to unlawfully force Plaintiff into foreclosure, as follows:

(a) in or about September, 2007, while Plaintiff was timely making all of her Platinum Loan payments, Defendant Chevy Chase, without any prior notice to Plaintiff, paid property taxes of $13,126.37 on Plaintiff's be-half and established an impound account therefor. Defendant Chevy Chase did so on the pretext that Plaintiff was delinquent in the pay-ment of property taxes. The property taxes advanced by Defendant Chevy Chase were purportedly in payment of the second installment of property taxes due for the 2006-2007 tax year, plus penalties and in-terest;

(b) plaintiff was shocked by Defendant Chevy Chase's precipitous action, not only because she was not advised of any purported intent of De-fendant Chevy Chase to advance the property taxes, nor given an op-portunity to pay the same, but also because it had been Plaintiff's custom and practice over a period of 20 years to delay paying property taxes until she had received a notice of delinquency from the Los An-geles County Tax Assessor, whereupon she would immediately pay all due property taxes. No prior lender or mortgage servicer had ever questioned Plaintiff's practice. Plaintiff is informed and believes and thereon alleges that as of the date Defendant Chevy Chase advanced property taxes, she had not received any notice of delinquency from the Los Angeles County Tax Assessor;

(c) plaintiff is informed and believes and thereon alleges that the amount Defendant Chevy Chase advanced for property taxes was added to the principal amount of the Platinum Loan;

(d) pursuant to the adjustable rate features of the Platinum Note, Plain-tiff's monthly payment adjusted to $12,208.95 as of February 1, 2008;

(e) however, without any prior notice to Plaintiff, Defendant Chevy Chase increased Plaintiff's monthly payment on the Platinum Loan by an additional, approximate $3,600.00 per month. The additional monthly payment amount was purportedly to cover a portion of the property taxes paid by Defendant Chevy Chase and to establish an impound ac-

count for the payment of future property taxes. Plaintiff is informed and believes and thereon alleges that the impound amount exceeded the amount of a permissible impound under RESPA;

(f) on or about September 21, 2007, Defendant Chevy Chase notified Plaintiff, for the first time, that it had advanced property taxes and had established an impound account. Plaintiff immediately contacted Defendant Chevy Chase and demanded that the impound account be rescinded. In response, Defendant Chevy Chase advised Plaintiff that it would readjust her payments to eliminate the impound account. Defendant Chevy Chase further advised Plaintiff to make the current month's payment (then $11,357.17) on the Platinum Note in full, plus an amount to cover a portion of the property taxes paid, plus an amount to be impounded for future property taxes. Defendant Chevy Chase represented to Plaintiff that if such payment was made, the impound account would be rescinded and a payment plan to pay-off the property taxes advanced would be proposed;

(g) notwithstanding its repeated promises to do so, Defendant Chevy Chase did not rescind the impound account and did not propose a payment plan. Further, Defendant Chevy Chase did not timely respond to Plaintiff's written inquiries and requests regarding these issues, in violation of RESPA;

(h) in November, 2007, again without any prior notice to Plaintiff, Defendant Chevy Chase paid additional property taxes of $11,625.14 on Plaintiff's behalf. Plaintiff is informed and believes and thereon alleges that Defendant Chevy Chase's additional advance for property taxes was added to the principal amount of the Platinum Loan;

(i) on or about January 1, 2008, while Plaintiff was still awaiting a response to her inquiries and requests regarding the property tax advances, a payment plan, and the impound account, Plaintiff made the new monthly payment due on the Platinum Loan in the amount of $12,208.95. Claiming the payment was partial only, Defendant Chevy Chase refused to credit Plaintiff's account with her $12,208.95 payment, in violation of RESPA. Defendant Chevy Chase continues to hold Plaintiff's $12,208.95 payment;

(j) in or about January, 2008, again without any prior notice to Plaintiff, Defendant Chevy Chase paid on Plaintiff's behalf the sum of $7,200.00 for purportedly unpaid homeowner's insurance. Plaintiff is informed and believes and thereon alleges that her homeowner's insurance payments were not delinquent. Plaintiff is further informed and believes and thereon alleges that the amount Defendant Chevy Chase advanced for homeowner's insurance was added to the principal amount of the Platinum Loan;

(k) on or about March, 2008, again without any prior notice to Plaintiff, Defendant Chevy Chase paid additional property taxes of $11,626.13 on Plaintiff's behalf. Plaintiff is informed and believes and thereon al-

leges that Defendant Chevy Chase's additional advance for property taxes was added to the principal amount of the Platinum Loan.

76. At no time did Plaintiff authorize Defendant Chevy Chase to advance the payment of property taxes and homeowner's insurance, or to establish an impound account. At no time did Defendant Chevy Chase rescind the impound account or propose a payment plan.

77. As a result of Defendant Chevy Chase's unlawful and unauthorized payment of Plaintiff's property taxes and homeowner's insurance, and as a further consequence of negative amortization, Plaintiff is informed and believes and thereon alleges the principal amount of the Platinum Loan now exceeds $4.3 million.

78. Pursuant to the Platinum Note, Plaintiff's monthly payment is calculated as a percentage of the principal amount due on the Platinum Note. As a result of Defendant Chevy Chase's unlawful and unauthorized payment of Plaintiff's property taxes and homeowner's insurance, and as a further consequence of negative amortization, the increase in the principal amount of the Platinum Note increased Plaintiff's required monthly payment.

79. Since tendering the new monthly payment of $12,208.95 to Defendant Chevy Chase, Plaintiff has made no further payments on the Platinum Note, even though she had and has the financial ability to do so. To make further payments would have been futile, given the refusal of Defendant Chevy Chase to recognize or to apply her prior payment to her account, and given further Defendant Chevy Chase's failure to respond to Plaintiff's inquiries and requests.

80. Defendant Chevy Chase's only response to Plaintiff's inquiries and requests was to commence a non-judicial foreclosure proceeding, as more fully alleged herein, and to wrongly report Plaintiff's alleged default to credit reporting agencies, in violation of the federal Fair Credit Reporting Act ("FCRA"). As a result, Plaintiff's once excellent credit rating has been irreparably damaged, such that it would now be difficult if not impossible for Plaintiff to procure an affordable replacement loan.

81. On or about July 8, 2008, Defendant recorded in the Office of the County Recorder for Los Angeles County a Notice of Default and Election to Sell Under Deed of Trust. (the "Notice of Default.") A copy of the Notice of Default is attached hereto as Exhibit 3.

82. The Notice of Default is deficient, for the following reasons:

(a) the amount claimed due to cure Plaintiff's alleged default is erroneous;

(b) the Notice of Default was recorded notwithstanding Defendant Chevy Chase's failure to timely and adequately acknowledge, investigate, and respond to Plaintiff's request for information about the Platinum Loan, the property taxes, and homeowner's insurance payments advanced, and the impound account, all as required by RESPA;

(c) Defendants failed to comply with the requirements of Senate Bill No. 1137, effective July 8, 2008, and incorporated into California *Civil Code* Sections 2923.5, 2923.6, 2924.8 and 2929.3 and California *Code of Civil*

Procedure Section 1161b. Senate Bill No. 1137 requires a mortgagee, trustee, beneficiary, or authorized agent to wait thirty (30) days after contact is made with a borrower prior to filing a notice of default. Further, a borrower must be advised of his/her right to request a subsequent meeting and if requested that meeting must occur within fourteen (14) days of the original contact. A notice of default must include a declaration from the mortgagee, trustee, beneficiary, or authorized agent that they have contacted a borrower and reviewed with the borrower his/her foreclosure options. Defendants failed to comply with these requirements;

(d) the fraudulent and predatory lending practices of Defendant Platinum and Defendant Chevy Chase, and their violations of state and federal law, all as alleged herein, render the Notice of Default and said Defendants' non-judicial foreclosure illegal and unlawful.

83. On or about May 22, 2008, pursuant to RESPA, Plaintiff made a qualified written request on Defendants Platinum and Chevy Chase for information relating to said Defendants' fraudulent and predatory lending practices. RESPA requires a response to a qualified written request within twenty (20) days and action by a lender or loan servicer to resolve a qualified written request within sixty (60) days.

84. Defendant Platinum and Defendant Chevy Chase neither responded to Plaintiff's qualified written request nor acted to resolve Plaintiff's qualified written request in the time allowed, or at all. The failure of Defendant Platinum and Defendant Chevy Chase to respond to or to act upon Plaintiff's qualified written request constitutes a violation of RESPA.

85. In further violation of RESPA, which prevents the reporting of alleged defaults to credit reporting agencies until a qualified written request is resolved, Defendant Platinum and Defendant Chevy Chase did so, causing irreparable damage to Plaintiff's once excellent credit rating, in violation of the FCRA.

86. At all times herein mentioned, Defendant Platinum and Defendant Chevy Chase, as Plaintiff's agents, owed to Plaintiff a fiduciary duty of utmost care, honesty, and loyalty in the loan transaction alleged herein, including a duty of full disclosure of all material facts.

87. Plaintiff is informed and believes and thereon alleges that at all times herein mentioned Defendant Platinum, Defendant Chevy Chase and DOES 1 through 30, inclusive, conspired, aided and abetted, encouraged, and knowingly gave substantial assistance to each other in accomplishing the wrongful conduct alleged herein, all to Plaintiff's damage as alleged herein. Said Defendants had knowledge of and agreed to the predatory lending practices, violations of state and federal law, and other wrongdoings alleged herein, all for the purpose of injuring Plaintiff, and for the further purpose of reaping their own substantial profits.

FIRST CAUSE OF ACTION
(Fraud — Intentional Misrepresentation Against Defendants Platinum, Chevy Chase, and DOES 1 through 30, inclusive.)

88. Plaintiff realleges and incorporates by reference, as though fully set forth herein, Paragraphs 1 through 88, inclusive, of this complaint.

89. Commencing in or about December, 2006, the Defendants identified in this cause of action falsely and fraudulently represented to Plaintiff:

(a) the true terms of the Platinum Loan, including but not limited to the existence, type, and amount of points and other brokerage fees paid to Defendant Platinum, the existence and amount of the prepayment penalty, the adjustable rate terms of the Platinum Loan, the true interest rate on the Platinum Loan, the negative amortization features of the Platinum Loan, the unaffordable increase in monthly payments, the total loan amount, and the nature and amount of closing costs;

(b) that the Platinum Loan satisfied generally accepted underwriting standards;

(c) that the Platinum Loan comported with prudent lending standards;

(d) the true identity of the lender who in fact financed the Platinum Loan;

(e) that Plaintiff's debt-to-income ratio was sufficient to justify the Platinum Loan;

(f) that Defendant Platinum was the originating lender and not merely a nominal lender;

(g) that the Platinum Loan was assigned, sold, or transferred to Defendant Chevy Chase or to one or more MBS Trusts;

(h) that the Platinum Loan was not retained in Defendant Platinum's loan portfolio but was pre-sold into the secondary mortgage market;

(i) that the Platinum Loan was the only loan product available to Plaintiff;

(j) that Defendant Chevy Chase acquired loan servicing functions for the Platinum Loan without notice to Plaintiff;

(k) that Plaintiff was qualified for the Platinum Loan with no documentation, based only upon the appraisal of the Property, Plaintiff's FICO credit score, and Plaintiff's cash reserves;

(l) the true appraised value of the Property;

(m) that the terms of the Platinum Loan complied with state and federal law, including TILA and RESPA;

(n) that Plaintiff had no right to rescind the Platinum Loan within three (3) business days of the close of escrow;

(o) that there was an employment, agency, working, and conspiratorial relationship between Defendant Platinum and Defendant Chevy Chase as relates to the Platinum Loan;

(p) that Defendant Platinum falsified Plaintiff's Loan Application;

(q) that the fees and charges for the Platinum Loan were lawful and proper and did not include any hidden finance charges;

(r) that the fees and charges paid to Defendant Platinum were lawful and proper, were not excessive, were incurred for genuine settlement services

rendered, and did not constitute an illegal kickback, unearned fee, or fee split;

(s) that Defendant Chevy Chase had the right to advance property taxes and homeowner's insurance premiums on Plaintiff's behalf without notice to Plaintiff or without her consent;

(t) that amounts advanced by Defendant Chevy Chase for property taxes and homeowner's insurance would not be added to the principal amount of the Platinum Loan;

(u) that Defendant Chevy Chase would rescind the impound account that it established for property taxes and homeowner's insurance;

(v) the amounts necessary to cure Plaintiff's alleged default on the Platinum Loan.

90. The foregoing representations made by the Defendants identified in this cause of action were in fact false. When the Defendants identified in this cause of action made the foregoing representations, they knew such representations to be false. The Defendants identified in this cause of action made the foregoing representations with the intent to deceive and to defraud Plaintiff by inducing her to execute the Platinum Note and Deed of Trust.

91. At all times during the loan process and at the time she executed the Platinum Note and Deed of Trust, Plaintiff was ignorant of the falsity of the representations of Defendants identified in this cause of action and could not in the exercise of reasonable diligence have discovered said Defendants' fraud.

92. Plaintiff would have not agreed to the Platinum Loan, nor would she have executed the Platinum Note and Deed of Trust, had the foregoing representations not been made.

93. Plaintiff justifiably relied on the representations of Defendants identified in this cause of action because Plaintiff did not and does not have knowledge of or experience with home loan practice procedures or home loan terms beyond that of a typical homeowner who does not work in or has not studied the mortgage industry, because said Defendants were purportedly reputable lenders, loan brokers, and/or loan servicers, and because of Plaintiff's personal relationship with Katzman.

94. Plaintiff did not discover of the fraud of Defendants identified in this cause of action until in or about May, 2008.

95. As a proximate result of the false and fraudulent representations of the Defendants identified in this cause of action, Plaintiff has incurred general damages in a sum according to proof at trial, together with interest thereon from and after December 21, 2006, in the maximum amount allowed by law.

96. As a further proximate result of the false and fraudulent representations of the Defendants identified in this cause of action, Plaintiff has incurred damage to her credit rating, in a sum according to proof at trial.

97. As a further proximate result of the false and fraudulent representations of the Defendants identified in this cause of action, Plaintiff has incurred damages equal to twice the amount of the finance charges paid by Plaintiff in connection with the Platinum Loan, pursuant to TILA, 15 *U.S.C.* Section 1640,

in a sum according to proof at trial, together with interest thereon from and after December 21, 2006, in the maximum amount allowed by law.

98. As a further proximate result of the false and fraudulent representations of the Defendants identified in this cause of action, Plaintiff has incurred damages equal to the amount of all remaining indebtedness on the Platinum Loan, pursuant to TILA, 15 *U.S.C.* Section 1641, in a sum according to proof at trial, together with interest thereon from and after December 21, 2006, in the maximum amount allowed by law.

99. As a further proximate result of the false and fraudulent representations of the Defendants identified in this cause of action, Plaintiff has incurred damages equal to the total amount paid by Plaintiff in connection with the Platinum Loan, including all payments of principal and interest and all payments of fees, charges, and points paid in connection with the Platinum Loan, pursuant to TILA, 15 *U.S.C.* Section 1641, in a sum according to proof at trial, together with interest thereon from and after December 21, 2006, in the maximum amount allowed by law.

100. As a further proximate result of the false and fraudulent representations of the Defendants identified in this cause of action, Plaintiff is entitled to statutory damages of $2,000.00, pursuant to TILA, 15 *U.S.C.* Section 1640

101. The conduct of the Defendants identified in this cause of action constitutes a series of intentional acts committed by such Defendants with the intention of depriving Plaintiff of property or legal rights or otherwise causing Plaintiff injury. Such conduct was despicable and has subjected Plaintiff to unjust hardship in conscious disregard of her rights, so as to justify an award of exemplary and punitive damages against such Defendants, in a sum according to proof at trial.

102. The Platinum Note and Deed of Trust provide that in the event of Plaintiff's default resulting in foreclosure procedures, the Defendants identified in this cause of action shall be entitled to reasonable attorney's fees. By virtue of California *Civil Code* Section 1717, the right to attorney's fees is reciprocal, entitling Plaintiff to recover attorney's fees if she prevails in this action. Plaintiff is further entitled to reasonable attorney's fees and costs pursuant, to TILA, 15 *U.S.C.* Section 1640.

SECOND CAUSE OF ACTION
**(Fraud — Negligent Misrepresentation Against Defendants
Platinum, Chevy Chase, and DOES 1 through 30, inclusive.)**

103. Plaintiff realleges and incorporates by reference, as though fully set forth herein, Paragraphs 1 through 88, inclusive, and Paragraphs 90 through 95, inclusive, of this complaint.

104. When Defendants identified in this cause of action made the false and fraudulent representations alleged herein, they had no reasonable grounds for believing the representations were true, and made the representations with the intent to induce Plaintiff to act as alleged herein.

105. As a proximate result of the negligent misrepresentations of the

Defendants identified in this cause of action, Plaintiff has incurred general damages in a sum according to proof at trial, together with interest thereon from and after December 21, 2006, in the maximum amount allowed by law.

106. As a further proximate result of the negligent misrepresentations of the Defendants identified in this cause of action, Plaintiff has incurred damage to her credit rating, in a sum according to proof at trial.

107. As a further proximate result of the negligent misrepresentations of the Defendants identified in this cause of action, Plaintiff has incurred damages equal to twice the amount of the finance charges paid by Plaintiff in connection with the Platinum Loan, pursuant to TILA, 15 *U.S.C.* Section 1640, in a sum according to proof at trial, together with interest thereon from and after December 21, 2006, in the maximum amount of allowed by law.

108. As a further proximate result of the negligent misrepresentations of the Defendants identified in this cause of action, Plaintiff has incurred damages equal to the amount of all remaining indebtedness on the Platinum Loan, pursuant to TILA, 15 *U.S.C.* Section 1641, in a sum according to proof at trial, together with interest thereon from and after December 21, 2006, in the maximum amount allowed by law.

109. As a further proximate result of the negligent misrepresentations of the Defendants identified in this cause of action, Plaintiff has incurred damages equal to the total amount paid by Plaintiff in connection with the Platinum Loan, including all payments of principal and interest and all payments of fees, charges, and points paid in connection with the Platinum Loan, pursuant to TILA, 15 *U.S.C.* Section 1641, in a sum according to proof at trial, together with interest thereon from and after December 21, 2006, in the maximum amount allowed by law.

110. As a further proximate result of the negligent misrepresentation of the Defendants identified in this cause of action, Plaintiff is entitled to statutory damages of $2,000.00, pursuant to TILA, 15 *U.S.C.* Section 1640.

111. The Platinum Note and Deed of Trust provide that in the event of Plaintiff's default resulting in foreclosure procedures, the Defendants identified in this cause of action shall be entitled to reasonable attorney's fees, by virtue of California *Civil Code* Section 1717, the right to attorney's fees as reciprocal, entitling Plaintiff to recover attorney's fees if she prevails in this action. Plaintiff is further entitled to reasonable attorney's fees and costs, pursuant to TILA, 15 *U.S.C.* Section 1640.

THIRD CAUSE OF ACTION
(Fraudulent Concealment — Against Defendants
Platinum, Chevy Chase, and DOES 1 through 30, inclusive.)

112. Plaintiff realleges and incorporates by reference, as though fully set forth herein, Paragraphs 1 through 88, inclusive, and Paragraphs 90 through 95, inclusive, of this complaint.

113. At all times herein mentioned, the Defendants identified in this cause of action owed a fiduciary duty to disclose to Plaintiff all material facts relating

to the Platinum Loan.

114. In promoting the Platinum Loan, and throughout the Platinum Loan process, and thereafter, the Defendants identified in this cause of action knowingly and willfully suppressed and concealed from Plaintiff material facts known to them but not to Plaintiff, including but not limited to the true terms of the Platinum Loan, as alleged herein; the true identity of the lender who in fact financed the Platinum Loan; that Plaintiff's debt-to-income ratio was insufficient to justify the Platinum Loan; that Defendant Platinum was the originating lender and not merely a nominal lender; that the Platinum Loan was assigned, sold, or transferred to Defendant Chevy Chase or to one or more MBS Trusts; that the Platinum Loan was not retained in Defendant Platinum's Loan portfolio but was pre-sold into the secondary mortgage market; that the Platinum Loan was not the only loan product available to Plaintiff and for which she qualified; that Defendant Chevy Chase acquired loan servicing functions for the Platinum Loan, without notice to Plaintiff; the true appraised value of the Property; that the terms of the Platinum Loan did not comply with state and federal law, including TILA and RESPA; that Plaintiff had the right to rescind the Platinum Loan within three (3) business days of the close of escrow; that there was an employment, agency, working, and conspiratorial relationship between Defendant Platinum and Defendant Chevy Chase; that Defendant Platinum falsified Plaintiff's Loan Application; that the fees and charges for the Platinum Loan included hidden finance charges; that the fees and charges paid to Defendant Platinum were excessive, were incurred for settlement services not rendered, and constituted an illegal kickback, unearned fee, and fee split; the true amounts necessary to cure Plaintiff's alleged default on the Platinum Loan; the foreclosure consequences of Plaintiff's failure to repay the advances of Defendant Chevy Chase for Plaintiff's property taxes and homeowner's insurance; and the foreclosure consequences of Plaintiff's failure to fund the impound account.

115. The Defendants identified in this cause of action intentionally suppressed and concealed the foregoing material facts from Plaintiff with the intent to deceive and to defraud Plaintiff and to induce or to execute the Platinum Note and Deed of Trust.

116. At the time of the concealment of the material facts alleged herein, Plaintiff was unaware of the true facts. As result of the fraudulent concealments of the Defendants identified in this cause of action, Plaintiff entered into the Platinum Loan, executed the Platinum Note and Deed of Trust, and forestalled taking any action to protect her interests. Plaintiff would not have executed the Platinum Note and Deed of Trust if all of the material terms of the Platinum Loan had been disclosed to her before close of escrow.

117. As a proximate result of the fraudulent concealments of the Defendants identified in this cause of action, Plaintiff has incurred general damages in a sum according to proof at trial, together with interest thereon from and after December 21, 2006, in the maximum amount allowed by law.

118. As a further proximate result of the fraudulent concealments of the

Defendants identified in this cause of action, Plaintiff has incurred damage to her credit rating, in a sum according to proof at trial.

119. As a further proximate result of the fraudulent concealments of the Defendants identified in this cause of action, Plaintiff has incurred damages equal to twice the amount of the finance charges paid by Plaintiff in connection with the Platinum Loan, pursuant to TILA, 15 *U.S.C.* Section 1640, in a sum according to proof at trial, together with interest thereon from and after December 21, 2006, in the maximum amount allowed by law.

120. As a further proximate result of the fraudulent concealments of the Defendants identified in this cause of action, Plaintiff has incurred damages equal to the amount of all remaining indebtedness on the Platinum Loan, pursuant to TILA, 15 *U.S.C.* Section 1641, in a sum according to proof at trial, together with interest thereon from and after December 21, 2006, in the maximum amount allowed by law.

121. As a further proximate result of the fraudulent concealments of the Defendants identified in this cause of action, Plaintiff has incurred damages equal to the total amount paid by Plaintiff in connection with the Platinum Loan, including all payments of principal and interest and all payments of fees, charges and points paid in connection with the Platinum Loan, pursuant to TILA, 15 *U.S.C.* Section 1641, in a sum according to proof at trial, together with interest thereon from and after December 21, 2006, in the maximum amount allowed by law.

122. As a further proximate result of the fraudulent concealments of the Defendants identified in this cause of action, Plaintiff is entitled to statutory damages of $2,000.00, pursuant to TILA, 15 *U.S.C.* Section 1640.

123. The conduct of the Defendants identified in this cause of action constitutes a series of intentional acts committed by such Defendants with the intention of depriving Plaintiff of property or legal rights or otherwise causing Plaintiff injury. Such conduct was despicable and has subjected Plaintiff to unjust hardship in conscious disregard of her rights, so as to justify an award of exemplary and punitive damages against such Defendants, in a sum according to proof at trial.

124. The Platinum Note and Deed of Trust provide that in the event of Plaintiff's default resulting in foreclosure procedures, the Defendants identified in this cause of action shall be entitled to reasonable attorney's fees. By virtue of California *Civil Code* Section 1717, the right to attorney's fees is reciprocal, entitling Plaintiff to recover attorney's fees if she prevails in this action. Plaintiff is further entitled to reasonable attorney's fees and costs, pursuant to TILA, 15 *U.S.C.* Section 1640.

FOURTH CAUSE OF ACTION
(Violations of TILA — Against Defendants Platinum, Chevy Chase, and DOES 1 through 30, inclusive, As to All Allegations and Remedies; Violations of TILA — Against Defendants US Bank, T.D. Service, MERS, Melmet, Security Union, and Does 31 through 50, inclusive, As to the Remedy of Rescission.)

125. Plaintiff realleges and incorporates by reference as though fully set forth herein, Paragraphs 1 through 88, inclusive, of this complaint.

126. The Platinum Loan is a "consumer credit transaction" subject to the provisions of TILA, 15 *U.S.C.* Sections 1601 *et seq.*

127. Defendants Platinum, Chevy Chase, and Does 1 through 30, inclusive, violated TILA in the following respects:

(a) by falsifying Plaintiff's Loan Application;

(b) by failing to provide Plaintiff with the written disclosures required under TILA prior to the close of escrow;

(c) by failing to set forth in any Platinum Loan document the disclosures required by TILA clearly and conspicuously in writing;

(d) by failing to provide Plaintiff with clear, complete, and accurate disclosures regarding, among other material terms, the total finance charge, the actual amount financed, the actual annual percentage rate (which is higher than the disclosed rate), the payment schedule, the monthly payments, the consequences of negative amortization, the total payments due on the Platinum Loan, and the fees and charges of Defendant Platinum;

(e) by extending credit to Plaintiff without regard to Plaintiff's repayment ability;

(f) by extending credit to Plaintiff without regard to Plaintiff's true current and expected income, current obligations, and employment;

(g) by failing to include Defendant Platinum's points and the other fees and charges paid to Defendant Platinum within Plaintiff's cost of credit as a finance charge to Plaintiff, thus constituting hidden finance charges;

(h) by charging Plaintiff excessive fees and charges not reasonably related to the performance of lawful or genuine settlement services, which fees and charges were thus finance charges that required full disclosure;

(i) by failing to provide Plaintiff with written notice of her right to rescind the Platinum Loan within three (3) business days of the close of escrow.

128. As a proximate result of the violations of TILA by Defendants Platinum, Chevy Chase, and Does 1 through 30, inclusive, Plaintiff has incurred general damages in a sum according to proof at trial, together with interest thereon from and after December 21, 2006, in the maximum amount allowed by law.

129. As a further proximate result of the violations of TILA by Defendants Platinum, Chevy Chase, and Does 1 through 30, inclusive, Plaintiff has incurred damages equal to twice the amount of the finance charges paid by Plaintiff in connection with the Platinum Loan, pursuant to TILA, 15 *U.S.C.* Section 1640,

in a sum according to proof at trial, together with interest thereon from and after December 21, 2006, in the maximum amount allowed by law.

130. As a further proximate result of the violations of TILA by Defendants Platinum, Chevy Chase, and Does 1 through 30, inclusive, Plaintiff has incurred damages equal to the amount of all remaining indebtedness on the Platinum Loan, pursuant to TILA, 15 *U.S.C.* Section 1641, in a sum according to proof at trial, together with interest thereon from and after December 21, 2006, in the maximum amount allowed by law.

131. As a further proximate result of the violations of TILA by Defendants Platinum, Chevy Chase, and Does 1 through 30, inclusive, Plaintiff has incurred damages equal to the total amount paid by Plaintiff in connection with the Platinum Loan, including all payments of principal and interest and all payments of fees, charges and points paid in connection with the Platinum Loan, pursuant to TILA, 15 *U.S.C.* Section 1641, in a sum according to proof at trial, together with interest thereon from and after December 21, 2006, in the maximum amount allowed by law.

132. As a further proximate result of the violations of TILA by Defendants Platinum, Chevy Chase, and DOES 1 through 30, inclusive, Plaintiff is entitled to statutory damages of $2,000.00, pursuant to TILA, 150 *U.S.C.* Section 1640.

133. As a further proximate result of the violations of TILA by Defendants Platinum, Chevy Chase, and Does 1 through 30, inclusive, Plaintiff is entitled to rescind the Platinum Loan, including the Platinum Note and Deed of Trust, as to all the Defendants identified in this cause of action.

134. As a further proximate result of the violations of TILA by Defendants Platinum, Chevy Chase, and Does 1 through 30, inclusive, Plaintiff is entitled to reasonable attorney's fees and costs, pursuant to TILA, 15 *U.S.C.* Section 1640.

135. Any and all statutes of limitations under TILA are tolled as a result of the failure of Defendants Platinum, Chevy Chase, and Does 1 through 30, inclusive, to comply with the requirements of TILA.

FIFTH CAUSE OF ACTION
(Violations of RESPA — Against Defendants Platinum, Chevy Chase, and DOES 1 through 30, inclusive, As to All Allegations and Remedies; Violations of RESPA — Against Defendants US Bank, T.D. Service, MERS, Melmet, Security Union, and Does 31 through 50, inclusive, As to the Remedy of Rescission.)

136. Plaintiff realleges and incorporates by reference, as though fully set forth herein, Paragraphs 1 through 88, inclusive, of this complaint.

137. The Platinum Loan is a "federally related mortgage loan" subject to the provisions of RESPA, 12 U.S.C. Section 2601 *et. seq.*

138. Defendants Platinum, Chevy Chase, and DOES 1 through 30, inclusive, violated RESPA in the following respects:

 (a) by failing to provide Plaintiff with a written Good Faith Estimate of Closing Costs Statement;

 (b) by failing to provide Plaintiff with clear, complete, and accurate disclo-

sures regarding, among other material terms, the total finance charge, the actual amount financed, the actual annual percentage rate (which is higher than the disclosure at close), the payment schedule, the monthly payments, the consequences of negative amortization, the total payments due on the Platinum Loan, and the fees and charges of Defendant Platinum;

(c) by failing to provide Plaintiff with written disclosure of the type or amount of fees and charges of the Platinum Loan;

(d) by failing to include Defendant Platinum's points and other fees and charges paid to Defendant Platinum within Plaintiff's cost of credit as a finance charge to Plaintiff, thus constituting hidden finance charges;

(e) by Defendant Platinum taking fees not reasonably related to the performance of lawful or genuine settlement services, thus constituting an illegal kickback, unearned fee, and fee split;

(f) by failing to provide Plaintiff with a booklet entitled *Consumer Handbook on Adjustable Rate Mortgages*, published by the Board of Governors of the Federal Reserve System, and by failing to provide Plaintiff with a loan information booklet;

(g) by failing to notify Plaintiff in writing that the Platinum Loan was assigned, sold, or transferred to Defendant Chevy Chase and/or to one or more MBS Trusts;

(h) by failing to notify Plaintiff in writing that the loan servicing functions on the Platinum Loan were transferred to Defendant Chevy Chase;

(i) by imposing impound amounts in excess of that permitted under RESPA;

(j) by refusing and failing to credit Plaintiff's account, either to principal or interest, with Plaintiff's payment of $12,208.95;

(k) by failing to respond to Plaintiff's qualified written request or to act to resolve Plaintiff's qualified written request in the time allowed, or at all;

(l) by reporting Plaintiff's alleged default to credit reporting agencies while Plaintiff's qualified written request remained unresolved;

(m) by failing to provide Plaintiff with a closing statement that clearly itemized the fees and charges imposed on Plaintiff.

139. As a proximate result of the violations of RESPA by Defendants Platinum, Chevy Chase, and Does 1 through 30, inclusive, Plaintiff has incurred general damages in a sum according to proof at trial, together with interest thereon from and after December 21, 2006, in the maximum amount allowed by law.

140. As a further proximate result of the violations of RESPA by Defendants Platinum, Chevy Chase, and Does 1 through 30, inclusive, Plaintiff has incurred damages equal to three times the amount of all fees and charges for settlement services paid by Plaintiff in connection with the Platinum Loan, pursuant to RESPA, 12 *U.S.C.* Section 2607, in a sum according to proof at trial, together with interest thereon from and after December 21, 2006, in the maximum amount allowed by law.

141. As a further proximate result of the violations of RESPA by Defendants Platinum, Chevy Chase and DOES 1 through 30, inclusive, Plaintiff is

entitled to statutory damages of $1,000.00, pursuant to RESPA, 12 *U.S.C.* Section 2605.

142. As a further proximate result of the violations of RESPA by Defendants Platinum, Chevy Chase, and Does 1 through 30, inclusive, Plaintiff is entitled to rescind the Platinum Loan, including the Platinum Note and Deed of Trust, as to all the Defendants identified in this cause of action.

143. As a further proximate result of the violations of RESPA by Defendants Platinum, Chevy Chase, and Does 1 through 30, inclusive, Plaintiff is entitled to reasonable attorney's fees and costs, pursuant to RESPA, 12 *U.S.C.* Section 2605.

144. Any and all statutes of limitations under RESPA are tolled as a result of the failure by Defendants Platinum, Chevy Chase, and DOES 1 through 30, inclusive, to comply with the requirements of RESPA.

SIXTH CAUSE OF ACTION
(Violations of State Statutes - Against Defendants Platinum, Chevy Chase, and Does 1 through 30, inclusive, As to All Allegations and Remedies; Violations of State Statutes - Against Defendants US Bank, T.D. Service, MERS, Melmet, Security Union, and Does 31 through 50, inclusive, As to the Injunctive Remedy)

145. Plaintiff realleges and incorporates by reference, as though fully set forth herein, Paragraphs 1 through 88, inclusive, of this complaint.

146. Defendants Platinum, Chevy Chase, and Does 1 through 30, inclusive, violated the provisions of California *Business and Professions Code* Section 1024 et. seq, by failing to deliver to Plaintiff within three business days after the receipt of Plaintiff's Loan Application a written statement containing an estimate of the maximum costs and expenses of the Platinum Loan, which maximum costs and expenses are set forth in California *Business and Professions Code* Section 10241.

147. Defendants Platinum, Chevy Chase, and Does 1 through 30, inclusive, violated the CRMLA in the following respects:

(a) by failing to enter into a written loan brokerage agreement with Plaintiff containing the information required by Section 50701 of the CRMLA, which agreement must include an explicit statement that said Defendants were acting as the agent of Plaintiff in providing brokerage services, that said Defendants owed a fiduciary duty to Plaintiff, a statement and identification of any agency relationships with third persons, a description of services to be performed, a description of the brokerage services to be rendered and a good faith estimate of the fees therefor, and a statement of the conditions under which Plaintiff would be obligated to pay for brokerage services rendered;

(b) by accepting fees at the close of escrow that were not disclosed to Plaintiff;

(c) by inducing Plaintiff to execute the Loan Application in which blanks were left to be completed after execution;

(d) by engaging in fraudulent home mortgage underwriting practices;

(e) by violating California *Business and Professions Code* Section 17200 et. seq, as more fully alleged herein, by knowingly concealing material information regarding the Platinum Loan;

(f) by engaging in fraudulent and dishonest conduct with respect to dealings with Plaintiff.

148. Defendants Platinum, Chevy Chase, and Does 1 through 30, inclusive, violated California *Civil Code* Section 2937, by failing to notify Plaintiff in writing of the assignment, sale, or transfer of the Platinum Loan to Defendant Chevy Chase and/or Defendant U.S. Bank, and by failing to notify Plaintiff in writing of the assignment, sale, or transfer of the Platinum Loan to one or more MBS Trusts.

149. Defendants Platinum, Chevy Chase, and Does 1 through 30, inclusive, violated the provisions of California *Civil Code* Section 2932.5 by assigning, selling, and transferring the Platinum Note, either by way of written endorsement, allonge, or actual delivery without any recorded assignment.

150. All of the Defendants identified in this cause of action violated the provisions of SB1137, as alleged herein.

151. As a proximate result of the violation of California *Business and Professions Code* Section 1024, *et. seq*, by Defendants Platinum, Chevy Chase, and Does 1 through 30, inclusive, Plaintiff has incurred damages equal to three times the amount of the fees and charges paid by Plaintiff in connection with the Platinum Loan, pursuant to California *Business and Professions Code* Section 10246, in a sum according to proof at trial, together with interest thereon from and after December 21, 2006, in the maximum amount allowed by law.

152. As a further proximate result of the violations of California *Business and Professions Code* Section 1024 *et. seq* by Defendants Platinum, Chevy Chase, and Does 1 through 30, inclusive, Plaintiff is entitled to reasonable attorney fees and costs pursuant to California Business and Professions Code Section 10246.

153. As a proximate result of the violations of the CRMLA by Defendants Platinum, Chevy Chase, and Does 1 through 30, inclusive, Plaintiff is entitled to damages equal to the amount of all fees and charges paid by Plaintiff in connection with the Platinum Loan, pursuant to CRMLA Section 50701, in a sum according to proof at trial, together with interest thereon from and after December 21, 2006, in the maximum amount allowed by law.

154. As a further proximate result of the violations of the CRMLA by Defendants Platinum, Chevy Chase, and Does 1 through 30, inclusive, Plaintiff is entitled to statutory damages of $2500.00, pursuant to CRMLA Section 50501.

155. As a further proximate result of the violations of the CRMLA by Defendants Platinum, Chevy Chase, and Does 1 through 30, inclusive, Plaintiff is entitled to reasonable attorney's fees and costs pursuant to CRMLA Section 50700.

156. As a proximate result of the violations of California Civil Code Sections 2937, 2932.5, and SB1137, none of the Defendants identified in this cause of action have standing or the right to non-judicially foreclose on Plaintiff's

Property, justifying a temporary restraining order, preliminary injunction, and permanent injunction restraining and enjoining all of the Defendants from non-judicially foreclosing on Plaintiff's Property.

SEVENTH CAUSE OF ACTION
(Quiet Title Against All Defendants.)

157. Plaintiff realleges and incorporates by reference, as though fully set forth herein, Paragraphs 1 through 157, inclusive, of this complaint.

158. Plaintiff is the owner in fee and in possession of and in control of the Property.

159. Plaintiff obtained fee simple title to the Property by a grant deed recorded as document number: _____ in the Official Records of Los Angeles County, California.

160. Plaintiff is informed and believes and thereon alleges that Defendants claim an interest in the Property adverse to Plaintiff's title, pursuant to which Defendants seek to non-judicially foreclose upon the Property. The claims of Defendants are without any right and Defendants have no right, title, estate, lien, or interest in the Property, such that any attempted non-judicial foreclosure on the Property is illegal and unlawful.

161. Plaintiff seeks a determination she holds of fee simple title to the Property free of any purported adverse claims of Defendants.

EIGHTH CAUSE OF ACTION
(Violation of California *Business and Professions Code* Section 17200 Against Defendant Platinum, Chevy Chase, and Does 1 through 30, inclusive.)

162. Plaintiff realleges and incorporates by reference, as though fully set forth herein, Paragraphs 1 through 157, inclusive, of this complaint.

163. The actions alleged herein of the Defendants identified in this cause of action constitute unlawful, unfair, and fraudulent business acts and practices, in violation of California *Business and Professions Code* Section 17200 *et. seq*.

164. The actions alleged herein of the Defendants identified in this cause of action constitute unlawful, unfair and fraudulent business acts and practices because such actions violate TILA, RESPA, the CRMLA, California *Business and Professions Code* Section 10240 *et. seq*, California *Civil Code* Sections 2937 and 2932.5, and SB1137.

165. Plaintiff has suffered injury in fact and lost money as result of said Defendants' actions as alleged herein.

166. The Defendants identified in this cause of action have received money and property belonging to Plaintiff and have been unjustly enriched thereby.

167. The unlawful, unfair, and fraudulent business acts and practices of the Defendants identified in this cause of action constituted and constitute a continuing course of unfair competition.

168. As a proximate result of the violation of California *Business and Professions Code* Section 17200 *et. seq* by the Defendants identified in this cause of action, Plaintiff is entitled to an order of the court enjoining said Defendants

from continuing to engage in unlawful, unfair, and fraudulent business acts and practices as alleged in this complaint, pursuant to California *Business and Professions Code* Section 17203.

169. As a further proximate result of the unlawful, unfair, and fraudulent business acts and practices of the Defendants identified in this cause of action, Plaintiff is entitled to an order of the court requiring said Defendants to make full restitution of all moneys they have wrongfully obtained from Plaintiff and an order of the court requiring said Defendants to disgorge all ill-gotten revenues and/or profits obtained from the Platinum Loan, pursuant to California *Business and Professions Code* Section 17203, together with interest thereon from and after December 21, 2006, in the maximum amount allowed by law.

NINTH CAUSE OF ACTION
(Temporary Restraining Order, Preliminary Injunction and Permanent Injunction Against All Defendants.)

170. Plaintiff realleges and incorporates by reference, as though fully set forth herein, Paragraphs 1 through 170, inclusive, of this complaint.

171. Defendants seek to non-judicially foreclose upon the Property pursuant to the Deed of Trust. For the reasons alleged herein, non-judicial foreclosure on the Property is illegal, wrongful, and violative of state and federal law.

172. Plaintiff is informed and believes and thereon alleges that Defendants will proceed with the sale of Property pursuant to the Deed of Trust and Notice of Default, unless and until retrained and rejoined by order of the court.

173. Non-judicial foreclosure on the Property will cause Plaintiff great and irreparable injury, for which pecuniary compensation would not afford adequate relief, in that Plaintiff would suffer the loss of her home.

174. Plaintiff has no adequate remedy at law for Defendants' non-judicial foreclosure of her Property.

175. Plaintiff is therefore entitled to a temporary restraining order, preliminary injunction, and permanent injunction, enjoining all Defendants, their agents, attorneys, and representatives, and all persons acting in concert or participating with them, from proceeding with the non-judicial foreclosure of Plaintiff's Property, including the sale or attempted sale of Plaintiff's Property.

TENTH CAUSE OF ACTION
(Violations of the FCRA - Against Defendants Platinum, Chevy Chase, and Does 1 through 30, inclusive.)

176. Plaintiff realleges and incorporates by reference, as though fully set forth herein, Paragraphs 1 through 88, inclusive, of this complaint.

177. Defendants Platinum, Chevy Chase, and Does 1 through 30, inclusive, are "consumer reporting agencies," as defined in 15 *U.S.C.* Section 1681(e).

178. Plaintiff is informed and believes and thereon alleges that commencing in or about February, 2007, Defendants Platinum, Chevy Chase, and Does 1 through 30, inclusive, violated the FCRA by willfully failing to comply with the FCRA in the following respects:

(a) by reporting information relating to Plaintiff's credit profile to consumer reporting agencies with actual knowledge of errors in the information provided;

(b) by reporting information to credit reporting agencies relating to Plaintiff's credit profile when said Defendants knew or consciously avoided knowing that the reported information was inaccurate;

(c) by failing to inform Plaintiff in writing about the negative information which said Defendants had reported to credit reporting agencies.

179. As a proximate result of the violations of the FCRA by Defendants Platinum, Chevy Chase, and Does 1 through 30, inclusive, Plaintiff is entitled to statutory damages of $1,000.00, pursuant to the FCRA, 15 *U.S.C.* Section 1681n.

180. As a further proximate result of the violations of the FCRA by Defendants Platinum, Chevy Chase, and Does 1 through 30, inclusive, Plaintiff is entitled to punitive damages, as the court may allow, pursuant to the FCRA, 15 *U.S.C.* Section 1681n.

181. As a further proximate result of the violations of the FCRA by Defendants Platinum, Chevy Chase, and Does 1 through 30, inclusive, Plaintiff is entitled to reasonable attorney's fees, pursuant to the FCRA, 15 *U.S.C.* Section 1681n.

WHEREFORE, Plaintiff prays judgment as follows:
ON THE FIRST AND THIRD CAUSES OF ACTION

1. For general damages according to proof;

2. For damages to Plaintiff's credit rating according to proof;

3. For damages equal to twice the amount of the finance charges paid by Plaintiff on the Platinum Loan according to proof;

4. For damages equal to the amount of all remaining indebtedness on the Platinum Loan according to proof;

5. For damages equal to the total amount paid by Plaintiff in connection with the Platinum Loan according to proof;

6. For statutory damages in the sum of $2,000.00;

7. For punitive damages;

8. For reasonable attorney's fees and costs;

9. For interest on the foregoing damages from and after December 21, 2006, in the maximum amount allowed by law.

ON THE SECOND CAUSE OF ACTION

10. For general damages according to proof;

11. For damages to Plaintiff's credit rating according to proof;

12. For damages equal to twice the amount of the finance charges paid by Plaintiff on the Platinum Loan according to proof;

13. For damages equal to the amount of all remaining indebtedness on the Platinum Loan according to proof;

14. For damages equal to the total amount paid by Plaintiff in connection with the Platinum Loan according to proof;

15. For statutory damages in the sum of $2,000.00;

16. For reasonable attorney's fees and costs;

17. For interest on the foregoing damages from and after December 21, 2006, in the maximum amount allowed by law.

ON THE FOURTH CAUSE OF ACTION

18. For general damages according to proof;

19. For damages equal to twice the amount of the finance charges paid by Plaintiff on the Platinum Loan according to proof;

20. For damages equal to the amount of all remaining indebtedness on the Platinum Loan according to proof;

21. For damages equal to the total amount paid by Plaintiff on the Platinum Loan according to proof ;

22. For statutory damages in the sum of $2,000.00;

23. For rescission of the Platinum Loan, including the Platinum Note and Deed of Trust;

24. For reasonable attorney's fees and costs;

25. For interest on the foregoing damages from and after December 21, 2006, in the maximum amount allowed by law.

ON THE FIFTH CAUSE OF ACTION

26. For general damages according to proof;

27. For damages equal to three times the amount of all fees and charges for settlement services paid by Plaintiff on the Platinum Loan according to proof;

28. For statutory damages in the sum of $1,000.00;

29. For rescission of the Platinum Note and Deed of Trust;

30. For reasonable attorney's fees and costs;

31. For interest on the foregoing damages from and after December 21, 2006, in the maximum amount allowed by law.

ON THE SIXTH CAUSE OF ACTION

32. For damages equal to three times the amount of all fees and charges for settlement services paid by Plaintiff on the Platinum Loan according to proof;

33. For damages equal to the amount of all fees and charges paid by Plaintiff on the Platinum Loan according to proof;

34. For statutory damages in sum of $2,500.00;

35. For an order enjoining Defendants from non-judicially foreclosing on Plaintiff's property;

36. For reasonable attorney's fees and costs;

37. For interest on the foregoing damages from and after December 21, 2006, in the maximum amount allowed by law.

ON THE SEVENTH CAUSE OF ACTION

38. For an order of court quieting title to the Property to Plaintiff free of any purported adverse claims of Defendants;

ON THE EIGHTH CAUSE OF ACTION

39. For an order of court enjoining Defendants from engaging in unlawful, unfair, and fraudulent business practices;

40. For an order of court requiring Defendants to make restitution to Plaintiff of all monies Defendants wrongfully obtained from Plaintiff;

41. For an order of court requiring Defendants to disgorge all ill-gotten revenues and/or profits obtained on the Platinum Loan;

42. For interest on the foregoing damages from and after December 21, 2006, in the maximum amount allowed by law.

ON THE NINTH CAUSE OF ACTION

43. For a temporary restraining order, preliminary injunction, and permanent injunction enjoining all Defendants, their agents, attorneys, and representatives, and all persons acting in concert or participating with them, from proceeding with the non-judicial foreclosure of Plaintiff's property, including the sale or attempted sale of Plaintiff's property;

ON THE TENTH CAUSE OF ACTION

44. For statutory damages in sum of $1,000.00;

45. For punitive damages;

46. For reasonable attorney's fees and costs.

ON ALL CAUSES OF ACTION

47. For costs of suit incurred herein; and

48. For such other and further relief as the Court may deem just and proper.

DATED: October 7, 2008 ALLAN LAW GROUP P.C.
A Professional Corporation

By: _____
 Martin B. Snyder, Esq.
 Attorneys for Plaintiff

"Homeowners in distress must present their case to a judge and seek justice."

US Senator Arlen Specter,
December 2008

HOMEOWNER'S ARSENAL
OF LEGAL
WEAPONS

"The Truth in Lending Act, and its built in
right of rescission, is a homeowner's best friend."

Mortgage Auditor and Expert Witness
Against Predatory Lenders

The Truth in Lending Act

The Truth in Lending Act (TILA) is a federal law which protects borrowers by ensuring all necessary disclosures have been made before the closing of the loan. It does not apply to first purchase mortgages.

Lenders are governed by TILA to disclose:

- loan origination fees
- interest
- points
- servicing fees
- annual percentage rate
- payment schedule
- number of payments
- loan amount
- pre-payment penalties

TILA also provides for the right of rescission. This notice is given to borrowers as part of the closing documents. The borrower has three days to rescind the loan after closing. If the loan is predatory, or the disclosures were not made, the borrower has three years.

TILA also requires the mortgage transaction be transparent. This means that all parties must be disclosed as well as their fees. Nominal lenders of securitized loans have violated TILA by not disclosing the true lender. In the case of appraisal fraud, the loan's annual percentage rate may also be miscalculated.

TILA provides for damages and attorney's fees if the lender is found to be in violation. TILA has a three year limitation and no limit if fraud is alleged. TILA has a one year limit to bring a claim for damages, except in the case of suspected fraud.

If you have a predatory loan that has adjusted and are in payment shock, you have a TILA claim if you were not told about the true terms of your loan.

TILA is a powerful consumer weapon to use against predatory lenders. The following case illustrates how TILA was violated in a predatory lending case.

CASE STUDY 9

Ronald and Nancy Smith
vs.
Encore Credit Corporation Et Al

Case Study Nine

UNITED STATES DISTRICT COURT
NORTHERN DISTRICT OF OHIO
EASTERN DIVISION
RONALD J. SMITH and NANCY L. SMITH
Husband and Wife,
Plaintiffs,

v.

ENCORE CREDIT CORPORATION; BEAR
STEARNS RESIDENTIAL MORTGAGE
CORPORATION; OPTION ONE MORTGAGE
CORPORATION; MOTION FINANCIAL;
ELLYN KLEIN GROBER; and DOES 1-10,
Defendants.

COMPLAINT FOR FRAUD,
DECLARATORY RELIEF
OHIO CONSUMER SALES
PRACTICES ACT, VIOLATIONS OF FEDERAL HOME LENDING
STATUTES, CONSPIRACY,
RICO, AND OTHER RELIEF

Plaintiffs sue Defendants for damages and other relief, and state:
A. Parties and Jurisdiction
　　1. Plaintiffs are of majority age and are residents of the State of Ohio residing in their home located in Canfield, Ohio, 44406, and are "consumers" as defined in Ohio Revised Code (hereafter "ORC") sec. 1345.01.
　　2. Defendant ENCORE CREDIT CORPORATION (hereafter "ENCORE") was, at all material times hereto, a corporation which was registered in California and Illinois which was acquired by Defendant BEAR STEARNS RESIDENTIAL MORTGAGE CORPORATION ("BSRMC") as of October 29, 2007, and now operates as BEAR STEARNS RESIDENTIAL MORTGAGE d/b/a ENCORE CREDIT CORPORATION. At all times material hereto, Defendant ENCORE engaged in a continuous and systematic course of, and actively sought business within the State of Ohio, thus satisfying the minimum contacts requirements under the United States Supreme Court's decision in *International Shoe v. Washington* in order to render Defendant ENCORE subject to the jurisdiction of this Court and amenable to being sued within this jurisdiction. Defendant ENCORE was also, at all times material hereto, engaged in the business of effecting and soliciting consumer transactions within the State of Ohio and

is thus a "seller" as defined by ORC sec. 1345.21(C); a "supplier" as defined by ORC sec. 1345.01(c) and the Ohio Consumer Sales Practices Act, ORC sec. 1345.01(C); a "creditor" as defined by the Federal Truth In Lending Act (15 USC sec. 1602(f)); and an "enterprise" as defined by ORC sec. 2923.31(C) as an individual engaged in the business of effecting or soliciting consumer transactions. At all times material hereto, Defendant ENCORE's principal place of business was located at 1901 Butterfield Road, Suite 1010, Downer's Grove, Illinois 60516, and as further described herein, claimed ownership and serviced Plaintiff's mortgage loan.

3. Defendant BSRMC is the successor-in-interest to Defendant ENCORE relative to the mortgage which is part of the subject matter of this action. Defendant BSRMC is incorporated in the State of Delaware, but at all times material hereto, Defendant BSRMC, by virtue of its acquisition of Defendant ENCORE, engaged in a continuous and systematic course of, and actively sought business within the State of Ohio, thus satisfying the minimum contacts requirements under the United States Supreme Court's decision in *International Shoe v. Washington* in order to render Defendant BSRMC subject to the jurisdiction of this Court and amenable to being sued within this jurisdiction. Defendant BSRMC was also, at all times material hereto by virtue of its acquisition of Defendant ENCORE, in an agency relationship with Defendant ENCORE and is thus liable for all acts committed by Defendant ENCORE. At all times material hereto, Defendant BSRMC engaged in the business of effecting and soliciting consumer transactions within the State of Ohio and is thus a "seller" as defined by ORC sec. 1345.21(C); a "supplier" as defined by ORC sec. 1345.01(c) and the Ohio Consumer Sales Practices Act, ORC sec. 1345.01(C); a "creditor" as defined by the Federal Truth In Lending Act (15 USC sec. 1602(f)); and an "enterprise" as defined by ORC sec. 2923.31(C) as an individual engaged in the business of effecting or soliciting consumer transactions.

4. Defendant OPTION ONE MORTGAGE CORPORATION ("OPTION ONE") is incorporated in the State of California with its principal place of business beign located at 6501 Irvine Center Drive, Irvine, California 92618. At all times material hereto, Defendant OPTION ONE engaged in a continuous and systematic course of business within the State of Ohio, thus satisfying the minimum contacts requirements under the United States Supreme Court's decision in *International Shoe v. Washington* in order to render Defendant OPTION ONE subject to the jurisdiction of this Court and amenable to being sued within this jurisdiction and venue. At all times material hereto, Defendant OPTION ONE was in an agency relationship with Defendant ENCORE and is thus liable for all acts committed by Defendant ENCORE. Defendant OPTION ONE was also, by virtue of its agency relationship with Defendant ENCORE, at all times material hereto engaged in the business of effecting and soliciting consumer transactions within the State of Ohio and is thus a "seller" as defined by ORC sec. 1345.21(C); a "supplier" as defined by ORC sec. 1345.01(c) and the Ohio Consumer Sales Practices Act, ORC sec. 1345.01(C); a "creditor" as defined by the Federal Truth In Lending Act (15 USC sec. 1602(f)); and an "enterprise" as defined by ORC sec. 2923.31(C) as an individual engaged in the business of

effecting or soliciting consumer transactions.

5. Defendant MOTION FINANCIAL ("MOTION") and their representative agents were, at all times material as they held themselves out to be, "mortgage brokers" as defined by ORC sec. 1322.01(E), and were organized under the laws of the State of Ohio and thus amenable to suit within this jurisdiction, with their principal place of business being located at 4866 Cooper Road, #106, Cincinnati, Ohio 45242. At all times material hereto, Defendant MOTION and its agents engaged in the continuous and systematic business of effecting and soliciting consumer transactions within the State of Ohio and is thus a "seller" as defined by ORC sec. 1345.21(C); a "supplier" as defined by ORC sec. 1345.01(c) and the Ohio Consumer Sales Practices Act, ORC sec. 1345.01(C); a "creditor" as defined by the Federal Truth In Lending Act (15 USC sec. 1602(f)); and an "enterprise" as defined by ORC sec. 2923.31(C) as an individual engaged in the business of effecting or soliciting consumer transactions.

6. Defendant ELLYN KLEIN GROBER ("GROBER") is and was, at all times material hereto, a natural person over the age of eighteen (18) who was employed by Defendant MOTION as a mortgage broker and was thus an authorized agent of Defendant MOTION. All actions committed by Defendant GROBER are thus attributable to Defendant MOTION.

7. Plaintiffs are unaware of the true identities and capacities of Defendants DOES 1-10 inclusive, and therefore sue these Defendants by fictitious names. Plaintiffs are informed and believe, pursuant to the course of events and facts set forth herein, that DOES 1-10 are responsible, together with the named Defendants above, for the acts and omissions set forth herein and that the Plaintiffs' injuries and damages were caused, together with the named Defendants hereinabove, by Defendants DOES 1-10. At the appropriate point in this litigation and in connection with matters to be revealed in formal discovery, Plaintiffs shall seek leave to amend their Complaint to add additional facts and party Defendants pursuant to and provided by the Federal Truth In Lending Act.

8. Jurisdiction of the subject matter in this Court is proper pursuant to 28 U.S.C. sec. 1331, as Plaintiffs have sought relief under multiple Federal Statutes.

9. Jurisdiction of the Federal claims is proper in this Court pursuant to 15 U.S.C. sec. 1601 et. seq. and 15 U.S.C. sec. 1640(e).

10. Jurisdiction over the state-law claims is proper under the doctrine of Supplemental or Pendent Jurisdiction pursuant to 28 U.S.C. sec. 1367(a).

11. The cause of action herein arose in Mahoning County, Ohio by virtue of a mortgage loan and related inter-temporal transactions associated therewith which concern the Plaintiffs' primary residential real estate which is located in Canfield, Ohio 44406 which is located within Mahoning County which is within this Judicial District.

12. Venue of this action is proper within this Court as at least one named Defendant is subject to suit within this Court, and thus all Defendants are properly sued in this Court.

B. Material Facts Common to All Counts

13. Prior to January 7, 2004, Plaintiffs had several discussions via telephone with authorized agents of Defendant MOTION concerning a possible refinance on the mortgages on their home. Plaintiffs directed Defendant MOTION to extract equity from their home for the purpose of paying off credit cards and other persona loans due to a deteriorating income stream versus prior year and also to be able to fund the March, 2004 mortgage payments. Plaintiffs believed that the best way to accomplish this would be through a fixed-rate loan at the lowest interest rate for which Plaintiffs qualified and with a monthly payment plan which Plaintiffs could afford given their financial situation as to income and expenses.

14. On or about January 7, 2004, Defendant GROBER, as authorized agent of Defendant MOTION, affirmatively represented to Plaintiffs that Plaintiffs qualified for and would be able to obtain a fixed rate mortgage loan in the principal amount of $528,500.00. In connection therewith, Defendant GROBER prepared or caused to be prepared a Uniform Residential Loan Application which was executed by Defendant GROBER on January 7, 2004. The subject Application contained a mechanically printed checkmark next to the box designated "fixed rate". Plaintiffs executed the Application on January 9, 2004 and returned same to Defendant MOTION.

15. Defendant MOTION also provided to Plaintiffs, on or about January 7, 2004, an "early Truth In Lending Statement" ("TIL") which set forth that Plaintiffs were obtaining a fixed rate mortgage loan.

16. However, Defendant MOTION failed to provide to Plaintiffs, on or about January 7, 2004 and prior to the date that Plaintiffs signed the Uniform Residential Loan Application, either a Good Faith Estimate ("GFE") showing no loan programs, or a early TIL for the sub-prime, adjustable rate, six (6) month Libor mortgage loan program.

17. In February, 2004, Plaintiffs were informed by Defendant GROBER that the fixed rate loan which Plaintiffs initially qualified for would not provide a sufficient loan-to-value ratio to enable Plaintiffs to obtain a cash-out refinance program. Plaintiffs were also advised that the only program then available to enable Plaintiffs to obtain a cash-out refinance would be an adjustable rate program requiring an appraised value of their property of $630,000.00.

18. Plaintiffs were also told that "time was running out" and that they were "essentially out of options". In reliance thereon, Plaintiffs agreed to the new adjustable rate program.

19. Thereafter but still in early February 2004, Defendant GROBER enlisted the services of non-party Statewide Appraisal to prepare an appraisal of Plaintiffs' property.

20. Several days later, Plaintiffs were presented with an e-mail copy of the appraisal which showed an appraised value of the property of approximately $570,000.00, which was insufficient to fund the cash-out program.

21. Plaintiffs were then contacted by Defendant GROBER, who advised

that she would speak to the appraiser to re-schedule another appraisal.

22. A second appraisal was performed by Statewide Appraisal on or about February 17, 2004 which now showed an appraised value of the property of $630,000.00 which enabled the loan program to be approved.

23. As Plaintiffs now had less than two weeks remaining before they would begin defaulting on numerous obligations, Plaintiffs agreed to proceed with the closing on the adjustable rate loan program.

24. On or about March 5, 2004, Defendants MOTION and ENCORE presented Plaintiffs with a literal pile of loan documents at the closing on the refinance loan. Plaintiffs were directed to sign the loan documents without being given time to review them or suggest modifications.

25. Included within the loan documents was another copy of the Uniform Residential Loan Application previously prepared by Defendant GROBER and provided by Defendant GROBER to the Plaintiffs on January 9, 2004. However, unbeknownst to the Plaintiffs at the time (that being at the closing), the version of the Application within the loan document pile presented to the Plaintiffs at the closing had been altered by a partial obliteration of the mechanical checkmark next to the box labeled "fixed rate", and the addition of a handwritten "X" in the box labeled "Adjustable Rate Mortgage (ARM)". The handwritten "X" was not made by either of the Plaintiffs, and this version of the document was not executed by any of the parties.

26. As a direct and proximate result of the unilateral and material alteration of the Application and the pressures placed on Plaintiffs manufactured by Defendants GROBER, MOTION, and ENCORE, on or about March 5, 2004, said Defendants placed Plaintiffs into a sub-prime adjustable rate mortgage program with a two (2) year fixed rate and an adjustable rate every six (6) months thereafter.

27. The end result of the false and misleading representations and material omissions of Defendants MOTION and ENCORE as to the loan program which Plaintiffs requested and were told by said Defendants that they qualified for, when viewed against the later actions of these Defendants as to which loan program the Plaintiffs were later told that they could only qualify for, which was told to Plaintiffs at a point less than 3 weeks before Plaintiffs would begin defaulting on obligations (and under circumstances where these Defendants had actual knowledge that the "only" loan program which Plaintiffs allegedly qualified for was in direct conflict with the original Uniform Residential Loan Application, early TIL, and Plaintiffs' stated intentions and directions to said Defendants at the time of original application for the loan), fraudulently caused Plaintiffs to execute predatory loan documents.

28. At no time whatsoever did Defendants MOTION and ENCORE ever advise Plaintiffs that:

 (a) the mortgage loan being processed was not in their best interest;

 (b) the terms of the mortgage loan being processed were less favorable than the fixed-rate loan which Defendant GROBER previously advised Plaintiffs that they qualified for;

(c) that the adjustable rate mortgage loan was an inter-temporal transaction (transaction where terms, risks, or provisions at the commencement of the transaction differ at a later time) on which Plaintiffs had only qualified at the initial "teaser" fixed rate but had not and could not qualify for the loan once the interest rate terms changed after year 2;

(d) that as a result of the change in interest rate after year 2 that Plaintiffs would not be able to meet their financial obligations on the loan given their income and expense history previously provided to Defendant GROBER;

(e) that Plaintiffs would likely be placed in a position of default, foreclosure, and deficiency judgment upon not being able to meet their increased loan obligations once the fixed rate interest period expired and the adjustable rate applied;

(f) that the originating "lender", that being Defendant ENCORE, had no intention of retaining ownership interest in the mortgage loan or fully servicing same and in fact may have already presold the loan, prior to closing, to a third party mortgage aggregator;

(g) that the mortgage loan was actually intended to be repeatedly sold and assigned to multiple third parties, including one or more mortgage aggregators and investment bankers (including but not limited to Defendants DOES 1-10), for the ultimate purpose of bundling the Plaintiffs' mortgage with hundreds or perhaps thousands of others as part of a companion, support, or other tranche in connection with the creation of a REMIC security known as a Collateralized Mortgage Obligation ("CMO"), also known as a "mortgage-backed security" to be sold by a securities firm (and which in fact ended up as collateral for Bear Stearns Asset-Backed Securities LLC Asset-Backed Certificates Series 2004-HES, created the same year as the closing);

(h) that the mortgage instrument and Promissory Note may be sold, transferred, or assigned separately to separate third parties so that the later "holder" of the Promissory Note may not be in privity with or have the legal right to foreclose in the event of default (which in fact occurred, as the plaintiff in the state court foreclosure action [identified herein *infra*] admitted in that proceeding that it did not have the original note);

(i) that in connection with the multiple downline resale and assignment of the mortgage and Promissory Note that assignees or purchasers of the Note may make "paydowns" against the Note which may effect the true amount owed by the Plaintiffs on the Note;

(j) that a successive assignee or purchaser of the Note and Mortgage may not, upon assignment or purchase, unilaterally impose property insurance requirements different from those imposed as a condition of the original loan (also known as prohibition against increased forced-placed coverage) without the Plaintiffs' prior notice and consent;

29. As a result of the closing and in connection therewith, Defendants

GROBER, MOTION, and ENCORE placed the Plaintiffs into a sub-prime adjustable rate mortgage program with a two (2) year fixed and adjustable rate every six (6) months thereafter with a misleading initial payment schedule which showed "fixed" payments and with the final loan documents spelling out "level" payments over the entire course of the loan, creating the impression as to a payment schedule which was untrue and in fact false.

30. As a direct and proximate result of the actions of the Defendants, Plaintiffs were placed into an adjustable rate mortgage program which Defendants knew that Plaintiffs did not and could not qualify for once the interest rate changed over the life of the loan, and which loan was "approved" based at least in part on the "revised" appraisal which was done at the request of Defendant GROBER and for the benefit of the Defendants.

31. Prior to the closing, Defendant ENCORE failed to provide to Plaintiffs the preliminary disclosures required by the Truth-In-Lending Act pursuant to 12 CFR (also known as and referred to herein as "Regulation Z") sec. 226.17 and 18, and failed to provide the preliminary disclosures required by the Real Estate Settlement Procedures Act ("RESPA") pursuant to 24 CFR sec. 3500.6 and 35007, otherwise known as the GFE.

32. Defendant ENCORE also intentionally failed and/or refused to provide Plaintiffs with various disclosures which would indicate to the Plaintiffs that the consumer credit contract entered into was void, illegal, and predatory in nature due in part to the fact that the final TIL showed a "fixed rate" schedule of payments, but did not provide the proper disclosures of the actual contractually-due amounts and rates.

33. Defendants failed and/or refused to provide a HUD-1 Settlement Statement at the closing which reflected the true cost of the consumer credit transaction. As Defendants failed to provide an accurate GFE or Itemization of Amount Financed ("IOAF"), there was no disclosure of a Yield Spread Premium ("YSP", which is required to be disclosed by the Truth-In-Lending Act) and thus no disclosure of the true cost of the loan.

34. As a direct and proximate result of these failures to disclose as required by the Truth-In—Lending Act, Defendant MOTION received a YSP in the amount of $10,570.00 without preliminary disclosure, which is a *per se* violation of 12 CFR sec. 226.4(a), 226.17 and 18(d) and (c)(1)(iii). The YSP raised the interest rate by 1.20% which was completely unknown to or approved by the Plaintiffs, as they did not received the required GFE or IOAF.

35. In addition, the completely undisclosed YSP was not disclosed by Defendant MOTION in their broker contract, which contract was blank in the area as to fees to be paid to Defendant MOTION. This is an illegal kickback in violation of 12 USC sec. 2607 as well as Ohio law which gives rise to all damages claims for all combined broker fees, costs, and attorneys' fees.

36. The Amount Financed within the TIL is also understated by $430.00, which is a material violation of 12 CFR sec. 226.17 and 18, in addition to 15 USC sec. 1602(u), as the Amount Financed must be completely accurate with no tolerance.

37. Defendants were under numerous legal obligations as fiduciaries and had the responsibility for overseeing the purported loan consummation to insure that the consummation was legal, proper, and that Plaintiffs received all legally required disclosures pursuant to the Truth-In-Lending Act and RESPA both before and after the closing.

38. Plaintiffs, not being in the consumer lending, mortgage broker, or residential loan business, reasonably relied upon the Defendants to insure that the consumer credit transaction was legal, proper, and complied with all applicable laws, rules, and Regulations.

39. At all times relevant hereto, Defendants regularly extended or offered to extend consumer credit for which a finance charge is or may be imposed or which, by written agreement, is payable in more than four (4) installments and was initially payable to the person the subject of the transaction, rendering Defendants "creditors" within the meaning of the Truth-In-Lending Act, 15 U.S.C. sec. 1602(f) and Regulation Z sec. 226.2(a)(17).

40. On or about March 5, 2004 at the closing, Plaintiffs executed Promissory Notes and Security Agreements in favor of Defendants ENCORE and OPTION ONE. These transactions, designated by Defendants as Loan No. 86512, extended consumer credit which was subject to a finance charge and which was initially payable to the Defendants.

41. As part of the consumer credit transaction the subject of the closing, Defendants retained a security interest in Canfield, Ohio 44406, which was Plaintiffs' principal residential dwelling.

42. Defendants engaged in a pattern and practice of defrauding Plaintiffs in that, during the entire life of the mortgage loan, Defendants failed to properly credit payments made; incorrectly calculated interest on the accounts; and have failed to accurately debit fees. At all times material, Defendants had actual knowledge that the Plaintiffs' accounts were not accurate but that Plaintiffs would make further payments based on Defendants' inaccurate accounts.

43. Plaintiffs made payments based on the improper, inaccurate and fraudulent representations as to Plaintiffs' accounts.

44. As a direct and proximate result of the actions of the Defendants set forth above, Plaintiffs overpaid in interest.

45. Defendants also utilized amounts known to the Defendants to be inaccurate to determine the amount allegedly due and owing for purposes of foreclosure.

46. Defendants' violations were all material in nature under the Truth-In-Lending Act.

47. Said violations, in addition to the fact that Plaintiff did not receive two (2) Notices of Right to Cancel, constitute violations of 15 USC sec. 1635(a) and (b) and 12 CFR sec. 226.23(b), and are thus a legal basis for and legally extend Plaintiffs' right to exercise the remedy of rescission.

48. Defendants ENCORE and MOTION assigned the Note and mortgage to Defendant OPTION ONE, which did not take these instruments in good faith or without notice that the instruments were invalid or that Plaintiffs had

a claim in recoupment. Pursuant to ORC sec. 1303.32(A)(2)(b)(c) and (f), Defendant OPTION ONE is not a holder indue course and is thus liable to Plaintiffs to the same extent as Defendant ENCORE.

49. Non-party Lasalle Bank National Association, as Trustee for Certificate Holders of Bear Stearns Asset-Backed Securities LLC Asset-Backed Certificate series 2004-HES, eventually filed a civil action for foreclosure against Plaintiffs in the Court of Common Pleas of Mahoning County, Ohio under case number 2005-CV-03869, with the Judgment Entry of Foreclosure being entered on or about January 12, 2007.

50. On information and belief and given that the consumer credit transaction was an inter-temporal transaction with multiple assignments as part of an aggregation and the creation of a REMIC tranche itself a part of a predetermined and identifiable CMO, all Defendants shared in the illegal proceeds of the transaction; conspired with each other to defraud the Plaintiffs out of the proceeds of the loan; acted in concert to wrongfully deprive the Plaintiffs of their residence; acted in concert and conspiracy to essentially steal the Plaintiffs' home and/or convert the Plaintiffs' home without providing Plaintiffs reasonably equivalent value in exchange; and conducted an illegal enterprise within the meaning of the RICO statute.

51. On information and belief and given the volume of residential loan transactions solicited and processed by the Defendants, the Defendants have engaged in two or more instances of racketeering activity involving different victims but utilizing the same method, means, mode, operation and enterprise with the same intended result.

A. Claims for Relief
COUNT I: VIOLATIONS OF HOME OWNERSHIP EQUITY PROTECTION ACT

52. Plaintiffs reaffirm and reallege paragraphs 1 through 51 hereinabove as if set forth more fully hereinbelow.

53. In 1994, Congress enacted the Home Ownership Equity Protection Act ("HOEPA") which is codified at 15 USC sec. 1639 et seq. with the intention of protecting homeowners from predatory lending practices targeted at vulnerable consumers. HOEPA requires lenders to make certain defined disclosures and prohibits certain terms from being included in home loans. In the event of noncompliance, HOEPA imposes civil liability for rescission and statutory and actual damages.

54. Plaintiffs are "consumers" and each Defendant is a "creditor" as defined by HOEPA. In the mortgage loan transaction at issue here, Plaintiffs were required to pay excessive fees, expenses, and costs which exceeded more than 10% of the amount financed.

55. Pursuant to HOEPA and specifically 15 USC sec. 1639(a)(1), each Defendant is required to make certain disclosures to the Plaintiffs which are to be made conspicuously and in writing no later than three (3) days prior to the closing.

56. In the transaction at issue, Defendants were required to make the following disclosure to Plaintiffs by no later than three (3) days prior to March 5, 2004: "You are not required to complete this agreement merely because you have received these disclosures or have signed a loan application. If you obtain this loan, the lender will have a mortgage on your home. You could lose your home and any money you have put into it, if you do not meet your obligation under the loan."

57. Defendants violated HOEPA by numerous acts and material omissions, including but not limited to:

(a) failing to make the foregoing disclosure in a conspicuous fashion;

(b) engaging in a pattern and practice of extending credit to Plaintiffs without regard to their ability to repay in violation of 15 USC sec. 1639(h).

58. By virtue of the Defendants' multiple violations of HOEPA, Plaintiffs have a legal right to rescind the consumer credit transaction the subject of this action pursuant to 15 USC sec. 1635. This Complaint is to be construed, for these purposes, as formal and public notice of Plaintiff's Notice of Rescission of the mortgage and note.

59. Defendants further violated HOEPA by failing to make additional disclosures, including but not limited to Plaintiff not receiving the required disclosure of her right to rescind the transaction; the failure of Defendants to provide an accurate TIL disclosure; and the amount financed being understated by $430.00.

60. As a direct consequence of and in connection with Plaintiffs' legal and lawful exercise of their right of rescission, the true "lender" is required, within twenty (20) days of this Notice of Rescission, to:

(a) desist from making any claims for finance charges in the transaction;

(b) return all monies paid by Plaintiffs in connection with the transaction to the Plaintiffs;

(c) satisfy all security interests, including mortgages, which were acquired in the transaction.

61. Upon the true "lenders" full performance of its obligations under HOEPA, Plaintiffs shall tender all sums to which the true lender is entitled.

62. Based on Defendants' HOEPA violations, each of the Defendants is liable to the Plaintiffs for the following, which Plaintiffs demand as relief:

(a) rescission of the mortgage loan transactions;

(b) termination of the mortgage and security interest in the property the subject of the mortgage loan documents created in the transaction;

(c) return of any money or property paid by the Plaintiffs including all payments made in connection with the transactions;

(d) an amount of money equal to twice the finance charge in connection with the transactions;

(e) relinquishment of the right to retain any proceeds; and

(f) actual damages in an amount to be determined at trial, including attorneys' fees.

COUNT II: VIOLATIONS OF REAL ESTATE SETTLEMENT PROCEDURES ACT

63. Plaintiffs reaffirm and reallege paragraphs 1 through 51 herein as if specifically set forth more fully hereinbelow.

64. As mortgage lenders, Defendants are subject to the provisions of the Real Estate Settlement Procedures Act ("RESPA"), 12 USC sec. 2601 et seq.

65. In violation of 12 USC sec. 2607 and in connection with the mortgage loan to Plaintiffs, Defendants accepted charges for the rendering of real estate services which were in fact charges for other than services actually performed.

66. As a result of the Defendants' violations of RESPA, Defendants are liable to Plaintiffs in an amount equal to three(3) times the amount of charges paid by Plaintiffs for "settlement services" pursuant to 12 USC sec. 2607(d)(2).

COUNT III: VIOLATIONS OF FEDERAL TRUTH-IN-LENDING ACT

67. Plaintiffs reaffirm and reallege paragraphs 1 through 51 hereinabove as if set forth more fully hereinbelow.

68. Defendants failed to include and disclose certain charges in the finance charge shown on the TIL statement, which charges were imposed on Plaintiffs incident to the extension of credit to the Plaintiffs and were required to be disclosed pursuant to 15 USC sec. 1605 and Regulation Z sec. 226.4, thus resulting in an improper disclosure of finance charges in violation of 15 USC sec. 1601 et seq., Regulation Z sec. 226.18(d). Such undisclosed charges include a sum identified on the Settlement Statement listing the amount financed which is different from the sum listed on the original Note.

69. By calculating the annual percentage rate ("APR") based upon improperly calculated and disclosed amounts, Defendants are in violation of 15 USC sec. 1601 et seq., Regulation Z sec. 226.18(c), 18(d), and 22.

70. Defendants' failure to provide the required disclosures provides Plaintiffs with the right to rescind the transaction, and Plaintiffs, through this public Complaint which is intended to be construed, for purposes of this claim, as a formal Notice of Recission, hereby elect to rescind the transaction.

COUNT IV: VIOLATION OF FAIR CREDIT REPORTING ACT

71. Plaintiffs reaffirm and reallege paragraphs 1 through 51 above as if set forth more fully hereinbelow.

72. At all times material, Defendants qualified as a provider of information to the Credit Reporting Agencies, including but not limited to Experian, Equifax, and TransUnion, under the Federal Fair Credit Reporting Act.

73. Defendants wrongfully, improperly, and illegally reported negative information as to the Plaintiffs to one or more Credit Reporting Agencies, resulting in Plaintiffs having negative information on their credit reports and the lowering of their FICO scores.

74. Pursuant to 15 USC sec. 1681(s)(2)(b), Plaintiffs are entitled to maintain a private cause of action against Defendants for an award of damages in an amount to be proven at the time of trial for all violations of the Fair Credit

Reporting Act which caused actual damages to Plaintiffs, including emotional distress and humiliation.

75. Plaintiffs are entitled to recover damages from Defendants for negligent non-compliance with the Fair Credit Reporting Act pursuant to 15 USC sec. 1681(o).

76. Plaintiffs are also entitled to an award of punitive damages against Defendants for their willful noncompliance with the Fair Credit Reporting Act pursuant to 15 USC sec. 1681(n)(a)(2) in an amount to be proven at time of trial.

COUNT V: VIOLATIONS OF OHIO CONSUMER PRACTICES ACT

77. Plaintiffs reaffirm and reallege paragraphs 1 through 51 above as if set forth more fully hereinbelow.

78. In providing various advices, mortgage brokerage services, lending services, and otherwise through its relations and communications with Plaintiffs, Defendants are subject to the provisions of the Ohio Consumer Sales Practices Act ("OCSPA"), ORC sec. 1345.01 et. seq.

79. In violation of the OCSPA, Defendants have committed unfair, deceptive, and unconscionable acts and practices in connection with the consumer transaction the subject of this action, including but not limited to:

(a) taking advantage of Plaintiffs' inability to protect their interests because of their inability to fully understand the terms of the transactions due to the numerous failures of the Defendants to disclose material information; altering of material terms; and misrepresentation of the terms of the transaction;

(b) charging Plaintiffs an excessive price for the services rendered;

(c) rendering services to Plaintiffs with the knowledge that there was no reasonable probability of repayment of the obligations in full by Plaintiffs; and

(d) by violations of the Ohio Mortgage Brokers Act set forth below and incorporated into this claim by reference.

80. Pursuant to ORC sec. 1345.09, Defendants are liable to Plaintiffs for each violation of the OCSPA in the amount equal to three (3) times actual damages in addition to Plaintiffs being entitled to injunctive relief barring any further violations pursuant to ORC sec. 1345.09(D).

COUNT VI: VIOLATION OF OHIO MORTGAGE BROKER'S ACT

81. Plaintiffs reaffirm and reallege paragraphs 1 through 51 hereinabove as if set forth more fully hereinbelow.

82. As a "mortgage broker" as defined by ORC sec. 1322.01(E), Defendant MOTION is subject to the requirements of said law. As set forth above, the Defendants knowingly concealed and misrepresented information which is required to be disclosed pursuant to Federal Statutes and Regulations.

83. Defendants MOTION and GROBER entered into the mortgage loan transaction the subject hereof with full knowledge that Plaintiffs did not quality for the loan program after the expiration of the initial 2-year "teaser" rate,

and that Plaintiffs would not be able to repay their obligation in full.

84. Defendants MOTION and GROBERA fraudulently induced Plaintiffs into signing a "bait and switch" mortgage loan package which included a legally unconscionable loan with full knowledge that same was contrary to applicable law and public policy.

85. The intentional concealment and material misrepresentations of Defendants MOTION and GROBER were made with knowledge of their falsity and, under the circumstances, maliciously and with reckless disregard to the rights of the Plaintiffs in connection with the overall inter-temporal transaction being part of the Defendants' predetermined process of reselling the loan to an aggregator and ultimate creation of a CMO utilizing Plaintiffs' mortgage as part of a tranche in a REMIC security.

86. Plaintiffs, not being investment bankers, securities dealers, mortgage lenders, mortgage brokers, or mortgage lenders, reasonably relied upon the representations of the Defendants in agreeing to execute the mortgage loan documents.

87. Defendants MOTION and GROBER are thus liable to Plaintiffs for an amount of damages to be determined at time of trial pursuant to ORC sec. 1322.11, 1322.00(A)(1-3) and a statutory injunction pursuant to ORC sec. 1322.11(B)(A), as a result of their violations ORC sec. 1322.07(B)(C).

COUNT VII: FRAUDULENT MISREPRESENTATION

88. Plaintiffs reaffirm and reallege paragraphs 1 through 51 hereinabove as if set forth more fully hereinbelow.

89. Defendants knowingly and intentionally concealed material information from Plaintiffs which is required by Federal Statutes and Regulations to be disclosed to the Plaintiffs both before and at the closing.

90. Defendants also materially misrepresented material information to the Plaintiffs with full knowledge by Defendants that their affirmative representations were false, fraudulent, and misrepresented the truth at the time said representations were made.

91. Under the circumstances, the material omissions and material misrepresentations of the Defendants were malicious.

92. Plaintiffs, not being investment bankers, securities dealers, mortgage lenders, mortgage brokers, or mortgage lenders, reasonably relied upon the representations of the Defendants in agreeing to execute the mortgage loan documents.

93. Had Plaintiffs known of the falsity of Defendants' representations, Plaintiffs would not have entered into the transactions the subject of this action.

94. As a direct and proximate cause of the Defendants' material omissions and material misrepresentations, Plaintiffs have suffered damages.

COUNT VIII: BREACH OF FIDUCIARY DUTY

95. Plaintiffs reaffirm and reallege paragraphs 1 through 51 hereinabove as if set forth more fully hereinbelow.

96. Defendants, by their actions in contracting to provide mortgage loan

services and a loan program to Plaintiffs which was not only to be best suited to the Plaintiffs given their income and expenses but by which Plaintiffs would also be able to satisfy their obligations without risk of losing their home, were "fiduciaries" in which Plaintiffs reposed trust and confidence, especially given that Plaintiffs were not and are not investment bankers, securities dealers, mortgage lenders, mortgage brokers, or mortgage lenders.

97. Defendants breached their fiduciary duties to the Plaintiffs by fraudulently inducing Plaintiffs to enter into a mortgage transaction which was contrary to the Plaintiffs' stated intentions; contrary to the Plaintiffs' interests; and contrary to the Plaintiffs' preservation of their home.

98. As a direct and proximate result of the Defendants' breaches of their fiduciary duties, Plaintiffs have suffered damages.

99. Under the totality of the circumstances, the Defendants' actions were willful, wanton, intentional, and with a callous and reckless disregard for the rights of the Plaintiffs justifying an award of not only actual compensatory but also exemplary punitive damages to serve as a deterrent not only as to future conduct of the named Defendants herein, but also to other persons or entities with similar inclinations.

COUNT IX: UNJUST ENRICHMENT

100. Plaintiffs reallege and reaffirm paragraphs 1 through 51 hereinabove as if set forth more fully hereinbelow.

101. Defendants had an implied contract with the Plaintiffs to ensure that Plaintiffs understood all fees which would be paid to the Defendants to obtain credit on Plaintiffs' behalf and to not charge any fees which were not related to the settlement of the loan and without full disclosure to Plaintiffs.

102. Defendants had full knowledge that a "bait and switch" adjustable rate predatory mortgage with an increase of 1.2% in the interest rate due to the YSP paid to the Broker for the "up sell" was not in the Plaintiffs' best interests, particularly as Defendants knew, at all times material, that Plaintiffs did not and could not qualify for the specific type of loan which was "approved".

103. Defendants cannot, in good conscience and equity, retain the benefits from their actions of charging a higher interest rate and YSP fee unrelated to the settlement services provided at closing.

104. Defendants have been unjustly enriched at the expense of the Plaintiffs, and maintenance of the enrichment would be contrary to the rules and principles of equity.

105. Plaintiffs thus demand restitution from the Defendants in the form of actual damages, exemplary damages, and attorneys' fees.

COUNT X: CIVIL CONSPIRACY

106. Plaintiffs reaffirm and reallege paragraphs 1 through 51 hereinabove as if set forth more fully hereinbelow.

107. In connection with the application for and consummation of the mortgage loan the subject of this action, Defendants agreed, between and among themselves, to engage in actions and a course of conduct designed to further

an illegal act or accomplish a legal act by unlawful means, and to commit one or more overt acts in furtherance of the conspiracy to defraud the Plaintiffs.

108. Defendants agreed between and among themselves to engage in the conspiracy to defraud for the common purpose of accruing economic gains for themselves at the expense of and detriment to the Plaintiffs.

109. The actions of the Defendants were committed intentionally, willfully, wantonly, and with reckless disregard for the rights of the Plaintiffs.

110. As a direct and proximate result of the actions of the Defendants in combination resulting in fraud and breaches of fiduciary duties, Plaintiffs have suffered damages.

111. Plaintiffs thus demand an award of actual, compensatory, and punitive damages.

COUNT XI: CIVIL ACTION FOR
VIOLATIONS OF OHIO RICO STATUTE

112. Plaintiffs reaffirm and reallege paragraphs 1 through 51 hereinabove as set forth more fully hereinbelow.

113. This claim is being brought by Plaintiffs pursuant to ORC sec. 2929.32 and 2929.34.

114. ORC sec. 2929.34 authorizes the institution of a civil action for violations of ORC sec. 2929.32, including the collection of an unlawful debt pursuant to a pattern of corrupt activity (ORC sec. 2929.32(a)(1)), and the acquisition of an interest in real property through a pattern of corrupt activity (ORC sec. 2929.32(a)(2)).

115. As set forth above, Defendants, who are "persons" within the statutory scheme, have engaged in a pattern of corrupt activity in order to not only seek the collection of an unlawful debt from Plaintiffs, but also to acquire an interest in real estate consisting of the Plaintiffs' primary residence.

116. The conspiracy the subject of this action has existed from January 7, 2004 to the present, with the injuries and damages resulting therefrom being continuing.

117. Defendants' actions and use of multiple corporate entities, multiple parties, and concerted and predetermined acts and conduct specifically designed to defraud Plaintiffs constitutes an "enterprise", with the aim and objective of the enterprise being to perpetrate a fraud upon the Plaintiffs through the use of intentional nondisclosure, material misrepresentation, and creation of fraudulent loan documents.

118. Each of the Defendants is an "enterprise Defendant" within the statutory scheme.

119. As a direct and proximate result of the actions of the Defendants, Plaintiffs have and continue to suffer damages.

120. Pursuant to ORC sec. 2929.34(B)(1), the court may order the Defendants' divestiture in any interest in real property, and Plaintiffs request the entry of Final Judgment against Defendants divesting their interest in the real property the subject of this action..

121. Pursuant to ORC sec. 2929.34(D), the Court may order injunctive relief without a showing of special or irreparable injury, and may issue a temporary injunction or temporary restraining order upon a showing of significant injury to the Plaintiff.

122. As set forth above, Plaintiffs have suffered significant injuries including the loss of their home, overpayment of fraudulent charges, damages to their credit rating, and a foreclosure.

123. Pursuant to ORC sec. 2929.34(E), Plaintiffs are also entitled to an award of three times actual damages sustained.

124. Pursuant to ORC sec. 2929.34(F), Plaintiffs are also entitled to reasonable attorneys' fees for having to bring this action.

RELIEF SOUGHT

WHEREFORE, having set forth the above-described legally sufficient causes of actions against the Defendants, Plaintiffs pray for the immediate issuance of a Preliminary Injunction or Temporary Restraining Order precluding the foreclosure sale of their property or any other disposition of the subject property pending the determination of this action; the entry of Final Judgment against all Defendants jointly and severally in an amount not yet quantified but to be proven at trial and such other amounts to be proven at trial; an award of three times the amount of actual damages sustained; for costs and attorneys' fees; that the Court find that the transactions the subject of this action are illegal and are deemed void; that the foreclosure which was instituted be deemed and declared illegal and void and that further proceedings in connection with the foreclosure be enjoined; and for any other and further relief which is just and proper.

DEMAND FOR JURY TRIAL

Plaintiffs demand trial by jury of all matters so triable as a matter of right.
 Respectfully submitted,

W. Jeff Barnes
(*counsel to seek admission pro hac vice*)
W. J. Barnes, P.A.
1515 North Federal Highway
Suite 300
Boca Raton, Florida 33432
Telephone: (561) 864-1067
Telefax: (702) 804-8137
 Attorneys for Plaintiffs

Maurus G. Malvasi
(Ohio Bar No. 0007763)
11 Overhill Road
Youngstown, Ohio 44512
Telephone: (330) 788-9900
Telefax: (513) 793-4400
Telefax: (513) 788-9265

"These claims can be won if
counsel for the homeowner can prove
the lender's intention to fraudulently induce
the homeowner into a transaction
for the lender's sole benefit."

Attorney Robert Allan

C H A P T E R

The Real Estate Settlement Procedures Act

The Real Estate Settlement Procedures Act is a federal law that protects homeowners during and after a mortgage transaction. RESPA applies to federally regulated mortgages, HUD-related loans, most equity loans, mobile home purchases and construction loans. Its statute of limitations is three years.

RESPA is designed to ensure that homeowners are aware of all fees, settlement costs, servicing and escrow requirements, loan sales or transfers. It governs the origination, settlement and servicing of the mortgage transaction.

RESPSA governs the settlement process, by requiring lenders to disclose all fees associated with the closing. RESPA covers both new purchases and refinances including equity lines. Disclosures include a "Special Information Booklet" and a "Good Faith Estimate."

Also required is a "Mortgage Servicing Disclosure Statement" which discloses to the borrower whether the lender expects to service the loan or transfer it to another lender. Lenders are required to give these documents to borrowers within three days of the application process.

RESPA also requires lenders to provide the borrower with a HUD 1 Settlement statement, which details all charges due at settlement. Borrowers can preview the HUD 1 one day prior to closing.

RESPA requires that lenders provide an "Initial Escrow Statement" detailing the costs of estimated taxes, insurance, and other charges anticipated at closing. Lenders must also provide an "Annual Escrow Statement" once a year, notifying the borrower of shortages or surpluses and any actions taken for that year.

In the event that a loan has been sold, RESPA requires lenders to provide a "Servicing Transfer Statement" fifteen days before the loan transfer. RESPA strictly inhibits lenders and third parties from taking kickbacks, rebates and referral fees, and insists on transparency in the financial transaction by disclosing the nature of the relationships between all parties.

RESPA ensures that borrowers have the right to choose their title, escrow and insurance company. If the lender provides some or all of these services through its subsidiaries, the lender is required to disclose this through an "Affiliated Business Arrangement Disclosure."

During the loan servicing period, borrowers have the right to question their lender in writing regarding a complaint related to the accounting, escrow and servicing of their loan. This is termed an "Official Written Request." Under RESPA, a lender must respond in twenty business days of receipt of the complaint. The lender has sixty business days to resolve the problem.

Violations of RESPA can be both civil and criminal. Violations of kickbacks, referral fees and unearned fees can be subject to $10,000 of penalties and one year imprisonment. Other violations regarding fees may be subject to penalties of three times the amount of the charge.

Borrowers who believe parties during the loan closing have violated RESPA may contact the Office of RESPA and Interstate Land Sales, at HUD. Borrowers may also bring a civil lawsuit against their lender for RESPA violations.

If you have learned that your loan is predatory, you have important rights under the RESPA law. It is best to hire a mortgage auditor

to investigate your loan and send one or more "qualified written requests" to your lender. This can result in restructuring or rescission of your predatory loan.

If your lender does not provide a written response within twenty business days, or rectify the problem within sixty days, it has violated RESPA. RESPA violations are part of your allegations against your lender.

Typical RESPA violations include:
- Paying a referral fee to obtain a loan.
- Paying a bonus during the financial transaction
- Violations in disclosures
- Violations in servicing the loan
- Rebates, contests or other inducements to obtain referrals
- Undisclosed or excessive fees during closing.

RESPA has been alleged in several of the complaints already presented in this book.

"New Haven Superior Court Judge Juliett L. Crawford dismissed a foreclosure case in late April when she concluded that Virginia-based Mortgage Electronic Registration Systems Inc. (MERS) 'failed to establish that it held either the mortgage or the note at the time' it filed its lawsuit against Madison homeowner Anna M. Miller, who defaulted on her mortgage in 2004 before she ever made a payment."

Douglas S. Malan, Connecticut Law Tribune

12

Quiet Title Action

One of the most powerful weapons in your arsenal is a "quiet title action." A quiet title action is filed to determine whether or not your lender is indeed a party of interest on your mortgage note and has any rights to your home, particularly the right to foreclose.

If you have determined that your loan is predatory and has been securitized, there is an excellent chance that errors were made in the rush to originate your loan and push you into closing it, in order for the loan to be sold, sliced and diced then issued as shares of mortgage backed securities. Your loan may have even been pre-sold, in which case, an investor bought a security that was based on the sale of your loan.

You might already own your home free in clear and just not know it!

When your mortgage was sold, your note was re-assigned and transferred multiple times. In many cases, these assignments and transfers were not done properly or legally. During the securitization process, your lender lost its standing on your mortgage and note. It cannot foreclose without having the standing to do so.

Your note morphed into shares of securities allegedly backed by the mortgages they represented. However, these shares bear no resemblance to the original note. In fact, many of the notes were destroyed or lost once a generic description of them was published.

Why is this a problem for your lender? The electronic systems used to record and track assignments became quickly overloaded or not used at all, leaving millions of unrecorded assignments. The recording of each assignment on title required that additional taxes be paid. Paying these taxes was undesirable.

Since there was no transparency at your closing, your mortgage had a fatal defect. When your loan was bought and sold at the same time, it failed to perfect a security instrument against your home.

And when it was sliced and diced then sold as shares, it became virtually impossible to trace your note back to the hundreds, or even, thousands of investors who own a piece of it. They are in fact, the true parties of interest on your loan.

Why is this good news for you? When your note was split from the mortgage, it made the mortgage null and void. During the securitization process, your note went on a wild journey, making the true parties of interest impossible to find. Since the parties of interest cannot be identified, you cannot be held accountable to pay the mortgage to a lender who sold your note and has been paid in full.

When you sue your lender for a quiet title action, you are claiming your lender has already been paid in full for the note and it has lost the power to enforce the mortgage. In the absence of proper assignments and recordings, your lender's interest in the property has been eliminated. You are demanding that the mortgage be extinguished and that you receive clear title to your home.

If you obtained a mortgage between 2001 and 2008, the probability of your loan being securitized is high. If your mortgage is adjustable, your payments variable and you pay less than the fully amortized amount each month, the probability is even higher. And even traditional fixed rate mortgages were sold by midsized and regional banks.

Whether you are in foreclosure, in payment shock, or current on your payments, it is time to attack your predatory lender with a quiet

title action. Quiet title means that you are demanding your lender prove it is, in fact, a party of interest on your mortgage note. You are alleging that you have the deed, and that there is a mortgage and note recorded against the property which has been satisfied by full payment plus a premium.

You are demanding that your lender produce each and every party of interest on your mortgage note. Because the lender at your closing was paid in full, plus paid a fee in an illegal transaction, in which it rented its license to an unchartered and unregistered lender to do business in your state.

And when your lender cries you are demanding unjust enrichment and a windfall, turn the tables. It is your lender who defrauded you by selling you a toxic loan so it could make more money, sell your loan for a premium and get paid for mortgage servicing rights. Now it wants your home, too? Don't think so.

Following are examples of quiet title actions and judicial orders.

"Every action shall be prosecuted in the name of the real party in interest. In foreclosure actions, the real party of interest is the current holder of the note and mortgage."

Judges Bryant and Tyack

CASE STUDY 10

Judicial Order by Judges Bryant and JJ Tyack

Case Study Ten

IN THE COURT OF APPEALS OF OHIO
TENTH APPELLATE DISTRICT

Everhome Mortgage Company,
Plaintiff-Appellee,
v.
Sara E. Rowland et al.,
Defendants-Appellees,
(Gregory E. Vignon,
Defendant-Appellant).

No. 07AP-615 (C.P.C. No. 07CVE04-5165)
(REGULAR CALENDAR)

O P I N I O N
Rendered on March 20, 2008

Shapiro & Felty, LLP, Richard J. Lacivita and John A. Polinko, for plaintiff-appellee.
Dinsmore & Shohl, LLP, and Adam R. Todd, for defendant appellant.

APPEAL from the Franklin County Court of Common Pleas

KLATT, J.

Defendant-appellant, Gregory E. Vignon, appeals from a judgment of the Franklin County Court of Common Pleas that granted summary judgment in favor of plaintiff-appellee, Everhome Mortgage Company ("Everhome"). For the following reasons, we reverse.

In April 2003, Vignon and his former wife, Sara E. Rowland, signed a promissory note and mortgage to secure a loan for the purchase of a house. Vignon and Rowland executed these instruments in favor of TrustCorp Mortgage Company ("TrustCorp").

On April 16, 2007, Everhome filed a foreclosure action against Vignon and Rowland. In its complaint, Everhome alleged it is the holder of the note and mortgage Vignon and Rowland signed. Everhome also alleged that Vignon and Rowland defaulted in payment on the note and, as a consequence, owed Everhome $143,830.83, plus interest.

On June 4, 2007, Vignon filed an answer admitting that he has an inter-
est in the property but denying that he defaulted in the payments. As an affir-
mative defense, Vignon asserted that Everhome was not a real party in interest.

Ten days later, Everhome filed a motion for summary judgment. Vignon
subsequently filed his memorandum contra, arguing that: (1) Everhome did
not establish itself as the holder of the note and mortgage; (2) he did not owe
the amount Everhome claimed; and (3) Everhome did not comply with the re-
quirements of Section 203.604(b), Title 24, C.F.R. In his supporting affidavit,
Vignon stated that he executed the note and mortgage at issue in favor of Trust-
Corp. He further stated that he never signed an agreement, note, or mortgage
in favor of Everhome.

The trial court entered final judgment in favor of Everhome on June 29,
2007. Vignon now appeals from that judgment and assigns the following error:

The trial court erred as a matter of law in granting summary judgment in
favor of Plaintiff-Appellee and against Defendant- Appellant in the Final
Judgment Entry in Foreclosure filed June 29, 2007.

Pursuant to Civ.R. 56(C), a court shall render summary judgment if "the
pleadings, depositions, answers to interrogatories, written admissions, affi-
davits, transcripts of evidence, and written stipulations of fact, if any, timely
filed in the action, show that there is no genuine issue as to any material fact
and that the moving party is entitled to judgment as a matter of law." In ruling
on summary judgment, a court is not permitted to weigh evidence or choose
among reasonable inferences. *Tonti v. East Bank Condominiums, LLC*, Franklin
App. No. 07AP-388, 2007-Ohio-6779, at ¶25. Instead, a court must resolve all
reasonable inferences in favor of the non-moving party. *Dupler v. Mansfield Jour-
nal Co., Inc.* (1980), 64 Ohio St.2d 116, 120. Thus, summary judgment is ap-
propriate only where: (1) no genuine issue of material fact remains to be
litigated; (2) the moving party is entitled to judgment as a matter of law; and
(3) viewing the evidence most strongly in favor of the non-moving party, rea-
sonable minds can come to but one conclusion, and that conclusion is adverse
to the non-moving party. *Harless v. Willis Day Warehousing Co.* (1978), 54 Ohio
St.2d 64, 66.

"[A] party seeking summary judgment * * * bears the initial burden of in-
forming the trial court of the basis for the motion, and identifying those por-
tions of the record that demonstrate the absence of a genuine issue of material
fact on the essential element(s) of the nonmoving party's claims." *Dresher v.
Burt* (1996), 75 Ohio St.3d 280, 293. If the moving party demonstrates that
there is no genuine issue of fact, "the nonmoving party then has a reciprocal
burden * * * to set forth specific facts showing that there is a genuine issue for
trial * * *." *Id.*

Appellate review of summary judgment is de novo. *Brown v. Scioto Cty. Bd.
of Commrs.* (1993), 87 Ohio App.3d 704, 711. Thus, an appellate court

applies the same standard as the trial court and conducts an independent review without deference to the trial court's determination.

By his only assignment of error, Vignon argues that the trial court erred in granting summary judgment because there is a genuine issue of fact about whether Everhome is the holder of the note and mortgage. He asserts that he executed the note and mortgage in favor of TrustCorp—not Everhome. He argues that because Everhome did not present evidence as to how it became the holder of the note and mortgage, it has not shown that it is a real party in interest. We agree.

"Every action shall be prosecuted in the name of the real party in interest." Civ.R. 17(A). A real party in interest is one who is directly benefited or injured by the outcome of the case. *Shealy v. Campbell* (1985), 20 Ohio St.3d 23, 24. The purpose behind the real-party-in-interest requirement is " 'to enable the defendant to avail himself of evidence and defenses that the defendant has against the real party in interest, and to assure him finality of the judgment, and that he will be protected against another suit brought by the real party at interest on the same matter.' " Id. at 24-25, quoting *In re Highland Holiday Subdivision* (1971), 27 Ohio App.2d 237, 240.

In foreclosure actions, the real party in interest is the current holder of the note and mortgage. *Chase Manhattan Mtge. Corp. v. Smith*, Hamilton App. No. C- 061069, 2007-Ohio-5874, at ¶18; *Kramer v. Millott* (Sept. 23, 1994), Erie App. No. E-94-5 (because the plaintiff did not prove that she was the holder of the note and mortgage, she did not establish herself as a real party in interest). A party who fails to establish itself as the current holder is not entitled to judgment as a matter of law. *First Union Natl. Bank v. Hufford* (2001), 146 Ohio App.3d 673, 677, 679-680. Thus, in *Hufford*, the Third District Court of Appeals reversed a grant of summary judgment where a purported mortgagee failed to produce sufficient evidence explaining or demonstrating its right to the note and mortgage at issue. In that case, the record contained only "inferences and bald assertions" and no "clear statement or documentation" proving that the original holder of the note and mortgage transferred its interest to the appellee. Id. at 678. The failure to prove who was the real party in interest created a genuine issue of material fact that precluded summary judgment. Id. at 679-680.

Similarly, in *Washington Mut. Bank, F.A. v. Green* (2004), 156 Ohio App.3d 461, the Seventh District Court of Appeals reversed the trial court's finding of summary judgment where the plaintiff failed to prove that it was the holder of the note and mortgage. There, the defendant executed a note and mortgage in favor of Check 'n Go Mortgage Services, not Washington Mutual Bank, F.A. Although Washington Mutual Bank, F.A. submitted an affidavit alleging an interest in the note and mortgage, it did not state how or when it acquired that interest. Id. at 467. The court concluded that this lack of evidence defeated the purpose of Civ.R. 17(A) by exposing the defendant to the danger that multiple "holders" would seek foreclosure based upon the same note and mortgage. Id.

In the case at bar, the note and mortgage identify TrustCorp—not Everhome—as the lender. Therefore, Everhome needed to present the trial court with other evidence to prove its status as the current holder of the note and mortgage. To accomplish this, Everhome relied upon the affidavit testimony of Becky North, an Everhome officer. In her affidavit, North stated that "the copies of the Promissory Note and Mortgage Deed attached to Plaintiff's Complaint *are true and accurate copies of the original instruments held by Plaintiff.*" (Emphasis added.) Beyond this tangential reference, North's affidavit contains no further averments regarding Everhome's interest in the note and mortgage.

We conclude that North's testimony is insufficient to establish that Everhome is the current holder of the note. First, Everhome failed to attach the note to its complaint. Thus, North's statement does not prove anything with regard to the note, much less that Everhome currently holds the note. Second, North does not specify how or when Everhome became the holder of the note and mortgage. Without evidence demonstrating the circumstances under which it received an interest in the note and mortgage, Everhome cannot establish itself as the holder.

Lacking the necessary evidence in the trial court record, Everhome attempts to introduce that evidence on appeal. In its brief, Everhome alleges that TrustCorp assigned to it TrustCorp's interest in the note and mortgage on April 19, 2007. Although evidence of an assignment would establish Everhome's status as the current holder of the note and mortgage, we cannot consider Everhome's belated allegation that an assignment occurred. See *State v. Ishmail* (1978), 54 Ohio St.2d 402, paragraph one of the syllabus ("A reviewing court cannot add matter to the record before it, which was not a part of the trial court's proceedings, and then decide the appeal on the basis of the new matter.").

Because Everhome did not present the trial court with evidence explaining how or when it became the holder of the note and mortgage, a genuine issue of material fact exists regarding whether it is a real party in interest. Therefore, the trial court erred in granting Everhome summary judgment, and we sustain Vignon's sole assignment of error.

On appeal, Vignon also disputes the amount owed under the note and argues that Everhome violated Section 203.604, Title 24, C.F.R. Because we reverse the trial court's judgment based on a factual dispute over the real party in interest, these remaining issues are moot.

For the forgoing reasons, we sustain Vignon's assignment of error. Therefore, we reverse the final judgment of the Franklin County Court of Common Pleas, and remand this case for proceedings in accordance with law and this opinion.

Judgment reversed and cause remanded.
BRYANT and TYACK, JJ., concur.

"In order to prove standing, Plaintiff must demonstrate that it was the owner of the note and mortgage at the time it commenced foreclosure action."

Judge Joseph Farneti

CASE STUDY

II

Judicial Order by Judge Farneti

Case Study Eleven

SUPREME COURT - STATE OF NEW YORK
I.A.S. TERM. PART 37 - SUFFOLK COUNTY

PRESENT:
HON. JOSEPH FARNETI
Acting Justice Supreme Court

AURORA LOAN SERVICES,
Plaintiff

v.

DONALD MACPHERSON, BELESKA
HOMESTEAD INC., MORTGAGE
ELECTRONIC REGISTRATION SYSTEMS,INC., AS NOMINEE FOR
FIRST MAGNUS FINANCIAL CORPORATION, 1104 NORTH SEA CO.,
INC., NEW YORK STATE DEPARTMENT OF TAXATION AND FINANCE,
"JOHN DOE 1 to JOHN DOE 25", said names being fictitious, the persons or
parties intended being the persons, parties, corporations or entities, if any,
having or claiming an interest in or lien upon the mortgaged premises de-
scribed in the complaint,
Defendants

ORIG. RETURN DATE: DECEMBER 31, 2007
FINAL SUBMISSION DATE: JANUARY 10, 2008
MTN. SEQ. #: 001
MOTION: MG

PLTF'S/PET'S ATTORNEY:
DRUCKMAN & SINEL, LLP
242 DREXEL AVENUE - SUITE 2
WESTBURY, NEW YORK 11590
516-876-0800

DEFENDANT DONALD MACPHERSON'S ATTORNEY:
IRWIN POPKIN, ESQ,
1138 WILLIAM FLOYD PARKWAY
SHIRLEY, NEW YORK 11967
631-281-0030

ORDERED that this motion by defendant DONALD MACPHERSON for an
Order, pursuant to CPLR 3211, dismissing the within complaint upon the

grounds that: (1) plaintiff does not have standing to institute the instant action; and (2) plaintiff failed to allege that the condition precedent to the commencement of this action has been satisfied, is hereby GRANTED, pursuant to CPLR 3211 (a)(3), for the reasons set forth hereinafter.

This is an action to foreclose a mortgage held by plaintiff in connection with the real property located at 1104 North Sea Road, Southampton, New York. Defendant DONALD MACPHERSON ("defendant") now moves to dismiss arguing that plaintiff does not have standing to institute the instant action and that plaintiff failed to allege that a condition precedent to the commencement of this action has been satisfied.

Defendant alleges that plaintiff was not the holder of the subject mortgage at the time the instant action was commenced and therefore had no standing to commence the action. The within complaint alleges that on or about July 25, 2006, defendant duly executed and delivered to FIRST MAGNUS FINANCIAL CORPORATION a note in the amount of 1,495,000.00and a mortgage as security therefor affecting the real property commonly known as 1104 North Sea Road, Southhampton, New York. As such, defendant challenges the standing of the plaintiff AURORA LOAN SERVICES, to commence this action to foreclose the aforementioned mortgage.

In opposition, plaintiff claims that it was the assignee of the subject mortgage prior to commencement of this action. In support thereof, plaintiff has annexed an assignment of mortgage dated October, 19, 2007, wherein MERS, Inc. as nominee for FIRST MAGNUS FINANCIAL CORPORATION, assigned a mortgage to AURORA LOAN SERVICES, LLC. The assignment indicates that the mortgage was executed by defendant on or about June 26, 2006. However, this assignment concerns a note having an original principal sum of $980,000.00, and a mortgage affecting property with an address of 9 Pheasant Run, Quogue, New York. Moreover, the Court notes that the mortgage at issue in the instant action is alleged to have been recorded in the Suffolk County Clerk's Office on August 4, 2006, in Liber/Reel 21354 at page 783, whereas the mortgage referenced in the assignment submitted by plaintiff is alleged to have been recorded in the Suffolk County Clerk's Office on July 26, 2006, in Liber/Reel 213476 at page 650.

In order to prove standing, plaintiff must demonstrate that it was the owner of the note and mortgage at the time it commenced this foreclosure action (*see e.g. Fannie Mae v Youkelsone*, 303 AD2d 546 [2003]). On this record, plaintiff failed to prove its standing with competent evidence to be entitled to the relief demanded in the complaint (*see Wells Fargo Bank Minn. v Mastropaolo*, 42AD3d 239 [2007]; *TPZ Corp. v Dabbs*, 25 AD3d 787 [2006]; *Fannie Mae v Youkelsone*, 303 AD2nd 546 supra: Aurora Loan Servs. V Grant, 17 Misc 3d 1102(A) Sup. Ct. Kings County 2007.

Accordingly, defendant's motion to dismiss the complaint is **GRANTED** upon the ground that plaintiff lacks standing to maintain this action.

The foregoing constitutes the decision and Order of the Court.

Dated: March 12, 2008

"A foreclosure Plaintiff must provide documentation that is the owner and holder of the note and mortgage as of the date the foreclosure action is filed."

Judge Kathleen M. O'Malley

CASE STUDY 12

Judicial Order by Judge O'Malley

Case Study Twelve

UNITED STATES DISTRICT COURT
NORTHERN DISTRICT OF OHIO
EASTERN DISTRICT

IN RE: FORECLOSURE ACTIONS
Case Nos.

: 07cv1007	07cv2660
: 07cv1059	07cv2677
: 07cv1060	07cv2776
: 07cv1122	07cv2789
: 07cv1252	07cv2797
: 07cv1367	07cv2826
: 07cv1515	07cv2951
: 07cv1827	07cv2961
: 07cv1872	07cv2963
: 07cv1936	07cv2993
: 07cv1981	07cv3022
: 07cv1985	07cv3039
: 07cv1992	07cv3143
: 07cv2010	07cv3259
: 07cv2257	07cv3306
: 07cv2636	
: 07cv2643	

JUDGE KATHLEEN M. O'MALLEY

ORDER Section I of the United States District Court for the Northern District of Ohio=s *Fifth Amended General Order No. 2006-16* (October 10, 2007), captioned "The Complaint and Service,"outlines specific filing requirements applicable to the numerous private foreclosure actions being filed in federal court. Specifically, Section 1.2.5 of that order provides:

1.2 The complaint must be accompanied by the following:

1.2.5 An affidavit documenting that the named plaintiff is the owner and holder of the note and mortgage, whether the original mortgagee or by later assignment, successor in interest or as a trustee for another entity.

--

None of the amendments to the order altered Section 1.2.5. That section has remained the same. Regardless, by its express terms, the *Fifth Amended General*

Order No. 2006-16 (October 10, 2007) applies to all then-pending and new fore-closure actions.

The Court is only concerned with the date on which the documents were executed, not the dates on which they were recorded (if recorded) with the county recorder's office.

Fifth Amended General Order No. 2006-16 (October 10, 2007) (Emphasis added).1 A foreclosure plaintiff, therefore, especially one who is not identified on the note and/or mortgage at issue, must attach to its complaint documen-tation demonstrating that it is the owner and holder of the note and mortgage upon which suit was filed. In other words, a foreclosure plaintiff must provide documentation that it is the owner and holder of the note and mortgage as of the date the foreclosure action is filed.

It is reasonably clear from Section 1.2.5 that an affidavit alone, in which the affiant simplyattests that the plaintiff is the owner and holder of the note and mortgage, is insufficient to comply with Section 1.2.5's "documentation" re-quirement. To the extent a note and mortgage are no longer held or owned by the originating lender, a plaintiff must appropriately document the chain of ownership to demonstrate its legal status *vis-a-vis* the items at the time it files suit on those items. Appropriate "documentation" includes, but is not limited to, trust and/or assignment documents executed before the action was com-menced, or both as circumstances may require.

In this case, the plaintiff is not identified on the note and mortgage as the originalowner/holder, and has either: (1) not timely filed adequate documen-tation demonstrating that it was the owner and holder at the time it filed suit; or (2) filed documentation indicating that an assignment or execution of trust interest occurred, but occurred after the filing of the complaint.

Accordingly, the plaintiff's complaint does not comply with Section 1.2.5 of the Court=s *Fifth Amended General Order No. 2006-16* (October 10, 2007).3 This case is **DISMISSED without prejudice. Pursuant to the Court's local rules, if re-filed, this case shall be marked as related and reassigned to the undersigned.**

IT IS SO ORDERED.
s/**Kathleen M. O'Malley**

KATHLEEN McDONALD O'MALLEY
UNITED STATES DISTRICT JUDGE
Dated: November 14, 2007

"While the Plaintiff have pled that they have standing. . . they may not have had standing at the time when the foreclosure complaint was filed."

Judge Thomas M. Rose

CASE STUDY 13

Judicial Order by Judge Rose

Case Study Thirteen

UNITED STATES DISTRICT COURT
SOUTHERN DISTRICT OF OHIO
WESTERN DIVISION AT DAYTON

IN RE FORECLOSURE CASES
CASE NO. 3:07CV043
07CV049
07CV085
07CV138
07CV237
07CV240
07CV246
07CV248
07CV257
07CV286
07CV304
07CV312
07CV317
07CV343
07CV353
07CV360
07CV386
07CV389
07CV390
07CV433

JUDGE THOMAS M. ROSE

OPINION AND ORDER
The first private foreclosure action based upon federal diversity jurisdiction was filed in this Court on February 9, 2007. Since then, twenty-six (26) additional complaints for foreclosure based upon federal diversity jurisdiction have been filed.

STANDING AND SUBJECT MATTER JURISDICTION
While each of the complaints for foreclosure pleads standing and jurisdiction, evidence submitted either with the complaint or later in the case indicates that standing and/or subject matter jurisdiction may not have existed at the time certain of the foreclosure complaints were filed. Further, only one of these foreclosure complaints thus far was filed in compliance with this Court's

General Order 07-03 captioned "Procedures for Foreclosure Actions Based On Diversity Jurisdiction.

Standing

Federal courts have only the power authorized by Article III of the United States Constitution and the statutes enacted by Congress pursuant thereto. *Bender v. Williamsport Area School District*, 475 U.S. 534, 541 (1986). As a result, a plaintiff must have constitutional standing in order for a federal court to have jurisdiction. *Id.*

Plaintiffs have the burden of establishing standing. *Loren v. Blue Cross & Blue Shield of Michigan*, No. 06-2090, 2007 WL 2726704 at *7 (6th Cir. Sept. 20, 2007). If they cannot do so, their claims must be dismissed for lack of subject matter jurisdiction. *Id.* (citing *Central States Southeast & Southwest Areas Health and Welfare Fund v. Merck-Medco Managed Care*, 433 F.3d 181, 199 (2d Cir. 2005).

Because standing involves the federal court's subject matter jurisdiction, it can be raised sua sponte. *Id.* (citing *Central States*, 433 F.3d at 198). Further, standing is determined as of the time the complaint is filed. *Cleveland Branch, NAACP v. City of Parma, Ohio*, 263 F.3d 513, 524 (6th Cir. 2001), *cert. denied*, 535 U.S. 971 (2002). Finally, while a determination of standing is generally based upon allegations in the complaint, when standing is questioned, courts may consider evidence thereof. *See NAACP*, 263 F.3d at 523-30; *Senter v. General Motors*, 532 F.2d 511 (6th Cir. 1976), *cert. denied*, 429 U.S. 870 (1976).

To satisfy Article III's standing requirements, a plaintiff must show: (1) it has suffered an injury in fact that is concrete and particularized and actual or imminent, not conjectural or hypothetical; (2) the injury is fairly traceable to the challenged action of the defendant; and (3) it is likely, as opposed to merely speculative, that the injury will be redressed by a favorable decision. *Loren*, 2007 WL 2726704 at *7.

To show standing, then, in a foreclosure action, the plaintiff must show that it is the holder of the note and the mortgage at the time the complaint was filed. The foreclosure plaintiff must also show, at the time the foreclosure action is filed, that the holder of the note and mortgage is harmed, usually by not having received payments on the note.

Diversity Jurisdiction

In addition to standing, a court may address the issue of subject matter jurisdiction at any time, with or without the issue being raised by a party to the action. *Community Health Plan of Ohio v. Mosser*, 347 F.3d 619, 622 (6th Cir. 2003). Further, as with standing, the plaintiff must show that the federal court has subject matter jurisdiction over the foreclosure action at the time the foreclosure action was filed. *Coyne v. American Tobacco Company*, 183 F.3d 488, 492-93 (6th Cir. 1999). Also as with standing, a federal court is required to assure itself that it has subject matter jurisdiction and the burden is on the plaintiff to show that subject matter jurisdiction existed at the time the complaint was filed. *Id.* Finally, if subject matter jurisdiction is questioned by the court, the plaintiff cannot rely solely

upon the allegations in the complaint and must bring forward relevant, adequate proof that establishes subject matter jurisdiction. *Nelson Construction Co. v. U.S.*, No. 05-1205C, 2007 WL 3299161 at *3 (Fed. Cl., Oct. 29, 2007) (citing *McNutt v. General Motors Acceptance Corp. of Indiana*, 298 U.S. 178 (1936)); see also *Nichols v. Muskingum College*, 318 F.3d 674, (6th Cir. 2003) ("in reviewing a 12(b)(1) motion, the court may consider evidence outside the pleadings to resolve factual disputes concerning jurisdiction…").

The foreclosure actions are brought to federal court based upon the federal court having jurisdiction pursuant to 28 U.S.C. § 1332, termed diversity jurisdiction. To invoke diversity jurisdiction, the plaintiff must show that there is complete diversity of citizenship of the parties and that the amount in controversy exceeds $75,000. 28 U.S.C. § 1332.

Conclusion

While the plaintiffs in each of the above-captioned cases have pled that they have standing and that this Court has subject matter jurisdiction, they have submitted evidence that indicates that they may not have had standing at the time the foreclosure complaint was filed and that subject matter jurisdiction may not have existed when the foreclosure complaint was filed. Further, this Court has the responsibility to assure itself that the foreclosure plaintiffs have standing and that subject-matter-jurisdiction requirements are met at the time the complaint is filed. Even without the concerns raised by the documents the plaintiffs have filed, there is reason to question the existence of standing and the jurisdictional amount. *See* Katherine M. Porter, *Misbehavior and Mistake in Bankruptcy Mortgage Claims* 3-4 (November 6, 2007), University of Iowa College of Law Legal Studies Research Paper Series Available at SSRN: http://ssrn.com/abstract-1027961 ("[H]ome mortgage lenders often disobey the law and overreach in calculating the mortgage obligations of consumers. … Many of the overcharges and unreliable calculations… raise the specter of poor recordkeeping, failure to comply with consumer protection laws, and massive, consistent overcharging.")

Therefore, plaintiffs are given until not later than thirty days following entry of this order to submit evidence showing that they had standing in the above-captioned cases **when the complaint was filed** and that this Court had diversity jurisdiction *when the complaint was filed*. Failure to do so will result in dismissal without prejudice to refiling if and when the plaintiff acquires standing and the diversity jurisdiction requirements are met. *See In re Foreclosure Cases*, No. 1:07CV2282, et al., slip op. (N.D. Ohio Oct. 31, 2007) (Boyko, J.)

COMPLIANCE WITH GENERAL ORDER 07-03

Federal Rule of Civil Procedure 83(a)(2) provides that a "local rule imposing a requirement of form shall not be enforced in a manner that causes a party to lose rights because of a nonwillful failure to comply with the requirement." Fed. R. Civ. P. 83(a) (2). The Court recognizes that a local rule concerning

what documents are to be filed with a certain type of complaint is a rule of form. *Hicks v. Miller Brewing Company*, 2002 WL 663703 (5th Cir. 2002). However, a party may be denied rights as a sanction if failure to comply with such a local rule is willful. *Id.*

General Order 07-03 provides procedures for foreclosure actions that are based upon diversity jurisdiction. Included in this General Order is a list of items that must accompany the Complaint.[1] Among the items listed are: a Preliminary Judicial Report; a written payment history verified by the plaintiff's affidavit that the amount in controversy exceeds $75,000; a legible copy of the promissory note and any loan modifications, a recorded copy of the mortgage; any applicable assignments of the mortgage, an affidavit documenting that the named plaintiff is the owner and holder of the note and mortgage; and a corporate disclosure statement. In general, it is from these items and the foreclosure complaint that the Court can confirm standing and the existence of diversity jurisdiction at the time the foreclosure complaint is filed.

[1] *The Court views the statement "the complaint must be accompanied by the following" to mean that the items listed must be filed with the complaint and not at some time later that is more convenient for the plaintiff.*

Conclusion

To date, twenty-six (26) of the twenty-seven (27) foreclosure actions based upon diversity jurisdiction pending before this Court were filed by the same attorney. One of the twenty-six (26) foreclosure actions was filed in compliance with General Order 07-03. The remainder were not.[2] Also, many of these foreclosure complaints are notated on the docket to indicate that they are not in compliance. Finally, the attorney who has filed the twenty-six (26) foreclosure complaints has informed the Court on the record that he knows and can comply with the filing requirements found in General Order 07-03.

[2] *The Sixth Circuit may look to an attorney's actions in other cases to determine the extent of his or her good faith in a particular action. See Capital Indemnity Corp. v. Jellinick, 75 F. App'x 999, 1002 (6th Cir. 2003). Further, the law holds a plaintiff "accountable for the acts and omissions of [its] chosen counsel." Pioneer Inv. Services Co. v. Brunswick Associates Ltd.Partnership, 507 U.S. 380, 397 (1993).*

Therefore, since the attorney who has filed twenty-six (26) of the twenty-seven (27) foreclosure actions based upon diversity jurisdiction that are currently before this Court is well aware of the requirements of General Order 07-03 and can comply with the General Order's filing requirements, failure in the future by this attorney to comply with the filing requirements of General Order 07-03 may only be considered to be willful. Also, due to the extensive discussions and argument that has taken place, failure to comply with the requirements of the General Order beyond the filing requirements by this attorney may also be considered to be willful.

A willful failure to comply with General Order 07-03 in the future by the attorney who filed the twenty-six foreclosure actions now pending may result in immediate dismissal of the foreclosure action. Further, the attorney who filed the twenty-seventh foreclosure action is hereby put on notice that failure to comply with General Order 07-03 in the future may result in immediate dismissal of the foreclosure action.

This Court is well aware that entities who hold valid notes are entitled to receive timely payments in accordance with the notes. And, if they do not receive timely payments, the entities have the right to seek foreclosure on the accompanying mortgages. However, with regard the enforcement of standing and other jurisdictional requirements pertaining to foreclosure actions, this Court is in full agreement with Judge Christopher A Boyko of the United States District Court for the Northern District of Ohio who recently stressed that the judicial integrity of the United States District Court is *"Priceless."*

DONE and **ORDERED** in Dayton, Ohio, this Fifteenth day of November, 2007.

s/Thomas M. Rose

THOMAS M. ROSE
UNITED STATES DISTRICT JUDGE

Copies provided:
Counsel of Record

"Foreclosure firms are so used to actions just going through unopposed. Now people are paying attention and pointing out the gaps. When I raise these defenses in foreclosure proceedings the shocked response from lenders is that 'it is a technicality'. Well, not paying your mortgage is a technicality, too."

Andrew Pizor, Counsel for Connecticut
Fair Housing Association

Fraud and Fraudulent Misrepresentation

Fraud occurs when misrepresentations are intentionally made in the inducement or execution of a contract or transaction. The misrepresentations must be material to the transaction, made with the knowledge that they are false and used to induce the party to act. They also must cause harm. Misrepresentations can include statements used in the inducement and execution of a fraudulent loan transaction. There is also fraudulent concealment in which, for instance, your broker or lender avoided disclosing the true terms of your toxic loan.

Fraudulent misrepresentation is alleged in predatory lending cases when borrowers were placed in loans that lenders knew were toxic; where transparency was compromised; when fees were stated as loan requirements, such as prepayment penalties, and when true loan terms were not disclosed.

Fraud can occur in the origination and processing of the loan by brokers, builders, appraisers, nominal lenders and actual lenders. Fraud can occur at the closing when true parties are not disclosed; when illegal kickbacks, referral fees and rebates are not disclosed; when borrowers are not informed

that their loan has been sold as a security. During servicing, fraud can occur when borrowers are not informed that their loan has changed hands multiple times or that their note has been sliced and diced into a mortgage backed security. Investor fraud has also been alleged with regard to inflated credit ratings which drove the price of mortgage backed securities higher.

Since fraud can only be alleged after the person becomes aware of being defrauded, filing a fraud claim has an extended statute of limitations. Many cases outlined in this book allege fraud. The following case in particular illustrates a pattern of fraud.

CASE STUDY 14

Philip Clark and Tania Haris
v.
Safe Harbour et al

Case Study Fourteen

IN THE UNITED STATES DISTRICT COURT
MIDDLE DISTRICT OF FLORIDA
TAMPA DIVISION

PHILIP CLARK and TANIA HARRIS,
Plaintiffs,

v.

PETER JAMES PORCELLI II, BONNIE HARRIS,
CHRISTOPHER TOMASULO, MICHAEL WALTER GAINES,
THOMAS CLAYTON LITTLE, ATTILA MADYAS TOTH,
KYLE REID KIMOTO, SHANE BOSWELL,
JOSEPH E. MADDOX III ,
SAFE HARBOUR FOUNDATION OF FLORIDA INC.,
SAFE HARBOUR FOUNDATION INC.,
SILVERSTONE LENDING LLC,
SILVERSTONE FINANCIAL LLC,
JOHN DOES No. 1-20.
Defendants.
Case No.:

COMPLAINT AND DEMAND FOR JURY TRIAL
INTRODUCTION

If Peter James Porcelli II had a motto, it might be "Try, try again." This past May, he plead guilty to all counts of a 19-count federal indictment for his involvement in a boiler-room cold-calling operation that collected millions of dollars in fraudulent membership fees for phony credit-card applications, leaving untold thousands of victims in his wake. That scheme had gone bust in 2004, when the Federal Trade Commission sought and obtained a federal injunction preventing Porcelli and his associates from ever again involving themselves in offering "credit products" — including financing and loans of any kind — to consumers.

Unfortunately for hundreds of Florida families, Porcelli and the others did not heed the terms of that injunction. In 2004 he and his associates formed the so-called "Safe Harbour Foundation." The Foundation's Articles of Incorporation claimed that the group's purpose was to "help save homeowners from foreclosure by introducing them to lenders." The real purpose was to introduce homeowners to Porcelli, so that he and his associates could defraud them with

illegal loans, steal the title and the equity in their homes, and ruthlessly evict them as soon as he could.

Even now, as Porcelli begins a 13-year sentence in federal prison, the criminal enterprise he set in motion is still active, threatening to evict more families and suck dry the one asset most Florida families have — the equity in their homes.

The families that Porcelli victimized slowly learned about each other, and have started to pool their efforts to fight back. Some still might save their homes from foreclosure or worse — others just hope to recover some fraction of the savings they lost. Either way, they are all determined that Porcelli should never be allowed to victimize anyone else the way he and his accomplices victimized them.

JURISDICTION AND VENUE

1. This Court has jurisdiction under 28 U.S.C. § 1331, providing for original jurisdiction of the U.S. District Court for civil actions arising under the laws of the United States.

2. Venue lies in the Middle District of Florida under 28 U.S.C. § 1391 (b) (2), for claims not arising in diversity, because a substantial part of the events or omissions giving rise to the claim occurred within the District, and a substantial part of property that is the subject of the action is situated within the District.

PARTIES

3. Plaintiff Philip Clark is an adult resident of Florida, living within the Middle District of Florida and owning a home within the District at the time these claims arose.

4. Plaintiff Tania Harris is an adult resident of Florida, living within the Middle District of Florida and owning a home within the District at the time these claims arose.

5. Defendant Peter J. Porcelli II is an adult resident of Florida, living within the Middle District at the time these claims arose. He is also known as "Peter James."

6. Defendant Bonnie Harris is an adult resident of Florida, living within the Middle District at the time these claims arose.

7. Defendant Christopher Tomasulo is an adult resident of Florida, living within the Middle District at the time these claims arose.

8. Defendant Michael Walter Gaines is an adult resident of Florida, living within the Middle District at the time these claims arose.

9. Defendant Thomas Clayton Little is an adult resident of Florida, living within the Middle District at the time these claims arose.

10. Defendant Attila Madyas Toth is an adult resident of Florida, living within the Middle District at the time these claims arose.

11. Defendant Shane Boswell is an adult resident of Florida, living within the Middle District at the time these claims arose.

12. Defendant Joseph E. Maddox III is an adult resident of Florida, living within the Middle District at the time these claims arose.

13. Defendant Kyle Reid Kimoto, upon information and belief, is an adult resident of Nevada. He is also known as "Kyle Reid."

14. Defendant Kathy Wellington, upon information and belief, is an adult resident of Florida.

15. Defendant First American Title Insurance Company is a corporation organized under the laws of Florida and whose principal place of business is Clearwater, Florida.

16. Defendant Safe Harbour Foundation of Florida, Inc. is a corporation organized under the laws of Florida and whose principal place of business is Clearwater, Florida.

17. Defendant Safe Harbour Foundation, Inc. is a corporation organized under the laws of Nevada and whose principal place of business is Las Vegas, Nevada.

18. Defendant Silverstone Lending, LLC, is a limited liability company organized under the laws of Florida and whose principal place of business is Clearwater, Florida.

19. Defendant Silverstone Financial, LLC, is a limited liability company organized under the laws of Florida and whose principal place of business is Clearwater, Florida.

20. Defendants John Doe, Nos. 1-20, are unknown parties who may have an interest in the real property at issue in this action.

21. All Defendants, except the John Doe defendants, are hereafter referred to as the "Known Defendants."

FACTS COMMON TO ALL COUNTS
Porcelli and Bonnie Harris form The Safe Harbour Foundation, Silverstone Lending, and Silverstone Financial

22. Porcelli and Bonnie Harris, in December of 2004, formed The Safe Harbour Foundation of Florida, Inc. ("SHF"), a Florida corporation.

23. That same month, Porcelli and Bonnie Harris also formed Silverstone Financial LLC. ("Silverstone Financial").

24. In June of 2005, Porcelli and Bonnie Harris formed Silverstone Lending, LLC ("Silverstone Lending")

25. Little materially participated in preparing the required corporate paperwork with the State of Florida for SHF, Silverstone Financial, and Silverstone Lending, and served as the registered agent for each company.

26. Little was aware of the federal injunctions against Porcelli, Bonnie Harris, and Tomasulo at the time he assisted with the formation of SHF, Silverstone Financial, and Silverstone Lending.

27. Shane Boswell, of 12890 Automobile Road, Suite A, in Clearwater, Florida — the same address as the company — and Joseph E. Maddox III, of 7002 67th Street North, in Pinellas Park, Florida, both served as directors of SHF.

28. SHF holds itself out as a non-profit organization, but upon information and belief, has not registered as such with either the Internal Revenue Service or the State of Florida.

29. In its articles of incorporation, SHF stated the company's purpose was to "help save homeowners from foreclosure by introducing them to lenders."

30. At the time Porcelli and Bonnie Harris incorporated SHF, they were subject to a federal injunction from the U.S. District Court, Northern District of Illinois, prohibiting them from offering lending services to the public.

31. Tomasulo, who participated in the operation of SHF, was subject to a similar injunction at that time.

32. The federal injunction resulted from a Federal Trade Commission enforcement action, arising out of acts of Porcelli, Harris, and Tomasulo to defraud consumers by marketing false credit opportunities in the 1990's.

33. Any steps by Porcelli, Bonnie Harris, or Tomasulo to help SHF's mission of "introducing [homeowners] to lenders" would violate the provisions of that federal injunction.

Attracting and Fleecing Desperate Homeowners

34. Porcelli, Bonnie Harris, and Tomasulo operated SHF, and acted as its agents.

35. SHF, through its agents, sought out homeowners who had substantial equity in their homes but faced temporary financial distress, so that they could steal the home equity from the homeowners through fraudulent, usurious loans.

36. SHF obtained lists of homeowners facing foreclosure and then contacted them directly through the U.S. mails and over the Internet.

37. SHF developed a flyer to mail to prospective targets and a website, safeharbourfoundation.com, to draw them in as well.

38. The flyer, attached as Exhibit A and incorporated by reference herein, contained numerous misrepresentations, designed to persuade homeowners that SHF would help them save their homes from foreclosure. In fact, nearly every homeowner caught in SHF's trap has lost the very home they tried to save.

39. The misrepresentations in SHF's flyer include but are not limited to:

a. SHF "guaranteed" to "save your home from foreclosure."

b. SHF held itself out as a "non-profit" corporation when its true purpose was to enrich its owners.

c. SHF promised a "guaranteed solution to stay in your home," "immediate relief from financial pressure," and to "Save your credit."

d. SHF stated that it "has been established to give people a second chance when no one else will," and that "our goal is to keep you in your home."

e. SHF warned to "Be careful of other companies who look to profit from your misfortune," and warned of "Investment Sharks" who "want you to fail so they can benefit from your loss," implying that SHF was not such an operation.

f. Finally, SHF advised "Do not make the mistake of thinking this will work itself out. Let the Safe Harbour Foundation pull you to safety."

40. The bottom of the flyer stated, "Call Peter James" (one of Porcelli's aliases) at 800-921-6807 — SHF's office number — and gave the safeharbourfoundation.com website.

41. The safeharbourfoundation.com website bore substantially the same material misrepresentations as the mailed flyer, along with similar graphics, except that it advised to call "Kyle Reid" (one of Kimoto's aliases) at 800-621-2976.

42. Upon receiving the flyer or viewing the website, homeowners in foreclosure would typically call "Peter James" to find out how to save their homes. At this point, Porcelli, Tomasulo, or Bonnie Harris would field the call and interview the homeowner to determine how much equity each homeowner had and the extent of arrearage for the foreclosed note. If the prospective deal met their criteria, SHF and its agents would move to the next step.

43. That next step was to promise the homeowner that SHF could find a lender to make up the arrearage and avoid the foreclosure. Most often, that lender would be Silverstone Financial or Silverstone Lending, which were wholly controlled by Porcelli, and Bonnie Harris.

44. Using financial data provided by the homeowner, SHF would arrange for the lender — usually one of the Silverstone companies — to provide a high-cost, short-term loan to the homeowner, which would be used to pay the arrearage. For purposes of this Complaint, "high-cost loan" means a loan that meets the criteria in 15 USC § 1602 (aa).

45. Although most homeowners needed only a few thousand dollars to avoid foreclosure, SHF arranged for loans that incorporated finance charges, origination fees, and underwriting fees that doubled or tripled the size of the loan.

46. These charges and fees were received by SHF, the Silverstone companies, and other entities controlled by the Defendants.

47. In some cases, the loans arranged by SHF had effective annual interest rates of 500% (Five Hundred Per Cent) or greater. In all cases, they exceeded the 45% (Forty-Five Per Cent) threshold set in Fla. Stat. Chapter 687 for criminal usury.

48. In addition to the criminally usurious interest rates, the SHF loans incorporated a purchase option for the benefit of the lender, effective upon the default of the borrower.

49. Defendants calculated the option purchase price by subtracting the current equity in the home from the estimated value of the home. This allowed the option purchaser — the SHF-arranged lender — to obtain all the equity in the home by simply paying off any liens senior to its own, with little or no money going to the homeowner.

50. Because of the criminal usury, borrowers found it difficult or impossible to avoid default, thereby triggering the lender's option and effectively forfeiting all of the homeowner's equity.

51. Gaines, an attorney formerly in good standing with the Florida Bar, aided SHF in preparing and administering these option contracts. Among other acts, he prepared the option documents, used his client funds account to process the option payments, and assisted in enforcing the options in court. At the time he did so, Gaines knew that his acts furthered a scheme to defraud the Homeowners.

52. Little, an attorney aided the lenders in enforcing these options by filing suits for specific performance in state court. At the time he did so, Little knew that his acts furthered a scheme to defraud the Homeowners.

53. Toth, a Florida notary, conducted "closings" on the loans by showing up at the borrowers' homes late at night and pressuring them to sign numerous papers in a very short period of time, sometimes conducting entire "closings" in a span of mere minutes.

54. Gaines, Little, and Toth each received payments for their services in connection with the illegal loans. These payments are listed on the closing documents for each loan.

55. At no time during any loan transaction did any Defendant disclose to any Plaintiff the existence of the federal injunction violated by Defendants' operation of SHF and the Silverstone companies.

56. Due to Defendants' actions, the Plaintiffs have lost clear title to their homes and been deprived of tens of thousands of dollars of equity in their homes.

COUNT I: CIVIL RICO (18 USC § 1961 et seq.)

57. Plaintiffs restate the allegations contained in the "Facts Common to All Counts" and incorporate them herein.

58. The Safe Harbour Foundation of Florida, Inc. is an "enterprise" within the meaning of 18 USC § 1961 et seq. For purposes of this Count, it is the "RICO Enterprise."

59. All other Defendants are "persons" within the meaning of 18 USC § 1961 et seq. For purposes of this Count, they are the "RICO Persons."

60. The RICO Persons, all of whom were associated with or employed by the RICO Enterprise, participated directly and indirectly in the conduct of the RICO Enterprise's affairs through a pattern of racketeering activity and

through the collection of unlawful debt. In do doing, the RICO Persons violated 18 USC § 1962 (c).

61. The RICO Persons have also, in violation of 18 USC § 1962 (d), conspired to violate 18 USC § 1962 (c).

62. The collection of unlawful debt included the RICO Persons' attempts to obtain security for, to foreclose upon security for, and to issue demands for repayment of the usurious loans described in the "Facts Common to All Counts." It also included receiving, controlling, or managing the real estate obtained as enforcement of those usurious loans.

63. The pattern of racketeering activity consisted of a series of related and continuous acts over a span of time, affecting all Plaintiffs and as many as two hundred other victims, constituting wire fraud and mail fraud.

64. The wire fraud and mail fraud consisted in part of the RICO Persons' furthering of their scheme to defraud the Defendants and others out of the equity in their homes, by sending false statements through the U.S. Mails and over interstate wire communications. The acts of mail fraud and wire fraud violated 18 USC §§ 1341 and 1343, respectively.

65. The false statements used to perpetrate the fraud include, but are not limited to, the web site and the flyer identified in the "Facts Common to All Counts." They also include numerous communications in the U.S. Mails and via wire whose purpose was to collect on the illegal loans.

66. As a result of the RICO Persons' violations of 18 USC 1962 (c) and (d), Plaintiffs have suffered extreme economic damage.

COUNT II: TRUTH IN LENDING (15 USC § 1601 *et seq.*)

67. Plaintiffs restate the allegations contained in the "Facts Common to All Counts" and incorporate them herein.

68. Silverstone Lending, LLC, Silverstone Financial, LLC, Porcelli, Bonnie Harris, and Tomasulo are "Creditors" within the meaning of 15 USC § 1601 (f) because they originated more than two "high-cost" mortgages within a twelve-month period at the time of the events described in this complaint.

69. The Creditors had a duty to disclose certain terms of the loans they made to Plaintiffs more than three business days before the loans were made, under 15 USC §§ 1631 and 1639.

70. The Creditors failed to accurately and truthfully disclose the terms as required by law. To the extent any disclosures were made, they were materially

false and misleading, and they were not done within the time requirements in 15 USC § 1639 (b) (1).

71. The Creditors also violated 15 USC § 1639 (e) by extending loans less than five years in duration where the aggregate amount of the regular periodic payments did not fully amortize the outstanding principal balance — in other words, they required a "balloon payment."

72. The Creditors also violated 15 USC § 1639 (f) by extending loans whose principal balance of the loan increased over time because the interest payments did not fully cover the amount of interest due — in other words, the loans were negatively amortized.

73. The Creditors also violated 15 USC § 1639 (h) by extending loans without regard to the borrowers' ability to pay. In fact, the Creditors sought out borrowers who could not repay the loans as a means of obtaining the collateral.

74. Because of the Creditors' violations of 15 USC § 1601 *et seq.* the Plaintiffs have suffered extreme economic damage.

75. The Creditors' violations of violations of 15 USC § 1601 *et seq.* were knowing, intentional, willful and malicious.

76. The Plaintiffs are entitled to recover their actual damages, along with twice the amounts of the finance charges in connection with the transaction, as well as equitable relief, along with attorneys' fees and costs.

COUNT III: UNLAWFUL MORTGAGE BROKERING AND MORTGAGE LENDING (Fla Stat. Chapter 494)

77. Plaintiffs restate the allegations contained in the "Facts Common to All Counts" and incorporate them herein.

78. SHF, Porcelli, Bonnie Harris, and Tomasulo are "acting as mortgage brokers" or "associates" within the meaning of Fla. Stat. § 494.001 (3).

79. SHF, Porcelli, Bonnie Harris, and Tomasulo acted as mortgage brokers without the license required by Fla. Stat. § 494.0025 (3).

80. Silverstone Financial LLC, Silverstone Lending LLC, and U.S. Loan Servicing have each "acted as a mortgage lender" within the meaning of Fla. Stat. § 494.001 (4).

81. Silverstone Financial LLC, Silverstone Lending LLC, and U.S. Loan Servicing acted as mortgage lenders without the license required by Fla. Stat. § 494.0025 (1).

82. Defendants Porcelli, Harris, Tomasulo, Gaines, Little, Toth, Kimoto, Boswell, and Maddox, along with Defendants SHF, Silverstone Lending, and Silverstone Financial, in the course of a course of business relating to the sale, purchase, negotiation, promotion and advertisement of mortgage transactions, have directly or indirectly: (a) knowingly or willingly employed a scheme or artifice to defraud; (b) engaged in more than one transaction, practice, or course of business which operated as a fraud upon Plaintiffs in connection with the purchase or sale of any mortgage loan; and (c) obtained property by fraud, willful misrepresentation of a future act, or false promise, in violation of Fla. Stat. § 494.0025 (4).

83. Defendants SHF, Porcelli, Harris, and Tomasulo, along with Silverstone Financial, and Silverstone Lending, violated Fla. Stat. § 494.0025 (8) by paying fees and commissions related to mortgage loan transactions to prohibited parties.

84. Defendants SHF, Porcelli, Harris, and Tomasulo violated Fla. Stat. § 494.0038 by receiving mortgage brokerage fees without a written mortgage brokerage agreement.

85. Defendants SHF, Porcelli, Harris, and Tomasulo violated Fla. Stat. § 494.0041 by receiving mortgage brokerage fees in excess of the statutory maximum.

86. Defendants Silverstone Financial and Silverstone Lending violated Fla. Stat. § 494.0068 (1) by failing to make the required disclosures governing transaction fees.

87. Defendants Silverstone Financial and Silverstone Lending violated Fla. Stat. § 494.0074 by imposing lender fees and charges in excess of the statutory maximum.

88. Pursuant to Fla. Stat. § 494.0019, these Defendants are jointly and severally liable to Plaintiffs for their violations of Fla. Stat. Chapter 494, as enumerated in this count.

COUNT IV: USURY (Fla. Stat. Chapter 687)

89. Plaintiffs restate the allegations contained in the "Facts Common to All Counts" and incorporate them herein.

90. The loans arranged and made by the Known Defendants to Plaintiffs imposed excessive fees and charges in violation of Fla. Stat. Chapter 687, prohibiting usury.

91. The Known Defendants knowingly and willfully conspired to and did

charge, take or receive interest thereon at a rate exceeding 45 percent per annum on each loan made to the Plaintiffs, in violation of Fla. Stat. § 687.071 (3).

92. Pursuant to Fla. Stat. § 687.071 (7), the loans are unenforceable in Florida.

93. Pursuant to Fla. Stat. § 687.04, Plaintiffs may recover in this action against the Known Defendants, an amount equal to double the usurious interest taken.

COUNT V: DECLARATORY JUDGMENT

94. Plaintiffs restate the allegations contained in the "Facts Common to All Counts" and incorporate them herein.

95. Known Defendants' actions have clouded the title to the real estate pledged as collateral by the Plaintiffs for the unlawful loans described in the "Facts Common to All Counts."

96. Plaintiffs are entitled to a positive judicial declaration restoring their ownership in their real property and clearing any claim or encumbrance caused by Known Defendants' illegal acts described throughout this Complaint.

COUNT VI: CIVIL CONSPIRACY

97. Plaintiffs restate the allegations contained in the "Facts Common to All Counts" and incorporate them herein.

98. Known Defendants have conspired among themselves and with others to commit illegal acts and to use the illegal methods described throughout this Complaint.

99. Known Defendants have taken numerous overt acts to further the conspiracy, as set forth in the "Facts Common to All Counts."

100. Known Defendants have acted in conscious disregard of and indifference to Plaintiffs' rights and intending to cause them harm.

101. Plaintiffs have been damaged by the acts of the conspiracy and are entitled to recover those damages from Plaintiffs jointly and severally.

102. Plaintiffs are also entitled to recover punitive damages from Known Defendants, jointly and severally.

JURY TRIAL DEMAND

Plaintiffs demand trial by jury on all counts so triable.

PRAYER FOR RELIEF

Plaintiffs pray for the following relief against all Defendants, jointly and severally, concurrently or, where appropriate, in the alternative:

1. Treble damages pursuant to 18 USC § 1964, in an amount to be proved at trial, but approximately Three Million Dollars.

2. Actual damages pursuant to 15 USC § 1640, in an amount to be proven at trial, but approximately One Million Dollars.

3. Rescission of the loan agreements, pursuant to 16 USC § 1635.

4. Actual damages pursuant to Fla. Stat. § 494.0019, in an amount to be proven at trial, but approximately Five Million Dollars.

5. Double the usurious interest collected pursuant to Fla. Stat. § 687.04, in an amount to be proven at trial, but not exceeding Ten Million Dollars.

6. Injunctive and declaratory relief that the usurious loans are unenforceable pursuant to Fla. Stat. § 687.071 (7).

7. Declaratory relief restoring Plaintiffs' ownership in their real property and clearing any claim or encumbrance caused by Defendants' illegal acts.

8. Actual damages for the acts of the conspiracy, in an amount to be proven at trial, but approximately One Million Dollars.

9. Punitive damages to the maximum extent allowed by law.

Respectfully submitted,
RICARDO & WASYLIK PL

/s/ Michael Alex Wasylik
Michael Alex Wasylik, Esq.
TRIAL COUNSEL
Fla. Bar No. 0067504
P.O. Box 2245
Dade City, Florida 33526
Tel: 352-567-3173
Fax: 352-567-3193
Email: info @ ricardolaw.com
COUNSEL FOR PLAINTIFFS

"Under Federal regulations, a homeowner
who can show that he/she was defrauded
in connection with a mortgage may be
entitled to void the mortgage."

Legal Analyst's Blog

14

Additional Legal Weapons

These additional laws are relevant to homeowners fighting the mortgage war. In preparing your complaint, research the statute in your state to determine if your situation applies. Your attorney will be familiar with how each law can be applied in your case.

1. The Home Ownership and Equity Protection Act (HOEPA)

HOEPA protects consumers who have higher than average interest loans. HOEPA requires lenders to disclose during origination the maximum interest rate charged over the life of the loan. The Lender must provide the borrower with an Adjustable Rate Mortgage booklet that explains variable loans before the borrower pays any origination fees.

HOEPA claims challenge excessive interest payments, prepayment penalties, higher interest default rates, negative amortized loans, and loans given to borrowers who cannot pay (toxic loans). HOEPA is associated with TILA. Borrowers can rescind high interest loans under HOEPA for up to three years.

2. Unjust Enrichment

Unjust enrichment is a claim in which one party is unfairly enriched at the expense of another. In a predatory lending case, the borrower can claim that the conspiracy of predators were enriched from the inflated loan amount and interest, while the borrower was impoverished by accepting a loan with excessive fees and costs that ultimately triggered foreclosure. Relief comes in the form of damages.

3. Racketeer Influenced and Corrupt Organization Act (RICO)

This is a complex law to interpret, and a difficult action to uphold. RICO has been argued in cases where lenders used the US Mail to commit fraud. It has also been used against lenders for false advertising of rates. It involves proving that an enterprise or a conspiracy was in effect in order to perpetrate a fraud or crime. In the case of securitized loans, the fraud perpetuated on the borrower by the conspiring broker, nominal lender and actual lender could bring about a RICO claim. RICO carries civil and criminal penalties. It has a four year limitation.

4. The Fair Housing Act

The Fair Housing Act (FHA) protects borrowers from discrimination. It ensures that people of all races and religions cannot be discriminated against during the lending process. It prohibits lenders from redlining minorities and reverse discrimination.

The Fair Housing Act also prohibits discrimination based on sex, handicap and national origins. Under FHA, borrowers can be awarded damages and attorney's fees, and lenders could face punitive damages. It has a two year limitation.

5. The Fair Credit Reporting Act

The three credit bureaus each create a profile that determines your Fair Isaac Credit Score. This score determines whether you qualify for credit and what interest rates you will be charged. Mortgages are largely qualified by credit scores, and the lower the score, the higher the interest rate. The bureaus have an obligation to investigate

disputed items and correct them. They also have online services to review your credit.

Under RESPA, a lender cannot report derogatory credit information during an investigation following an "official written request." You can challenge any late payments reported directly with the bureau by following their dispute procedures.

There are other laws including usury, negligence, civil conspiracy, conversion, breach of fiduciary duty, unfair competition, violations of the Business or Professional Code—and others, that may apply to your case.

Your attorney will review all origination, closing and servicing documents and practices, as well as any correspondence between you and your broker or lender. She will then develop your complaint based on the facts and the law.

Having read this book, it is now time to fight your mortgage war.

This book has outlined the issues, tactics, war plan and your arsenal of legal weapons. You can win this war, just like the homeowners profiled in this book. It is not too good to be true. You deserve damages and you deserve to get your house free and clear. It is the least you deserve, given how you have been treated by your lender.

I hope that the plan of engagement outlined in this book will also help you heal from the trauma of almost losing your precious home. If you need professional help in dealing with the stress and anxiety of a lawsuit, please seek out a psychotherapist or psychiatrist who can support you throughout your ordeal.

It is time for your personal bailout. It is time for you to get back your American dream. Do not be intimidated and do not give up until your case is heard in court. Your home is worth fighting for. Good luck.

I will be rooting for you.

Iris Martin, M.S., Psychological Services, University of Pennsylvania, is an expert in transformational psychology. In 1985, she created "Corporate Therapy," which became a global model for organizational transformation among Fortune 500 organizations worldwide. It was even adopted by President Clinton and used during his second Administration on key domestic and global initiatives. Based on her groundbreaking and bestselling book *From Couch to Corporation*, which won the prestigious "One of the Most Important Books in Psychology" Award by the American Psychological Association, executives, politicians, consultants and coaches have built careers using this systemic bottom line model, and the book is required reading in many graduate psychology and business programs around the world.

As a political activist, Iris has served on Governor Ed Rendell's exclusive finance committee for over a decade, is a member of the Clinton Global Initiative and the White House Millennium Council, and is the former Pennsylvania Chairwoman of the DNC's Women Leadership Forum. While at the White House, Iris created a documentary featuring the transformational work of both Hillary and Bill Clinton, as well as co-wrote the Clinton

Administration's "Scorecard of Achievements" published by the Democratic National Committee and a position paper outlining the transformations achieved by President Clinton. She also contributed to two States of the Union Addresses and other key presidential initiatives.

Iris Martin's first novel, *The President's Psychoanalyst*, was optioned by Goldie Hawn and her production company, Cosmic Entertainment, to be made into a major motion picture. Iris relocated at the request of Cosmic to assist in its development, and has settled into Malibu, California. She is currently writing a Broadway musical based on the songs of Joni Mitchell.

Iris is also a luxury real estate investor and became interested in the mortgage meltdown when she learned about homeowners in distress. *Mortgage Wars* is her third book, which uncovers the conspiracy of predators aimed at defrauding homeowners in the name of profit, and outlines a step by step homeowners' plan of engagement against predatory lenders. Her next book, *The Power to Transform*, will be available in January 2010.

Iris is an excellent public speaker and has been a keynote speaker at LAFFERTY GROUP GLOBAL CONFERENCES, giving speeches in Paris, Stockholm, Sydney, Copenhagen, Brussels, London, Florence, Dublin and Kuala Lumpur, as well as a global speaker for IBM, a strategic partner. Her consulting clients have included IBM, Bank of Scotland, British Airways, NatWest Bank, SmithKline Beckman, Scott Paper, ARAMARK, Tennessee Valley Authority, KODAK, ATT, Gemini Consulting, The City of Philadelphia, the Police Commissioner of Philadelphia, and others.

Iris can be reached via email at pacificcoastpub@aol.com or through our web site www.yourmortgagewar.com or at Pacific Coast Publishing, Inc. 2509 Wilshire Blvd, Los Angeles, California 90052, (310) 589-5420.